Astrophotography

Thierry Legault is a world-renowned astrophotographer. In 1999, Legault received the prestigious Marius Jacquemetton prize from the Societe Astronomique de France for his astronomical photographs. He is so highly regarded in this industry that the International Astronomical Union officially bestowed the name *Legault* on asteroid #19458.

Legault co-authored the book *New Atlas of the Moon* (Firefly, 2006) and has written numerous articles about astrophotography for French and American magazines. He regularly presents courses and gives astrophotography lectures in Europe, America, and Asia.

Legault's images, most notably those of the International Space Station, have been published and broadcast worldwide, including in NASA publications, *Nature*, *Scientific American*, *The Times*, *The Wall Street Journal*, *Popular Science*, *Aviation Week*, as well as on numerous television stations including The Discovery Channel, BBC, CNN, ABC, CBS, Fox, CBC, and MSNBC.

Thierry earns his living as an engineer and is currently living in the suburbs of Paris, France.

For more information visit www.astrophoto.fr

Thierry Legault

Astrophotography

rockynook

Editor: Joan Dixon
Translation: Alan Holmes and Thierry Legault
Copy editor: Judy Flynn
Layout: Petra Strauch
Cover Design: Helmut Kraus, www.exclam.de
Printer: Friesens Corporation
Printed in Canada

ISBN: 978-1-937538-43-9

1st Edition 2014
© 2014 Thierry Legault

Rocky Nook, Inc.
802 E. Cota Street, 3rd Floor
Santa Barbara, CA 93103
www.rockynook.com

Original French title: Astrophotographie, 2nd Edition
© 2013 Groupe Eyrolles, Paris, France

 Library of Congress Cataloging-in-Publication Data
Legault, Thierry, author.
 Astrophotography / by Thierry Legault. -- 1st ed.
 pages cm
 ISBN 978-1-937538-43-9 (softcover : alk. paper)
 1. Astronomical photography. 2. Photography--Digital techniques. I. Title.
 QB121.L44 2014
 522'.63--dc23
 2013040681

Distributed by O'Reilly Media
1005 Gravenstein Highway North
Sebastopol, CA 95472

Acknowledgements

I wish to thank Alan Holmes at Santa Barbara Instrument Group (SBIG) for his generous and essential help with translating this manuscript from French to English. Thanks also to Michael Barber and Alan at SBIG for their pivotal contribution in initiating my contact with Rocky Nook publishing and facilitating further discussions.

I would like to thank Rocky Nook Publishing, and especially Joan Dixon, for their confidence in this book and their commitment to seeing it through to publication. I appreciate the excellent job they have done with the new layout and preparation of the manuscript.

I also would like to thank Arnaud Frich for proposing the idea of this book to me and to Eyrolles [the publisher of the original French edition], and for his valuable assistance in acquiring the photographs of astronomical equipment presented here. I further thank Eyrolles for offering me the opportunity to achieve this idea with total freedom in my choice of design and content. I especially thank my editor, Stéphanie Poisson, for her patience, kindness, guidance, and careful proofreading.

I must mention the pioneers of film and digital astrophotography, those for whom boundaries were made to be overcome, particularly Jean Dragesco, Christian Arsidi, Gérard Thérin, Christian Viladrich, Donald Parker, Robert Gendler, and Damian Peach. The authors who passed on to me the desire to observe and photograph the sky, including Pierre Bourge, Jean Dragesco, Serge Brunier, Patrick Martinez, and Guillaume Cannat, also were essential to my success in astrophotography.

I owe a debt of gratitude to all the software developers and webmasters who have given us the means to plan our imaging sessions and to make the most of our images, in particular Arnold Barmettler (CalSky), Chris Peat (Heavens-Above), Tony Philips (spaceweather.com), Christian Buil (IRIS), Cyril Cavadore (PRISM), and Jean-Philippe Cazard (Astrosurf). I owe special thanks to Christian Buil, who gave me the desire to get into digital photography and helped me succeed through his CCD cameras, software, and writings that have taught me so much.

I also thank the many distributors who have put their equipment at my disposal for the photographs in this book: Médas Instruments (Vichy, France), Optique Unterlinden (Colmar, France), and La Maison de l'Astronomie (Paris, France). I thank Rémi Petitdemange and Richard Galli (Optique Unterlinden), Thomas Maquaire (Nikon France), Vincent Hamel (Meade France), Scott Roberts (Explore Scientific), Corey Lee and Bryan Cogdell (Celestron), and Nick Hudson (True Technology Ltd).

I must acknowledge the contribution of my course trainees and all amateurs who, with their relevant questions over the years, helped me to compose this book so that the answers flow as clearly as possible. I also thank all the amateurs who have given me words of encouragement online and during conferences, meetings, and workshops.

Many people from all around the world have helped me photograph celestial wonders, especially François Colas, Jean-Luc Dauvergne, and the staff of the Kennedy Space Center. I have been helped by many people and organizations who aided my quest to photograph the southern sky and several total eclipses under the best conditions, particularly Serge Koutchmy, Jaime Vilinga, the Ministry of Research and Technology of Angola, and the University of Luanda, as well as all those who warmly welcomed us in Tchivinguiro, Angola.

Table of Contents

Foreword

Look upward on a hot summer night. The stars are right there, at your fingertips, just waiting to be photographed. Find a spot away from the city lights, set up your camera on a tripod, adjust the zoom to the wide-angle position, choose a constellation, or just aim randomly toward the Milky Way. Focus manually, and start a 20-second exposure. Congratulations, you just captured your first astronomical photograph! If you enjoyed the challenge and want to go further, this book is written for you. It is also for those who are disappointed in their results and want to learn how to improve.

The book you are holding in your hand contains most of what I experienced and learned over a period of more than 20 years using telescopes, digital cameras, CCD cameras, video cameras, and software of all kinds. After deciding that the advent of digital sensors marked the beginning of a new era in amateur astronomy, I bought my first CCD camera in 1993. It is with the same enthusiasm that I continue to photograph the night sky in all its facets today. One can say that the digital revolution has kept its promise: the results achieved by many amateurs today exceed the best results of the greatest observatories a generation ago.

Do not be intimidated by the number of pages in this book. It is due to the scope of the topic and the wide variety of celestial objects available to photograph. You cannot photograph a galaxy in the same manner that you would a planet or an eclipse. Focal lengths used to photograph the entire celestial sphere (page 9) and Saturn (page 80) differ by a factor of more than a thousand! In addition, a wide variety of imaging equipment is now available, and it is necessary to discuss all the types of gear commonly used in astrophotography. For example, the explanation in chapter 5 about the advantages and disadvantages of refractors doesn't apply to you if you own a Newtonian telescope—unless you decide, after reading these pages, to change your setup!

I designed this book to make it as complete and self-sufficient as possible. However, this is not a course in digital photography, computers, or general astronomy, and reading some additional resources about those subjects may therefore be useful. Anyway, you do not need to be a computer whiz or an optical scientist to capture

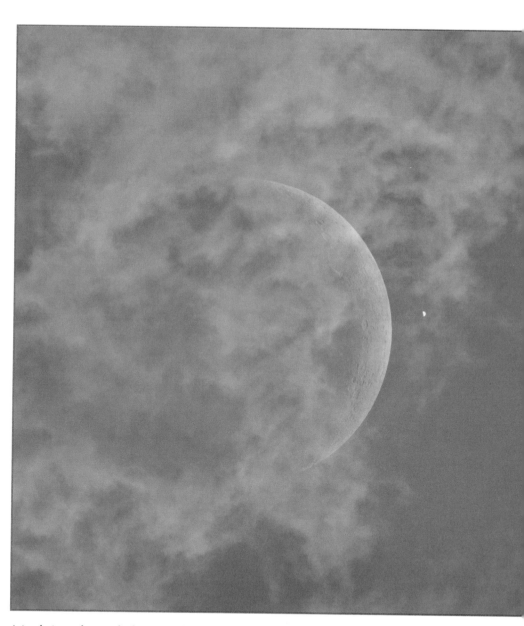

Astrophotography can also be practiced in broad daylight, and even in the presence of clouds, as was the case for this close approach of the moon and Venus on June 18, 2007

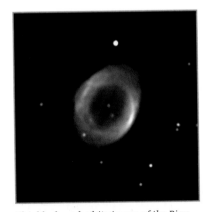

This black-and-white image of the Ring Nebula in Lyra is of particular importance to me. After several nights with unconvincing results, it was my first presentable deep-sky image, made with a CCD camera and an 11" Schmidt-Cassegrain telescope in the spring of 1994. It was this image that encouraged me to persevere in astrophotography.

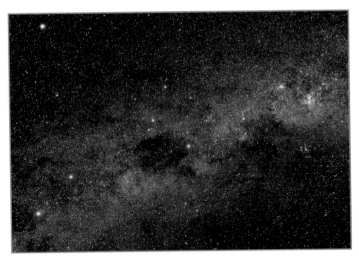

The southern Milky Way, photographed with a DSLR, crosses the beautiful constellations of the Southern Cross, Centaurus, and Carina

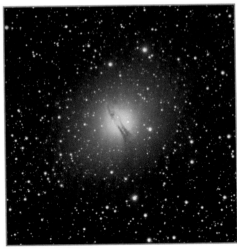

The galaxy NGC 5128 (Centaurus A), photographed with a CCD camera and a 4" refractor using the techniques described in chapter 7

beautiful pictures; astrophotography is within the reach of all. Nevertheless, this book does not claim that by waving a magic wand you'll get images anywhere similar to those found in astronomical magazines and books. Some subjects are easy to photograph and require little equipment, while others require complex and expensive gear. Above all, beyond the hardware and software aspects of imaging, do not forget a vital link in the chain of imaging: you. Take your time! In many respects, astrophotography can be compared to learning a musical instrument; both require a bit of practice and perseverance, plus a touch of curiosity and common sense. How many times have we seen amateurs fall victim to the horseman syndrome—"when I fall it's always because of my horse"—and endlessly buy larger, heavier, more expensive, and in theory, more powerful equipment, mistakenly thinking that the new items would produce better results than what they had obtained using a telescope or a camera that they had not taken sufficient time to master?

You will not find here an exhaustive overview or detailed user manual for all hardware and software available for this market. Since these products are becoming more numerous every day, and are constantly evolving, this book could not go into such details without becoming quickly obsolete. When I do mention particular brands or refer to a product, it is usually to highlight the special features they

offer. But if I don't mention a specific instrument, camera, or software package by brand, it doesn't mean that I don't recommend them or that they not useful. Instead, I attempted here to present the basic concepts and outline the general techniques you'll need tonight, or in 10 years, as well as solutions to small problems you will inevitably encounter in the development of your skills, whether on the first or the hundredth evening spent capturing astroimages. If there is a hundredth! You have every right to practice astrophotography only two nights a year, during your vacation. In this case, your requirements and technical resources will certainly not be comparable to those of an avid enthusiast who spends several nights a month pursuing the best possible result.

Armed with the basics found in this book, you'll be able to determine the gear most suited to your needs, your requirements, and your budget from the manufacturers' offerings, and you will be able to distinguish between marketing hype and real quality. You'll also be able to properly implement the image-processing techniques discussed in this book with whatever software package you have chosen.

Discover and experience astrophotography at your own pace and with the equipment you already have; don't try to apply all the techniques described in this book on the first day, and don't rush out to buy all the equipment

mentioned here. Simply look for the answers to your questions as they arise.

I also hope this book helps to refine your vision so that you can identify excellence, on your photographs or those of others, and more important, so you identify areas that need improvement and how to achieve better results. However, we should keep in mind that a result can't be properly assessed without considering the power of the equipment used, and the experience of the imager.

I attempt to explain, as much as I can, the reasons behind some techniques. Recipes applied blindly seldom produce good results, which is particularly true in astrophotography where each situation is unique. I tried to keep the book at a modest mathematical and technical level, avoiding complex formulas; we will not go further than the square root. Above all, I focused on core concepts and essential techniques, those that have proven themselves and demonstrated their effectiveness in the field; I deliberately ignored techniques with doubtful practical utility. So, I did not try to describe all of the imaginable processing methods. I focused only on those that improve the astronomical photographs in a tangible way.

Finally, this book is primarily about imaging and processing photographs taken for aesthetic purposes, commonly called "pretty pictures," and that's a wide-ranging subject! The use of images for measuring physical phenomena or for scientific research is so vast and exciting that another entire book should be dedicated to it (see the sidebar on the next page).

Thanks to the dazzling progress in the power of modern cameras and equipment, astrophotography has never been easier than it is today. May this book help you to participate in this exciting technological leap!

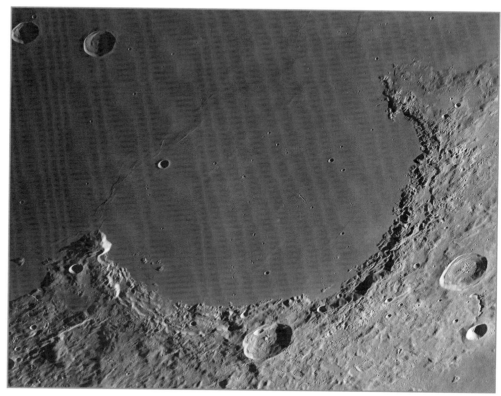

The Iris Gulf, photographed using an astronomical video camera on a 14" telescope, using the techniques described in chapter 5

How to Read This Book

As an introduction to astrophotography and imaging of the night sky, begin by reading chapter 1. It will outline how to capture pictures of celestial objects and phenomena visible with your unaided eye using only a simple camera.

To understand the different types of cameras used in astronomy and their most important characteristics, similarities, and differences, please read chapter 2. In its wake, chapter 3 explains the fundamental techniques useful for correcting the unavoidable artifacts found in RAW images produced by your camera.

Chapter 4 describes general techniques, such as focusing, that will be useful for all types of astronomical targets when you're using cameras and telescopes.

If you have a telescope, are considering acquiring one, or are already dabbling in astrophotography and want to improve your results, in chapter 5 you will find a description of the photography of planets and the moon. Chapter 6 is dedicated to solar photography and relies heavily on techniques learned in chapter 5. Lastly, imaging comets, asteroids, stars, nebulae, and galaxies is discussed in chapter 7.

A STEP TOWARD SCIENCE

You might ask, "Why bother photographing the sky as an amateur, considering the extraordinary photographs of planets, nebulae, and galaxies taken by major professional telescopes and space probes that are available at a multitude of websites and astronomical publications?" Part of the answer to this question lies in the desire to get our own pictures of the stars: after all, most of the tourists who visit the Egyptian pyramids, Niagara Falls, or the Great Wall of China also take photographs, even though these sites have already been photographed millions of times, with beautiful tomes devoted to them. The pleasure of photographing the sky is a natural progression from the visual observation of the night sky, especially since long-exposure photography offers infinitely more profound and colorful views of faint objects such as nebulae and galaxies.

Above all, many types of phenomena constantly occur in the sky. When we are amazed by an event such as a meteor shower, an eclipse, the emergence of a giant sunspot, a solar flare, or the display of a beautiful comet, photographing it is a way to retain that memory and share it with others who did not experience it.

In addition, it is entirely possible to go beyond the purely aesthetic aspect of astrophotography and use images of celestial bodies to study their behavior and deduce the physical mechanisms that govern them, or even reveal new insights. In some cases, advanced amateurs can do useful work assisting professionals who, while certainly having more sophisticated means and deeper skills, are so few that it is impossible for them to perform a complete survey of a celestial object or to continuously monitor it. The potential topics of study are numerous, most requiring no technical or scientific knowledge of imaging beyond what is described in this book. Astronomical software is available to help with the analysis. There is software for measuring stellar brightness (photometry), for calculating positions and trajectories (astrometry), and for unscrambling their spectral lines (spectroscopy). Here are some of the most common scientific topics:

- Searching for novae and supernovae and monitoring their brightness variations
- Monitoring brightness variations of variable stars, including the search for extra-solar planets
- Searching for new asteroids or comets, and determining their orbits
- Determining the shape and rotation period of asteroids from their brightness variations or stellar occultation measurements
- Determining the chemical composition of stars and comets and ascertaining certain physical characteristics, such as speed and temperature
- Monitoring the atmospheric activity of the major planets, including recording the evolution of Jupiter's cloud bands and hurricanes, seasonal cyclones on Saturn, huge dust storms and changes in the polar ice caps on Mars
- Monitoring solar activity

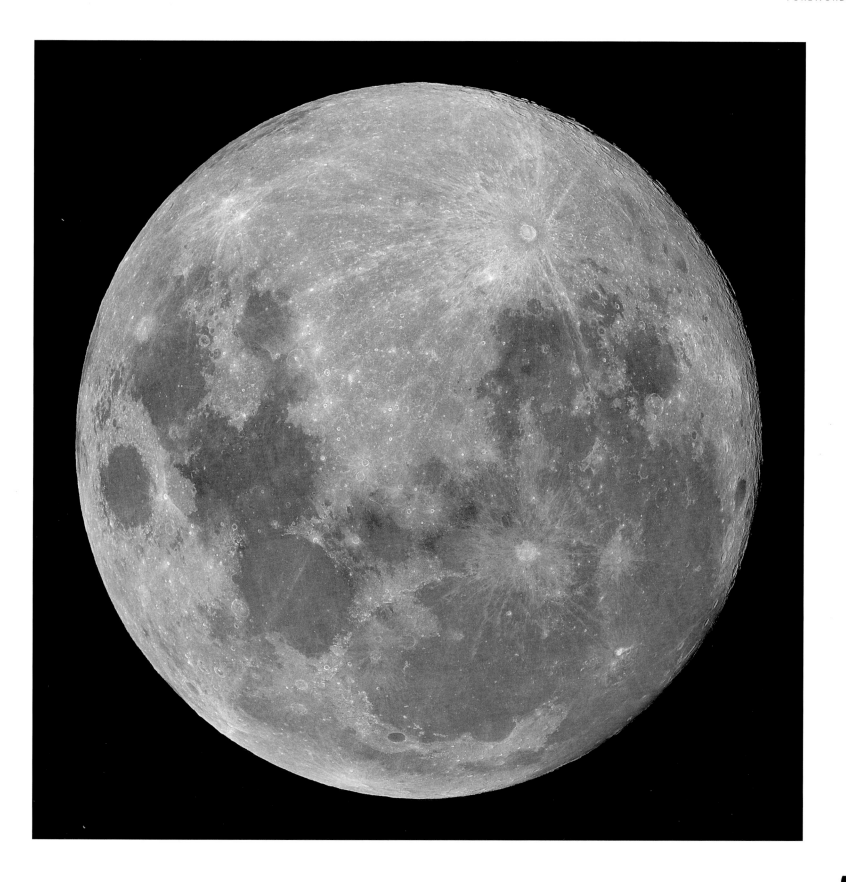

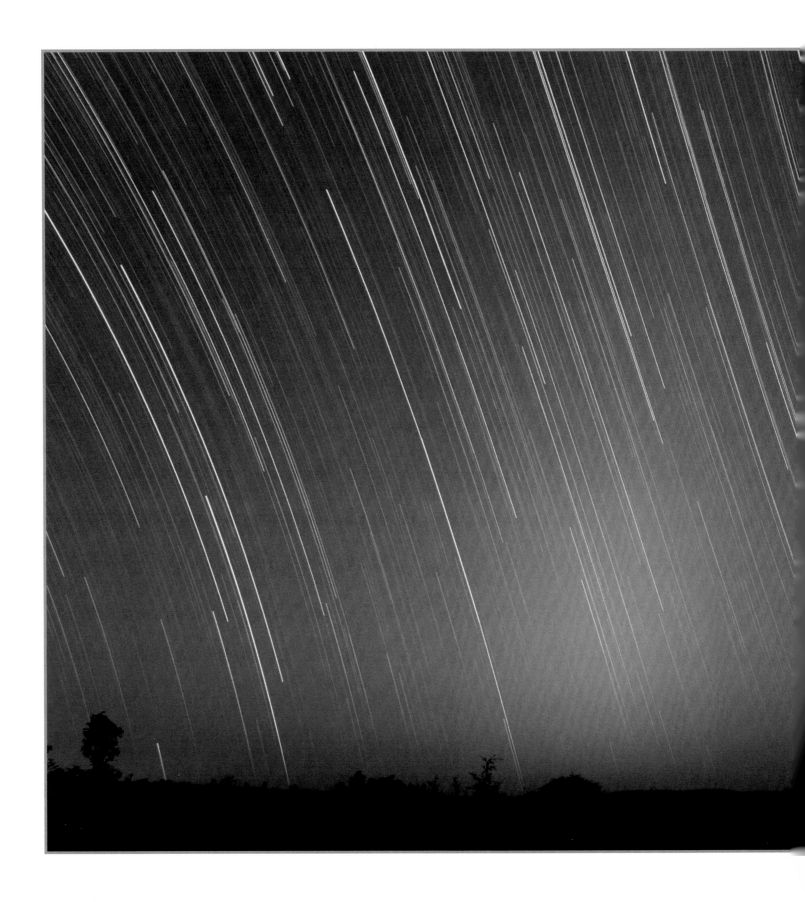

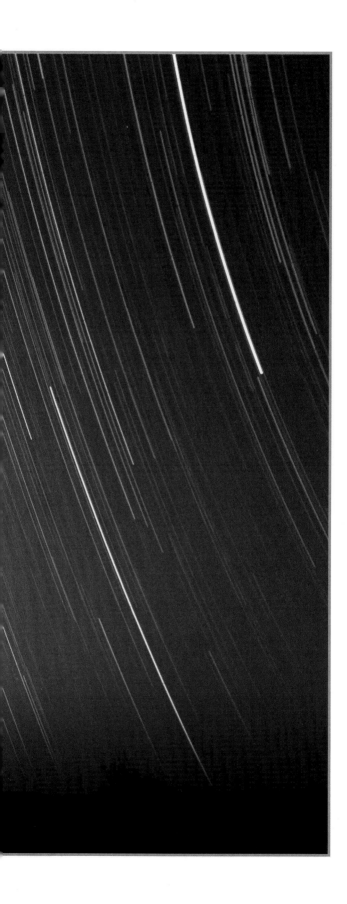

Chapter 1

Astrophotography without a Telescope

Owning an astronomical telescope—a refractor or a reflector—is not essential to photographing the sky. The most beautiful celestial sights that are visible to the unaided eye can be imaged with the same digital camera you use to photograph friends and family.

Star trails centered on the celestial equator, taken from austral Africa (Angola) with a DSLR equipped with a 16mm wide-angle lens. The photograph was taken in the easterly direction; the stars are rising and they are rotating around the celestial north pole (right side of the image) and around the south pole (left side, below the horizon). The glow in the center of the image is neither dawn nor light pollution but rather the zodiacal light.

Compact, intermediate, and DSLR cameras (top to bottom). Intermediate cameras fall somewhere between the other two categories; they have a fixed lens but offer more manual control than compact cameras.

The celestial bodies and astronomical events that are within reach of a digital camera on a tripod are numerous: constellations, star trails, planetary conjunctions, lunar crescents and earthshine, meteors, and even artificial satellites. Also, for the fortunate or traveling amateur, the zodiacal light, auroras, and lunar or solar eclipses can be photographed. It is an ideal way for sky watchers and beginning astrophotographers to become familiar with using their camera in nighttime conditions or for skilled astrophotographers to obtain magnificent photographs of celestial sights that can be seen by the unaided eye.

Of course, not all celestial objects are within reach of digital single lens reflex (DSLR) cameras. Detailed views of the planets, sun, moon, galaxies, and nebulae require an astronomical telescope with a motorized mount, as we will see in later chapters. Also, the long exposures required by subjects like star trails and meteors are limited to the most capable and versatile of all digital cameras: the DSLR.

Cameras and Settings

Digital cameras can be classified in two large categories: compact and single lens reflex (SLR) designs. Cameras in the first group usually have a nonremovable zoom lens. Cameras in the second group allow you to view the scene through a removable lens and offer more sophisticated functions (that are not always useful for astrophotography) and better image quality. Because smartphones have a fixed lens, a small sensor, and automatic modes, they fall in the compact category.

Among the numerous camera functions, one of the most important is the exposure mode. In astrophotography there is no need for complex modes and expert programs. Only one mode is essential: manual. Astrophotographers need to freely choose the exposure time and lens aperture because automatic settings are seldom reliable when it comes to photographing small or faint celestial bodies. Manual exposure mode is available on all DSLR cameras but unfortunately not on all compact cameras. However, on some compact cameras, preprogrammed modes with names like *night scene* or *starry sky* will help when you take pictures with an exposure time of several seconds at full aperture. The quality of such shots taken with a compact camera is understandably not as good as the quality of those from a DSLR.

Another advantage of a DSLR over a compact camera is its ability to have the autofocus function disabled so

APERTURE, DIAPHRAGM, AND F-STOP

On a telescope or lens, the *aperture* is the diameter of the opening (entrance pupil), which determines the amount of light the system collects. Unlike astronomical telescopes, photographic lenses incorporate a set of blades, called an iris *diaphragm*, that adjusts the aperture, much like the iris in your eye. On a lens, an aperture setting (called an *f-stop*) is usually represented by the ratio of the focal length to the diameter of the diaphragm. A smaller f-stop value corresponds to a larger aperture. A lens is commonly identified by its focal length and its full-aperture f-stop. For example, the Nikon 24mm f/2.8D lens offers the following f-stops: f/2.8, f/4, f/5.6, f/8, f/11, f/16, and f/22. On zoom lenses the maximum aperture may remain constant or change from one end of the focal range to the other. Note that the ratio between two successive f-stops is 1:1.4, but the quantity of light that passes through the diaphragm varies by a factor of two from one f-stop to the next (the square of 1.4). In astronomy, where light is never excessive, photographers often prefer the full-aperture setting. However, the optical quality of less-expensive lenses may not be good at this setting, so it helps to close down the diaphragm by one to two stops.

you can focus manually. You can try automatic focusing by carefully centering a bright star or a planet in the focus reticle, but don't expect a good result since most cameras do not lock focus on such targets. It is wise to check the sharpness of the resulting shot on the LCD screen of your camera by enlarging it as much as possible. It is often necessary to switch to manual focusing and find the correct focal setting by trial and error. If your DSLR has a live-view mode, don't hesitate to use it at maximum enlargement because it is much more precise than focusing through the viewfinder. On most interchangeable lenses, there is a mark for infinity on the distance scale, but the precision of this mark is seldom good enough for critical focusing. On most compact cameras, manual focusing is not available, but night scene modes automatically focus at infinity.

The exposure time (also called shutter speed) is the period of time when the light is allowed to hit the sensor. Fainter scenes require longer exposure times. For astrophotography the exposure time can range from 1/8000 second to several minutes.

When selecting a camera, it's important to pay attention to the longest exposure time available. Unlike DSLRs, which allow for unlimited exposure times, most compact cameras do not allow exposures longer than 30 seconds. For some compact cameras the limit is even lower—only a few seconds. Therefore, it is not possible to photograph subjects that need exposures of several minutes, like star trails or meteors, with these cameras. On compact cameras, the reason for this limitation is technological; exposures longer than several seconds result in very poor, probably unusable, images.

On a DSLR, exposures longer than 30 seconds are possible with the B (bulb) setting

A full-aperture f-stop (for example, f/1.4 or f/2 for a fixed focal-length lens or f/2.8 for a zoom lens)—which is referred to as fast lens—is an advantage for most astronomical subjects because they are so faint. On compact cameras, only optical zoom settings are useful. Digital zoom simply crops the central area of the image, with no increased detail, so this function is useless because you can just as easily crop the image later on a computer. Don't overlook fixed focal-length lenses for DSLRs, even if zoom lenses seem more useful. Fixed focal-length lenses often have a smaller full-aperture f-stop (equating to a larger aperture opening) and better image quality at the edges. For example, an ordinary 50mm lens can perform well and is reasonably priced. Similarly, Samyang manual lenses have an excellent price-to-performance ratio, and the lack of autofocus is not a problem in astronomy. The websites LensTip (www.lenstip.com) and photozone (www.photozone.de) have detailed reviews of many lenses.

Mirrorless interchangeable lens cameras (MILCs), sometimes referred to as hybrids, were the most recent to appear on the market. They share many advantages of an SLR: interchangeable lenses (though with fewer options), manual mode, and long exposure times. Many MILCs don't have a viewfinder, but that is not a prohibitive limitation for astrophotography. Entry-level MILCs have a sensor that is barely larger than sensors in compacts, so for long exposures, the MILCs with a large sensor (APS-C) are more appropriate. Before you buy an MILC, make sure you can use a remote control to start and stop exposures.

Photographing most of the astronomical subjects listed in the rest of this chapter requires a wide-angle lens (short focal length), with the exception of eclipses, which benefit from telephoto lenses with a long focal length. Good all-purpose wide-angle lenses for wide-field astrophotography have focal lengths from 10mm to 16mm and are designed for an APS-C sensor, such as the affordable 16mm f/2.8 Zenitar, 14mm f/2.8 Samyang, and 11–16mm f/2.8 Tokina. It is useful to estimate the angular field covered by the lens, to ensure that all objects will be included in the image, or to determine the best focal length depending on the circumstances. The table below lists the field of view, along the length and width of the sensor, for several common focal lengths and sensor sizes.

If your budget permits, you should purchase a DSLR that offers all the necessary functions. It will have an image quality far better than a compact camera for long

The LCD screen on this compact camera shows all the essential settings for astrophotography (here colored in yellow):
- *Flash: Disabled*
- *Focus: Infinity (∞ icon)*
- *Self-timer: Activated*
- *Exposure mode: Manual (M icon)*
- *Color balance: Daylight (sun icon)*

The angle of view depends only on the focal length and the size of the sensor. The first few rows correspond to wide-angle lenses, the last ones to telephoto lenses. The second column pertains to DSLRs with a 24 × 36mm sensor (sometimes called full-frame DSLRs) and compact and intermediate cameras whose focal lengths are usually given in terms of a 24 × 36mm equivalent, even if their sensors are much smaller. (The equivalent indicates the focal length that should be used with a 24 × 36mm sensor to obtain the same field of view. For example, the zoom lens of the Casio EX-Z120 has a range of 8–24mm and an equivalent range of 38–114mm.) An APS-C sensor (third column) corresponds to DSLRs and MILCs with sensor dimensions of approximately 15 × 23mm, which is two-thirds as large as a 24 × 36mm sensor (40 % of the surface area). For ultrawide-angle lenses (less than 16mm), the field of view is approximate because of distortion. The last column gives the exposure time for a blur of 5 pixels (due to the rotation of the earth) around the celestial equator, for a common pixel size of 5 microns. When the field is closer to the celestial pole, the maximum exposure time is longer; it can be doubled at 60° declination.

Focal length	Angle of view 24 × 36mm sensor (DSLR and compact equivalents)	Angle of view APS-C sensor (DSLR)	Exposure time for 5-pixel blur at celestial equator
10mm	100° × 122°	74° × 97°	35 sec
12mm	90° × 112°	64° × 88°	30 sec
14mm	81° × 104°	56° × 78°	26 sec
16mm	74° × 97°	50° × 71°	22 sec
20mm	62° × 84°	41° × 60°	17 sec
24mm	53° × 74°	35° × 51°	14 sec
28mm	46° × 66°	30° × 45°	12 sec
36mm	37° × 53°	24° × 35°	10 sec
50mm	27° × 40°	17° × 26°	7 sec
85mm	16° × 24°	10° × 15°	4 sec
100mm	14° × 20°	8.5° × 13°	3.5 sec
135mm	10° × 15°	6.5° × 10°	2.5 sec
200mm	7° × 10°	4.5° × 6.5°	1.5 sec
300mm	4.5° × 7°	3° × 4.5°	1 sec

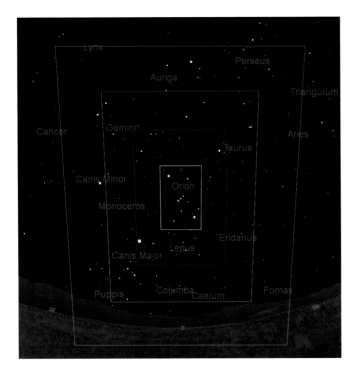

Like TheSkyX (page 185), Stellarium and Starry Night helps you prepare an imaging session by displaying a realistic view of the sky from a specified place and date in addition to the field of view of a camera that is mated to a lens or telescope. In this example, a 10mm lens with an APS-C sensor, comparable to a 16mm lens on a 24 × 36mm sensor (red rectangle), vertically encompasses the Milky Way from the horizon (Canis Major) to the zenith (Auriga). The green rectangle corresponds, respectively, to 16mm and 24mm focal-length lenses, the blue one to 24mm and 40mm, and the white one to 50mm and 85mm. The white field just covers the constellation of Orion.

exposures. Only with a high-end, expensive compact camera—like the Canon G1 X and the Sony RX100—or better yet, an MILC with a relatively large sensor (about 1″), RAW format capability, full manual mode, and a fast lens can you hope to achieve excellent astrophotos.

For any camera you plan to use, make sure it includes the necessary settings for astronomy as previously described. Avoid being pulled into the pixel race. The number of pixels is not a guarantee of image quality, no more than the number of pages in a book! The size of the pixel is more important than the number of pixels, which is why 24 × 36mm sensors, which are larger than APS-C sensors and have larger pixels, produce higher-quality images (but at a much higher price for the body and lenses). All of today's reflex cameras—whether Canon, Nikon, Pentax, or Sony—can deliver excellent results in astrophotography. At an equal sensor size, the lens is more important than the model of the body, or even the brand. Recent DSLRs generally have more pixels than older cameras; this may seem like a disadvantage because the pixels in newer cameras are smaller and collect less light. However, the efficiency of pixels (chapter 2) has increased over time, which more or less compensates for the size reduction. Don't make a habit of buying each new camera model, because oftentimes the differences are mainly cosmetic. However, if your DSLR is more than five or six years old, you should seriously consider an upgrade. Or spend your money on a better lens!

Nowadays, most cell phones include a camera. They can be utilized for short exposures—such as for eclipses, the moon, and so forth—but their lack of manual settings and tripod socket, in addition to their lower-quality images (especially regarding noise), makes them inappropriate for serious astrophotography.

Camera Mounts and Settings

Astrophotography requires that you place your camera on a tripod. It is impossible to take handheld photographs because, except for partial eclipses, the shutter speeds are always longer than 1 second. One photographic rule says that the maximum handheld exposure time is roughly equal to the inverse of the lens focal length (for example, 1/50 second for a 50mm lens). The image stabilizer (anti-shake) feature of some cameras and lenses is not effective for most astrophotography and must be deactivated when a tripod is used.

You attach your camera to a tripod by screwing the tripod into the socket on the bottom of your camera. Of course, horizontal framing (landscape mode) is possible with any tripod head, but it is best to buy a tripod that also allows vertical framing (portrait mode). The tripod should be sturdy enough to support the weight of your camera; a light compact camera does not need the same tripod as a DSLR with a heavy lens. When you include the terrestrial landscape in a scene, a bubble level will ensure that the horizon is level. A horizon that is tilted, even slightly, is very disturbing! Photo retailers offer convenient bubble levels that attach to the accessory shoe of your camera.

For very short exposures, you can press the shutter button with your finger, if the tripod is sturdy enough. But the classic solution is to use the camera's self-timer so the picture is taken 2 to 10 seconds after you release the shutter button. It is nearly essential to have a remote control. DSLR manufacturers usually offer optional remote control devices; some of them are wireless and others use a cable, and some are simply a switch and others (that are more expensive) work as intervalometers and allow you to take

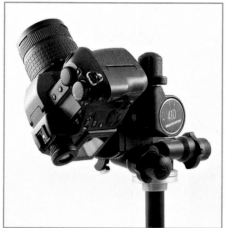
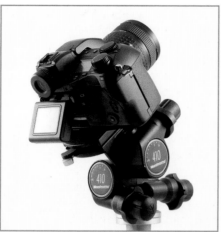
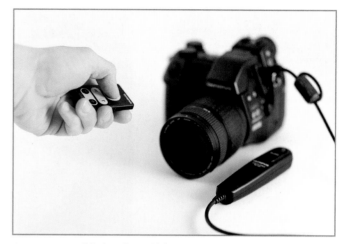

Choose a tripod head that allows vertical framing (left) and rotation up to the zenith (right)

A remote control (infrared or cable) is very useful to avoid shaking the camera

a sequence of pictures automatically. Another option is to operate the camera from a computer, if the camera manufacturer offers a remote control program for this purpose.

Before you capture an image, don't forget to turn off the flash (unless you want to illuminate the foreground) and the stabilization system, if your camera has one. Choose the highest-resolution and highest-quality JPEG format available. If your camera offers RAW format and you are familiar with processing such files, do not hesitate to use it. Minimize any sharpening options because sharpening increases noise. Avoid high ISO settings; use intermediate settings (ISO 200 to 1600), especially with compact cameras and intermediate cameras. In RAW mode the ISO setting is not as critical because the most important thing is how much light reaches the sensor, which depends on the aperture and exposure time. A higher ISO setting results in a brighter image on the screen because it amplifies the light signal, but it also amplifies noise. Appendix 7 of this book describes how you can decide on the optimal ISO setting for each DSLR. Avoid the automatic color balance setting, because the colors are not predictable. Instead, choose the daylight setting, which has a color temperature of 5500K (Kelvin). If you are shooting in severe light pollution, try using the tungsten or artificial light setting (3000K to 4000K) to reduce the reddish tint of the sky; the disadvantage is that this setting gives the stars and Milky Way a bluish color cast. The stars should generally be white, and the Milky Way should have a hint of yellow or red in some dense areas. Don't forget that if you are shooting in RAW mode, the color balance setting has no influence on the content of the RAW file, and you can change it during post-processing when you convert the RAW file to a color image.

One of the advantages of digital imaging in astrophotography is that you can take as many pictures as you want and inspect them on your camera's LCD screen immediately after capture. You can easily adjust the framing, focus, and exposure until you find the best settings. But don't forget that an LCD screen in a dark environment can be quite flattering to an image. Objects usually look brighter, sharper, and more contrasty than when you see the image later on a computer screen.

Astronomical Subjects

Planetary Conjunctions

At times, several planets are visible to the naked eye (Mercury, Venus, Jupiter, and Saturn) and may appear to be grouped closely together with the moon and bright stars in the same area of the sky. The celestial bodies seem to be close together, but it is only an effect of our perspective—their actual distances from Earth and between each other are quite different. Such groupings are inviting and easy to photograph. They are generally visible at twilight, either in the west in the evening or in the east in the morning.

Astronomy magazines usually provide forecasts of such conjunctions that specify the angular distance between celestial bodies, which allows you to decide what

A gathering of planets in May 2002 over the Palace of Versailles, taken with an intermediate camera with a 1-second exposure, zoomed in to a 35mm wide angle (left) and a 140mm telephoto angle (right, cropped image). Venus and Mars accompany the thin lunar crescent, and Jupiter is visible in the upper-left corner. Several stars in the Auriga and Taurus constellations are also visible.

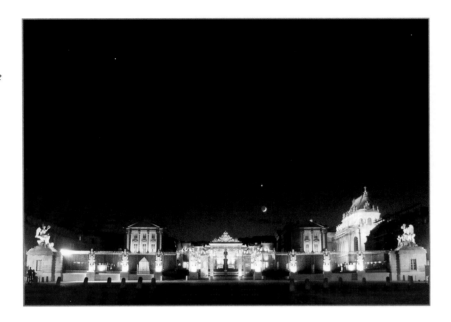

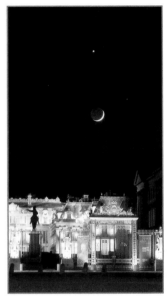

focal length you want to use (the table on page 3). Avoid framing the group too tightly because a photograph that shows only several bright points makes the scale impossible to guess. Viewers would not know if the image was taken with a telephoto lens or a wide-angle lens. Instead, include a carefully chosen foreground in the photograph, such as a nice landscape, building, or monument. A thin lunar crescent along with earthshine, taken two to four days before or after a new moon, artistically enhances such photographs and indicates the scale of the picture and the angular separation between planets.

When you attempt this type of photography, begin by taking a series of images with varying exposure times, starting at 1 second (for example, 1 second, 2 seconds, 4 seconds, etc.), and immediately check the results on the LCD screen at maximum enlargement to see which exposure time streaks the celestial objects due to the rotation of the earth. Then take your images with an ISO setting that produces a dark blue sky without overexposing the foreground or the earthshine.

Constellations and the Milky Way

Most constellations can be entirely framed with a 50mm lens when you use 35mm film or a full-frame sensor or when you use a 35mm lens with an APS-C sensor. Photographing constellations with a fixed camera is complicated by only one problem, but it is a big one: the earth rotates on its axis, which makes the celestial vault appear to rotate in the opposite direction. Beginning astrophotographers are always surprised by the speed of this movement. Indeed, it reaches 15 arc seconds per second of time near the celestial equator, which translates to $1/2°$ in 2 minutes; that's enough time for the sun or moon to move by one diameter. The angular speed decreases closer to the celestial pole, 10" per second at a declination of 50° and 5" per second at 70°.

Refer again to the table on page 3, and let's consider an example of a 20mm lens mounted on an APS-C DSLR. The angular field of view is $40° \times 60°$. If the sensor array is composed of 16 megapixels, the image measures about 3300×5000 pixels. Simple division reveals that each pixel subtends an angle of $60/5000 = 0.012°$, or 43", in the sky (this parameter is called *sampling;* the calculation will be detailed in chapter 4). Therefore, an exposure of 3 seconds on a field close to the celestial equator is long enough to show a blur of 1 pixel on the photograph. Even if the final image is reduced to fit the screen of the computer, it is quickly apparent that it is not possible to use exposures

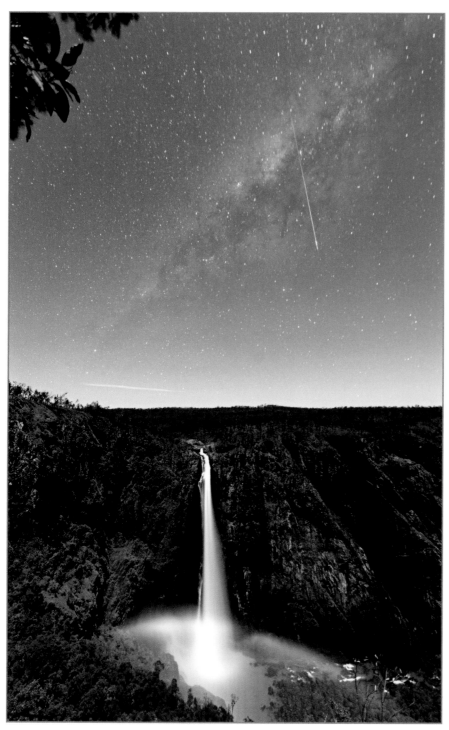

Despite the full moon that turned the sky blue, the Milky Way, crossed by a bright meteor, is visible on this 1-minute exposure taken with a 14mm f/2.8 lens on a 24 × 36mm DSLR over Wallaman Falls, Australia

These closeups of Orion's belt and sword, each with a longer exposure time, show the blurring effects of the rotation of the earth

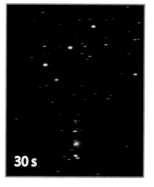

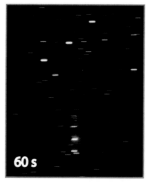

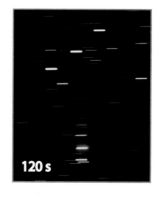

LIGHT POLLUTION

Despite the United Nations Educational, Scientific, and Cultural Organization (UNESCO) declaration that the night sky belongs to all humanity, the places in industrialized countries from which you can properly admire and photograph the universe within which our small planet glides are becoming increasingly rare. Between streetlamps that illuminate the sky more than the ground, the permanent lighting of monuments, and the devastating shopping mall floodlights that mostly illuminate the sky, it is indeed more and more difficult to avoid the effects of urban lighting. The primary tool of astronomers is not a telescope, it's a car!

In the United States, the International Dark-Sky Association works to make lighting companies and communities aware of more rational lighting solutions that are less harmful for nocturnal wildlife, migratory birds, astronomers, and public coffers. The association also works to avoid the day, not so far away, when the term *Milky Way* is only a confusing reference in fairy tales. Their effort is beginning to bear fruit; some cities and natural parks have taken light pollution seriously. The solutions are known and need only to be implemented: turn off decorative lighting late at night, install streetlamps with shields that direct all the light toward the ground, use movement sensors to activate lights only when they are needed, and so forth.

Even with a 10-second exposure, the light pollution from a city can be very detrimental to quality astrophotography

longer than about 15 seconds with such equipment. Fortunately, such an exposure is sufficient to record the Milky Way and all stars that are visible to the naked eye, especially if you use a fast lens with a wide aperture (f/1.8 to f/2.8). The maximum acceptable exposure time is inversely proportional to the focal length of the lens. For example, changing from a 50mm lens to a 24mm lens allows you to double the exposure time. Your choice of lens depends on the area of the sky and the amount of blur you are willing to accept.

The most common ISO settings used for the Milky Way are between 800 and 3200.

For photographing astronomical subjects, except eclipses, it is essential to go far away from cities and streetlights. Otherwise the stars will be drowned in a green or orange background caused by the astronomer's number one enemy: light pollution. For the same reason, you should avoid a full or gibbous moon unless it helps illuminate the landscape. Of course, the absence of clouds is also essential. Even a thin veil of high clouds is detrimental to astrophotography.

The Canon 8–15mm f/4 fisheye zoom lens (left), and the affordable Peleng 8mm f/3.5 fisheye lens (right)

The Fisheye: A Unique Lens

A fisheye lens has a very short focal length and is designed to capture an image with the largest possible field on a DSLR. When they are aimed at the zenith, the most common fisheye lenses produce a circular image with an angular diameter of 180°, which covers the whole celestial vault and the horizon. Depending on the characteristics of the fisheye lens and the sensor, this circular image may fit within the width, length, or diagonal of the camera sensor. Thus, the circular image of an 8mm fisheye lens (Sigma, Canon, Nikon, Peleng, Samyang) that has a diameter from 22mm to 25mm is fully visible on a 24 × 36mm sensor, but a 4.5mm fisheye lens (Sigma) is needed to obtain the same coverage on an APS-C sensor. For the latter, the 8mm fisheye lens would approximately fill the width of the sensor, with black corners. Thanks to these very short focal lengths, exposures of tens of seconds are possible without significant blur of the stars. Fisheye lenses are especially sensitive to both light pollution, even when miles away from a city, and moisture collecting on their prominent front element.

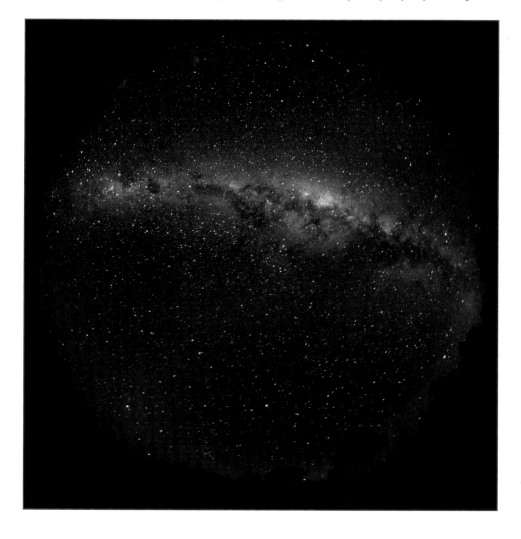

A 2-minute exposure of the entire austral sky obtained with a fisheye lens. The Magellanic Clouds are close to the horizon (top left).

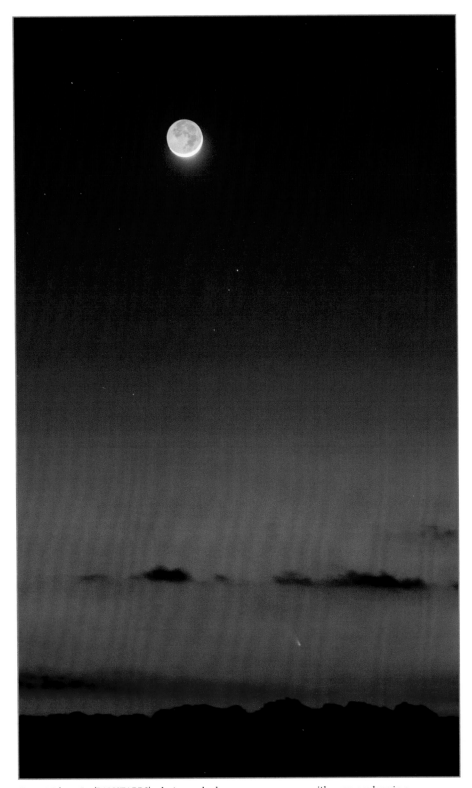

Comet C/2011 L4 (PANSTARRS), photographed near a young moon with a 135mm lens in a 2-second exposure, was hardly visible with the naked eye in the twilight of March 13, 2013

Comets

Bright (but rare!) comets, such as the comet Hale-Bopp that visited us in 1997, are easily photographed with exposures of several seconds. A comet that is fainter, but still visible to the unaided eye from dark locations, appears as a small fuzzy patch on pictures taken with the techniques for constellations described in the previous section.

Increasing the Exposure Time

To capture more stars and a better image of the Milky Way, you need to increase the exposure time. To thwart the affects of the rotation of the earth, the best solution is to track the motion of the sky with the help of a motorized equatorial mount, as discussed in chapter 7.

For a fixed camera, another solution is to combine (stack) several short exposures to obtain the equivalent of a longer exposure (preferably without any visible landscape, because it would not be sharp after it registers the star fields). For example, 20 successive 15-second exposures will give a result that is not as good as a single 5-minute exposure taken with a tracking system, but it will be much better than a single 15-second photograph. Of course, since the stars move between successive shots, it is necessary to register the images before you sum or average them during stacking. Use the following steps for software programs such as Photoshop or PaintShop Pro:

1. Open the first and the second images of the series and display them at full scale (100 %). If the files are in RAW format, open all of them and apply the same brightness and contrast settings to each file.
2. Copy and paste the second image over the first image as a new layer, and change the Blending mode of the new layer to Difference.
3. Translate the layer with the manual shifting function until you get a satisfactory superimposition of the two layers (the image is uniformly black), then change the layer mode to Normal.
4. Repeat the same operation (step 2) with the next image in the series by copying and pasting over the working image.
5. Change all layers to the Screen blending mode and merge them all together.

Register the images by translating a layer in Photoshop's Difference mode. If the registration is not correct, the stars will be doubled.

Depending on the area of the sky and the lens used to take the photographs, the registration may be a translation (combination of horizontal and vertical movement) or a rotation (the whole image rotated around a point). In the second situation, each layer has to be rotated, before translation, by an angle that you determine by trial and error. In chapter 7 we will see that most astrophotography processing programs can automatically adjust the rotation and translation of an image to combine an image set, which makes these operations faster and much more precise than the manual operation described in the previous discussion.

Star Trails

Sometimes, with the help of a wide-angle lens, you can employ the rotation of the earth to your advantage to dramatize the movement of the celestial vault* and show the aesthetic beauty of star trails curving around the pole. The exposure time increases significantly and can reach several hours. For this type of astrophotography it is critical to choose a site far from any source of light pollution; even a single streetlight is unacceptable.

The camera must be capable of taking long exposures, so only DSLRs or MILCs can be used. But even high-performance equipment is not free of a troublesome phenomenon that occurs with a digital sensor, which we will explore at length in other chapters: a thermal signal, often called thermal noise or dark current. It manifests as a large number of brightly colored points that are distributed at random throughout an image: the infamous *hot pixels*. Hot pixels become more visible as the exposure time increases, so it is preferable to take a series of photographs with exposure times ranging from 1 minute to several minutes instead of a single exposure of several hours. This also helps reduce the signal baseline level due to the sky background in the final image (even at a very dark site, the atmosphere itself emits a bit of light). The series of exposures can then be combined in a computer using the method described on page 13. The ISO setting does not need to be as high as when you photograph the Milky Way.

* The *celestial vault* is the apparent surface of the imaginary sphere on which celestial bodies appear to be projected.

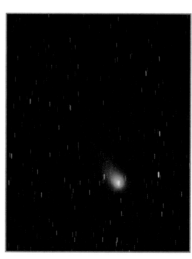

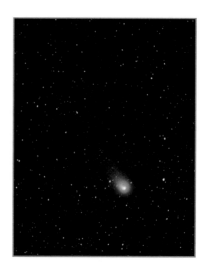

Comet C/2001 Q4 (NEAT) was visible in the sky of the Southern Hemisphere in May 2004. A single 6-second exposure (left) with a 200mm lens on a DSLR minimized the blur caused by the rotation of the earth, but it limited the visibility of the comet to its bright nucleus. A longer exposure of 1 minute (center) shows the tail of the comet, at the expense of overall image sharpness. A combination of 10 successive 6-second exposures produces, after registration, a good view of the tail without streaking (right).

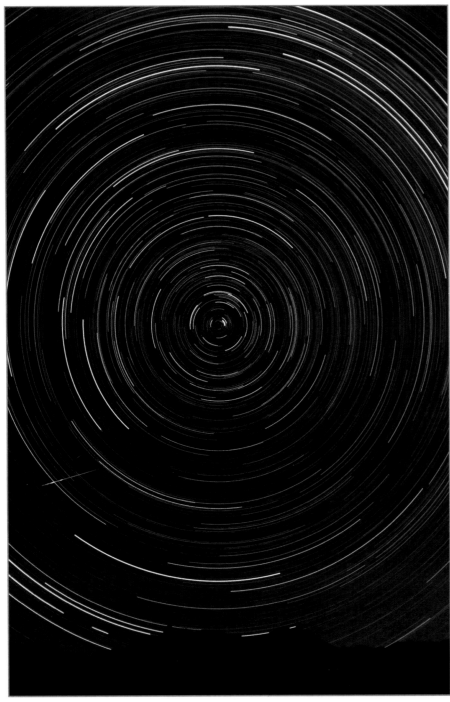

A bright Perseid meteor crosses the field of this 4-hour rotation (eight exposures of 30 minutes each) centered on the celestial north pole

Many DSLRs have a long-exposure noise reduction option. After each long exposure, the camera shoots a second frame of the same duration—but the shutter remains closed—to reproduce the hot pixels. The second exposure is automatically subtracted from the first exposure before the camera records the file on the memory card. This is why the camera is busy for 2 minutes when you take a 1-minute exposure. Although long-exposure noise reduction is recommended for photographs of constellations and comets, you must deactivate it for star trails made from a series of images because the trails would have a gap where each of the duplicate frames were taken. For star trails, the interval between exposures should not exceed 1 or 2 seconds to avoid small discontinuities in the star trails. An intervalometer helps ensure short intervals and prevents the need to touch the camera, which must remain perfectly still during the whole sequence.

The best solution to eliminate hot pixels in star trail images is to take an additional frame, after the series of exposures, with the same exposure, and leave the lens cap on the lens. This image, called a *dark frame* (described in more detail in chapter 3), must be taken at the same ambient temperature as the series of images (that is, the camera must still be outside). You can subtract the dark frame from each image in the series to correct the hot pixels, as described later.

Careful framing is essential for a successful final image. Many photographers aim their cameras at the celestial pole, which is near Polaris in the Northern Hemisphere. But you don't have to center the pole in the frame, especially if you can include a nice foreground, such as a mountain, the ocean, or a forest. The angle of rotation of a star trail around the celestial pole is proportional to the total exposure time: 15° per hour, a quarter of a turn in

AVOIDING DEW ON THE LENS

At most locales, dew may form on an exposed lens in a fraction of an hour. In humid conditions dew can form in several minutes. A lens shield can delay dew formation, but it is generally not sufficient. The solution is to warm the front of the lens. A simple way to avoid dew for several hours is to attach hand-warming heat packs, available in sporting goods stores, to your lens with a rubber band or Velcro strip. Kendrick, a manufacturer of astronomy equipment, sells dew heaters of different lengths for telescopes, eyepieces, lenses, and so forth.

This image shows star trails that are dimmed because of dew forming on the lens

A hand warmer is fastened on the lens (left). The warmer shown here is reusable; it can be reactivated in a few minutes with boiling water. You can also use a small dew resister for astronomical equipment (right).

6 hours, and a complete turn in 24 hours. You can capture a more unusual picture by aiming your camera at another area of the sky, like the celestial equator.

Considering the duration of the exposures, you must pay special attention to two problems: dew on the optics and the life of the battery. The battery must last long enough to cover the total exposure time, because you cannot interrupt the photographic session to change a battery. Since the life of a battery usually decreases at lower temperatures, it's a good idea to make preliminary tests on a cloudy night and possibly use an additional power supply for your camera (that is, an optional battery grip or AC adapter).

Unless you use long-exposure noise reduction or a dark frame, you must use software to eliminate the hot pixels before you combine the series of images. If there are not too many hot pixels, you can remove them with the duplication stamp or clone brush tool, which is also useful for removing airplane and satellite tracks. If you shot a dark frame, you can subtract it with another feature that is available in most post-processing software. In Photoshop you use the Apply Image command in the Image menu and choose the Subtract option. In PaintShop Pro you use the Arithmetic function in the Image menu. After you perform the dark-frame subtraction operation for every image in the series, you have to combine the first image with the second, then with the third, and so on. You can use the same process as before, but this time use the Lighten option in Photoshop or Brighter Pixels in PaintShop Pro. With this process the result is much more pleasant than a simple superimposition of images. If the camera was

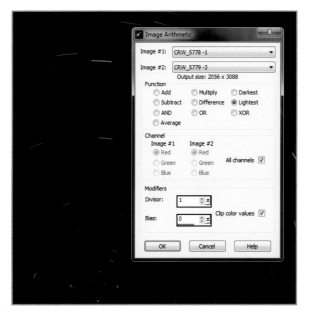

You can eliminate hot pixels by subtracting a dark frame that contains only the same hot pixels as the images in the series

When you superimpose a series of images, the star trails become faint because of the lightness of the sky background (left). Thanks to the Lighten option, you can overcome this problem (right).

absolutely still during the exposures, and if the exposures were taken at minimal intervals, the arcs of the star trails should connect nicely. There are some free software programs that combine a series of star trail images.

Meteors

Meteors, those thin streaks of light caused by interplanetary dust particles as they enter Earth's atmosphere, play hard to get. Although meteors generally last only a fraction of a second, capturing one in a photograph requires hours of patience—and a bit of luck. It is impossible to react quickly enough to aim the camera toward a meteor when one appears. The solution is to use a wide-angle lens and to expose an image as long as possible in hopes that a cooperative meteor will cross your field of view. Therefore, you use the same technique as for photographing star trails.

As with star trails, you must choose a location with no light pollution (including moonlight). The faintest meteors that are still visible to the naked eye are too fleeting to leave a trace on a photograph. To have a chance of capturing the nice streak of a bright meteor, you must use an exposure of many minutes with the lens at its largest aperture and, for a zoom lens, at its shortest focal length. Of course, it's best to shoot during a meteor shower. Several meteor showers occur each year, at fixed dates, and their intensity varies from year to year. The table below lists the most predictable meteor showers. Each shower has its own radiant (that is, the constellation from which the meteors seem to emerge), but there is an equal probability of seeing meteors in any part of the sky, so you can aim your camera in any direction.

Zodiacal Light

The zodiacal light is caused by interplanetary dust, mainly located in the plane of the ecliptic, which is illuminated by the sun. It is shaped like a large spindle of very faint light and is apparent on exposures of several minutes. It is most visible in the east one to two hours before sunrise and in the west one to two hours after sunset, but only if there is no light pollution. The best places to see the zodiacal light are in the deserts of Africa, South America, and Australia. Nowadays seeing the zodiacal light in industrialized countries is more a dream than a reality.

Polar Auroras

The auroras that are visible at the earth's polar regions are caused by the excitation of atoms in the upper atmosphere by streams of fast particles emitted by the sun during solar events such as flares and coronal mass ejections (CMEs). When the particles reach the earth, they are channeled by the earth's magnetic field. The lights are often visible at latitudes above 60°, particularly in northern Scandinavia, Iceland, Alaska, and Canada, and they are slightly more frequent during the equinoxes. The auroras look like large moving patches or draperies of light and last from a few seconds to several hours. They are usually green (ionized oxygen) but can sometimes be red (nitrogen and oxygen.) You can capture beautiful wide-angle shots in only a few seconds. Exposures longer than 30 seconds are seldom required. Spaceweather.com (www.spaceweather.com) provides information about current solar events and aurora forecasts and alerts, and it also has an aurora photo gallery.

Lunar and Solar Eclipses

Lunar and solar eclipses (described further in chapters 5 and 6) are good subjects for a still camera, but safety

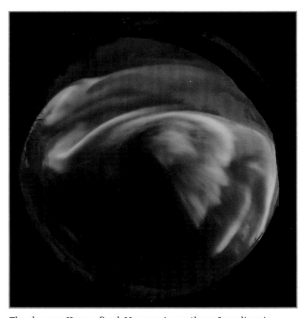

The sky over Komagfjord, Norway, in northern Scandinavia, flares with auroras in December 2012. This image was taken with a 10-second exposure with a fisheye lens. Jupiter is near the Pleiades at the top of the image.

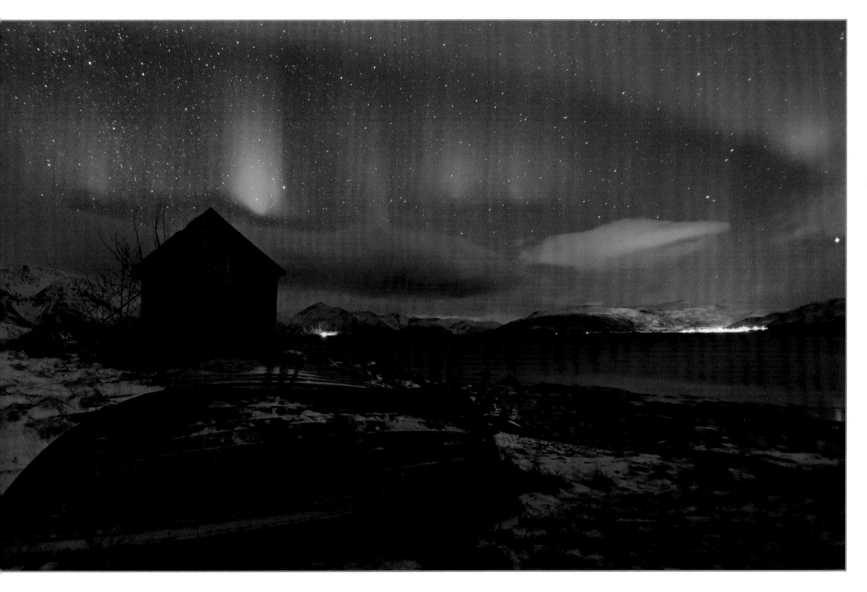

measures like filters are absolutely essential for photographing the partial phases of a solar eclipse. As stated before, you must use a telephoto lens to get a large enough image of the lunar or solar disk to discern some details. For the partial phases of a lunar eclipse, a short exposure time of about 1/1000 second is sufficient. To capture an image of earthshine at totality, you will need an exposure of one to several seconds, but make sure that the apparent movement of the moon (about 15" per second) does not create a blur of more than a few pixels. You can calculate the maximum acceptable exposure time as previously described for photographing earthshine.

To photograph a partial eclipse of the sun, and an annular eclipse or the partial phases of a total solar eclipse, you will need to securely fasten a solar filter in front of your lens. Before the eclipse, you can experiment in daylight to figure out the exposure time and avoid an unpleasant surprise after the eclipse ends. With a telephoto lens the exposure time for totality may vary by a large amount, depending on which part of the solar corona you choose to photograph (see chapter 6 for more details), but here too the rotation of the earth may limit the maximum exposure. As with a wide-angle lens, photographs that include people and landscapes can give magnificent results. Don't

Another view of an aurora, taken with a 14mm lens

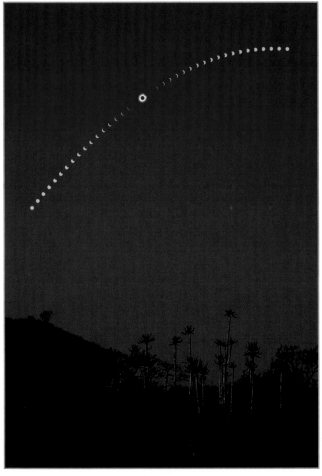

A partial lunar eclipse on December 21, 2010, photographed with a 135mm lens on a DSLR with a 24 × 36mm sensor and a 1-second exposure, at Mont-Saint-Michel, France

A total eclipse on June 21, 2001, in Angola. Because the site is in the Southern Hemisphere, the eclipse began on the right and ended on the left. The making of eclipse sequences (called beads) is described in appendix 6.

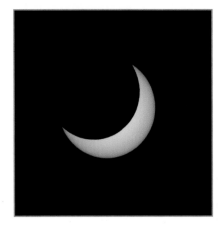

A partial eclipse taken with a 300mm lens equipped with a special filter sheet and a DSLR. The image was exposed for 1/4000 second at f/4, ISO 100.

Each hole in this sieve, which was held a few inches above a sheet of white paper, creates a small image of the partially eclipsed sun (pinhole effect)

forget to remove the filter at the beginning of the totality, and replace it immediately at the end!

Artificial Satellites

Most artificial satellites fall into two groups: low-orbit satellites and geostationary satellites.

Low-orbit satellites are at an altitude of a few hundred miles or kilometers. They complete a revolution around the earth in about 90 minutes. Some of them are visible to the unaided eye if they are illuminated by the sun; this occurs shortly before sunrise and shortly after sunset. Their apparent speed is close to that of airplanes cruising at high altitude (about 1° per second). Of course, you can recognize airplanes by their flashing lights. Both satellites and airplanes usually cause streaks on long-exposure photographs; the streaks are sometimes interrupted when the object enters the shadow of the earth.

The International Space Station

The International Space Station (ISS) orbits the earth at an altitude of about 250 miles (400 kilometers), and its brightness is comparable to that of Venus. Its orbit is inclined 51.6° to the equator; it is visible from all locations below 60° latitude. With an apparent speed of 1.2° per second at the zenith, the ISS crosses the sky from west to east in a few minutes and is visible when the sun is less than 20° below the horizon. In the evening, depending on the depth of twilight, it may disappear in the shadow of the earth before it reaches the horizon. Similarly, at dawn it may emerge from the shadow of the earth. You can find

Sunday 9 February 2014

Time (24-hour clock)	Object (Link)	Event
⊗ 19h18m57s	ISS →Ground track →Star chart	Appears 19h13m40s 2.0mag az:233.8° SW horizon / at Meridian 19h18m35s -3.5mag az:180.0° S h:49.6° / Culmination 19h18m57s -3.9mag az:151.7° SSE h:53.3° / distance: 496.8km height above Earth: 405.1km / elevation of Sun: -13° angular velocity: 0.86°/s / Disappears 19h20m36s -3.1mag az: 83.9° E h:24.5°
⊗ 20h53m08s	ISS →Ground track →Star chart	Appears 20h50m01s 1.9mag az:266.8° W horizon / Disappears 20h53m08s -0.6mag az:277.3° W h:18.2°

After you click See the International Space Station *on the home page, CalSky lists all visible passages from a specific location and their main attributes (marked in yellow): time, direction, and height of appearance, culmination and disappearance, and the position of the sun below the horizon. For the date shown in the figure, two passages are calculated. During the second passage, the ISS quickly disappears in the shadow of the earth. Click the Star Chart link to see the path of the ISS among the constellations. The Heavens-Above website shows similar passage information.*

the dates and times of ISS transits in your area on the websites CalSky (www.calsky.com) and Heavens-Above (www.heavens-above.com).

It is best to photograph an overpass of the ISS from a wide field. Use an exposure of about 2 to 10 seconds; place your camera on a tripod and use a wide-angle lens. Focus on a bright star, planet, or distant streetlight, and direct your camera at the area of the sky indicated by the calculation website. Be prepared to make a last-minute position adjustment!

Iridium Flares

The remarkable Iridium telecommunications satellites—there are about 100 of them—are in low orbit at about 480 miles (780 kilometers). Due to their polar orbit, they are visible from anywhere on earth, and their apparent speed reaches 0.5° per second at the zenith. When their flat antennas are oriented correctly, they reflect sunlight directly to the observer. This glint makes the satellite visible to the naked eye for a moment, with a magnitude approaching −8 (more than 20 times brighter than Venus!).

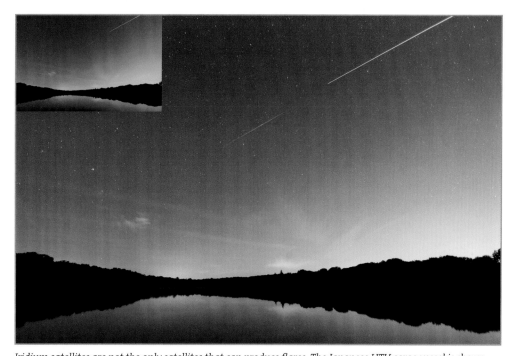

Iridium satellites are not the only satellites that can produce flares. The Japanese HTV cargo vessel is shown above the Big Dipper in this wide-angle, 30-second exposure, taken July 8, 2013, a few hours before it docked to the ISS (bright streak at top right). Because there was severe light pollution, the white balance was set to tungsten for RAW image processing, which made the pollution less obtrusive than a daylight setting (insert).

Time	Brightness	Altitude	Azimuth	Satellite	Distance to flare centre	Brightness at flare centre	Sun altitude
Sep 9, 21:24:01	-5.2	61°	110° (ESE)	Iridium 3	7 km (E)	-8.5	-12° ☽
Sep 10, 06:17:53	-1.0	58°	210° (SSW)	Iridium 42	26 km (W)	-8.4	-11° ☽
Sep 10, 21:19:59	-2.7	63°	115° (ESE)	Iridium 76	17 km (W)	-8.5	-11° ☽
Sep 11, 06:11:44	-5.6	59°	209° (SSW)	Iridium 80	7 km (E)	-8.4	-12° ☽
Sep 11, 21:15:22	-5.5	62°	116° (ESE)	Iridium 46	6 km (E)	-8.5	-11° ☽
Sep 13, 06:04:42	-1.2	55°	218° (SW)	Iridium 43	26 km (W)	-8.4	-13° ☽

Similar to CalSky, the Heavens-Above website displays Iridium satellite flashes that are visible from a specific location, along with their characteristics: date and time, magnitude, position in the sky (elevation above the horizon and azimuth), and maximum intensity from the best location (flare center). Click the date to see a chart that shows the path of the satellite with the area of the flash.

Is this a shooting star? No, it's an Iridium satellite flare (exposure of 2 minutes with a DSLR and a 24mm lens).

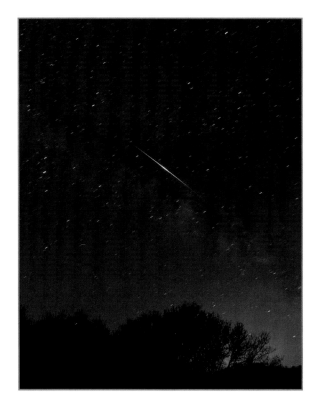

A single exposure of 10 minutes with a DSLR and a 50mm lens at f/5.6, aimed at the celestial equator, recorded this swarm of geostationary satellites, which show up as small dots of light in the middle of star trails. The two close groups are the ASTRA cluster (left) and the HOT BIRD cluster (right). It's best to leave your camera in long-exposure noise reduction mode, then slightly shift the orientation of your camera and take a second picture. If the position of a dot is different in the two photos, it is a satellite—if not, it is a hot pixel.

the brightness difference between two similar satellites—one at low altitude and the other in geostationary orbit—may reach a factor of 10,000 (10 magnitudes). There is no way to spot geostationary satellites with the unaided eye, or even with binoculars. Fortunately, their nearly stationary position in the sky makes them easier to photograph because a tripod-mounted camera can accumulate enough light during a long exposure to make them visible as a small point of light in the middle of star trails, but make sure you don't confuse geostationary satellites with hot pixels! Most of the year these satellites are illuminated by the sun all night long, except around the equinoxes when they can be eclipsed by the shadow of the earth for as long as 90 minutes.

Geostationary satellites orbit over the terrestrial equator. From our point of view on the earth, this corresponds to the celestial equator. The easiest way to capture a geostationary satellite is to aim your camera toward the south (or, from the Southern Hemisphere, toward the north) at an angle from the horizon of about 90° minus your latitude (for example, at a latitude of +40° north, aim your camera 50° above the southern horizon). Since dozens of satellites share the equatorial strip, they are sometimes closely clustered. CalSky and other websites (such as Hansa Electronic, www.hansa-electronic.com/satcalceng.asp) give the positions of numerous geostationary satellites for any

Geostationary Satellites

Geostationary satellites have a completely different appearance. They travel at an altitude of about 22,200 miles (35,800 kilometers) and make one revolution around the earth in one terrestrial day, which makes them appear to hang motionless in the sky. The best-known geostationary satellites are for television signals—we direct our TV dishes toward them—and the Meteosat satellites. They are both easier and more difficult to photograph than low-orbit satellites. They are more difficult to photograph because their distance makes them considerably dimmer;

observation site. Note that the well-known GPS satellites do not belong to any of the groups mentioned here because they orbit at 12,500 miles (20,200 kilometers).

Processing and Touch-Ups

This section describes some image processing techniques you can use to improve and complete celestial images. These techniques have nothing to do with astronomy, and you may already apply them to your other pictures. More sophisticated processing techniques, and techniques that are specifically suited to astrophotography, will be described in later chapters (particularly chapters 3 and 7). Most of these specialized techniques are possible with special astronomy programs, not common image processing software.

When you develop a RAW file, the original data from the sensor is converted into an image that can be displayed and printed. RAW format is supported by software from your camera manufacturer, such as Canon Digital Photo Professional (DPP) or Nikon Capture NX 2. You can also process RAW images with all-purpose programs like Adobe Photoshop, Adobe Lightroom, and DxO Optics Pro. The basic settings and operations are as follows:

- Brightness, contrast, and highlights and shadows (or light and dark tones): Adjust these parameters to obtain a sufficiently bright and contrasty image. The brightest elements (for example, a lunar crescent or a landscape) should not be excessively overexposed, and the darkest objects should stand out from the sky background.
- Sharpness and noise reduction: Use minimal sharpness, and adjust the noise reduction (especially color noise) to minimize any noise that may have been introduced.

- White balance: Use the daylight white balance setting (5500K). If there is orange light pollution, you can use a slightly lower color temperature to make the sky appear bluer and give the light pollution a more acceptable yellow tint. Use lens aberration corrections (vignetting, distortion, and chromatic aberration) if they are available.

After you post-process your image, save it in JPEG format if you do not plan to process it further; otherwise save it in TIFF format (preferably 16 bit). With a TIFF file, you can later change the levels of each color to balance the sky background and neutralize any strong color bias that may have occurred because of light pollution.

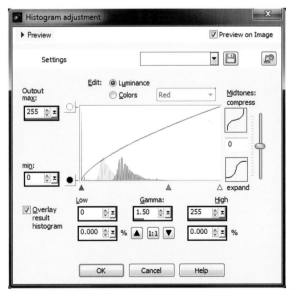

In PaintShop Pro, the Adjustment Using Levels function, similar to the Curves function in Photoshop, provides a comprehensive set of controls that you can use to adjust the brightness levels and contrast curve and to view the histogram

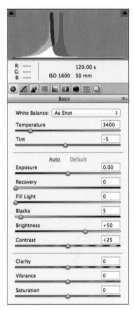

The built-in Photoshop Camera Raw module provides a histogram and other RAW processing functions, including lens correction, sharpness, and noise reduction

Functions like a cloning brush or duplication stamp allow you to correct very small zones around a hot pixel or a dust shadow. You can make more precise corrections by zooming in to the defect.

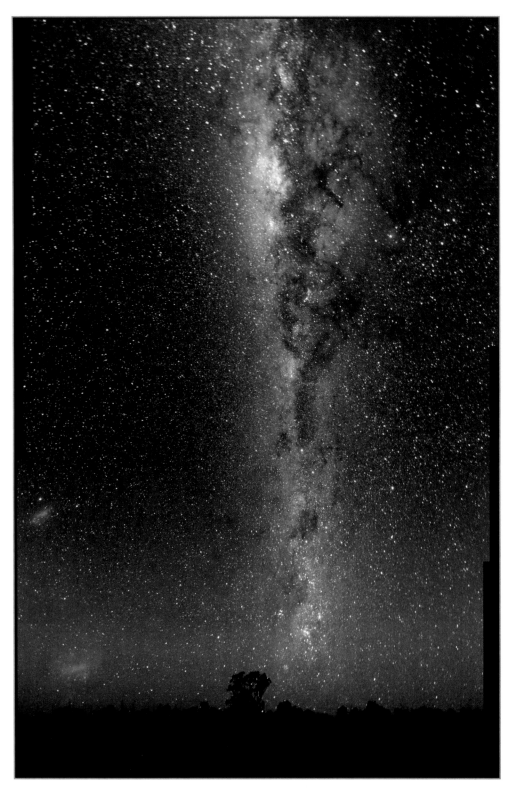

Creating Panoramas and Mosaics

In wide-field photography, capturing a panorama is a relatively simple way to expand the field of view. For a horizontal panorama that includes some landscape features, first use a level to verify that the alignment of the tripod head is perfectly horizontal. Next, capture a sequence of overlapping photographs. Overlap the images by at least 20–30 % so you'll have enough registration points to stitch the final image together. For example, if the field of view of the lens is 50°, rotate the camera by about 35° to 40° for each image. Some tripods have an angle scale on the head to help you maintain a constant angle for all the images. Use exactly the same settings for all the shots, including exposure time, aperture, ISO, white balance, and so forth. Minimize the time between shots, especially if you include a landscape in the frame or if the light changes quickly, such as at sunrise or sunset. It is also important to use a processing program that includes lens aberration corrections, particularly vignetting and distortion, to prevent artifacts where the images are stitched together. To assemble the final panorama, you can try an image-stitching program (such as PTGui, Autopano, or others). They can be very efficient, but starry fields often confuse them. You can assemble a panorama in Photoshop by following these steps:

1. Develop all RAW files with exactly the same parameters and lens aberration corrections
2. Expand the working area of the first two images so it covers the overlapped region
3. Use the registration landmarks to overlap the images, then merge them with the Lighten option
4. Repeat the previous two steps for each remaining frame
5. Merge all the layers and crop the image to remove the black borders

When you become proficient with single-row panoramas (1-D), you can attempt multi-row panoramas, or mosaics (2-D). Mosaics are more difficult to make because you have to rotate the camera on two axes with a controlled

A vertical panorama of three frames of the southern Milky Way, before cropping. The images were shot with a 28mm lens on an APS-C sensor. The green glow near the horizon is called airglow, which is the emission of natural light from the atmosphere.

Selected images from a sequence of 900 30-second exposures taken overnight with a fisheye lens at the Pic du Midi Observatory. After a transit of the ISS near Mars and Saturn at dusk, the moon rises in the second half of the night, followed by Venus and Jupiter.

angle of rotation: one axis for each row of pictures, and the other axis, which must be perpendicular, to step to the next row. The most skilled photographers can make impressive cylindrical mosaics (one row of images that covers the full 360° of the horizon) and even full-sky cubic mosaics (360° × 180°). The usual format for such mosaics is QuickTime Virtual Reality (QTVR). It requires good-quality stitching software, such as PTGui, to assemble the images and the free Apple QuickTime application to display the image on its own or in a web browser.

Making Time-Lapse Movies

You can make spectacular time-lapse video sequences from a stack of a few dozen photos taken at regular intervals. To eliminate brightness variations during the sequence, the camera settings (exposure time, aperture, ISO, etc.) must remain constant throughout the sequence, and the noise must be kept low to suppress unpleasant flickering in the final movie. If you want to include views that transition from before sunset or after sunrise, you need to manually adjust the exposure time of the images in the sequence to compensate for the brightness variation. Set the duration of each exposure by trial and error; the exposures should range from a few seconds to a minute, similar to still shots of the sky. Be sure to include an interval of at least a few seconds between shots so the camera will have time to save each image to the memory card. Amateurs have different opinions about which file format to use. Some people recommend RAW format, and others prefer a reduced-resolution JPEG format. The advantage of the latter is much smaller files, but there aren't as many editing options, such as exposure adjustment and color balance.

If you capture your images in RAW format, develop them as usual and convert them to the highest-quality JPEG to reduce the amount of compression. To create a time-lapse movie, you need to reduce all the images to the video format you want to use: 640 × 360 for 360p, 854 × 480 for 480p, 1280 × 720 for 720p, or 1920 × 1080 for 1080p (full HD). You will probably have to crop the upper and lower edges of each frame because the aspect ratio of the video format is not likely to be the same as the aspect

ratio of your pictures (full HD video is 16:9, and a DSLR sensor is 3:2). If you don't crop your images, some online video sites (such as YouTube, Vimeo, and Dailymotion) will add black bars to the edges. You can resize your entire series of images in one operation with programs like Photoshop or Lightroom or by using VirtualDub filters (discussed next).

Now you're ready to make the video sequence. Although Adobe Premiere Elements offers additional functions like zoom and pan, it's a good idea to start with VirtualDub, a free program that has all the basic functions you need. Open the first image of the sequence with the Open Video File command (File menu), and VirtualDub will open all the files with continuously incremented file names (for example, img4235, img4236, img4237, etc.). If necessary, enable the Resize filter (Video menu) to resize and crop the images (for example, 1920 × 1080 and 16:9). In the Video menu, chose the frame rate and the compression type (codec). The uncompressed option results in the highest quality, but the final file size will be much too large to upload to the Internet. Test the other compression types and, if necessary, download other codecs from the Internet

(DivX and VidX are among the codecs most commonly used by amateurs). Finally, run the Save to AVI command (File menu) to save the video file that you can then upload to YouTube, Vimeo, or Dailymotion.

To ensure that your viewers don't get bored, make short movies of 5 to 10 seconds. Create longer movies only if there are interesting events during the sequence. The video frame rate is usually 24 or 25 images per second; there is no need to use a faster frame rate. If you use a frame rate slower than 15 frames per second, your movie can get jerky. At 24 frames per second, a 10-second video features 240 individual images; if the interval between each frame you shot was 15 seconds, the total shooting time would be 3,600 seconds (1 hour).

Advanced enthusiasts often use a motorized rail, or dolly (commercially purchased or homemade), to slowly move the camera vertically or horizontally during shooting. This technique requires an excellent knowledge of time lapse and is worthwhile only if you include a foreground close enough so the change of perspective is noticeable.

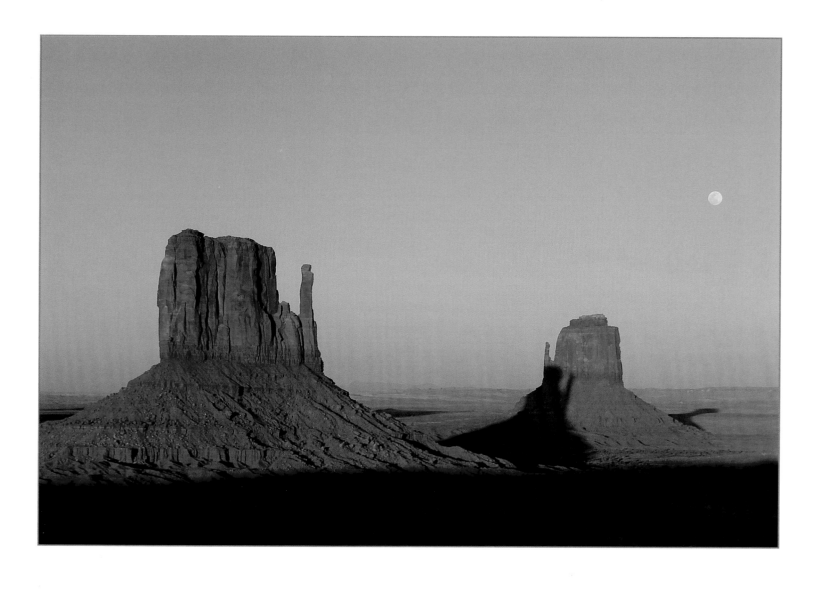

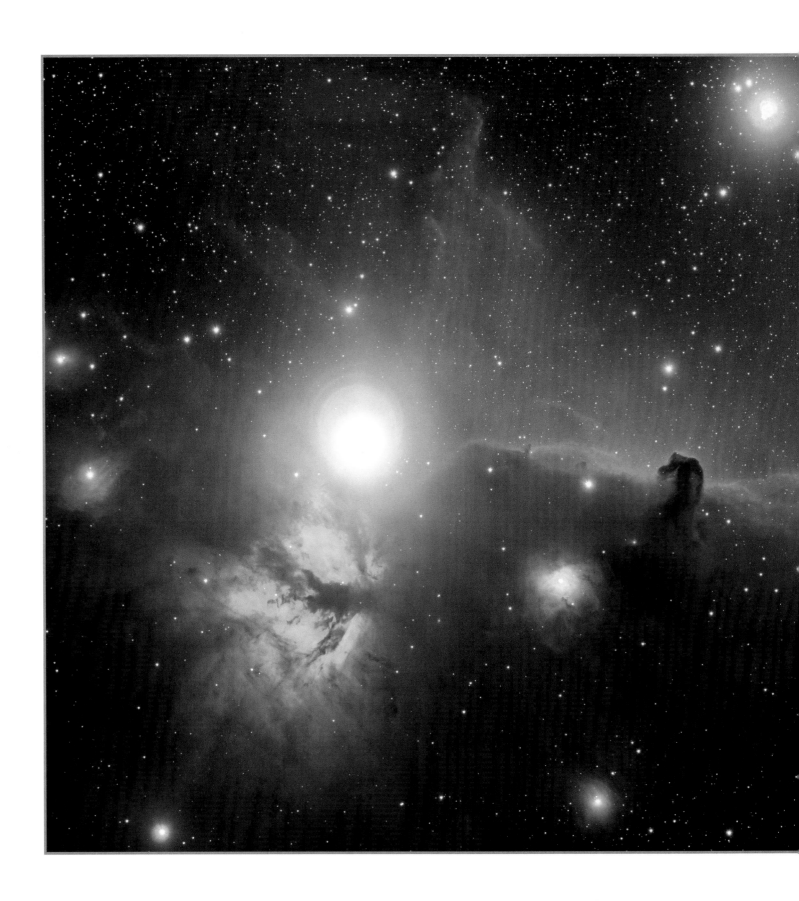

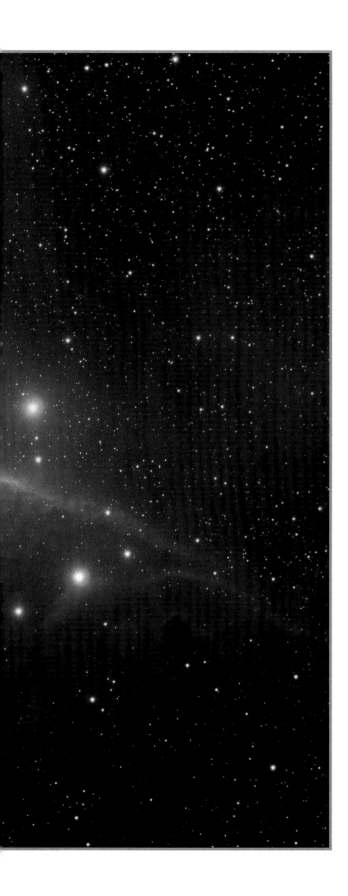

Cameras for Astrophotography

Consumer digital cameras, specialized charged-coupled device (CCD) cameras, and video cameras all have their place in astrophotography. It is important to understand their basic functionality to get the best performance from each type of camera.

The antiblooming feature of this CCD sensor makes it possible to simultaneously photograph the dim nebulosity of the Horsehead Nebula and the very bright star Alnitak in the belt of Orion

Despite their strong morphological differences, all digital cameras used in astrophotography share a common characteristic: the sensor, which is a small electronic chip designed to capture light. The various cameras are more complementary than competitive, and each of them is suited for a specific type of celestial target—and budget!

Video cameras can work wonderfully for the moon and planets, and CCD cameras produce better results in long-exposure, deep-sky photography. Consumer digital cameras (as described in chapter 1), and especially DSLRs, do not have just one specialty; they can be used for many types of targets. Their greatest advantage is that they open the doors of astrophotography to amateurs, thanks to an excellent performance-to-price ratio. The main differences between dedicated CCD astrophotography cameras and DSLRs are not always obvious; for example, a monochrome (black-and-white) sensor in a CCD camera might be seen as a drawback, but it gives the camera unsurpassed flexibility and sensitivity.

The photosite structure is easily recognizable on this image of a webcam sensor photographed through a microscope. Each cell is about 5 microns across.

The Sensor

To best understand the contents of the next chapters, it is useful to understand basic sensor functionalities and characteristics.

Sensor Structure

A sensor is an electronic chip, with leads and a small glass window that protects the light-sensitive surface of the silicon. This silicon surface is a checkerboard of microscopic cells, each of which captures and counts particles of light, called photons. For this reason, the cells are called photosites. Most people use the term *pixel* (picture element), but we'll use *photosite* because, as we'll see, the terms are not the same.

One of the main attributes of a sensor is the number of photosites it contains. Since photosites are generally arranged in a square pattern, it's easy to calculate how many there are. For example, a sensor with an array of 1,500 by 2,000 photosites contains 3 million pixels, or 3 megapixels. These days in amateur astrophotography, the number of photosites varies from several hundred thousand to about 25 million. In professional astronomy, detectors composed of giant mosaics of large sensors may reach tens of millions of photosites.

Another important parameter is the size of each photosite, but this is another oversimplification. It's more accurate to refer to the distance between two photosites rather than their size, because the light-sensitive parts of the surface do not always occupy the entire surface, as you can see in the above photo of a sensor taken with a microscope. The size of a photosite is expressed in microns or micrometers (μm). One micron is equal to about 0.00004 inch. Photosite sizes generally vary from 3 to 24 microns. For most sensors used in astrophotography, the sizes range from 4 to 10 microns. Photosites are usually square, but some sensors have rectangular photosites.

If you multiply the size of each photosite by the number of photosites, you can find the dimensions of the sensitive surface. For example, a sensor of 3,000 by 4,500 photosites, with square photosites of 5 microns each, measures 15 × 22.5mm, which corresponds to an APS-C sensor. Small webcam sensors measure about 3mm on a side, and the sensors of small compact cameras are barely larger. For intermediate cameras, the dimensions rise to 5–10mm on a side, and the sensors of DSLRs are larger than 15mm for each dimension. The sensors of the Canon EOS 5D Mark III and the Nikon D700, for example, are identical to the size of the 24 × 36mm sensor in the SBIG STL-11000m CCD camera. Very few sensors larger than

Some common sensors, printed here (from left to right) at their actual sizes: 1/4" (webcam), 1/3" (video camera), KAF-402E and KAF-3200E (CCD cameras), CMOS APS-C sensor (reflex), KAI-11000M (24 × 36mm CCD camera). Their exact dimensions are summarized in the field calculation table in chapter 4. The light-sensitive surface is the darker rectangle in the center of the chip.

that are available to amateurs. The table on page 70 gives the sizes of the most common sensors. So they can cite the largest possible number of photosites in their cameras, manufacturers tend to reduce the size of photosites and keep the overall sensor size the same, but this practice is at the expense of image quality.

Generally, the cost of a sensor is not driven by the number of photosites, but rather by the size of the sensitive surface. The semiconductor wafers from which sensors are made inevitably contain several fatal defects that are randomly spread across the wafer. As the sensor size increases, the rejection rate increases accordingly, because it's increasingly likely that a sensor contains one of those defects. That's why the price of a sensor rises exponentially with size. A small webcam sensor manufactured in very large quantities costs only a few dollars, but a large 24mm × 36mm sensor may cost more than $1,000.

Sensors called charge-coupled devices (CCDs) were the first to appear, in the early 1970s. These first-generation sensors had a small number of photosites, and their main application was video, which usually requires fewer photosites than still photography. Scientists, and especially professional astronomers, quickly understood the numerous benefits of this invention, and some observatories began to use CCDs by the late 1970s. At the end of the millennium, a new type of sensor appeared that used complementary metal oxide semiconductors (CMOS), which had historically been used for all sorts of electronic components. At first CMOS sensors were not appropriate for astrophotography because they were not very sensitive, and the images they delivered were noisier than the ones produced by CCDs. Some manufacturers, like Canon, finally succeeded in making very capable CMOS sensors that were less costly and more energy efficient than comparable CCDs. Despite their strong technological differences, CCD and CMOS sensors have similar operational characteristics, and it is often impossible for photographers to tell which type of sensor is in a camera.

Image Acquisition

The acquisition of a digital photograph requires more than just an exposure. The camera must execute several other operations that are transparent to the photographer.

Exposure Phase

Contrary to popular belief, a camera sensor is an analog device. When a photon reaches a photosite, its energy causes an electron to be ejected from a silicon atom, due to the photoelectric effect. The main function of a photosite is to form an electron trap (or an electron well). Such traps indefinitely store the electrons that are released by the photoelectric effect; they can't escape to neighboring photosites or rejoin their original atom. One of the main advantages of sensors, compared to film, is their linear response to light; that is, there is a direct proportion between the number of photons received and the number of electrons stored. (It's a bit more complex than

DIMENSIONS OF SENSORS IN FRACTIONS OF AN INCH

Sensor manufacturers often give the size of their sensors in fractions of an inch. As a result, many small webcams and video cameras have what is called a 1/4" sensor. You might think the diagonal of the light-sensitive surface is one-quarter inch, or 6.35mm. But its actual size is 4.5mm. For a so-called 1/3" sensor, the diagonal is a bit less than one-quarter inch, and so on. The measurements refer to the external diameter of vidicon tubes, which were used in video cameras decades ago. They have no specific relationship to the size of today's sensors. When marketers grab numbers, it sometimes seems that math is no longer an exact science.

this, because electrons that do not originate from light mix with other electrons, as we will discover in chapter 3.)

When an exposure is captured on a digital sensor, light reaches the sensor and the photoelectric effect occurs, causing electrons to accumulate in the photosites. Of course, a photosite cannot store an infinite number of electrons. The capacity of most sensors is several tens of thousands of electrons. Everything else being equal, the capacity of a photosite is proportional to its surface area; therefore, larger photosites are better, as we'll see in chapter 3. When the number of electrons exceeds the capacity of the sensor, the wells are full and the extra electrons overflow into the adjacent photosites; this spreading effect is called *blooming*. To avoid this problem, some sensors have an antiblooming feature. Drains along the photosites collect most of the surplus electrons, but there's a drawback: the drains occupy space on the surface, which reduces the sensor's ability to collect photons. The loss of sensitivity can be as much as 20–50%. All sensors designed for general consumers have drains, but some CCD sensors are designed without them. To partially compensate for this loss of sensitivity, sensor designers use microlenses, which are microscopic, dome-shaped tubes that are aligned over the rows of photosites. Their purpose is to direct photons from insensitive areas to sensitive ones.

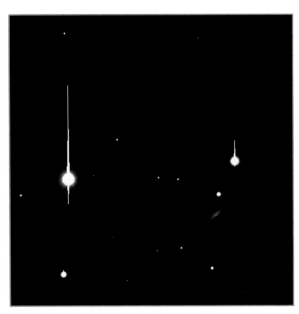

When the capacity of a photosite is exceeded, the extra electrons overflow in a direction that is dictated by the internal structure of the sensor. The result is a spike, clearly visible here on the two brightest stars in this image, which was taken with a CCD sensor that does not have an antiblooming feature.

Reading and Digitization Phase

At the end of an exposure, the electrons in the photosite are emptied, and the camera electronically measures the total charge. Thanks to another electronic component called an analog-to-digital converter (ADC), computers understand this measurement as an integer. It is not equal to the number of photons captured or the number of electrons stored. Rather, it is proportional to both, which retains the linear relationship.

The type of ADC that's used affects the range of numbers it outputs—more precisely, the number of bits is affected. In photography, an 8-bit converter is the accepted minimum. It outputs a number between 0 and 255; that is, 256 (2^8) possible values. Some cameras have a 16-bit converter, resulting in a range of numbers between 0 and 65,535; that is, 65,536 (2^{16}) possible values. Other cameras have 12-bit or 14-bit converters.

Number of bits	Number of levels	Range of values
8	256	0 to 255
10	1,024	0 to 1,023
12	4,096	0 to 4,095
14	16,384	0 to 16,383
16	65,536	0 to 65,535

Number of levels and range of values for the most common ADCs in cameras

BITS AND BYTES

A bit is the smallest increment of information that computers understand. This information is called *binary* because it has only one of two values: 0 or 1. Two bits can have four values, 3 bits can have eight values, and so on in successive powers of two. A group of 8 bits is called a *byte*.

Your eyes cannot discern more than 100 levels of gray, so why do we need more than 256 gray levels? When you display or print an image, 8 bits is sufficient. However, a deep-sky photograph usually contains very dim light that occupies the lowest gray levels. You can employ numerous processing steps, described later in this book, to emphasize these small variations in intensity, but it's possible only because these subtle shades are not lost by being lumped into one gray level.

For example, suppose that an 8-bit converter outputs a value of 128—that's half the dynamic range available from 8 bits. If the camera had been equipped with a 16-bit converter, the output value would be about 32,768—half the dynamic range available from 16 bits. If a neighboring photosite stores 0.2% fewer electrons, the 16-bit converter will output a value of 32,703, and the 8-bit converter *should* output a value of 127.7. Instead, it rounds the value to the closest integer, 128, and the small difference of light between the two photosites has been lost.

Using a converter with more bits of resolution is like weighing a person in tenths of a pound instead of pounds; the result is more precise, at least up to a certain point. It would be absurd to measure our weight to a thousandth of a pound! Similarly, using a 16-bit converter is pointless if the camera delivers noisy images, because the last bits, the ones that are supposed to give the highest precision, are drowned in noise and are therefore useless. Camera manufacturers must choose a converter that is consistent with the quality of the overall electronic chain. Beware of advertising claims; a camera with a 16-bit converter does not automatically give you better images than a camera with a 14-bit converter!

The digitization chain is designed so the maximum value corresponds to a number of electrons that is slightly smaller than the capacity of the photosite. For example, if the capacity of the photosites for a given sensor is 30,000 electrons and an 8-bit converter is used, the converter's output value of 255 could be obtained at about 25,000 electrons; that is, about 100 electrons per level (25,000/255). Beyond this number of electrons, the output of the converter is locked at 255.

As described in appendix 3, the main functional difference between CCD and CMOS sensors is that each photosite on CMOS sensors can be addressed and read independently while CCD sensors require successive transfers of the photosite contents line by line. During these operations, the photosites of a CCD sensor remain sensitive to light, and if nothing prevents light from reaching them, the image will suffer from a defect called *smearing*, in which a bright object leaves a vertical trace. The most obvious way to avoid smearing is to use a mechanical shutter that's installed just in front of the CCD sensor. This shutter closes at the end of the exposure, just before the contents of the sensor are read. However, this solution adds cost, and it is not convenient for video because it requires continuous shooting. To avoid the use of a shutter, a type of CCD sensor called an *interline sensor* (or *electronic shutter*) has been developed. The advantage of an interline sensor is that it eliminates the need for a mechanical shutter, which is a potential source of vibration and failure. The downside of an interline sensor is that it reduces the percentage of the total sensor surface that is exposed to light; therefore, a CCD interline sensor is less sensitive than a noninterline sensor (also called a *full-frame sensor*), although microlenses help reduce this loss of sensitivity.

Quantum Efficiency and Spectral Sensitivity

In an ideal world, the photoelectric effect would allow your sensor to capture all the photons that reach it. The quantum efficiency—that is, the ratio between the number of photons that impact a photosite and the number of electrons the photosite collects—would be 100%. Unfortunately, the quantum efficiency is never 100%, for these and other reasons:

❯ The sensitive surface of the sensor, and its cover, reflect some of the incoming light. Sensors are dark gray instead of black, which is evidence that not all light is absorbed.

❯ Even when a sensor has microlenses, the photosites do not completely fill the surface of the sensor. Photons are lost in the spaces between the photosites, especially at the antiblooming drains and, for an interline sensor, the transfer registers.

❯ Although ultraviolet photons have more energy than visible light photons, they do not penetrate silicon very well. Most of the photons cannot trigger the photoelectric effect. Infrared photons with wavelengths longer than 1 micron may pass completely through the silicon and do not have enough energy to trigger the photoelectric effect.

Therefore, a single number cannot express the quantum efficiency of a sensor—you have to take the wavelength into account. The efficiency is usually represented by a curve that shows the value of the quantum efficiency (as a percentage) as a function of the wavelength, from ultraviolet, through blue and red, to the near infrared.

300 400 500 600 700 800 900 1000

Ultraviolet Blue Green Red Infrared

The luminous spectrum. Wavelengths are usually expressed in nanometers (nm) or angstroms (Å); 1 nm is 10 Å. Moving from left to right across the spectrum, the wavelengths are as follows: less than 400 nm is ultraviolet, between 400 nm and 500 nm is blue, between 500 nm and 600 nm is green, between 600 nm and 700 nm is red, beyond 700 nm is near infrared. Of course, there is no sudden transition between colors, and these values are approximate.

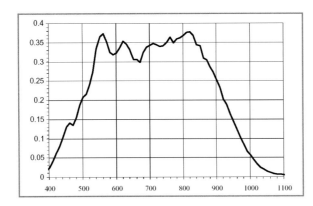

The quantum efficiency of the Kodak KAF-0400, a sensor that was introduced in the 1990s, which has 400,000 photosites. It was one of the first sensors used by amateurs and was in my first CCD camera, purchased in 1993. (Truesense Imaging/Kodak document)

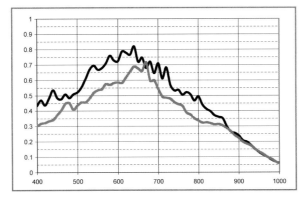

The quantum efficiency of the Kodak KAF-0402E sensor (black line), which has a higher sensitivity in blue wavelengths than its ancestor, the KAF-0400 (blue line). (Truesense Imaging/Kodak document)

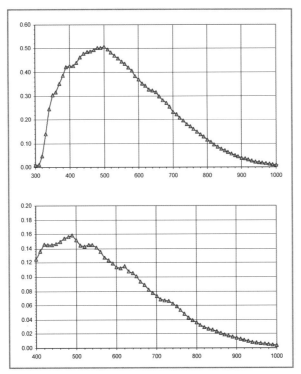

The quantum efficiency of the Kodak KAI-11000M interline sensor, with microlenses (top) and without (bottom). (Truesense Imaging/Kodak document)

The first sensors used by amateur astrophotographers had a significant shift toward red and infrared wavelengths, at the expense of blue wavelengths. Their sensitivity to the Hα red line, which is so important in astronomy, was excellent. Technological improvements increased the efficiency in blue wavelengths and maintained good sensitivity in red wavelengths. The sensitivity peak, situated in green or red wavelengths, depending on the sensor, usually varied from 25–60% for CCD interline sensors and CMOS sensors and from 40–80% for full-frame CCD sensors. These remarkable figures are testament to the superiority of electronic sensors over film, in terms of sensitivity. Film is further penalized by its quantum efficiency of only a few percent and by its reciprocity failure. Electronic sensors make it easy to photograph Messier objects, and they have made thousands of deep-sky objects available to amateur astrophotographers.

> **NEAR AND FAR INFRARED**
>
> Electronic sensors used in photography are sensitive to infrared light, but only near infrared, which corresponds to wavelengths just slightly longer than red (up to 1000 nm). They cannot detect far infrared wavelengths, such as the thermal heat that radiates from a living being, but they can record the energy that radiates from a soldering iron.
>
> Don't confuse an infrared filter with an infrared-blocking filter. The former transmits wavelengths beyond 700 nm or 1,000 nm (depending on the filter), and the latter blocks infrared wavelengths and transmits only visible light.

Color Sensors

The quantum efficiency figures discussed so far are for monochrome sensors. They deliver grayscale images because they can't distinguish photons of blue light from photons of green or red light. But you can produce color images with the help of filters, such as red, green, and blue, as discussed in chapters 5 and 7.

The common solution on consumer-level equipment is to use a sensor whose photosites are covered with a mosaic of tiny color filters. A *Bayer matrix CCD array* uses an arrangement called a *Bayer pattern* (from the name of its inventor), which is a group of four photosites in a

two-by-two pattern. Numerous color filter arrangements are possible—such as cyan, magenta, yellow, and green—but the most common arrangement is based on red, blue, and green filters. Each two-by-two group of photosites includes one red, one blue, and two green filters. Therefore,

most 8-megapixel sensors have 2 million red photosites, 2 million blue photosites, and 4 million green photosites. Because the filters are usually partially transparent to near infrared light, an additional filter (called an infrared-blocking filter, or IRB filter) is placed over the sensor.

An example of a Bayer pattern

The advantage of a Bayer array is that it's easy to manufacture, but it suffers a major drawback, particularly for astronomy: a large portion of the incoming photons are lost. All photons of blue and red light are rejected when they hit a photosite that's covered with a green filter; the same is true for other mismatched color wavelengths and filters. Also, the transmission rate of each filter for its corresponding color is far from 100 %. A quick calculation shows that, on average, a color sensor collects less than one-fourth of the photons that its monochrome counterpart collects! It's easy to understand why monochrome sensors are highly prized in astrophotography, where the light is always faint. For the red light emitted by most nebulae, the sensitivity loss may be even worse (chapter 7); a color sensor may collect 20 times fewer photons than the monochrome version of the same sensor.

MONOCHROMATIC AND MONOCHROME

Don't confuse the terms *monochromatic* and *monochrome*. Light is said to be monochromatic if its wavelengths are confined to a very narrow range, such as the Hα red light emitted by most nebulae. A monochrome sensor is sensitive to a very broad range of wavelengths; it produces grayscale images because it cannot differentiate colors.

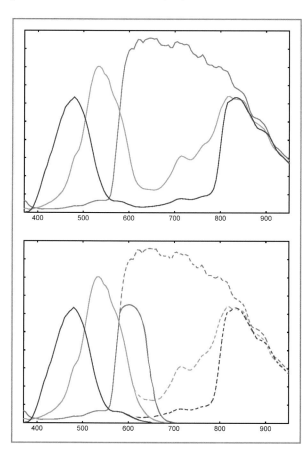

Typical efficiency curves of a color sensor (here, a CMOS Kodak sensor). At top, without an IRB filter; at bottom, with an IRB filter. (Truesense Imaging/Kodak document)

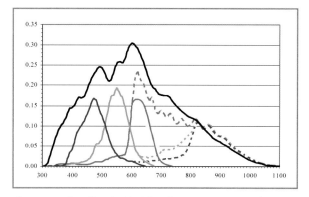

The area enclosed by the black line (monochrome sensor) and the areas enclosed by the red, green, and blue lines (color sensor) demonstrate the huge difference between the sensitivities of these two types of sensors. The difference is amplified because on a color sensor only one of every two photosites collects green photons and only one of every four photosites collects red and blue photons. (Truesense Imaging/Kodak document)

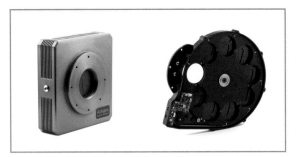
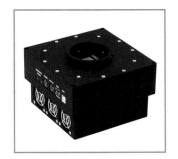
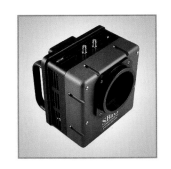

Several CCD cameras.
From left to right: Starlight Xpress,
Apogee (with filter wheel), FLI, and SBIG.

On a sensor that has a Bayer array, the red, green, and blue colors are interpolated (appendix 3) in an operation called demosaicing. When software like Photoshop opens a RAW image from a consumer-level digital camera, it performs this operation while it balances the colors with color coefficients that are determined from (1) the sensor characteristics and (2) the color balance setting the photographer used, which is recorded in the EXIF data of the image file.

Since a color pixel contains three data values (red, green, and blue), an image with 12 million color pixels has 36 million data points. Strictly speaking, a sensor with 36 million photosites would be required, each of which would provide one red, one green, or one blue data point. However, a camera sensor that has 12 megapixels contains only 12 million photosites, not 36 million. The other 24 million data points are reconstructed with interpolation, which is not the same as using a camera with 36 million photosites—interpolation only guesses the true value of the missing data. This confusion between photosites and pixels allows camera manufacturers to advertise numbers that benefit them the most!

SENSITIVITY

Consumer digital cameras include a setting called *sensitivity* or *ISO* that is used to quantify how sensitive the sensor is to light. With film, the speed is modified by changing the film itself, but it has a drawback: an ISO 400 film allows you to take photographs with four times less light than if you use ISO 100 film, but films with higher ISOs have coarser grain. In a digital camera, the physical sensor is not changed, so its quantum efficiency is the same! The change from ISO 100 to ISO 400 is done by amplifying the signal from the sensor by a factor of four. Here too there is a price to pay, as described in the next chapter.

Types of Cameras

Three main types of digital cameras are used by amateur astronomers: astronomical CCD cameras, consumer digital cameras (compacts, intermediates, and DSLRs), and video cameras. Webcams belong to the latter category.

CCD Cameras

CCD cameras were the first digital cameras used by amateurs, long before the appearance of consumer digital cameras and webcams. Their commercialization began in the early 1990s. A French amateur, Christian Buil, designed and built the first amateur CCD camera in 1985.

At first glance, a CCD camera is a strange object—no lens, no buttons, no screen, and no viewfinder. It's just a metal body with a small fan, a glass window protecting the sensor, and several sockets. Like a webcam, a CCD camera is not autonomous and must be connected to a computer. The connection transmits the photographer's commands to the camera and allows it to capture images through acquisition software. The software can work as an intervalometer that launches a series of photographs with any exposure time. The first cameras used a parallel or serial link to the computer. These days a USB link is most common. Some cameras can be controlled through an Ethernet link, which is very useful for a remote observatory.

Above all, a CCD camera captures exposures of several minutes, sometimes even hours. But, as we'll see in the next chapter, the thermal vibration of silicon atoms causes a parasitic signal to appear in the image. This signal is more apparent with long exposures and when the temperature of the sensor is high. To eliminate the parasitic signal as much as possible, the sensor must be cooled. Professional observatories use a drastic but effective solution: liquid nitrogen. Amateur-level cameras employ a small electronic component, called a Peltier module, to cool the sensor. This

module, which is commonly used in small refrigerators for cars, is an assembly of two flat plates separated by semiconductor blocks; one face is cooled, and the other is heated when an electrical current is passed through it. The assembly is typically placed against the back of the sensor. The metal body and the fan help dissipate the heat that's emitted by the warm face. The efficiency of the module is measured by the temperature difference between the ambient air and the sensor. On amateur-level cameras, this difference is generally between 20°C and 30°C. Most CCD cameras have temperature regulators that maintain the sensor at a fixed temperature that's specified by the user (within the achievable range of temperatures). This is a big advantage, as we'll see in the next chapter.

The process of cooling the sensor is complicated. As soon as an object is cooled below the dew point of the surrounding air, moisture condenses on its surface. If the sensor were exposed to ambient air, it would be covered with moisture, and dust would soon settle on it—the photographs would be dark and fuzzy. Sensors are therefore protected in a space that is as airtight as possible, and sealed under a glass window. Some cameras have an airtight, sealed chamber filled with nitrogen; some of them include a small amount of desiccant to absorb moisture that would otherwise slowly migrate into the camera. The desiccant must be regenerated in an oven periodically. By following basic precautions (for example, not storing the camera in a humid place), you can eliminate moisture problems.

Most cameras are equipped with a mechanical shutter that's designed to block light from the sensor during readout. The shutters generally are not capable of very short exposure times—the limit is around 1/100 second. A mechanical shutter is not essential for an interline sensor.

CCD cameras are powered with 12-volt DC or AC adapters. DC adapters are convenient for mobile amateurs who need to run their camera from a car battery. However, when the cooling function is on, a CCD camera can pull a current of several amperes. If the photography session is long, it's wise to use a battery other than the one in your car so you can start your car at the end of the night! You can calculate the required battery capacity, in amp-hours, by multiplying the consumption of the camera (in amperes) by the number of hours of use. Don't forget to include the power requirement of the computer and other components, such as a telescope, dew heater, guide camera, and so forth.

Some CCD cameras have a color sensor, but most of them are monochrome. The rest of this book outlines the advantages of a monochrome sensor in terms of sensitivity and versatility. If you use a monochrome sensor, you'll need an accessory called a filter wheel to produce color images. The wheel lets you place various colored filters in front of the sensor without having to disassemble it or remove it from the telescope. Depending on the model and the size of the sensor, such a wheel usually contains filters that are 1.25" or 2" in diameter. As shown in the photographs on page 27, certain cameras have two sensors placed side by side. The small one is used for a very important function in deep-sky imaging: autoguiding (chapter 7).

At the end of the exposure, the image is transmitted to the computer while digitization is performed. On most current CCD cameras the readout rate is about 300,000 to more than 1 million photosites per second (a total of 2 to 10 seconds for a sensor with 3 million photosites). This may seem slow compared to a typical DSLR, but high-precision digitization and low noise are not always compatible with

From left to right: a motorized filter wheel integrated in a CCD camera (you choose a filter from the acquisition software), a CCD camera and its manual filter wheel, an autonomous motorized filter wheel and its control box

These images were taken with the same exposure time, but different binning modes were used (1 × 1, 2 × 2, and 4 × 4). The signal increase is obvious. With binning, the field of view does not change, but the sharpness of small details may be reduced, depending on the image quality.

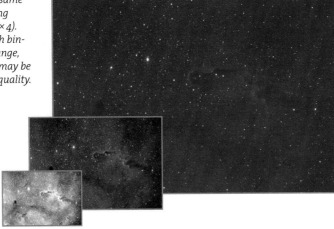

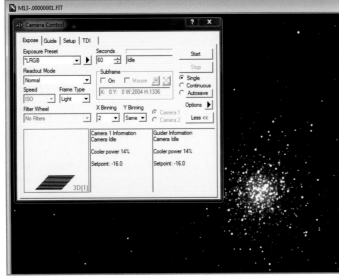

This command panel of MaxIm DL acquisition software allows you to choose the exposure time, the number of exposures, the file name, the binning mode, the crop window, and other parameters, such as temperature regulation and the position of the filter wheel

a fast readout. Some cameras have a faster readout rate, at the expense of more noise.

All CCD cameras have two very practical functions that would be nice to have on a DSLR: binning and cropping. During binning, the contents of the adjacent photosites are summed, during readout, to create larger virtual photosites. The most common binning mode is 2 × 2, which combines photosites in square groups of four. The 3 × 3 binning mode combines 9 photosites, 4 × 4 binning combines 16 photosites, and so on. In 2 × 2 binning, the signal received by each virtual photosite is multiplied by four, compared to unbinned images (also called 1 × 1 mode), and the readout time is divided by four since there is four times less data to digitize and transfer to the computer. Of course, even if the image covers the same field of view, it contains four times fewer pixels. Binning is particularly useful in two circumstances: when the celestial target is very dim and during the framing and acquisition of the object. For example, in 4 × 4 binning, the readout time of the image is very short, and most objects can be detected in exposures as short as a few seconds. Currently, some DSLRs can record RAW files with a smaller number of pixels than the maximum allowed by the sensor (in Canon cameras this mode is called sRAW, for small RAW). DSLRs accomplish this by using undersampling (using a fraction of the photosites), not binning, so the sensitivity is not increased.

Cropping an image at the time of acquisition consists of reading and downloading only a portion of the photosites, in either a square or rectangular configuration. This function is helpful if the object, such as an asteroid, occupies only a small part of the sensor. This function is also used with CCD cameras to speed their ability to focus on a star (chapter 4).

Appendix 2 lists most CCD camera and imaging accessory manufacturers, as of 2013.

Consumer Digital Cameras

As discussed in chapter 1, all types of cameras (compacts, MILCs, and DSLRs) can be used for astrophotography without a telescope, but there are limitations depending on the camera type and its functionality. With the help of an afocal adaptation (described in chapter 4), you can take pictures of the planets, the moon, and the sun with compacts and intermediates that are attached to an astronomical instrument, although intermediates are generally difficult to adapt behind an eyepiece because of their larger lens.

Amateur photographers who want to do astrophotography, especially long exposures, should buy a DSLR. This type of camera has numerous advantages, such as unlimited exposure time, easier connection to a telescope, remote control by a computer, and, above all, better image quality because the sensor has larger photosites and can record RAW images with 12 or 14 bits and no data loss due to compression.

When you have a DSLR mounted on an astronomical instrument, you must not touch the camera to release the shutter because vibrations will smear the image. One solution is to use the camera's self-timer. A better solution is to use a remote control, either wired or infrared. The cheapest devices—for example, the Nikon MC-DC1 or MC-DC2 (for the Nikon D5200), and the Canon RS-60 or RS-60E3 (for the Canon EOS 700D)—have a simple button, which is sufficient for single shots, but for a series of long exposures you have to stay near the camera to start and stop each exposure while you time it with a stopwatch.

The most sophisticated—and expensive—devices are called intervalometers. They can take a series of shots, and you can adjust the duration of the individual exposures and the interval between them. The TC-80N3 for the Canon EOS 6D and the MC-36 for the Nikon D800 are such devices. Note that these accessories, which are also offered in wired or wireless versions by third-party manufacturers (Phottix, Hama, Kaiser, Hähnel, and others), are not interchangeable between brands, and they may not even be used on all models in their own brand. Because it has different connectors, the Canon RS-60 remote control works on the Canon EOS 700D but not on the EOS 6D (it uses the TC-80N3). Free software programs that are provided with cameras (such as Canon EOS Utility), or optional software programs (such as Nikon Camera Control Pro), can control the camera from a computer through a USB connection. However, the bulb setting is not available, so you can use an intervalometer only for exposures up to the maximum

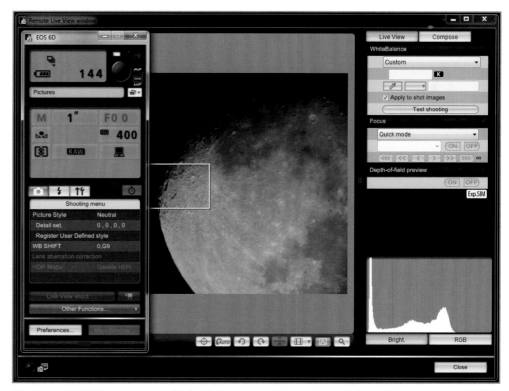

The Magic Lantern firmware for Canon DSLRs incorporates an intervalometer that can launch a series of shots in bulb mode. It also has many other photo and video control features.

The Canon EOS Utility program provided with the camera offers a trigger switch, imaging parameter controls, and live-view images on a computer that you can download with a USB connection. A 10x zoom on part of the image allows you to achieve fine focusing.

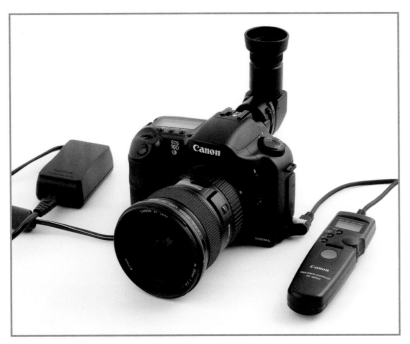

A DSLR equipped with a programmable remote control (intervalometer), an AC adapter, and an angle finder

For years Canon CMOS sensors have been ahead of competing sensors with regard to image quality for long exposures, because they have a very low thermal signal. But all of today's reflex cameras, including Nikon, Pentax, and Sony, are comparable in terms of quantum efficiency, readout noise (at high ISOs), and thermal signal. They all deliver excellent results in astrophotography. The brand and the number of pixels have become less important than the sensor size, with the 24×36mm format being the best. Because of its small size, the performance of the Four Thirds format (Olympus) is not as good as that of the APS-C format. Canon DSLRs are currently favored by astrophotographers because of their defiltering and Clip-Filter technologies (chapter 7), and because of their ability to be controlled by third-party programs, such as PRISM, MaxIm DL, EOS Camera Movie Record (EOS_movrec), Backyard-EOS, Astro Photography Tool, AstrojanTools, Magic Lantern, and others. The Canon live-view mode can also simulate manual exposure settings so you can focus on faint stars. The reflex mirror is not lowered in live-view mode, so there are no vibrations.

Astronomical Video Cameras

In the late 1990s amateurs had the inspired idea to install a webcam, without its own lens, on an astronomical instrument to take pictures of the planets and the moon. They quickly realized that video was by far the best way to photograph celestial objects. The images they obtained were much better than the ones taken with more expensive equipment (CCD cameras and DSLRs), for reasons we'll explore in chapter 5. As soon as it appeared, the Philips Vesta Pro was adopted by amateurs because of its superior image quality. It was replaced first by the ToUcam Pro, then by the ToUcam Pro II, and finally by the SPC900NC. The major limitations of webcams are the bit depth of the videos and the low frame rate.

Astrophotography enthusiasts have now replaced webcams with video cameras designed for industrial and scientific applications. In 2013 the most popular brands were Imaging Source, Lumenera, Basler, Point Grey, IDS, iNova, and QHY. These cameras, priced from a few hundred to several thousand dollars depending on the sensor (between a half million and several million pixels), offer the best possible performance. The very fastest cameras use Gigabit Ethernet or USB 3.0 connections.

Some of these cameras include 10- or 12-bit ADCs, which is an attractive advantage—at least on paper. In

available setting (usually 30 seconds). The Magic Lantern website (www.magiclantern.fm) offers firmware that is enriched with additional features, including a built-in intervalometer, for most Canon DSLRs.

Good batteries allow DSLRs to work for several hours, but most batteries lose some of their capacity in the cold. Moreover, using the camera's LCD screen for framing and focusing shortens the battery life. Keep one or more additional batteries in your pocket, or have an optional battery grip on hand, for series of long exposures. The best way to prevent batteries from dying during an exposure is to use an optional DC or AC adapter that replaces the camera battery. An AC adapter can be connected to a DC-to-AC converter (available in most car parts stores) that runs off a car battery.

DSLR sensor dimensions range from the APS-C format, which is approximately 15×23mm, to the full-size 24×36mm format. Amateurs dream about the latter, but it's much more expensive and is a mixed blessing. You can leverage its potential only if you couple it with quality lenses or astronomical instruments that have an adequate field coverage (chapter 7), which excludes much of the equipment on the market.

Several astronomical video cameras,
from the smallest sensor to the largest.
Top row: Basler, Lumenera
Bottom row: DMK (Imaging Source), IDS

practice, noise dominates planetary imaging (chapter 3), which usually overwhelms the extra bits and renders them useless. If you have such a camera, compare the results in 10- or 12-bit mode to 8-bit mode to see if the additional information is worth a slower frame rate, larger file size, and increased processing time.

The acquisition programs for these cameras provide basic settings, like exposure time, gain, frame rate and recording time (in seconds or number of frames), and the number of bits (for cameras that offer more than 8 bits). Partial frame and binning commands are also available. These programs record a sequence of images in either a single video file or in a series of image files. Video files are saved in either AVI or SER format. The SER format, which is widely used in astronomy, is used for recording uncompressed (large!) videos at a depth of 8 bits or more. AVI files (8 bit) are usually compressed, resulting in a loss of data, to gain speed and to reduce storage space. The compression is performed by a codec (encoder/decoder). The types and variants of video codecs are innumerable; each is characterized by a particular mathematical compression algorithm. Among the most popular in the world of video are H.264, DivX, Xvid, WMV, MPEG-2, MPEG-4, and QuickTime. You have to install the codec on your computer before

you can use it to record and play back compressed video. For recording video or a series of files, the most common formats are FITS (8- to 16-bit uncompressed monochrome images), TIFF (8- or 16-bit uncompressed color), BMP (8-bit uncompressed color), and JPEG (8-bit compressed color).

EMCCD: THE SENSOR OF THE FUTURE?

We will see in the next chapter that the electronics associated with a sensor generate readout noise. The primary advantage of electron multiplying CCD (EMCCD) technology is that it amplifies the signal (i.e., electrons stored in the photosites) upstream of where noise is introduced, making it negligible. With conventional sensors, readout noise prevents you from breaking long exposures into many very short exposures, because the noise increases with the sum of the images. You might want shorter exposures to freeze turbulence in planetary imaging or to alleviate potential tracking errors in deep-sky imaging due to polar alignment, periodic error, wind buffeting, or autoguiding.

Although many of these cameras are available in color versions, most astrophotographers prefer the sensitivity and versatility of the monochrome versions. Color is indeed useful for Mars, Jupiter, and Saturn, but it is not necessary for the other planets, the moon, and the sun. In fact, color is detrimental when you photograph Venus in the ultraviolet spectrum or when you photograph the sun in the light of Hα. For color imaging, you can add a filter wheel to a monochrome sensor; the wheel has red, green, and blue filters, and possibly a clear filter for the luminance layer. If you use a computer-controlled filter wheel, you can integrate a sequencer in the acquisition program and launch a sequence of images with each filter.

A camera with the highest possible frame rate is always attractive, but remember that the actual maximum rate is directly related to the exposure time. For example, when you photograph Saturn with an exposure of 1/50 second, your camera will not produce a frame rate faster than 50 images per second.

Computers

Your computer requirements depend on the type of camera you use and the constraints of imaging. For example, mobile amateurs who use a video camera or a CCD camera will need a laptop; it is prohibitive, because of reliability and power requirements, to take a desktop computer into the field. A laptop is not as prone to the cold and damp of night, as long as it stays on, because it warms and dries the surrounding air. If it is used only to store and view images during the night, a low-cost model can be adequate. A video camera requires a large hard drive and high-speed storage. A high frame rate transmitted by a fast camera imposes challenging constraints. A 2 million pixel sensor, which corresponds to 2,000,000 bytes (2 MB) of data in 8 bits, running at 50 frames per second (fps), transmits 100 MB of data every second. One hour of recording will require 360,000 MB (360 GB) of storage space! Fast cameras with large sensors also require hard drives with a high write speed: 100 MB per second in the previous example, but 400 MB per second for a 4-megapixel sensor operating at 100 fps. Whether you use a traditional hard drive or a solid-state drive (SSD), watch out for the theoretical speeds advertised by manufacturers—the reality is often much slower. The writing and reading speeds may be very different, and they can be reduced when the drive is simultaneously servicing other programs (operating system, antivirus, etc.). The speed may also be reduced if another part of the data chain is bottlenecked (such as the computer's internal bus, the camera connection, etc.).

The computer display requirements depend on the resolution of the sensor. With a small sensor, a 1024 × 768 display is sufficient. However, for images taken with sensors up to several million pixels, a full HD display (1920 × 1080 pixels) is interesting to have (even if its 2-megapixel resolution is unable to show a full-scale image of 8 million pixels). Displays should have a minimum of 65,000 colors and 64 gray levels, but it's best to have 16 million colors and 256 gray levels. Gigabytes pile up quickly in astrophotography, and external hard drives quickly become necessary. Keep your best RAW images and videos; they're the equivalents of film negatives. If the camera does not assign explicit file names, identify the files by subject and date, and keep notes about the imaging parameters (instrument, location, camera settings, etc.)—it's all too easy to forget those details after the fact.

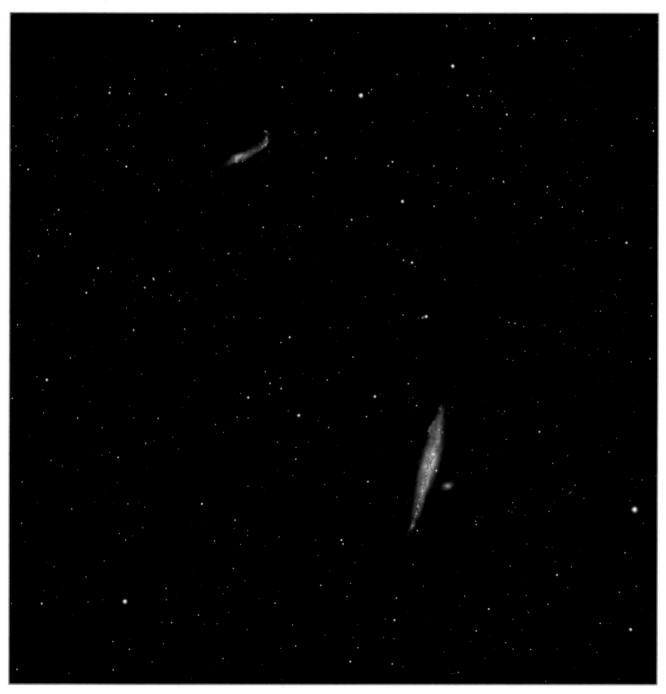

The galaxies NGC4656 and NGC4631 in the Big Dipper

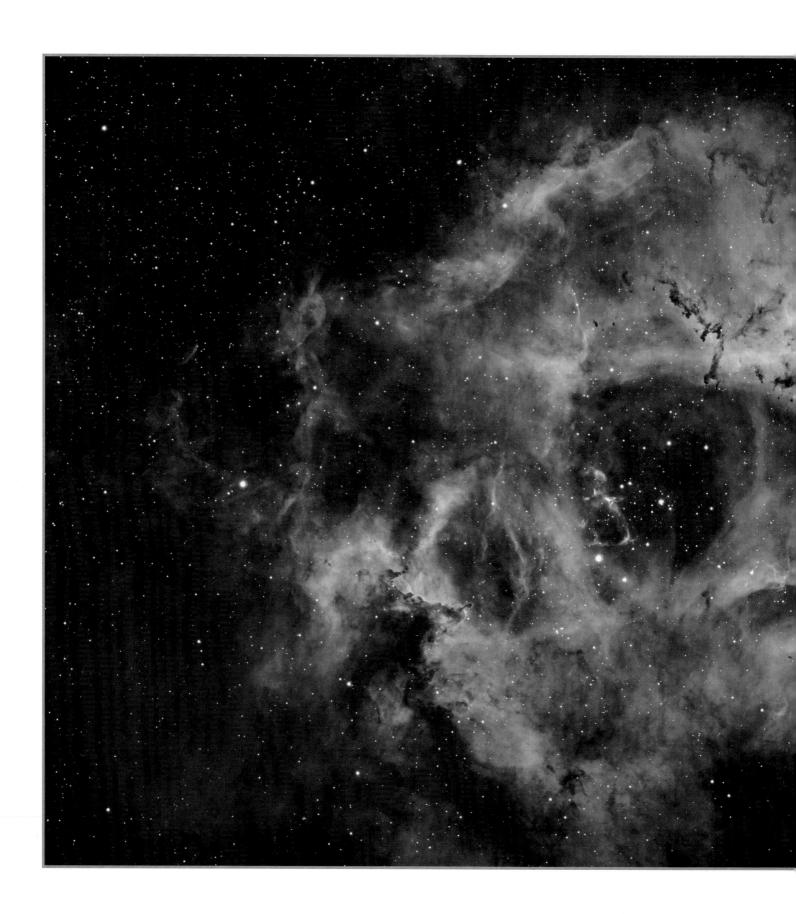

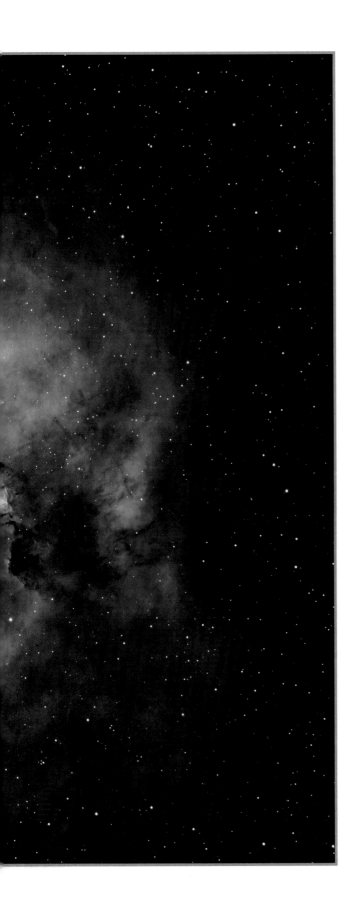

Chapter 3
Image Calibration and Compositing

Even with the advanced sensors available today, astronomical images may be affected by artifacts caused by sensor imperfections or telescope limitations. Some artifacts will appear regardless of the type of celestial object photographed. Several methods and algorithms, specific to astronomy, can be employed to reduce or eliminate these artifacts and make the images more scientifically accurate and aesthetically pleasing.

The Rosette Nebula in the constellation Monoceros

The central part of an image of the Rosette Nebula, obtained with a 5" refractor and a monochrome CCD camera with an exposure of 5 minutes. The image on the previous page is a combination of 60 images such as this one, calibrated, aligned, and combined as described in this chapter.

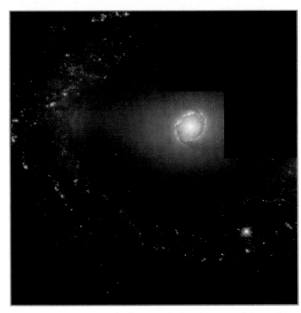

It's not just amateurs who have to deal with image defects. The RAW images coming from the Hubble Space Telescope contain defects that are easily visible, such as cosmic rays that impact the sensor during the exposures. They are subject, before release to the public, to processing algorithms similar to those described in this chapter. (Images from NASA and STScI)

In everyday language, the term *digital* is often associated with the idea of precision or even perfection. However, an electronic device, as well as the light captured by a camera, cannot escape the laws of physics: in the real world, perfection does not exist! Even images collected with space probes and professional instruments suffer from flaws. Any camera or instrument introduces artifacts into the raw image, which are like a signature of the process. One of the biggest challenges of digital imaging is to reduce or eradicate these defects using simple and efficient processing.

In this chapter, we will examine the characteristics of three major defects and investigate techniques to minimize each of them: the thermal signal, variations in uniformity, and, the most dreadful of all, the photon noise inherent in the image. The explanations given should help you to understand the answers to many questions that appear in this book. For example, is a combination of 10 exposures of 1 minute equivalent to a single exposure of 10 minutes? Or, why is it more difficult to photograph galaxies than to photograph planets from the center of a city?

called *hot photosites* (they become *hot pixels* when they are displayed in the image) because they behave as if they were at a higher temperature than their neighbors, even if this is not the case. Fortunately, in most sensors most photosites are well behaved and accumulate thermal electrons very slowly. As a result, an exposure of several minutes in total darkness produces an image showing a black background sprinkled with dots of varying brightnesses. The presence of some hot pixels is normal with exposures of several seconds with a DSLR. It is not a sign that the camera is defective. After all, what are a few pixels out of a total of 10 or 20 million? It is even better to have a few hot pixels than a multitude of "warm" ones.

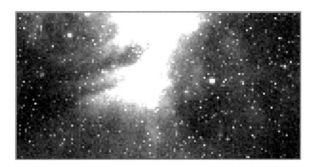

Enlarged portion of a 5-minute exposure taken with a CCD camera, before and after correction of the thermal signal. The displayed levels (see appendix 1) have been strongly expanded to give a better view of the thermal signal.

The Components of an Image

The Thermal Signal

Light is not the only component of the signal collected by a digital camera to create an image. In chapter 2, we have seen that a sensor stores the information in each photosite through electrons, thanks to the photoelectric effect. But an additional phenomenon occurs. At room temperature, the silicon atoms in photosites are subject to pummeling from adjacent atoms, which occasionally causes ejection of electrons. During long exposures, these unwanted electrons accumulate and add to the ones liberated by the photoelectric effect.

One could speculate that this accumulation of electrons of thermal origin is homogeneous from one photosite to another, producing a uniform background in the image. Actually, due to small differences in chemical composition or crystal lattice defects, each photosite has its own unique behavior and accumulates thermal electrons at its own pace. Some photosites are especially prolific; they are

Enlarged portions of images with 5-minute exposures taken in darkness at ambient temperature with two different models of digital cameras. The thermal signal may vary tremendously from one model to another. It may even vary from one camera to another of the same model, probably because of small differences in the manufacturing processes of the different sensors. Even if the origin of this signal is not light, the information stored in a hot photosite appears colored since the camera interprets the contents of a photosite according to the color of the filter that covers it.

Enlarged portion of a 10-minute exposure taken in darkness with a CCD camera, at 20°C (68 F) on the left and −20°C (−4 F) on the right. In contrast to the best DSLRs, most CCD cameras cannot be effectively used for exposures longer than about 30 seconds without the need to cool the sensor.

For a specific photosite, the number of thermal electrons is proportional to the duration of exposure; that is to say, the time over which the thermal agitation of atoms can generate electrons. But there is another factor: the sensor temperature. As the temperature increases, the atoms become more and more agitated and more easily release electrons. This relationship is exponential: each time the temperature increases from 6°C to 7°C (11–12 F), the thermal signal (also called the *dark current*) doubles. The benefit of cooling the sensor is obvious: a decrease of 13°C (23 F) lessens the thermal signal by a factor of 4, while it is reduced by a factor of 8 for cooling by 20°C (36 F), and so on. This means that a difference as small as 1°C (1.8 F) can have a visible effect on the dark signal.

Current CCD cameras have less dark current than their ancestors, but sensor cooling is essential for exposures longer than 30 seconds or so, and even then the thermal signal is still clearly visible and requires correction. Some DSLRs achieve a surprisingly low level of thermal signal, to the point that it sometimes goes unnoticed on exposures several minutes long. Manufacturers jealously guard their secrets, but we can assume that algorithms identifying hot pixels, or a dark frame, are applied to the image data in-camera before saving the RAW image.

Electroluminescence

A glow may be visible in a corner or along an edge on long exposures taken with some cameras. It is caused by an electronic component, the preamplifier, that remains powered during the exposure (even when data is not being read out) and emits a very faint light seen by the sensor. Cameras showing this phenomenon are not suitable

for deep-sky imaging, unless the effect is confined to a very small area.

The electroluminescence phenomenon, shown here in the lower-left corner, in this long exposure taken with a DSLR

The Bias Signal

When capturing a very short exposure in the dark with a CCD camera, one might expect an image where all pixels have zero value since no light reaches the sensor and no thermal signal has time to accumulate. In reality, the pixels all show a small positive value, more or less constant across the image. The explanation for this surprising result is that any background image contains noise that causes small random variations around the mean value. It is important for further processing to leave this noise unaffected. If the average background value were exactly zero, the small positive variations due to noise would be kept but not the small negative ones, having been clipped

A bias image is generally uniform, but when the contrast is strongly pushed to show very small intensity variations in the image, a faint vertical and/or horizontal pattern may be seen, in addition to noise. On the left, a bias frame taken with a CCD camera shows very subtle waviness in a part of the image. On the right, a bias frame from an astronomical video camera with a CMOS sensor is shown. The grid pattern and the faint background inhomogeneities disappear after the subtraction of a master bias or a master dark, techniques described later in this book.

to zero. To avoid this clipping, the electronic design is set so that the background of a short exposure taken in the dark with most DSLRs and all CCD cameras does not look completely dark but is dark gray in the RAW file. For obvious reasons, the signal contained in this image is called the bias (or offset) signal.

In JPEG images taken with a DSLR, in contrast to RAW images, this signal does not remain because the camera has already subtracted it before recording the file on the memory card.

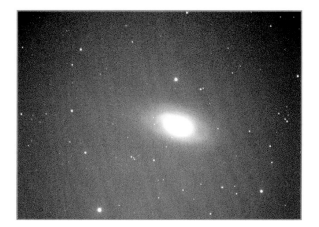

Image obtained with a CCD camera on a Schmidt-Cassegrain telescope with an F/6.3 focal reducer. Because of small mechanical or optical misalignments, the vignetting effect is not always perfectly centered in the image.

Uniformity Defects

Some defects appear in the luminous signal before it even reaches the sensor. While practically impossible to remove with film, they are easily corrected with digital imaging and astronomical software.

The Causes and Properties of Uniformity Defects

Uniformity defects typically take one of two forms:

1. Vignetting: A darkening of the periphery of the image that is well known by photographers. Any optical instrument, lens or telescope, shows this phenomenon to a certain extent depending on its optical design, its aperture, its mechanical properties, and the possible presence of additional optics (focal reducer, Barlow lens, etc.). The magnitude of the vignetting also depends on the size of the sensor: the larger the sensor, the more pronounced the vignetting. In extreme cases, the corners may even become completely black. Vignetting leads to a nonuniform background that makes it difficult or impossible to obtain a satisfying display of all parts of the image simultaneously with high contrast and brightness, especially in deep-sky images or very faint objects, where background uniformity is essential.

2. Dark spots: Small dark spots sprinkled across the image are caused by particles of dust that settle on the sensor or on the window just in front of it and project a shadow on the sensor. Their size, sharpness, and intensity depend on the size of the particle, its distance from the detector surface, and the focal ratio of the lens or instrument. The sensors in compact and intermediate-level cameras, thanks to their fixed lenses, are well protected from dust, compared to those in DSLRs, CCD cameras, and video cameras.

Several spots due to dust particles are visible near the left and top edges on this image extracted from a lunar video taken with a telescope at F/40

Image of blue sky taken with a DSLR and a lens opened at f/2.8 (on the left) and f/32 (on the right). When the focal ratio is increased (diaphragm closed), the vignetting is generally less pronounced but the shadows of dust particles are smaller and sharper. A wide light beam causes larger and lower contrast shadows, while a narrower beam gives shadows that are smaller but more visible.

Appendix 4 describes the main causes of uniformity defects and provides some tips on how to reduce them.

There is a third cause of nonuniformity that can be important: each photosite in a sensor has a sensitivity to light that is very close, but not perfectly uniform. On Canon DSLRs, I have measured an average sensitivity nonuniformity of 0.5%, which is quite good. This very good performance makes the effect hard to see in an image since it is difficult to separate from noise, but it may be noticible, especially in bright scenes.

Calibration of an Image

Correction of the Thermal Signal

Once mixed up in the photosite, electrons of thermal origin are impossible to distinguish from the electrons of luminous origin. However, we can remove the thermal signal that overlays the image by taking advantage of the fact that it is reproducible. Indeed, even if the hot pixels look like they are randomly distributed across the chip, in any specific sensor they are always at the same location, the behavior of each photosite's thermal signal being constant from exposure to exposure. The way to remove this signal is simple: take an exposure with the same exposure time and at the same temperature as the luminous image (light frame), but in total darkness. This image is called a *dark* or *dark frame* and will be subtracted from light frame images. This correction is essential for deep-sky images but is not necessary for short exposures (up to about 1 second) because the thermal signal does not have sufficient time to become significant.

Acquisition of a Dark Frame

Considering the sensitivity of a sensor, protecting it from any source of light is essential for a good dark frame. There must be no light leakage from a poorly fitted lens cap or from the viewfinder of the camera.

Since the thermal signal depends on the temperature and the exposure time, the dark frame must be obtained in conditions similar to those of the image to be corrected. With a CCD camera that has a regulated temperature, the dark frames can be made anytime during the night and even reused from other nights. A library of dark frames, containing darks corresponding to different temperatures and exposure times, can be built up during cloudy nights, with the camera in the refrigerator if necessary (if the regulation is sufficiently insensitive to the temperature of the camera body). But when the temperature of the sensor is not stabilized by regulation, it will surely vary from night to night and even during a single night, depending on changes in ambient temperature and also on the usage of the camera. The temperature of a DSLR sensor increases as the camera is continuously used, and it may take 15 minutes, or more, to stabilize. In this case, it is very important to take the dark frames just after the images of

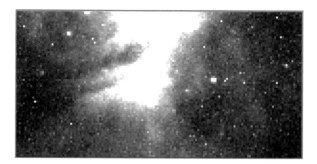

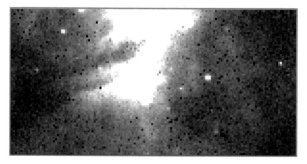

At top, the image on page 43 after subtraction of a dark captured at a temperature in error by 5°C (9 F). The correction is not adequate since hot pixel residues are clearly visible. If, on the other hand, the dark frame had been taken at too high a temperature (bottom), the background of the image would be peppered with dark points.

the sky, or even alternate dark frames with light exposures.

On DSLRs, a function called *long-exposure noise reduction* is included to remove the thermal signal. When it is activated in the camera menu, the camera, just after the main exposure, automatically takes a second exposure of the same duration while leaving the shutter closed. It then subtracts the latter from the former before recording the file on the memory card. The term *long-exposure noise reduction* is ambiguous since the process involves the subtraction of a *signal* and not a *noise* in the strict sense of the word. This distinction is important because, as we shall see later, a true noise remains after subtraction of the thermal signal. The inconvenience of this method is that half of the available time at night is devoted to capturing dark frames! (Note: Don't confuse *long-exposure noise reduction* with *high ISO noise reduction*.)

The Adaptive Dark

When dark frames cannot be obtained in identical temperatures and exposure times, there is another solution: using a dark frame taken in different conditions and letting the astronomical software determine the best scaling coefficient to apply so that the thermal signal correction is optimized. This technique is based on a remarkable property of the thermal signal: the dark signals of two dark frames taken at different temperatures, or exposures, are proportional. This means that for each photosite, the thermal signal has the same ratio between the two images.

For example, if two dark frames of 1-minute and 5-minute durations have been obtained at the same temperature, most astronomical software can be used to analyze the two images and to calculate a dark frame for the shorter exposure by applying a scaling coefficient that would be, in this case, very close to 1/5 to all of the photosite values of the longer exposure.

Correction of the Uniformity Defects

As with the thermal signal, the uniformity defects can be corrected because they are reproducible. Only one extra image is necessary to remove the variations caused by the three most common problems: dust shadowing, vignetting, and sensitivity nonuniformity. This extra image must be of a very good quality because an error of correction of only one or two percent, hardly perceptible on a RAW image, can become obvious after calibration and processing. The correction image is called a *flat-field* because it is simply an image of a uniformly illuminated (flat) target. Of course, the image itself will not be uniform because of the nonuniformities, and thanks to the fact that it contains only the uniformity defects, it can be used directly to correct an image of the sky.

Making a Flat-Field Frame

Different techniques are available to make a flat-field frame. The classic method is to take an image of the dark-blue sky at dawn, when the stars are no longer visible. The downside of this method is that we must wait for the end of the night before disassembling the instrument. Also, the sky itself is not uniform (it is brighter in the direction of sunrise or sunset) and this illumination gradient may be visible on the flat-field frame, especially for wide-field imaging.

Shortly after beginning imaging in 1993, I developed the following method: A simple sheet of white paper (photocopier paper is perfect and is available in large sizes), acting as a light diffuser, is used to completely cover the front of the instrument. An exposure of a few seconds is then captured with the camera, and during the exposure I stand in front of the instrument with a photographic flash triggered by hand. After a few trials necessary to determine the right distance between the flash and the instrument so that the image is not too bright or too dim, I take 5 to 10 images for combining later.

I still use this method, which gives me good flat-field frames without heavy hardware, because I can use it at any time during the night. Any material that diffuses light can be used instead of paper, such as Plexiglas or frosted glass. The only requirement is that the diffuser should be uniform and the shapes of nearby lit objects should not be distinguishable through it.

Another solution is to make a light box that contains both the diffuser and one or several lights. White LEDs are practical as light sources since they are small, their power consumption is low, and they can even be powered with a 12-volt battery. Such a light box, fastened to the front of the instrument so that the light diffuser covers its entire aperture, is an easy accessory for obtaining good flat-field frames without disturbing your neighbors. Avoid tungsten bulbs because they appear quite orange when turned down to low levels.

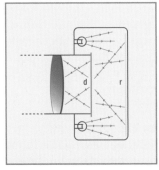

Different solutions for obtaining a flat-field frame. On the left, using a sheet of white paper and a flash; on the right, a light box includes a white surface (r) that blocks the light from going directly from the bulbs to the diffuser (d), providing extra diffusion.

The Conditions for a Good Flat-Field Frame

A flat-field frame must be carefully taken in exactly the same conditions as the images to be corrected:

- ❯ Optical setup: Keep constant the focal length setting for a zoom, and the position of optical or mechanical accessories on the telescope, such as any focal reducers, Barlow lenses, filters, flip-mirrors, focusers, and so on.
- ❯ Focusing: Even if the target of a flat-field frame is a uniform background without details, the focus position must remain identical because the amount of vignetting and the shape of the dust shadows may change significantly with focus.
- ❯ Position of the camera in rotation: The vignetting pattern may not be perfectly centered in the field because of small mechanical offsets or misalignments.

It is best not to disassemble the camera between images of the sky and the flat-fields since dust could settle on the surface of the sensor (or blow away).

In contrast, the distance between the uniform screen or diffuser and the telescope does not matter; if this distance is large, the size of the screen must be sufficient to cover the entire field of view of the telescope. The color of the light source for the flat-field does not need to be perfectly white; astronomical software is able to make a good flat-field correction even in the presence of a dominant color.

A good signal level for the flat-field is essential; the usual target is to reach a maximum value between half and two-thirds of the sensor's available range. For example, for a 16-bit CCD camera (range 0 to 65,535), a value of 30,000 to 40,000 is perfect. With an antiblooming sensor, avoid the highest values (over 60,000 in 16-bit) to avoid any nonlinear region in the sensor's response. Of course, the flat-field must not have any saturated regions, even very small.

How the Flat-Field Correction Works

The flat-field correction is always performed after subtraction of a bias signal and thermal signal (for long exposures). However the mathematical operation is different. Indeed, it would be absurd to subtract a flat-field image, which contains high values, from a deep-sky image whose levels are very low. The result would contain meaningless

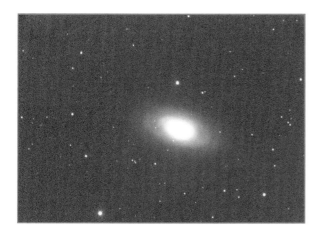 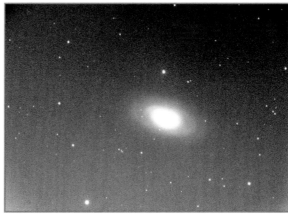

On the left, the vignetting of the image shown on page 45 has been corrected with a flat-field. On the right, the correction with another flat-field taken after a rotation of the camera on itself. The correction is not as good.

negative values! Since the result of uniformity defects is to locally reduce the optical signal on the sensor, this signal must be reamplified by the correction. Therefore, the flat-field correction is made by dividing the astro-image by a flat-field image pixel by pixel, not by subtracting. Of course, the bias signal (obtained with a bias image) must have been removed from both images prior to this division.

For example, suppose a deep-sky image has vignetting that causes a signal falloff in the corners by 25 % relative to the center of the image, so the average center background value is 1,000 and the average corner background is 750. The flat-field image, if it is good, has the same amount of darkening in the corners—for example, 10,000 in the center and 7,500 in the corners. When the first image is divided by the second, the average value in the center becomes 1,000/10,000 = 0.1 and the value in the corners becomes 750/7,500 = 0.1. The background becomes uniform, and the vignetting is removed.

For practical reasons, when astronomical software performs the flat-field correction, it automatically multiplies the result by the mean value of the entire flat-field image after the division, so the global values of the astro-image remain in the same range. In the previous example, the mean value of the flat-field would probably be around 9,000, so the software multiplies the results of the division on a pixel-by-pixel basis by this value, so the final average background in the center and in the corners of the corrected image become 0.1 × 9,000, or 900.

Image Calibration

Calibration needs three specific images: bias frame, dark frame and flat-field frame. Each includes the artifacts listed in the following table.

Information	Bias signal	Thermal signal	Uniformity defects
Bias frame	X		
Dark frame	X	X	
Flat-field frame	X		X
RAW frame	X	X	X

The general equation of calibration is therefore as follows:

$$\text{Calibrated frame} = \frac{\text{RAW frame} - \text{dark frame}}{\text{Flat-field frame} - \text{bias frame}}$$

The bias signal is present in all frames. It is also eliminated by the subtraction of the dark frame, which contains it as well (beware not to subtract the bias signal twice!). However, it must be explicitly subtracted from the flat-field image before its application.

In the case of a short exposure (planetary imaging), a dark frame is equivalent to a bias frame. In deep-sky imaging, if the exposure time of the flat-field exceeds a few seconds, it will contain some thermal signal and the bias frame can be replaced by a dark frame of the same exposure time as that of the flat-field.

The use of an adaptive dark (described earlier) implies that the bias signal is subtracted from the dark frame before application of the scaling coefficient (therefore

Image calibration is one of the special features of astronomical programs such as MaxIm DL, shown here

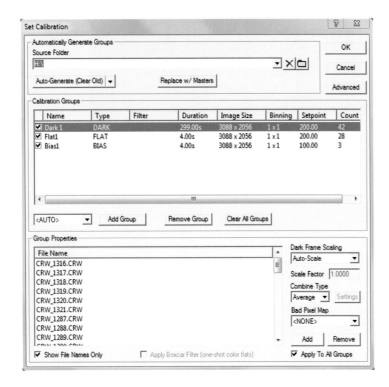

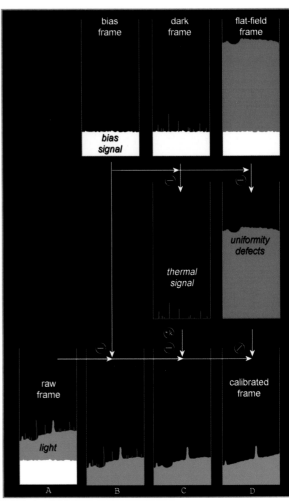

excluding the bias from the scaling operation). In this case, the numerator of the preceding calibration equation becomes

$$\text{(RAW frame } - \text{bias frame) } - \\ \text{scaling coefficient} \times \text{(dark frame } - \text{bias frame)}$$

It is easy to see that if the coefficient is 1 (no scaling), we obtain the initial calibration equation. For a CCD camera whose readout time can last seconds and even tens of seconds, it is important to take the bias frame at the same temperature as the dark frame.

Non-astronomical programs are able to subtract one image from another but not to divide them. Therefore, it is not possible to carry out the intensive calibration possible with an astronomical processing program. Photoshop and DxO Optics, for example, include a vignetting suppression function for photographic lenses, but this operation is carried out assuming a simple mathematical vignetting model and not using real flat-field image data that would also include dust shadows.

The calibration frames, their signals, and combinations, presented in cross-section. In column A, a RAW frame contains the bias signal (white), the thermal signal (hot pixels, blue), the optical signal (green) including the sky background plus two stars in addition to a dust particle shadow (small indentation on the left), and some vignetting. In column B, the bias signal is subtracted from the RAW frame. In column C, the thermal signal is also eliminated, after subtraction of the bias signal included in the dark frame and possible scaling (coefficient k). In column D, the removal of dust shadows and vignetting by division, after subtraction of the bias signal included in the flat-field frame (light signal in red). The calibrated image also includes a linear gradient that will be removed later (chapter 7). With short exposures (planetary imaging), column C is omitted.

The other decisive advantage of astronomical programs is that they can perform all calibration operations on a series of images in one command: all you have to do is specify the names of the calibration images (bias, dark, and flat-field) and the names of the series of images to be corrected. In addition to these basic operations, high-performance programs are able to identify, in the calibrated frames, the remaining hot pixels (undercorrected thermal signal) and cold pixels (from dead photosites or overcorrected thermal signal), or even defective columns, and replace them with the mean of their neighbors.

Calibration of DSLR Images

The corrections described earlier can be performed with DSLR images as well as with CCD camera images, with the condition that the DSLR files are saved in RAW mode. Indeed, when they're saved in JPEG mode, the data contained in the files is no longer linear (it is no longer proportional to the quantity of light received), so the flat-field correction cannot work. Also, the data compression inherent in a JPEG file would lead to a poor result.

In RAW mode, the only parameter that has a direct influence on the data stored in the file is the ISO setting. For an accurate dark, it is essential to use the same ISO value used for the images to correct. For a flat-field, this is of no importance and any ISO setting can be used. For example, you can take your flat-fields at the minimum ISO value (ISO 100 or 200, depending on the camera), even if the images of the sky have been taken at ISO 800; they will contain less noise and be smoother. We can even say that, in terms of noise, a combination of eight flat-field images taken at ISO 800 is equivalent to just one flat-field taken at ISO 100 (the behavior of noise will be described later in this chapter). All other parameters of the camera (color balance, sharpness, etc.), except the long-exposure noise reduction option that must be deactivated, have no influence on the data of the RAW file and therefore can be set to any value.

When the sensor of a DSLR includes a dust-removal system, it is better to use it before the imaging session to remove as many particles as possible but to deactivate it during the session so that it cannot operate automatically at switch-on or switch-off. Otherwise, a dust pattern might change between the moment the images of the sky are taken and the time when the flat-field is collected.

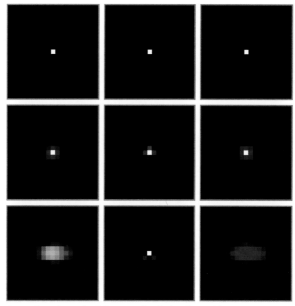

Strongly enlarged subframes of a dark taken with a DSLR in RAW mode, centered around three photosites covered with red, green, and blue filters, respectively. While converting the RAW data into a color image, demosaicing transforms hot photosites (top row) into colored hot pixels (central row).

Because of interpolations applied during demosaicing, the signal of the hot photosite leaks a little bit into adjacent pixels. This is the reason the subtraction of the thermal signal must be done before demosaicing by astronomical software.

In the bottom row, the dark image has been obtained in JPEG mode. Due to compression artifacts, the hot photosites are greatly enlarged when transformed by the camera into a color JPEG image.

The Calibration of Video Images

To calibrate a video, capture short bias and flat-field sequences. For the flat-field sequences, adjust the light to achieve a histogram level between 50 and 80 % of full scale (the average level is between 130 and 200 in 8-bit) while keeping the same settings used for the video that is to be calibrated: the same exposure time and gain for bias and the same gain for a flat-field. Make sure that the average level of the bias data is above zero. Otherwise, increase the black level setting during acquisition.

Noise and Its Reduction

I have described defects that affect all astronomical images. In a perfect world, this chapter would stop here. Actually, we must take into account another phenomenon, as insidious as omnipresent: noise.

Noise is visible as a grainy effect of varying intensity; in a way it is the analog of silver film grain. If it is substantial, the noise can mask low-contrast details or even be confused with true details. In a color image, where each color layer has its own noise, the result is a patchwork of small color dots. In all cases, it is an artifact that alters the accuracy and beauty of the image, like background clicks in a poor hi-fi sound system.

The Sources of Noise

Schematically, noise can be associated with each signal. This noise alters the corresponding signal and prevents it from being perfectly reproduced. It can be recovered only with some uncertainty as to its exact value. In a camera, the electronic chain (sensor, amplifiers, converters, etc.) introduces a noise commonly called the *readout noise*. This noise is visible through its perturbation of the bias signal, so it is present in every image taken with the camera, and its amplitude (mathematically called the standard deviation) is generally expressed in electrons per photosite. A good CCD camera can reduce readout noise to below 20 electrons; some DSLRs even show a readout noise of less than 2 electrons.

The thermal signal is also affected by a noise. This means that if we take two dark frames in exactly the same conditions of temperature and exposure time, the thermal signal will be almost, but not perfectly, identical. If we subtract one dark from the other, we will obtain an image over which the mean level is zero but with noise; the thermal signal has been cancelled, but the small random variations of this signal, the noise, remain (and combine with the readout noise).

Another very important noise in astronomy is associated with the light itself. The light is composed of particles, photons, which arrive randomly in time and never in exactly the same quantity, just like raindrops falling on the ground. Think of a star with a very stable light emission from which we receive through a given telescope an average of 1,000 photons per second. If we measure for

SIGNAL AND NOISE

The fundamental difference between signal and noise is that only the former can be reproduced identically. Consider an analogy of a movie played on TV; if the channel plays it again another day, you will of course look at the same scenes, the same actors, the same dialog, and so on. So you can think of all these elements as signals. But, in the case of bad reception, you may have sparkling parasitic grains appearing on the screen, sometimes called snow. When the movie is played again, there is no reason the same parasitic grains would appear exactly at the same place and the same instant. It is this random characteristic that makes this phenomenon a noise: it never occurs again in an identical fashion. In astronomy, imagine noise not as something additive that would sum to a signal but as an uncertainty (plus or minus) of that signal, which prevents you from measuring the light with perfect accuracy. The higher the noise, the less precise your signal measurement will be.

Note that advertising spots interrupting the movie at crucial moments are a signal, because they can be (and often are!) replayed again and again. This shows that everything that is unwanted is not necessarily a noise. In astrophotography, the best example is the thermal signal: even if digital camera manufacturers call it "long exposure noise," it is a true signal. This distinction is not just a question of words, as seen later in this chapter. When the thermal signal is removed, what remains is...a noise that accompanies it! So if we say that the thermal signal is a noise, how should we label this remaining noise?

each second the exact quantity received, we could receive, for example, 1020 photons the first second, 988 for the next one, then 1006, and so on. The random variation of the quantity of photons is reflected in the number of electrons stored in the photosite and is naturally called *photon noise*. Note that the photon signal can be separated into two categories: the useful signal (the light coming from the celestial bodies) and the undesirable one (sky background and light pollution).

The combination of noises occurring in an image taken with a digital camera is often called *digital noise*. But this

does not mean that the noise is caused only by the camera itself. The better the quality of the electronics of the camera, the more preponderant the photon noise is. The photon noise is the ultimate physical limit; as far as internal noise is concerned. Even if using a "perfect" camera, the image will inevitably contain photon noise.

Noise Behavior

The most important property of the photon noise and the noise associated with the thermal signal is that their amplitude depends on the magnitude of the associated signal. The greater the signal, the greater the noise, but the laws of physics, fully confirmed by measurement, reveals that there is not a linear relationship between them. Quantitatively, noise increases as the square root of the signal intensity. Thus, a signal, when increased by a factor of 100, suffers from a 10 times increase in noise. This behavior has important consequences:

❯ The thermal signal is not a nuisance in itself since we can remove it with a dark frame, but the noise that remains after this operation is. To minimize this noise, we need to minimize the thermal signal. This is the reason CCD camera sensors are cooled.

❯ The same rule applies for light pollution. It is not the sky background signal that is undesirable, because it is easy to remove by processing; it is the photon noise that remains and that cannot be removed. This is why a dark sky is important—to lessen the noise in long exposure images.

❯ For the useful celestial light, what is important is not the absolute noise level but the ratio between the photon signal and the noise, which is called the *signal-to-noise ratio,* or *SNR*.

The photon SNR varies as the square root of the signal. Therefore, it improves as the signal increases, just as the accuracy of opinion polls improves with the number of people questioned. For example, a signal that can be collected nine times more yields an SNR that is three times better. The SNR is a fundamental factor of the quality of an image: a higher SNR implies an image that is deep and soft, with dim parts of nebulas and galaxies or low-contrast planetary features rendered more visible.

The square root rule has another important consequence: as soon as a source of noise dominates even slightly over other sources, these other sources can be considered negligible. Therefore, it is useless to try to lessen secondary sources of noise; it is more profitable to concentrate on the primary noise source. This primary source depends on the camera, the celestial objects, and the circumstances (exposure time, level of light pollution, use of filters, etc.). For a bright object like the sun, the moon, or a planet, the main noise is the photon noise from the object itself. In this case, a camera with ultra-low readout noise is not necessary. If, for example, the photosites have a capacity of 40,000 electrons (a typical value with DSLRs at a lower ISO setting), an object that fills half the dynamic range of the sensor produces about 20,000 electrons per photosite and therefore an average noise of 140 electrons per photosite (the square root of 20,000). If the camera has a readout noise of 5 or even 50 electrons, this does not change anything since the result is so dominated by the photon noise. Even light pollution is not a problem for bright objects: the planets can be photographed from Manhattan or from Tokyo because the photon noise of the sky background is negligible. On the other hand, for deep-sky objects, photon noise from the object is lower and other sources of noise usually become important: the readout noise, the noise accompanying the thermal signal, and, of course, the noise from light pollution that is often the primary source of noise in suburban sites of developed countries.

Bit Depth and Noise

All DSLRs can work in JPEG mode (8 bits) and in RAW mode (12 or 14 bits, depending on the camera), while most CCD cameras work in 16 bits. One could suppose that more bits are better since it gives more precision to the data; this is true, but only to a certain extent that is limited by the level of noise.

Let's use the example of a bathroom scale. It is easy to understand that a scale that gives your weight rounded to the nearest dozen pounds would not be very satisfying in comparison to another one that offers an accuracy of a 10th of pound. But, what about a scale that would offer a precision of 1 millionth of a pound? Would it be really useful for you, since the simple fact that whether or not you are wearing glasses when you weigh yourself would

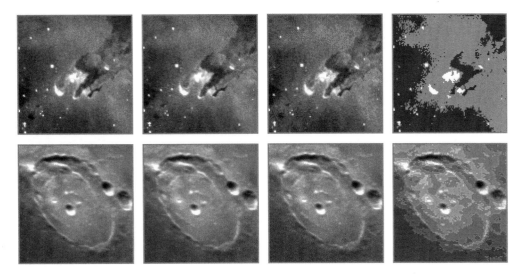

These images have been taken with a 16-bit CCD camera and the raw data has been modified to simulate 14-bit, 12-bit, 10-bit, and 8-bit data depth for the deep-sky image and 12-bit, 10-bit, 8-bit, and 6-bit for the lunar image. The lunar image begins to show degradation at less than 10-bit resolution and the deep-sky data at less than 14-bit resolution. Note that these guidelines are approximate and may be different for other cameras or in other circumstances (exposure time, light pollution, etc.).

Another implication of the photon noise is that for bright objects (sun, moon, planets), it is useless to employ more than 11 to 12 bits because the extra precision is lost in the noise. Also, in the video cameras used for planetary imaging, the gain is a kind of amplification, like the ISO setting in DSLRs. A high gain setting, often used with planets, amplifies the readout noise and can even make the extra bits over 8-bit useless. A 10-bit or 12-bit video camera is not automatically better in practice than an 8-bit one!

Photosite Size and Image Quality

How does the size of the photosites affect the SNR of the image for deep-sky imaging? Let's take two sensors that differ only by the size of their photosites and examine what happens:

completely change the number of millionths of a pound displayed? The same principle applies to cameras and their digitization resolution: beyond a certain limit, the extra precision is lost in the noise and is therefore useless.

For example, the photosites of the Canon 50D have a capacity of almost 30,000 electrons at ISO 100. Its digitization to 14-bit precision in RAW mode (actually slightly less than 16,384 levels) leads to a resolution of about 2 electrons per level. But its readout noise at ISO 100 is 14 electrons. In reality, for this camera, 14 bits is more than sufficient and has no advantage over 13-bit or even 12-bit digitization. It is obvious that 16-bit digitization would be totally useless. Note that this calculation is optimistic since it takes into account only the readout noise and not the other sources of noise (thermal, photon, etc.) that make the useful number of bits even lower. At ISO 1600, the 50D has a lower readout noise (3 electrons) but the capacity of the photosites decreases to about 2,000 electrons, leading to a digitization resolution of one one-tenth electron per unit: the 14-bit digitization is still more than sufficient.

The same kind of calculation can be performed for a CCD sensor, such as, for example, the Kodak KAI-11002 used in some CCD cameras. Its saturation signal is 50,000 electrons and its readout noise is 13 electrons. 14-bit digitization (3 electrons per level) would be perfect for this sensor. Of course, 16-bit digitization (1 electron per level) would also do the job well, but without practical advantage over 14-bit precision since the noise in any image cannot be lower than 13 electrons.

- ❯ The readout noise is identical or close (it might be a bit higher with larger photosites)
- ❯ The thermal signal increases proportionally to the size of the photosite, and the noise increases also
- ❯ The luminous signal gathered by each photosite increases proportionally to the size of the photosite, giving a better SNR

Unless the thermal noise is dominant, which is generally not the case with modern cameras, increasing the size of the photosites is overall favorable to the SNR of the image, at the expense of a lower resolution (see chapter 4). It is not a matter of chance that the photosites of DSLRs are considerably larger than the ones of compact cameras!

A portion of an image of the daytime sky, taken with a camera with small photosites (on the left) and a camera with large photosites (on the right). The larger capacity of the latter is the main cause of the better SNR of its images.

In planetary imaging with a video camera, since the focal length is usually adjusted to achieve the desired sampling and photon noise is dominant, the difference between large and small photosites is much less important.

Improving the Signal-to-Noise Ratio

An obvious technique to improve the SNR is to make the exposure time longer. However, this is not always possible, either because the bright portions of the object would be overexposed or because the mount is not capable of tracking well enough for a longer exposure. In many situations it is better to take several successive images with the same settings (framing, exposure time, etc.) and combine them during processing, as explained later. With regard to the total quantity of thermal and photon signals and their associated noise, 10 exposures of 1 minute is equivalent to 1 exposure of 10 minutes. However, they are not equal when it comes to readout noise because it occurs 10 times in the first case. This means that it is multiplied by the square root of 10; about 3 times in the first case, and only once in the case of a single exposure. Actually, it is important to know if the readout noise is negligible compared to other noise sources (photon, thermal). In practice, for similar results between summing short exposures and a single long one, the exposure must not be sliced too thin; for example, a deep-sky exposure of 10 minutes cannot be replaced by 600 exposures of 1 second!

The table below shows the possible improvement in photon SNR as either the individual exposure time or the number of exposures is increased. Gathering 25 times more signal leads to an SNR that is 5 times higher, while we must collect 100 times more signal to obtain an SNR 10 times higher. The square root rule implies that the benefit ends up hitting a ceiling and that there is a threshold above which the prize earned is not worth playing the game. To overcome this limitation, the most obvious solution (but not the least expensive) is to use a sensor with better quantum efficiency—or use a larger telescope. This is why professional telescopes, whose main aim is to observe very faint objects and capture spectra of them, are so large.

Signal factor	2	4	9	16	25	100	400	1,000
SNR improvement factor	1.4	2	3	4	5	10	20	32

A frequent question is: What is the minimal duration of each individual exposure at which the lesser signal begins to degrade the image? It is impossible to give a simple answer because it depends on the imaging conditions: camera, instrument, filters, level of pollution, and so on. The first parameter is tracking quality: if you do not autoguide (see chapter 7), you may be limited to 10 to 60 seconds before streaking is visible, unless you work with a short-focal-length instrument or a lens. Otherwise, there is an optimal exposure time beyond which there is no real advantage for each exposure. The way to determine it from real data is described in appendix 7. If, for example, the optimal minimum duration is 4 minutes for your setup and your location, then 10 exposures of 4 minutes will give a result comparable to 4 exposures of 10 minutes.

Combining successive images improves the SNR due to the random nature of the noise. If you can imagine the noise affecting a signal as a series of mountains and valleys that completely change from one image to the next, you will understand that while the signal accumulates proportionally with the number of images, noise accumulates more slowly because some valleys in one image may combine with some mountains in another and vice versa. Of course, this property of the noise occurs only if the combined images are distinct: combining one image with itself several times improves absolutely nothing!

Compositing Methods

Astronomical software uses different methods to combine images taken in similar conditions. Each has certain advantages and drawbacks.

Before you combine a series of images of the same field, you must register all the images so that the position of all objects coincides rigorously. The registration methods are different if the object is a planet, the moon, the sun, or a deep-sky field; they are described in chapter 5, chapter 6, and chapter 7.

Compositing by Sum and Median

The two basic methods of compositing are to find either the arithmetic sum or the median sum. It's important to understand their advantages and their limitations because you may have to use each frequently.

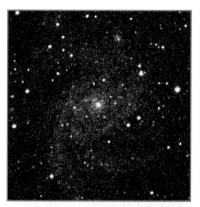

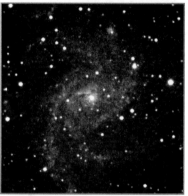

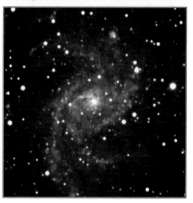

The galaxy NGC 6946 taken with a DSLR on a refractor. At top is a calibrated exposure of 5 minutes. In the center and on the bottom are combinations of 4 and 16 such exposures, leading to respective improvements of 2 times and 4 times in SNR.

Shown here are three images of M17, a nebula in Sagittarius. Each example is a composite of five CCD images taken using a different technique. In the top figure, an artificial satellite left a bright trail during one of the exposures. In the center, the trace is still visible on the mean of the five images. In the figure on the bottom, a median combine allowed use of the affected image with the others, removing the trace. Satellite and airplanes trails are very frequent on deep-sky images.

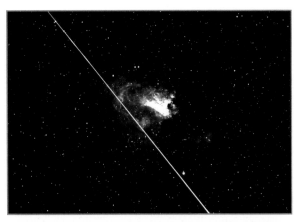

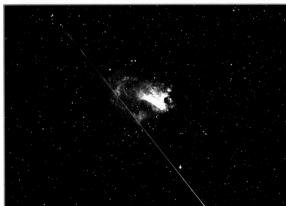

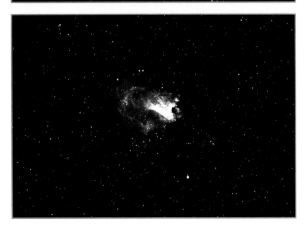

THE MEDIAN

Suppose we want to combine five calibrated and registrated images and for a given photosite (or pixel), the different values are as follows:

$$99, 103, 101, 98, 102$$

First, these values are sorted out in increasing order:

$$98, 99, 101, 102, 103$$

Second, the central value, 101 in this example, is extracted. Doing this operation for all pixels of the image results in an image called the median.

If we calculate the mean of the preceding values, we get 100.6, which rounds up to 101. Here, the results are similar for the median and the mean. This is the case when the combined values are consistent and none is an outlier compared to the others. On the other hand, if a satellite, an airplane, or a cosmic ray had been registered in one image on this photosite, it could cause a saturation of the signal to the maximum value, such as, for example, 16,383 for a DSLR working in 14-bit. It is easy to calculate that the median sum will not be affected by this defect and has not changed while the mean is now about 3350, which obviously is not a realistic value. The advantage of the median lies in its ability to reject a defect present in one image of the series (or even in several images, with the condition that the number of affected images is fewer than half the total number of images).

The median sum is not offered by consumer software like Photoshop. It's a specialty of astronomical processing software, which is able to calculate the overall contribution of each image to the median, on a pixel-by-pixel basis. For all images to contribute, the pixel values must be close. It is common, for mathematical reasons, to see the image's contribution decreasing a little bit. In the previous example, one might obtain, for example, 23%, 21%, 20%, 19%, 17%, but a strong variation (for example 5%, 54%, 26%, 14%, 1%) is a sign that the images are not consistent.

In theory, the median is a bit less efficient than the sum in improving the SNR, but this difference is difficult to perceive in practice.

The calculation of the median supposes that the number of images is odd. However, astronomical software knows how to deal with an even number of images (for instance, they might take the mean of the two central values).

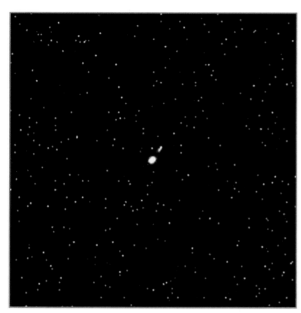

This white spot in the middle of a dark frame is not a hot photosite but a cosmic ray that impacted the sensor during the exposure. Such phenomena occur frequently on long exposures, especially if the observing site is located at higher elevations. The median is an effective way to remove them.

Summing images simply consists of adding, for each photosite or pixel, all the signals in the different images. With bright objects, this may lead to an overflow of the values, causing saturation and therefore a loss of information. To avoid this problem, the software can also calculate the average (mean) of the images; that is, the sum divided by the number of images. When it comes to SNR, the sum and the mean are identical.

Processing using the median is more sophisticated because you can cancel some defects present in the individual images (see the sidebar "The Median").

However, the median imposes an important constraint: all of the images to be combined must be consistent and have comparable light levels. This is the case when all frames have the same settings (such as exposure time) and were taken in a short time interval. But, for exposures captured over periods longer than 20 minutes or so, or over several nights, some factors can significantly alter the background levels between the beginning and the end of the series:

❯ Moonrise or moonset changes the brightness of the sky
❯ The field moves relative to the horizon (and therefore from sources of light pollution), changing the background level in the image
❯ Even if imperceptible with the unaided eye, variations in atmospheric transparency due to humidity, high clouds, or a thin layer of dew on the optics will modify the brightness of objects in images and can also change the background light pollution level

Therefore, the images should be *normalized* before being combined; that is, their levels should be adjusted to match, either additively (addition or subtraction of a constant) for the sky background variation or multiplicatively (multiplied by a constant near 1.0) for the variation in intensity, or both. It is tedious to perform these operations manually, but fortunately advanced programs such as PixInsight are able to perform the normalization operations automatically.

Compositing by Sigma-Clipping

Another method that may also be used to reject the abnormalities is called sigma-reject or sigma-clipping. It consists of calculating, for each pixel, the sum or the mean with prior rejection of the values that are judged aberrant. This method needs a parameter that sets the tolerance interval outside of which the values are rejected and that is expressed in a number of standard deviations (sigma). For example, if the parameter chosen is 2, all values that are outside an interval of plus or minus 2 sigma from the mean value are not taken into account in the combination. The usual value lies between 2 and 5; if it is too low, valid data is rejected, and if it is too high, rejection is disabled. This method also supposes that the images are fairly consistent and, if necessary, have been normalized beforehand.

The sum, median and sigma-clipping methods are the most used methods and give very satisfying results for common situations. CCDStack and PixInsight also employ other sophisticated calculation methods that may help in particular situations, such as Poisson sigma-reject (the sigma is linked to an assessment of noise in the image), linear factor reject (the rejection is more aggressive in background areas), and clip min/max (the lowest and the highest values in the stack are rejected).

Although the combination of images with consumer processing software can be performed only using layers, astronomical software is able to combine images through a number of different algorithms such as median or sigma-clipping (as shown here in PixInsight)

Combination methods that use minimum or maximum values are similar to the median combine except that the lowest or highest values are kept, respectively. Such methods are used only in very specific situations, such as star trails (as seen in chapter 1).

Reduction of Noise on a Single Image

Most consumer programs have different methods of noise processing for a single image. Digital cameras also implement noise reduction algorithms within the camera, at least in JPEG mode.

Because noise is most evident in the highest spatial frequencies of an image (small-scale details), the application of a low-pass filter or a similar noise reduction algorithm may help to smooth the image. The most sophisticated algorithms used by specialized software such as Noise Ninja and Neat Image smooth the image while preserving maximum detail, after a determination of the characteristics of the noise deduced through analysis of the flat areas of the

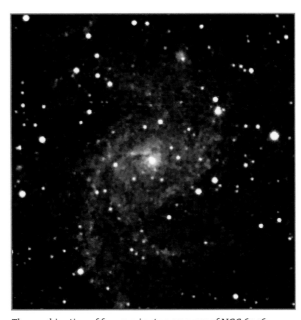

The combination of four 5-minute exposures of NGC 6946 (shown on page 55) has been processed with software specialized for noise reduction. Despite the improvement of the image, the quality is far from the result obtained from combining 16 images.

image. Photoshop incorporates a noise reducing function acting separately on the luminance level (detail) and the chrominance data (color).

Since it is impossible to truly separate the noise from small details, the drawback of all noise reduction processing is that if it is applied without moderation, it may lead to a loss of detail or to an artificial appearance of the image, yielding a "plastic" aspect to flat areas. Such processing can be used with profit for the touch-up of the final image, but we must not ask from it more than it can give. These techniques are not able to replace the improvement of the SNR offered, for example, by increasing the total exposure time. They are not able to extract details that are invisible due to insufficient exposure time or a high noise level.

Advice for Image Calibration

Let's come back a moment to the calibration process, whose role is to remove the thermal signal and uniformity defects. The calibration of an image does not improve its SNR; it can even reduce it because each calibration image contributes its own noise. For example, even if one image is subtracted from another, their noise increases as if they were added (following the square root rule).

This is why using only one image for each calibration step is not a good solution because the noise of this single image will contribute to all calibrated images and will possibly dominate the noise in the final image. It is much better to take several calibration images of each type and combine them to obtain what are usually called the master bias, the master dark, and the master flat-field. The aim is to improve the calibration frame's SNR so that the influence of its noise on the final result becomes negligible.

The combination of each series of calibration images (bias, dark, and flat-field) is best done by a median combine because removing all of the defects present in a single image is essential for creating a calibration master. For the master flat-field, the set of images must be normalized beforehand (by a multiplication factor), an operation that can be performed automatically by astronomical programs during the collection of the master flat-field.

HOW MANY CALIBRATION FRAMES?

The most frequent question asked by amateurs about the calibration process is probably this: how many bias, dark, and flat-field frames should I take? The simple answer is as many as possible. Once again, considerations about noise can help us to determine the optimal number beyond which the benefit is not worth the extra effort and is imperceptible. That number depends on the type of object:

- Deep-sky exposures have a low SNR, comparable to that of dark images. Ten to 15 dark frames is a good figure to reduce their noise to negligible levels if you are using dithering (see chapter 7) because the residual noise will be spatially smoothed by the image shifts. If dithering is not used, the ideal would be to collect more dark frames than raw images, even if it takes time. For flat-field images, the situation is very different: if their signal level is as high as it should be, then they have a much better SNR than the deep-sky images and three to five flat-field images are sufficient; a higher number does not improve the result. If bias frames are intended to be subtracted from only the flat-field, only one is sufficient, but if they are subtracted from the master dark (in the case of adaptive darks), they should be captured in equal quantity to the dark frames.
- For short exposures on bright objects (the moon, the sun, planets) that, when correctly exposed to achieve a higher SNR, are comparable in signal intensity to that of a flat-field image, it is prudent to take more flat-field images than in the previous case, about a dozen. Flat-field frames have more noise in an absolute sense than bias images, so even a single bias image is generally sufficient.

Type of images	Bias Frame	Dark Frame	Flat Frame
Deep-sky without adaptive dark, with dithering	1	10 to 15	1 to 5
Deep-sky without adaptive dark, without dithering	1	At least as many as raw frames	1 to 5
Deep-sky with adaptive dark, with dithering	At least as many as dark frames	10 to 15	1 to 5
Deep-sky with adaptive dark, without dithering	At least as many as dark frames	At least as many as raw frames	1 to 5
Bright objects (planets, moon, sun)	1 to 5	Not necessary	10 to 15

This table shows the recommended number of calibration images.

THE CALIBRATION, STEP-BY-STEP

During your first night of astrophotography, do not worry too much about calibration images. You will have many other dragons to slay to tame your equipment. With a DSLR, take your first shots in JPEG mode and switch on the long-exposure noise reduction setting; the images will be directly presentable. Later on, especially if your images suffer from obvious defects such as vignetting or dust shadows, you will try to take bias, dark, and flat-field images (of course, at that moment, all your images should be taken in RAW mode), and you can experiment with the calibration of the images using astronomical software. Then, you will be ready to make calibration masters employ various combinational techniques to achieve the best possible result.

Calibrating and combining images are simple but effective techniques that no skilled astronomer, amateur or professional can ignore. They must be performed with care to obtain a pleasant, aesthetic, and realistic image of the sky. If these steps are ignored, the remaining defects will be painful or even impossible to remove correctly by subsequent tinkering with any software, whether consumer or astronomical.

Although image calibration allows you to reduce or to remove the thermal signal, the vignetting, and dust shadows, reducing these problems before they appear improves the SNR and therefore leads to better images. For example, strong vignetting in the periphery of an image causes a loss of SNR in this area due to the lower signal level. Even if a good master flat-field removes the vignetting, the corners will have a poorer SNR than the center of the image. Moreover, a perfect flat-field is difficult to obtain, and this difficulty increases with the amount of vignetting. As a result, it is important to try to reduce the causes of vignetting as well as the contribution of thermal signal or dust shadows, for similar reasons.

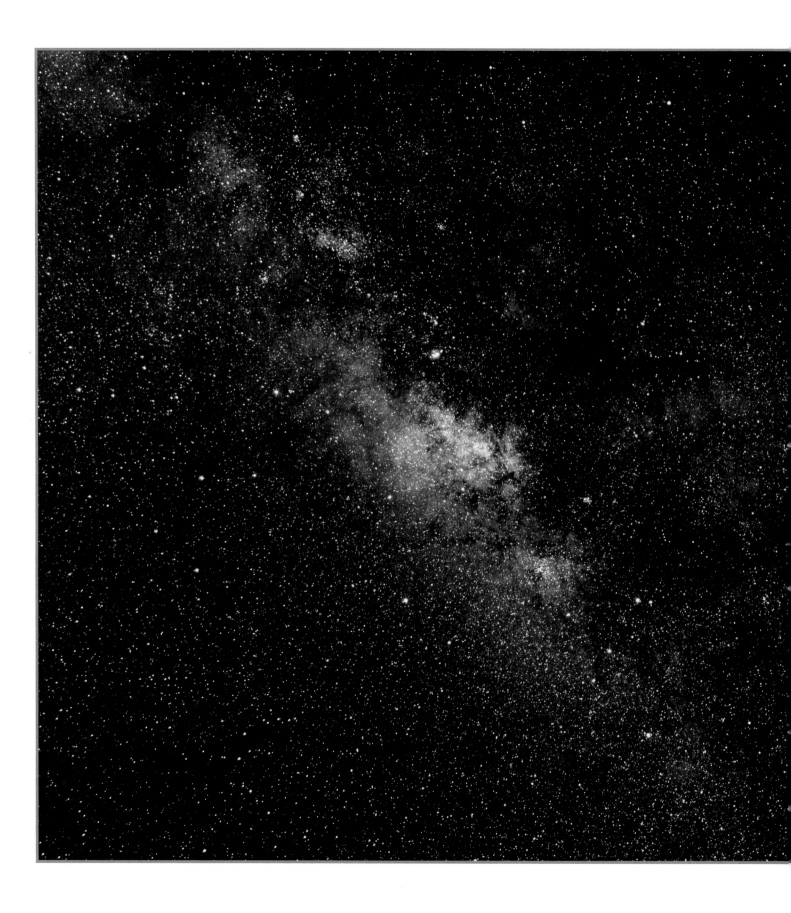

Chapter 4
Using Your Equipment

How do you attach a camera to a telescope? How can you calculate the angular coverage of your setup? How do you precisely focus the telescope? How do you collimate the optics of the telescope? The answers to these questions are important for all types of astrophotography, and they are discussed in this chapter.

Image of the denser area of the Milky Way: Sagittarius and Scorpio. Combination of several 5-minute exposures with a DSLR and a 24mm f/5.6 lens piggybacked on a motorized equatorial mount.

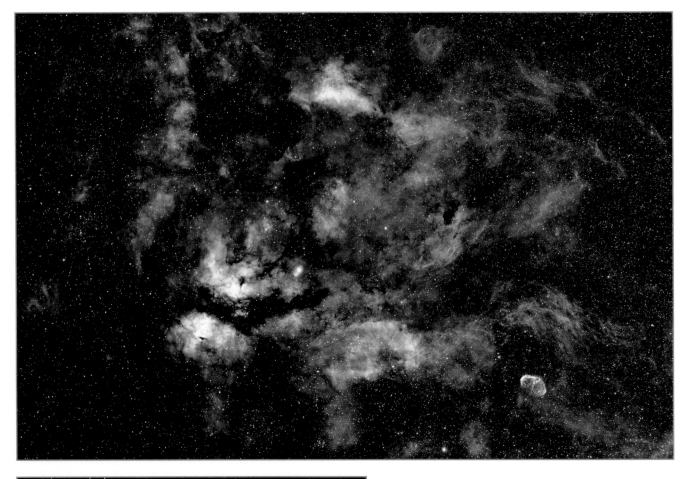

This large nebular complex surrounding the star Gamma Cygnus, photographed with a monochrome 24 × 36mm CCD camera and a 300mm telephoto lens, covers a field of several degrees. In the lower-right corner lies the Crescent Nebula. Below, a closeup of this nebula is shown with another CCD camera on a 1000mm refractor. The longer focal length, yielding a higher resolution, allows one to record finer details for the nebula but to the detriment of the field of view, which is reduced.

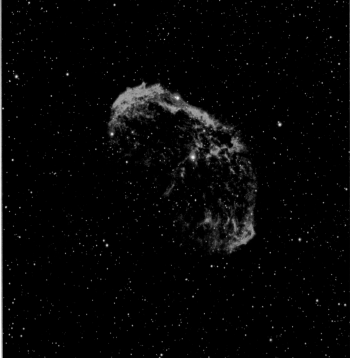

Before we get into specific techniques used for planetary, solar, and deep-sky photography, we'll look at several basic techniques that the astrophotographer needs to master, whatever the celestial target. There are a lot of different ways to attach a camera to a telescope, and it is easy to get lost in the jungle of adaptor rings offered by the manufacturers. To add to the confusion, eyepieces and Barlow lenses, commonly used for visual observation, may need special adaptors and spacers for proper positioning, as will focal reducers specific to deep-sky photography. Adding further to the confusion is the question of the angular field of view covered by the sensor, and related to this is the size of the celestial target in the final image.

Astrophotographers who want the best from their telescope should also be concerned with another topic: the alignment of their telescope optics (the collimation), which is a simple but essential operation, especially on reflectors. Also, while focusing is now a mere formality in consumer photography with modern cameras, the situation is quite different in astrophotography, where autofocus is rarely usable. Therefore, some focusing techniques and tips are useful for trying to achieve a sharp image.

Attaching the Camera to the Telescope

A telescope (reflector or refractor) is a general-purpose modular system to which many visual or photographic accessories can be attached. Some of them are designed for the attachment of cameras; others help to increase or reduce the effective focal length of the telescope, enabling astronomers to achieve some of the flexibility of the zoom lens that they use for conventional photography. However, the focal length of a telescope can be modified only within certain limits (some do not even have focal reducers available) and not to any desired value!

Piggyback Attachment

In chapter 1, you saw that it is possible to use a camera while it is simply mounted on a tripod, but with an important limitation: because the camera is fixed, the exposure time must be short enough to avoid the effects of the rotation of the earth; beyond several seconds, even with a wide-angle lens, the image is blurred.

Astronomers who own an equatorial mount can avoid this problem by attaching the camera to the mount itself or to the tube of the telescope (the latter is referred to as a piggyback mounting). A piggyback mounting is available for many telescopes and holds the camera or the lens by its tripod screw. If the lens is heavy, it is important to use a sturdy attachment and to rebalance the telescope mount. With a motorized equatorial mount carefully aligned on the celestial pole (see chapter 7), long exposures can be taken while maintaining the same field of view.

Prime Focus Attachment

Any serious telescope is equipped with a prime focus adaptor, perhaps as an option. Prime focus attachment consists of mounting the camera at the back of the telescope without an accessory such as an eyepiece, a Barlow lens, or a focal reducer. With a DSLR, it might be tempting to leave the lens on the camera, but it is a mistake because the telescope already acts as a lens (except that there is neither a diaphragm nor an autofocus system!).

On the camera side, the standard adaptation is a T-ring, a threaded coupling with a diameter of 42mm and a thread pitch of 0.75mm. This coupling enables attachment of most CCD cameras. For a DSLR body, a T-ring adapter

corresponding to the specific bayonet attachment of the camera is necessary. T-rings are available for all common DSLR brands: Canon, Nikon, Olympus, Pentax, and so on.

Most video cameras use C-mount threads, for which telescope adaptor rings are available from astronomical equipment retailers.

Canon DSLR equipped with its T-ring, and T-rings for Olympus and Nikon bodies

A video camera equipped with a telescope coupling that allows it to be inserted just like an eyepiece. The coupling is threaded to receive a filter.

Camera piggybacked on a telescope. With a wide-angle lens, the camera must be placed so that the end of the telescope does not hide a portion of the field of view. (Top) This simple system does not allow any rotation of the field of view; the sides of the image will inevitably be parallel to the celestial axes (right ascension and declination). (Bottom) The rotation collar of the lens enables such a rotation.

On the instrument side, the adaptors may have various designs:

❱ A threaded adaptor, male or female, which is often specific to the instrument, such as, for example, an adaptor that screws directly onto the back of the Schmidt-Cassegrain telescope (or on a dedicated focal reducer).
❱ A male tube of the same diameter as an eyepiece, which can be inserted into the eyepiece holder of a telescope. There are three possible diameters: 0.96" (low-end instruments), 1.25", and 2" (for the largest sensors).

The second design simplifies the rotation of the camera for proper framing, but it may cause vignetting in some situations (see chapter 3).

AVOIDING REFLECTIONS

The internal face of the ring used to adapt the camera or other accessories must not be reflective. If it is, the contrast of the image can be reduced and unwanted reflections may appear in the field of view. When the rings are not black-anodized, there are two solutions: black matte paint and self-adhesive felt.

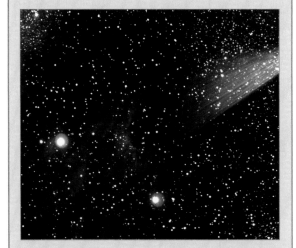

Two types of reflections are visible on this image: (1) The circular halo surrounding bright stars is caused by the filter placed in front of the camera, and (2) the rays on the right part of the image are due to the light of another bright star reflecting off an aluminum ring just outside the field of view.

Increasing the Focal Length

For photography of the planets, which have a small angular size, it is necessary to amplify the focal length of the telescope to record more details on their surface. To do this, we have to use an accessory used for visual observation: an eyepiece or Barlow lens.

Using good achromatic Barlow lenses is a satisfying solution for increasing the focal length without altering the image quality. This accessory consists of a divergent (negative) optical lens whose purpose is to increase the magnification produced by an eyepiece. Its amplification factor is always written on its tube. For example, a 2x Barlow lens doubles the magnification of an eyepiece placed at its end. Placed directly in front of the sensor, and without an eyepiece, the Barlow lens amplifies the focal length of the telescope, as well as its focal ratio, in similar proportions. In classical photography, a 2x extender is equivalent to a Barlow lens.

However, another parameter has to be taken into account with a Barlow lens. The amplification factor is variable. It depends on the distance between the lens and the sensor; if this distance is increased, a 2x Barlow lens can become a 2.5x lens, a 3x lens, and so on. The calculation formula is given later, in the section "Amplification Factor of a Barlow Lens."

There are two ways to mount a Barlow lens in front of the sensor. If the camera attachment is a 1.25" or 2" nosepiece, the Barlow lens can simply be interposed between the telescope and camera. But, in the case of an attachment using a T-ring, a special photographic adaptor must be used. The Barlow lens, or more precisely just the front part of it (the portion that contains the glass lenses), can be inserted into the adaptor. In this case, a Barlow lens that can be separated into two elements should be used. Fortunately, most Barlow lenses are of this type. There are two ways to change the distance between the lenses and the sensor: using an adaptor that allows such variation or using a set of supplementary rings that can be inserted or removed as desired.

When amplification factors of more than four or five times are needed, there are two solutions: using two Barlow lenses (in this case, their amplification factors have to be multiplied) or using an eyepiece. In astrophotography with a DSLR, a video camera, or a CCD camera, an eyepiece works in projection mode, which is different than

A BASIC NOTION: THE FOCAL RATIO

The focal ratio of a telescope, also called the F/D ratio, is constantly used in astrophotography. It is the ratio between the focal length of the telescope (F) and its optical diameter (D). For example, a 4" refractor with a focal length of 40" has a focal ratio of 10. In classical photography, the focal ratio is often called *aperture* and takes values such as 2, 2.8, 5.6, 8, 11. Beware that in astronomy, the word *aperture* is often used to designate the optical diameter of the instrument (D).

The focal ratio cannot always be easily estimated from the external dimensions of the telescope or the lens, especially in the following cases:

- The Cassegrain family of telescopes (Schmidt-Cassegrain, Maksutov-Cassegrain, etc.) have an effective focal length that is much longer that their tube, thanks to a light beam that is folded and a secondary mirror that produces focal length magnification
- Because of a complex optical design, wide-angle photographic lenses have a front lens whose diameter is much larger than their focal ratio leads us to expect; for example, the front lens diameter of a 28mm f/2.8 lens is much larger than 10mm

In addition, optical accessories such as Barlow lenses and focal reducers, commonly used in astrophotography, modify the shape of the cone of light and therefore change the final focal ratio of the instrument.

The focal ratios of the most common astronomical instruments are as follows:

- 5 to 12 for refractors
- 3 to 8 for Newtonians and Schmidt-Newtonians
- 10 for Schmidt-Cassegrains
- 10 to 15 for Maksutov-Cassegrains

Compared to photographic lenses, astronomical telescopes have larger focal ratios.

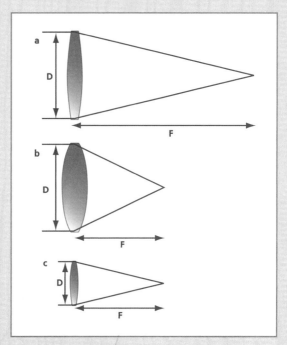

Telescopes a and b have the same diameter, but b has a smaller focal length. Telescope c has the same focal length as b but a smaller diameter, creating a larger focal ratio, equivalent to that of a.

Installation of a Barlow lens in front of a video camera

Most Barlow lenses can be separated into two pieces: the optical elements and the eyepiece tube

visual observation and the notion of magnification is not the same. Here too the amplification factor depends on the distance between the eyepiece and the sensor. The calculation formula is a bit different from the one for Barlow lenses. The eyepiece must be attached through a special adaptor, like the one mentioned earlier for the optical part of a Barlow lens. Good eyepieces such as Orthoscopics or Plössls are perfectly usable in astrophotography, as long as their external diameter is compatible with the adaptor.

Two couplings, allowing an adjustment of sensor spacing, that are able to receive the optical part of a Barlow lens or an eyepiece. However, note that not all eyepieces can be used; the largest ones may be incompatible with the size of the internal housing designed to receive them.

MAGNIFICATION OR AMPLIFICATION

Magnification is a notion that makes sense only in visual observations. It represents the ratio between the apparent angular size of the object when viewed through an instrument and when viewed with the un- aided eye. Thus, a telescope with an eyepiece offering, for example, a magnification of 50x shows the moon with an apparent angle of 25°, as opposed to 0.5° with the unaided eye; the moon looks 50 times larger with the telescope. In the same manner, 7 × 40 binoculars offer an enlargement of seven times; the objects are seen seven times larger, as if they were placed seven times closer to the observer.

The idea of amplification pertains to an optical ac- cessory system that is designed to increase the effec- tive focal length of the telescope. That also increases the linear size of the object at the focal position of the instrument, that is, on the sensor. Thus, an instrument with a focal length of 40" coupled with an accessory with 3x amplification produces an image on the sensor that has the same size as one produced by an instru- ment whose native focal length is 120".

Amplification Factor of a Barlow Lens

To calculate the true amplification factor (A) of a Barlow lens, you need two parameters: the focal length of the Barlow lens (f) and the distance between the optical lens and the sensor (d):

$$A = \frac{d}{f} + 1$$

For example, a Barlow lens with a focal length of 100mm installed 150mm in front of the sensor gives an amplifica- tion of (150/100 + 1) = 2.5 times.

By narrowing the cone of light, a Barlow lens amplifies the effective focal length of the instrument and moves the focal plane further behind the telescope

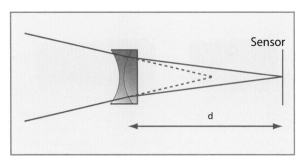

Sensor

d

In this formula, the focal length of the Barlow lens is represented as positive, although strictly speaking, the fo- cal length of a divergent lens is negative. The focal length of most Barlow lenses falls between 50mm and 130mm (2" to 5"). The problem is that many manufacturers never specify the value! Fortunately, there is an empirical way to determine it: Take an image of a planet (or any other object, possibly a distant terrestrial object) with and with- out the Barlow lens and measure the distance between the lens and the sensor. Then calculate the size ratio of the object in the two images; the result is the amplifica- tion factor (A). Of course, this size ratio calculation can be performed by using the size of the object in pixels, an easy task with digital images. Use the following formula to find the focal length of the Barlow lens:

$$f = \frac{d}{A - 1}$$

For example, if Jupiter spans 50 pixels on the image with- out a Barlow lens and 125 pixels with a Barlow lens 90mm from the sensor, we can deduce that A is 2.5 (125/50) and f is about 60mm (90/1.5).

Note that the design of Barlow lenses sold by Tele Vue Optics (www.televue.com) under the trade name Power- mate is more sophisticated than that of classic Barlow lenses. Their magnification factor changes very little with the distance to the sensor, so the preceding formula doesn't apply. The Tele Vue website includes information about their behavior.

Amplification Factor of an Eyepiece Used in Projection

To calculate the true amplification factor (A) of an eye- piece, you need two parameters: the focal length of the eyepiece (f) and the distance between it and the sensor (d):

$$A = \frac{d}{f} - 1$$

For example, a 15mm eyepiece placed 90mm in front of the sensor has an amplification factor of 5X (90/15 − 1).

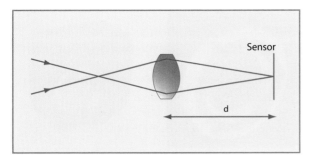

An eyepiece used in projection amplifies the effective focal length of the telescope

Use of Focal Reducers

In contrast to planetary photography, with deep-sky photography it's sometimes necessary to reduce the focal length of the telescope, enlarging the field of view and reducing the exposure time (see chapter 7 for more details). For that, you can use an accessory called a *focal reducer*. As with other optical devices, it must be positioned using the proper rings and adaptors. In a sense, it works like a Barlow lens except that it is a convergent system and therefore its amplification factor is less than 1, leading to a reduction of the focal length.

Using a focal reducer is much more restrictive than using a Barlow lens. First, it works correctly only within a narrow range of reduction factors, within a narrow range of separation between it and the sensor. Outside this range, optical aberrations usually corrupt the image, especially at the edges. If this distance is too large, it may even be impossible to focus!

Second, a focal reducer, unlike a Barlow lens, moves the focal plane inward toward the telescope. This is one of the reasons it is generally impossible to use a focal reducer with a Newtonian telescope, whose focal plane does not lie far enough behind the focuser. On the other hand, this accessory is often used on Schmidt-Cassegrains whose focusing systems allow placing the focal plane far from the rear of the telescope. It is useful for these instruments, whose focal length tends to be too long. Both Celestron and Meade offer a 0.63x reducer for their Schmidt-Cassegrain telescopes that changes the focal ratio from f/10 to f/6.3. Their useful field corresponds to a circle of about 20 to 25mm diameter; beyond that, aberrations

and vignetting become prohibitive. The focal length for the Celestron reducer is about 230mm.

Meade and Optec also offer focal reducers with reduction factors down to 0.33 to 0.5, compatible with sensors with diagonals up to about 15mm. Dedicated focal reducers are available for various refractors; they are generally the best solution for these instruments. A focal reducer designed for a specific type or model of instrument seldom works correctly on other types of instruments, especially for large sensors. The Celestron Edge HD, with a back focus of about 150mm, can be equipped with a large focal reducer capable of covering a large sensor allowing space for accessories such as a filter wheel.

Reduction Factor of a Focal Reducer

To calculate the reduction factor (R) of a focal reducer, you need two parameters: the focal length of the reducer (f) and the distance between it and the sensor (d):

$$R = 1 - \frac{d}{f}$$

For example, a focal reducer of 230mm focal length placed 90mm in front of the sensor produces a reduction factor of 0.61 (1 − 90/230).

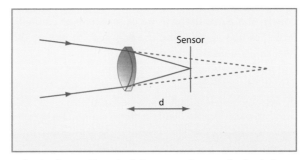

A focal reducer widens the light cone and moves the focal plane forward

How can you determine the focal length of a reducer? The easiest method is to take the reducer in your hand, bring the moon or sun to focus on a piece of paper, and then measure the distance between the reducer lens and the sharp lunar or solar image.

On the left, a focal reducer for an apochromatic refractor. On the right, a dedicated reducer for a Schmidt-Cassegrain telescope.

Two flat-field images taken with a 24 × 36mm DSLR on a Schmidt-Cassegrain telescope, at prime focus (top) and with a focal reducer (bottom). The white rectangle corresponds to an APS-C DSLR.

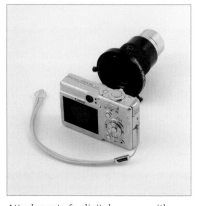

Attachment of a digital camera with a fixed lens behind an eyepiece; at top using the tripod screw of the camera with the help of an adjustable support, and at bottom using a ring fastened on the eyepiece and to the lens of the camera

With an afocal adaptor, the scale and the field depend on the setting of the zoom. For the image on the left, the adaptor is set to a wide-angle position, and for the one on the right, to a telephoto position. In the wide-angle position, the field of view of the camera may be larger than the field of view of the eyepiece, causing vignetting by the eyepiece.

Afocal Attachments

Of all the camera connection methods, the trickiest is attaching an afocal adaptor to a digital camera with a fixed lens. The only solution is to image through the eyepiece, but in this case it's difficult to adjust the distance between the lens and the camera; the lens, like the eye, must be placed as close as possible to the eyepiece. Astronomical equipment retailers offer a lot of different solutions for attachment, depending on the camera. Because of their weight and their large lens, intermediate cameras are difficult to adapt in this manner.

The lens zoom makes it possible to change the size of the field of view and the size of the objects. The calculation of equivalent focal length is easy: multiply the focal length of the lens by the magnification given by the eyepiece. For example, a 20mm eyepiece on a refractor of 600mm focal length produces 30x magnification; if a camera with a zoom lens set on the 50mm position is placed behind this eyepiece, it will produce an equivalent focal length of 1500mm for the image sensor.

You must focus visually with the eyepiece before installing the camera. Then the autofocus system of the camera can be used if the target is of sufficient size and brightness. This is useful for the moon and sun but seldom works with planets or stars. The compact cameras that do not offer a manual focus mode may have an "infinity" focus position; in this case, use this position and do the final adjustment with the eyepiece.

This ring is composed of a female bayonet taken from a used DSLR body and an adaptor made by a machinist; it enables attaching a photographic lens to this CCD camera

Attaching a Photographic Lens to a Camera

Attaching to a Video or CCD Camera

It's perfectly conceivable to use a video or a CCD camera behind a photographic lens. Of course, you will need a coupling that must be, in most situations, made to your specification by a machinist. The only difficulty is to calculate, as precisely as possible, the thickness of the ring so that focusing with the internal mechanism of the lens is possible, given that the focusing range of common lenses is only a few millimeters. The table shown later in this section indicates the distance from the sensor to the lens flange for most DSLR brands. However, such a connection is not always possible; the thickness of a CCD camera with a filter wheel may be too large, making focusing at infinity impossible. Also, certain rare lenses, such as the Canon 300mm f/2.8 and 85mm f/1.2, cannot be used because the manual focusing ring of the lens works only if a DSLR body powers the lens up.

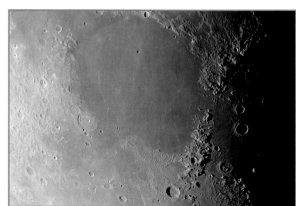

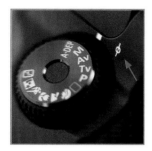

This small mark on the DSLR body shows the position of the sensor plane

Note that on modern Canon lenses there is no diaphragm ring; the position of the diaphragm is set via the DSLR camera settings. However, there is a trick that makes it possible to set the diaphragm to the desired value: put the lens on a Canon DSLR body, chose your diaphragm setting, push the depth of field preview button, and then, while pressing the button, remove the lens. The diaphragm will stay closed until the lens is installed back on the DSLR.

Distance (mm)	Brand
9.2	Pentax Q (hybrid)
17	Nikon 1 (hybrid)
17.52	Video C-mount
18	Canon EF-M, Sony E and FZ (hybrids)
19.25	Micro 4/3 (hybrid)
27.80	Leica M
38.67	Olympus 4/3
42	Canon FL, FD
44	Canon EF/EF-S, Sigma
44.5	Konica, Minolta, Sony A
45.5	M42, Pentax K
46	Olympus OM
46.5	Nikon F
47	Leica R

Distance from the lens flange to the sensor for most camera brands

Attachment of a Lens to a DSLR Body of a Different Brand

You can find rings on the Internet for attaching a lens from one brand of DSLR to another brand. It can be interesting to try an old but good lens obtained at a bargain price. Of course, all automation (autofocus, exposure) is lost, but that's not important in astronomy. However, the distance between the lens flange and its focal plane must be compatible with the distance between the camera flange and the sensor, taking into account the thickness of the ring. For example, we can deduce from the preceding table that it is not possible to mount an old Canon lens (FD) on a recent Canon camera (EOS) because focusing at infinity is impossible. On the other hand, it is possible to adapt a Nikon lens to this body with the help of a 3mm thick ring.

Calculating the Field and Pixel Resolution

In normal photography, a well-known rule is that increasing focal length enlarges objects to the detriment of the field of view. The same rule applies in astronomy, and it's all the more important because a planet cannot be photographed at the same focal length as a nebula. The simple equations in the following sections will allow us to determine the size of the object on the sensor and the optimum focal length.

Calculating the Field of an Image

The angular field (AF) depends on only two parameters: the focal length (F) of the instrument and the size (S) of the sensor, both expressed in the same unit (millimeters or inches). For S, the dimension to consider may correspond to the height, the width, or the diagonal of the sensor, depending on which field is needed. Of course, the focal length to use is the effective focal length, which may be modified by the presence of a Barlow lens or a focal reducer. The following approximate formula gives AF in degrees and works for focal lengths larger than 50mm:

$$AF = 57.3 \times \frac{S}{F}$$

The field of view of the image depends on the focal length of the telescope or the lens. These frames show the field covered by an APS-C DSLR using different focal lengths for the Andromeda Galaxy (M31), one of the largest deep-sky objects. Calculating the field of view and comparing it to the angular size of the object helps determine if it is possible to fit it entirely in the image.

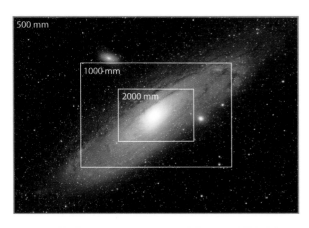

The field of view of the image also depends on the size of the sensor. These frames show the M31 field covered by different sensors on a telescope with a 1000mm focal length.

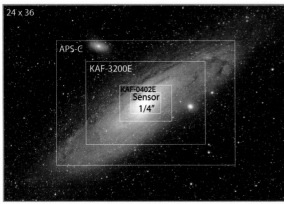

For example, a sensor whose size (S) is 15 × 23mm installed at the prime focus of a telescope whose focal length (F) is 1 meter (1000mm) covers a field of (57.3 × 15/1000) = 0.86° = 51' for the small side and (57.3 × 23/1000) = 1.3° for the large side.

If you know the dimensions of the small side (s) and the large side (l) of the sensor and you wish to calculate the size of its diagonal (d), just use the Pythagorean theorem:

$$d = \sqrt{s^2 \times l^2}$$

The table below lists the fields covered by the small and the large side of each sensor for common focal lengths and sensor sizes.

The maximum focal length (F) for a target of angular size (A), in degrees, is easily determined by reversing the previous formula:

$$F = 57.3 \times \frac{S}{A}$$

For example, to photograph the entire full moon (mean diameter 0.53°) with a sensor whose small side is 15mm, you need a focal length smaller than (57.3 × 15/0.53) = 1600mm. Considering the need to have some margin for centering, the practical limit is closer to 1300mm.

Field of View (small and large sides) for different sensors and focal lengths

Sensor / Focal length	50mm	100mm	200mm	500mm	1,000mm	2,000mm	5,000mm	10,000mm
2.8 × 3.7mm (1/4" type)	3.2° / 4.2°	1.6° / 2.1°	48' / 1.0°	19' / 25'	9.6' / 12'	4.8' / 6.3'	1.9' / 2.5'	1' / 1.2'
3.6 × 4.9mm (1/3" type)	4.1° / 5.6°	2.0° / 2.8°	1.0° / 1.4°	24' / 33'	12' / 16'	6.1' / 8.4'	2.4' / 3.3'	1.2' / 1.6'
4.8 × 6.5mm (1/2" type)	5.5° / 7.4°	2.7° / 3.7°	1.3° / 1.8°	33' / 44'	16' / 22'	8.2' / 11'	3.3' / 4.4'	1.6' / 2.2'
6.7 × 9.0mm (2/3" type)	7.6° / 10°	3.8° / 5.1°	1.9° / 2.5°	46' / 1.0°	23' / 30'	11' / 15'	4.6' / 6.1'	2.3' / 3.0'
10 × 15mm	11° / 17°	5.7° / 8.6°	2.8° / 4.3°	1.1° / 1.7°	34' / 51'	17' / 25'	6.8' / 10'	3.4' / 5.1'
16 × 24mm (APS-C)	18° / 26°	9.1° / 13°	4.5° / 6.5°	1.8° / 2.6°	55' / 1.3°	27' / 39'	11' / 15'	5.5' / 7.9'
24 × 36mm	27° / 41°	13° / 20°	6.8° / 10°	2.7° / 4.1°	1.3° / 2.0°	41' / 1.0°	16' / 24'	8.2' / 12'

Calculating the Sampling and Size of Objects

Sampling is the angular field covered by one photosite of the sensor. As seen in chapters 5 and 7, it is essential to have the telescope working at a sampling value appropriate for the target. Considering that the size (P) of the photosite is usually given in microns and the focal length (F) in millimeters, the following formula gives directly the sampling in arc seconds for a photosite:

$$SAMP = 206 \times \frac{P}{F}$$

For example, an 8-micron photosite placed at the focal plane of a 500mm telescope produces a sampling value of (206 × 8/500) = 3.3 arc seconds per photosite.

The size of a celestial object in pixels on an image is easily deduced from the sampling by dividing the angular size of the object (in arc seconds) by the sampling. For example, since the angular size of Jupiter is 40", a sampling of 3.3 arc seconds per photosite means Jupiter has a size of 12 pixels (too small to record details on the Jovian globe; the focal length has to be increased).

Reverse reasoning allows you to deduce the angular size of an object from its dimension in pixels and the sampling. Similarly, it is not difficult to determine the true focal length of an instrument from the size of the object in pixels and in arc seconds.

Telescope Collimation

Telescopes are always composed of several optical elements. When they are designed, the optician naturally strives to ensure that all these elements are aligned, not only to each other but also with the tube and the eyepiece holder of the instrument. In reality, the inevitable imperfections of manufacturing and flexure and mechanical problems can affect alignment. While the alignment of small optical elements (less than 4") such as photographic lenses or small refractors is relatively easy, this is not the case for larger elements. All telescopes over 120mm, regardless of their quality, must be equipped with screws that allow the alignment—or collimation—of one or two elements. It is the price you pay to obtain the best performance from optics polished with astronomical precision, to a fraction of a micron: they deserve accurate alignment!

The collimation of the telescope is as important in photography as it is in visual observation, and not even sophisticated image processing can fix the damage caused by an alignment error. With a bit of practice, the collimation is a straightforward and humdrum operation. Failing to collimate a telescope would amount to using a car without ever checking the pressure of the tires or the oil level or using a violin that is never tuned.

Collimation is usually performed by observing a star centered in the field of view at high magnification (preferably high in the sky to lessen the effects of atmospheric turbulence) and adjusting the alignment screws to make the star image symmetrical. Two steps of alignment are required:

1. Start with a magnification of 1 to 1.5 times the diameter of the instrument in millimeters (about 200x for a 150mm telescope) and slightly defocus the star, which will show a disk composed of rings with similar brightness and contrast. The aim of the adjustment is to obtain a symmetrical shape, like a bull's-eye target.

Collimation level 1: the figures are increasingly symmetrical (from left to right)

2. By increasing the magnification (to two to three times the diameter of the instrument) and carefully focusing on the star, you can observe the Airy disk. A telescope that is strongly misaligned shows an uneven pattern with a tail: the coma tail (see chapter 7). When the first diffraction ring is complete and uniform around the center of the pattern, the alignment can be considered perfect.

Collimation level 2: the Airy pattern is increasingly symmetrical (from left to right)

The collimation of a Schmidt-Cassegrain or a Maksutov-Cassegrain with a separate secondary mirror is performed through the secondary mirror collimation screws at the front of the telescope (at top). The collimation of a refractor is performed with the help of the screws at the front of the lens barrel (at bottom).

Tips for a Good Collimation

With a bit of experience, it is possible to go directly to the second step of alignment, but the atmospheric turbulence (also called seeing) can considerably distort the Airy pattern, so you may be limited to the first step. For reflectors, centering the shadow of the secondary mirror on the defocused pattern at low to medium magnification is a method often recommended in user manuals but this technique is not accurate enough and should be reserved for an instrument that has never been aligned. Even after this operation, the telescope may achieve only half of its resolving power. Who would accept a car whose engine works only at 50% power? The first step of alignment offers much better accuracy than no alignment at all, but only the second step ensures that the telescope works at more than 90% of its capability.

The relationship between the orientation of the asymmetry and the screw to turn varies among instruments, so it must be determined by trial and error during the first session of collimation, following the user manual. The screw must be rotated with care and moderation; no screw should be loose or excessively tightened. The rotation of the screws will be minimal: a telescope that is strongly misaligned may need half a turn or even a complete turn of a screw, but final collimation at the second step is usually performed with the smallest possible movement. Each time one or several screws are touched, the star must be recentered in the field of view. The best solution is to collimate with a setup as close as possible to the one used for photography and to avoid using accessories not used with the camera (such as a star diagonal).

What Adjustment for What Telescope?

The steps just described correspond to the adjustment of the secondary mirror of a Schmidt-Cassegrain or a Maksutov-Cassegrain. The Schmidt-Cassegrain is a telescope that possesses several advantages, especially excellent compactness and reasonable cost, but its user should be aware that the collimation sensitivity is by far the most critical of all common optical designs. The quality of its image depends on small fractions of a turn of its collimation screws, and if the alignment is never checked, there is absolutely no chance you have a good collimation. I remember using a brand-new Schmidt-Cassegrain,

taken out of its box for the first time by its owner during an astronomy workshop. The misalignment was so pronounced that the visual images were awful, even at low power; it was almost impossible to focus the stars, which were fuzzy with a long tail. The user was disappointed, but after a few adjustments of the collimation screws, the images seen through the telescope were sharp. I myself check the collimation of my Schmidt-Cassegrain telescope every time I use it, particularly after transportation by car.

A Maksutov-Cassegrain with a separate secondary mirror has to be collimated in the same way, but unlike the Schmidt-Cassegrain, its collimation is usually very stable, thanks to the insensitivity of its optical formula to misalignments.

On a Newtonian telescope, the steps described earlier correspond to the alignment of its primary (or main) mirror. However, the secondary mirror must have been aligned beforehand; this operation, usually performed by geometrical methods during the day, is described in numerous websites and books.

Most lens barrels of refractors over 100mm to 120mm diameter have collimation screws. Even if the collimation of this kind of instrument is very stable, a periodic check is not without merit: the number of misaligned refractors is larger than one might think. When the user does not succeed in obtaining a good Airy pattern, the reason may be that an element has shifted with respect to the other(s); in this situation, the instrument must be sent back to the supplier.

Substitutes for a real star are sometimes used:

- An artificial star made by reflecting a powerful bulb or flashlight from a metal ball placed at a long distance from the telescope. The inconvenience of this method is that the horizontal orientation of the telescope does not correspond to its normal use.
- For a Newtonian, a collimation laser inserted in the eyepiece holder and whose beam reflects several times from the two mirrors. With this method, the eyepiece holder needs to be aligned perfectly with the tube.

In all cases, my advice is to check the final alignment on a real star; it is the most reliable and accurate method...and the least costly.

Focusing

Focusing consists of placing the sensor at the focal plane of the telescope, that is, at the place where all rays coming from a star converge. Unlike the eye during visual observation, a sensor has no ability to compensate for slight errors in focus and needs very precise positioning. And as for misalignment, no image processing is able to compensate for a bad focus! As opposed to common photography where autofocus generally does a very good job, manual focusing is the rule in astronomy and is one of the greater difficulties for the beginner, who may spend time trying to find the best position only to be unsure that he has finally found it. Even experienced astrophotographers use accessories and tricks that help them to achieve the sharpest possible image.

Focusing Tolerances

Fortunately, focusing may be considered good inside a small range, the width of which depends on two parameters: the focal ratio of the telescope and the amplitude of the focusing error that can be tolerated. The size of the photosites also influences focusing: the distance is a bit larger for large photosites than for small ones.

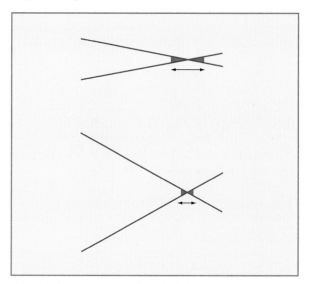

There is a focusing range within which focusing is considered satisfactory. The smaller the focal ratio (wider light cone), the smaller the focusing tolerance.

Suppose your telescope is perfect. At the focal plane, all rays coming from one point in the sky converge at the same point, having traveled exactly the same distance from the light source. This means that their optical paths are identical; they arrive at the focal plane "in phase." But if the focusing is not at the optimum position, the rays will follow paths of slightly different lengths (see the sidebar below). The main significance of this is that the focusing tolerance interval is proportional to the square of the focal ratio: at prime focus, a telescope working at f/5 has an acceptable focus range 4 times smaller than a telescope

CALCULATING THE FOCUSING TOLERANCE INTERVAL

The wavefront error caused by a focus error can be expressed as the maximum difference of the optical path between different rays reaching the focal plane, given in fractions of a wavelength (λ). The following formula calculates the acceptable focus range (L, in the same units as $\Delta\lambda$) as a function of the focal ratio (F/D) and the wavefront error ($\Delta\lambda$):

$$L = \pm 8 \times \left(\frac{F}{D}\right)^{2} \times \Delta\lambda$$

For example, for a maximum path difference of 1/4 λ in green (λ = 0.56 microns) at f/10, L is ±0.1mm.

For planetary photography, we can consider that focusing is very good at 1/8 λ accuracy, correct at 1/4 λ, mediocre at 1/2 λ, and bad beyond 1 λ. The tolerance interval for deep-sky imaging (which is less critical due to larger pixel sampling, atmospheric turbulence, and tracking errors) can be doubled compared to that for planetary imaging.

When we want to calculate the positioning tolerance for a given focusing element, the focal ratio to take into account in this calculation is the one appropriate for this element. On a refractor or a Newtonian telescope, the focal ratio is that for the lens or the primary mirror. But on a Schmidt-Cassegrain telescope, since focusing is performed by moving the primary mirror, the focal ratio to use at this level is 2. Using this value, the equation above gives a focus range smaller than 1/200 mm for planetary imaging, corresponding to about 1/300 of a turn of the focusing knob!

Approximate focus range, based on the focal ratio (F/D) and the path difference, for deep-sky imaging. For planetary imaging, these values can be divided by 2.

at f/10 and 16 times smaller than a telescope at f/20. The table below gives, for green light, the focus tolerance (+/−) as a function of the focal ratio and the precision required.

Focusing quality Focal ratio	Very good	Correct	Mediocre
2	±0.004mm	±0.008mm	±0.018mm
4	±0.018mm	±0.04mm	±0.08mm
6	±0.04mm	±0.08mm	±0.16mm
8	±0.08mm	±0.14mm	±0.3mm
10	±0.12mm	±0.2mm	±0.4mm
15	±0.2mm	±0.5mm	±1mm
30	±1mm	±2mm	±4mm

An additional rack-and-pinion focuser for Schmidt-Cassegrain or Maksutov-Cassegrain telescopes can complement the internal focusing mechanism for easier focus adjustment

IS FOCUSING IDENTICAL FOR ALL CELESTIAL OBJECTS?

If you focus on a star hundreds of light-years away, is the setting valid for the moon, which orbits at "only" 384,000 kilometers (239,000 miles) average distance from Earth? A simple optical calculation shows that the difference of focal position between these celestial objects, at the focal plane of a 1000mm (40") focal-length telescope, is about 1 billionth of a millimeter, a totally negligible, non-measurable quantity. All celestial objects, even the artificial satellites, are so far away that they can be considered to be at infinity. This is also the case for the center and the limb of the moon and the sun: they have the same focus position. If a solar or lunar image shows a sharp center and a fuzzy edge (or vice versa), the cause is an instrument aberration (field coverage; see chapter 7), not focusing.

Focusing Systems

Two types of focusing systems are available on telescopes: the rack-and-pinion system common on Newtonians and refractors (as shown in the images on page 144) and the system that moves the primary mirror common on Schmidt-Cassegrains and other telescopes of the Cassegrain family. The latter is implemented through a rotating knob placed on the rear face of the telescope and coupled to an internal mechanism designed to translate the primary mirror. In this system, it is not the camera that moves into coincidence with the focal plane but the opposite.

The distance scale on a photographic lens is seldom precise enough for a good focusing

The advantage of this system is its very large focusing range behind the telescope, allowing the use of a large variety of accessories (focal reducer, binocular viewer, flip mirror, etc.). For these telescopes, the movement of the primary mirror is amplified by the convex secondary mirror whose amplification factor is generally 5, causing the focal plane to shift 25 times (the square of 5) more than the movement of the primary mirror. For example, a movement of the primary mirror of 1mm causes the focal plane to move 25mm. However, this system also has drawbacks, especially lateral shifts. Mechanical play in the focusing system can cause a lateral translation of the image at the focal plane when the rotational direction of the focusing knob is reversed. This translation is quite variable from one telescope to another and may reach several arc minutes, making it difficult to center a planet on the small sensor of a video camera. In this situation, there are two solutions: either use an additional focuser like the ones used on refractors and Newtonians or finish the focusing while always turning the focusing knob in the same direction (clockwise or counterclockwise). Also, the focusing sensitivity of positioning the primary mirror can be very touchy (see the sidebar "Calculating the Focusing Tolerance Interval" on the previous page) and an additional focuser (Crayford type, manual or motorized) may help to improve the reliability and the ease of focus.

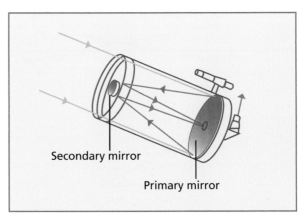

Exploded view of a Schmidt-Cassegrain telescope. The primary mirror is moved to achieve focus. The focal ratio of this mirror is 2 and the convex secondary mirror amplifies it by a factor of 5 (as would a 5x Barlow lens) to obtain the final focal ratio of 10.

Two thin strings at right angles produce diffraction spikes on a bright star; the spikes get thinner as the focus improves (from left to right). A variant of this method is the Bathinov mask, formed by a slit pattern.

Tips and Tricks for Good Focusing

Focusing methods vary according to camera type. With a video camera, you see a continuous image on the computer screen and the best way to judge the quality of the focus is to check the sharpness of this image, as when visually focusing. On a DSLR, using the viewfinder may seem like a good way to focus, but experience shows that the accuracy is often poor, even on bright objects like the moon or the sun, unless an angle finder with 2x or 2.5x magnification is used. Of course, using this method on deep-sky targets is impossible; they are generally not even visible because the viewfinder of a DSLR is considerably darker than an eyepiece. Keep in mind also that to look through the viewfinder of a DSLR installed on a refractor or a Schmidt-Cassegrain, you might need to resort to some pretty uncomfortable positions only possible for a circus contortionist!

Focusing in Live View

Fortunately, all recent DSLR cameras have a live-view mode that provides the user with a continuous display of the image seen by the sensor on the screen of the camera, or even on a computer if the camera is linked to it through the control software provided by the manufacturer. The most interesting feature of this mode is the ability to zoom in on a part of the image with 5x or 10x magnification so that the quality of focusing can be assessed very precisely on a lunar crater or on a star.

When a DSLR is used with an autofocus lens, the live-view system is much more reliable than autofocus. Even if autofocus emits a sound that means that it has focused on the moon or on a bright star, there is no assurance that the image is sharp because these systems are not designed to work with such small targets.

Focusing on a Star

The stars are so far away that their angular size is, at best, on the order of a thousandth of an arc second. Therefore, they can be considered to be point sources of infinitesimal size and constitute a practical target for focusing. The best focus position is obtained when their image size at the focal plane is smallest.

One method of focusing consists of placing two wires or strings at a right angle to each other in front of the telescope, like a Newtonian spider vane. When the telescope is aimed at a bright star, the strings produce diffraction spikes centered on the image of the star for exposures of several seconds. The better the focusing, the longer, brighter, and thinner the spikes. Fishing strings work well; their thickness must be chosen carefully.

Another method is to put a mask with two holes diametrically opposed in front of the telescope. As long as focusing is not good, the two holes produce two separate images from the same star. As the focus improves, the two images get closer and finally merge. This method is sometimes called the *Hartmann mask technique*, but this is not technically correct because a real Hartmann mask is a mask drilled with lots of holes and designed for optical quality measurements. Experience shows that the accuracy of this method is questionable, certainly inferior to the accuracy that can be achieved when you use the string method.

Paradoxically, the CCD camera is probably the easiest camera to use to precisely focus on a star due to a capability that DSLRs do not have: windowing. CCD acquisition software can continuously download the contents of a small window centered on a star. This image of the star can be refreshed quickly because of its small size and analyzed by the software in real time. The simplest analysis consists of measuring the intensity of the brightest pixel, the aim

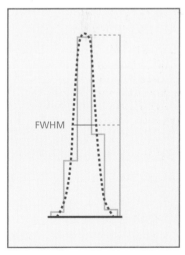

The image of a star generally spreads across several photosites (continuous green line). Its shape can be modeled as a bell curve of varying width (dotted line); the width at half maximum (FWHM) is calculated by the acquisition software.

being to maximize this value for the best focus. However, this technique is too sensitive to atmospheric turbulence, and a more reliable and stable technique is to calculate the full width at half maximum (or FWHM) of the star and minimize this metric for best focus. The FWHM is probably the most precise focusing method; its value is the same for all stars in the field, subject to the condition that the peak value of a star does not reach saturation.

The typical evolution of the FWHM with the focus position follows a parabolic curve whose bottom corresponds to the focus tolerance interval (between positions 32 and 34 in this example)

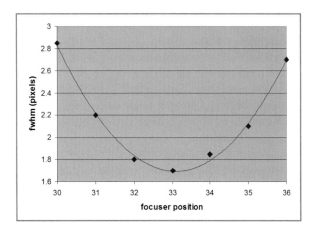

Measuring the Focusing Position

Whatever camera and focusing method you use (diffraction spikes, FWHM, live view), it's helpful to have a system that measures the position of the mechanical element that moves during focusing so that different positions can be tested without fear of losing the best one. In addition, focus can be touched up during the night to compensate for thermal shifts of the telescope with the confidence that you can come back to the initial position if needed. I have been using a small, inexpensive accessory for many years that now I could not work without: a dial micrometer. It consists of a circular dial with a small needle that rotates with the movement of a finger. It's installed on a fixed part of the instrument and its finger presses against a part that moves with focus (the opposite is also conceivable). You may need a small homemade metal or wooden bracket or an articulated arm to attach it. A micrometer resolving to 0.01mm or even 0.001 inch is sufficient for most telescopes.

While it is easy to install a dial micrometer on a refractor or a Newtonian telescope whose focusing system has easily accessible moving parts, you can't attach one directly to a Schmidt-Cassegrain or Maksutov-Cassegrain telescope. However, some accessories are available that provide a scale or digital measurement capability that performs the same function as a micrometer.

A micrometer is cheap ($50 to $100) and provides invaluable help for focusing

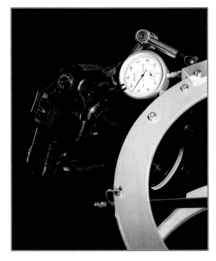

On the left, installation of a micrometer on a refractor. A small piece of aluminum, placed under the finder, supports a shaft that holds the micrometer through a small ball-and-socket joint. The finger presses on the moving part of the eyepiece holder. On the right, installation of a micrometer on a Newtonian telescope is made using a small articulated arm, with the finger pressing against the camera.

Several images of the same star taken at different positions of the focuser. The readings given by the micrometer allow finding the best position again immediately, in this case, the third one, which is the best of the series.

The Parfocal Eyepiece

Another helpful device frequently used with video cameras is an eyepiece inserted into a parfocal position; when focusing is good visually through the eyepiece, it is also good through the camera. A ring is placed on the eyepiece and positioned on the focuser so that its focal plane corresponds to the focal plane of the telescope. The astrophotographer must set the ring as follows:

- ❯ Focus the camera precisely
- ❯ Insert the eyepiece and find the best focus position by sliding it manually in the focuser
- ❯ Adjust the clamp ring on the eyepiece male tube against the focuser
- ❯ Check the adjustment by focusing visually through the eyepiece and verify that the image on the camera is good

The eyepiece should provide sufficient magnification to allow a good assessment of the focus. A reticle eyepiece is recommended because it forces the eye to maintain focus on a fixed position (the reticle). The tolerance of adjustment depends on the focal ratio at the eyepiece; it is about 1mm at f/30 and a few hundredths at f/5. Of course, each adjustment of the ring corresponds to a given mechanical setup of the camera, taking into account the possible presence of a filter (see the text box on this page).

Why is it necessary to check focus during the night? The reason is that the temperature often decreases with the passing hours. Telescope tubes contract because they are generally made of aluminum, causing a change of focus (carbon fiber shrinks less, but at the expense of longer times to reach thermal equilibrium). Thermal expansion effects are especially visible on some instruments, such as Cassegrain telescopes, for which a small change in position of the secondary mirror causes a large change in the focal plane position, as seen earlier. Most of the time, when focusing is performed at the beginning of the night, the quality is poor several hours later; on some telescopes, temperature changes can cause a visible defocus in less than half an hour. The Robofocus motorized focusing system includes a temperature sensor that, after it determines the behavior of the telescope according to the temperature, automatically adjusts the focus position when the temperature varies.

A clamp ring on the male sliding tube of an eyepiece.

DOES A FILTER CHANGE THE POSITION OF FOCUS?

A filter placed in front of a telescope or a lens (for example, a solar filter) does not change the focus because the rays that come from a point in the sky are parallel when they go through the filter. On the other hand, if the filter is placed between the telescope and the camera, in the convergent beam, it shifts the focal plane back and therefore changes the focus. If ε is the thickness of the filter and n the refractive index of the glass used, the shift is as follows:

$$\delta = \varepsilon \frac{n-1}{n}$$

Since most filters are made with a glass whose index is close to 1.5, the formula shows that the filter shifts the focal plane by one-third of its thickness; for example, a filter that's 3mm thick shifts the focal plane back by about 1mm.

A filter placed between the telescope and the camera shifts the focal plane back

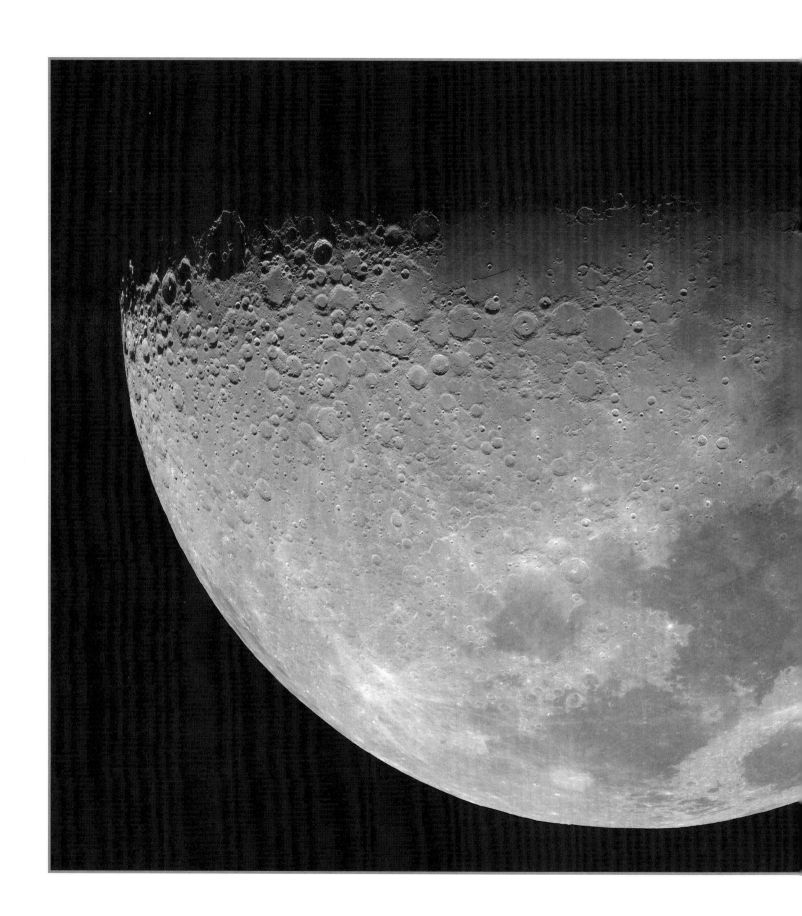

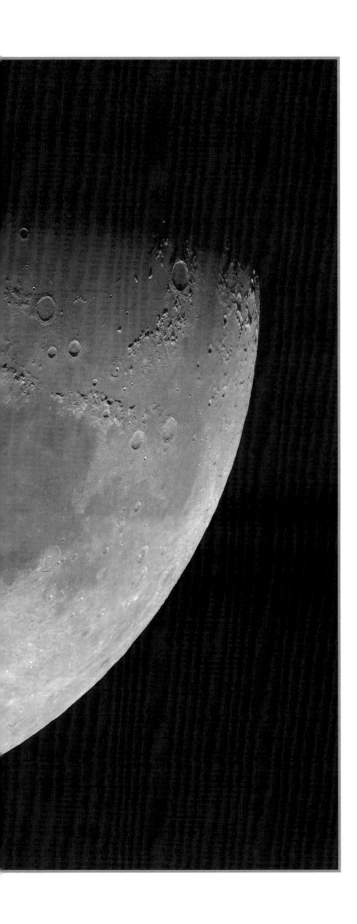

Chapter 5
The Planets and the Moon

All the planets, as well as thousands of asteroids that cohabit the solar system with the earth, can be photographed by the amateur, but only three of them show good surface detail: Mars, Jupiter, and Saturn. This is not counting our natural satellite, the moon, which, when it comes to photography, has many similarities with the planets.

Big, bright, and full of contrasty details, the moon is a good target for the beginner

The famous Airy pattern. To be observed clearly, the magnification should be at least twice the diameter of the telescope in millimeters (for example, at least 200x for a 100mm telescope). The number of visible rings depends on the diameter of the telescope and the brightness of the star.

The planets are brightly lit astronomical objects and therefore can be observed and photographed from a city center or in the presence of strong moonlight with no disadvantage. However, their angular size is small: none exceeds 1 arc minute. To record details on Mars, Jupiter, or Saturn, the focal length of the telescope must be increased to several meters with the devices described in the previous chapter. It is not an option to use a telephoto lens such as you might use to photograph the larger nebulas in the sky: its focal length is insufficient, as is its diameter. Detailed views of the planets are reserved to the domain of astronomical telescopes.

The term *high resolution* is sometimes used for planetary imaging because it's an aspect of astrophotography for which we try to coax the very best from our telescopes. A good planetary image is never the result of chance: optical quality, telescope collimation, good sampling, accurate focusing, adequate processing, and steadiness of the atmosphere are some of the basic ingredients needed for a good shot of Mars, Jupiter, Saturn, or lunar craters and mountains. In this field, more than any other, perseverance and care are essential.

Telescopes and Resolution

All astronomers know that one of the fundamental characteristics of a telescope is the diameter of its optics. They even use this information, and not the focal length, to describe their telescopes: "I own a 4" refractor" or "I use a 16" Dob." The diameter determines the quantity of light collected, which is so important in deep-sky observing. But it also determines the maximum quality of detail the telescope is able to show. Indeed, if the image of a point source such as a star had an infinitely small dimension at the focal plane, you could enlarge the image given by any telescope to obtain more and more detail, endlessly. Unfortunately, Nature has decided otherwise; at the focal plane of a telescope, the image of a star looks like a small disk (also called a *false disk*) containing most of the light from the star and surrounded by rings of decreasing brightness. This pattern is called an *Airy pattern* and it's caused by the diffraction of light by the telescope aperture. We know that light has two forms; it sometimes behaves as a particle and sometimes as a wave. From a noise standpoint we observe particle behavior (chapter 3). When determining a stellar spot size, we encounter the wave effects. Diffraction makes the details on a planet's surface or its edge soft and diffused. The smaller these details and the lower the contrast, the more difficult it is for a given telescope to deliver an image that is sharp and clear. When they're smaller than a certain size, detection of details is impossible.

The angular diameter (d) of the false disk (in arc seconds) is proportional to the wavelength (λ, in microns) and inversely proportional to the optical diameter (D, in millimeters):

$$d = 500 \frac{\lambda}{D}$$

For example, a 100mm telescope gives in green light (wavelength 0.56 µm) a false disk of 2.8 arc seconds.

The most significant consequence revealed by this equation is that a large telescope is able—in theory—to show smaller and more numerous details than a small one.

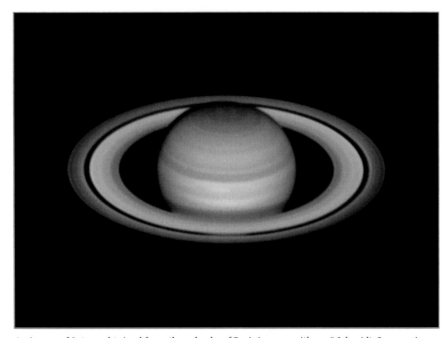

An image of Saturn obtained from the suburbs of Paris in 2003 with a 12" Schmidt-Cassegrain telescope and a webcam. Thanks to excellent seeing conditions and a maximum angle of the rings, Encke's division is visible at the very end of the rings. This division is a smaller version of Cassini's division; its angular width is only 0.05 arc seconds, but its extended length and high contrast help in its detection. It would not have been possible to record a similarly sized small circular spot of low contrast on the surface of the planet.

What Are the Limits of Resolution?

Specifications sheets and user manuals for telescopes mention a characteristic called *resolving power,* which is represented in arc seconds. The resolving power is simply calculated by the formula 130/D, where D is the diameter of the telescope in millimeters. For example, the resolving power is about 1 arc second for a 130mm telescope, 1/2 of an arc second for a 260mm telescope, and so on.

The resolving power does not represent, as many people believe, the size of the smallest detail detectible with the telescope. If that were the case, how would it be possible to detect Cassini's division, whose width is 0.7 arc second, with a 3" telescope whose resolving power is greater than 1 arc second? In reality, the formula for calculating the resolving power does not apply to the detection of an isolated detail but to the separation of the components of a double star, which is a very different problem. Detecting one detail and separating two details are two distinct challenges for which your success depends not only on the diameter of the telescope but also on the shape and contrast of the detail. After all, we see and record stars whose angular diameter is infinitesimal with a telescope, but this says nothing about the diameter of the telescope or its quality!

However, we should not conclude that a telescope is able to show details as small as desired or even that everything that appears in an image is automatically real detail. We must never forget that the image produced by a telescope is not the reality but a blurred representation of it; diffraction and other artifacts introduced during imaging make the detected structures less believable if the details are small and of low contrast. In other words, a telescope is a filter that amplifies but also damages the information, all the more so when this information is subtle. The black drop effect, observed and photographed during the transits of Venus in front of the sun, is one of the best examples illustrating the caution we should use in capturing an image. And when there is doubt, a comparison with images taken using large telescopes or space probes is useful.

OPTICAL INTERFEROMETRY AND AMATEURS

Optical interferometry is merging the light beams collected by several telescopes (at least two) to improve the quantity of information contained in the final image. Simple in theory, this technique is terribly complex to implement because the optical path followed by all beams must be matched to less than 1/10 micron while the length of the path constantly changes due to the rotation of the earth. The complex systems used on large telescopes are at the limit of current technology and beyond an amateur's capability.

Also, in contrast to the simplified explanation that is often given to the general public, coupling two telescopes does not produce an image having the same quality of detail as an image produced by a giant telescope whose diameter is equivalent to the distance between the coupled telescopes. Actually, the image is equal to the image obtained by one instrument but streaked by very thin interference fringes that powerful computers must analyze to extract information that can be interpreted by the scientific team.

Note that optical interferometry, in contrast to radio interferometry, cannot be performed after the fact by merging digital images taken with different telescopes; for physical reasons that are beyond the scope of this book, optical interferometry absolutely requires that the beams be merged before they reach the sensor.

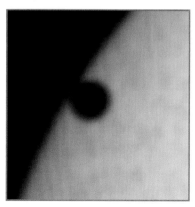 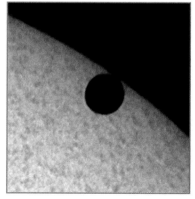

The black drop effect, observed in the last century during solar transits of Venus, was a subject of controversy (left). For some, it was real and linked to the Venusian atmosphere. For others, it was a simple consequence of limited telescope performance and caused by diffraction and chromatic aberration. Now we know that the second theory was right: higher-quality images (right) do not show the effect.

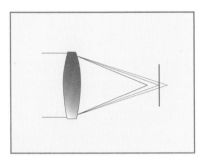

A simple single lens has a convergence point that varies with wavelength

Telescopes for Planetary Imaging

The perfect universal telescope doesn't exist, neither in theory nor in practice. One could devote hundreds of pages describing all the properties and aberrations attached to each optical system. Newtonian and Cassegrainian telescopes are designed to give excellent image sharpness on the optical axis, at the center of the field. This is sufficient for photographing planets with a small angular diameter, which doesn't require telescopes with large field coverage as desired for deep-sky imaging. Here are some guidelines (photographs of telescopes can be found in chapter 7):

- ❯ The telescope having the best performance/diameter ratio is the apochromatic refractor (see the section "Chromatic Aberration") or a Cassegrainian reflector optimized for the planets
- ❯ The telescope having the best performance/price ratio is the Newtonian telescope
- ❯ The telescope designs having the best performance/size ratio are the Schmidt-Cassegrain and the Maksutov-Cassegrain

For a given diameter, the optical quality is by far the most important factor because the contrast and sharpness of the image depend closely on it. On the other hand, the focal length is of no importance because, whatever it is, it must be amplified with the help of Barlow lenses or projection eyepieces. In other words, the focal ratio is not a selection criterion for a planetary telescope: except for achromatic refractors, telescopes with a small F/D ratio are able to produce images as good as the ones produced by a telescope with a large F/D ratio.

In planetary photography, a large diameter is not automatically the first choice; a telescope of intermediate size but with good optical quality and quality construction is better than a monster impossible to tame and that, because of atmospheric turbulence, will rarely show good images. Experience shows that the best telescope is the one that suits you, that you use most often, and that you know well!

Two characteristics are often mentioned as important for image quality: chromatic aberration for refractors and the central obstruction for a reflector.

Chromatic Aberration

A simple lens with precise curves is able to make all rays converge at the same point at the focal plane, but only for one wavelength of light (one color); other wavelengths converge at different points located behind or in front of it because the refractive index of the glass varies with wavelength. When focusing is good for one color—for example, green—the star is surrounded by a strong halo composed of violet, blue, and red that destroys the contrast and the sharpness of the image. Galileo's refractor, whose objective was composed of only one lens, was much worse than any low-end department store refractor! It was only with the invention of the achromatic objective, constructed using two lenses of different refractive index, that one could obtain much better correction. However, the word *achromatic* is misleading because it seems to mean that the chromatic aberration has been completely removed. In reality, this objective design forces two wavelengths to converge at the same point (generally blue and red), with the residual at other wavelengths being constrained within acceptable limits. The focal shift is

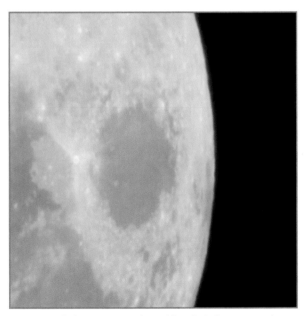

A portion of a lunar image taken with a digital camera and an achromatic refractor. The purple fringe surrounding the limb is caused by chromatic aberration.

more pronounced at deep red or violet wavelengths, and a purple halo usually surrounds bright stars or is next to the lunar limb. Chromatic aberration increases with the diameter of the refractor (at equal focal ratio), and it decreases with the focal ratio (at equal diameter). To reduce the residual aberration, most achromatic refractors have a focal ratio between 9 and 15.

At the other end of the refractor price range are apochromatic objectives composed of two or three lenses, some made with special glass. The best refractors offer chromatic correction so perfect that the remaining color aberration in the image is invisible in visual observation and negligible in photography. Due to such improved correction, focal ratios are available down to 5 to 8 without the aberration being troublesome. The most commonly employed glasses are called ED (for extra-low dispersion) or fluorite glass, which are more expensive than typical glasses and restricted to mid-range and top-of-the-line refractors. To complicate things, different manufacturers have created a jungle of terms that do not have the same meaning: *semi-apochromat, apochromat, ortho-apochromat, neo-apochromat, super-apochromat,* and so on. Depending on the type of ED glass used, the number of lenses, and the optical formula, the performance may vary notably from one model to another.

Since the eye is mainly sensitive to green light, an achromatic objective that is satisfying for visual observation may produce a nasty surprise when used in photography due to the sensitivity of the sensors to wavelengths across the visible and, for monochrome sensors, to the near infrared. To reduce the purple or violet glow, filters have appeared under names such as Contrast Booster, Fringe Killer, and Minus Violet. They are designed for achromatic refractors and remove problematic wavelengths, especially violet and even some blue, giving objects a yellowish color. Useful for achromatic refractors, especially the ones with a short focal ratio, they do not improve the image on a true apochromatic refractor or, of course, on a reflector.

The Effect of a Central Obstruction

On a telescope, the secondary mirror masks part of the light gathered by the telescope, causing a loss of light and a reduction of contrast. The obstruction is usually expressed by the ratio between the diameter of the secondary mirror holder and the diameter of the main mirror (but some manufacturers express it as a percentage of the area masked, which is a more favorable figure). For example, for a 10" telescope whose secondary mirror diameter is 3", the obstruction is 30%, but the area ratio reveals that the loss of light is only 9%. Its effect is greater on the contrast, though, since the loss may reach, for small planetary details, 30 to 35%. For such details, the 10" telescope offers only the contrast equivalent of a 5" to 6" unobstructed telescope, while keeping its ultimate resolving power unchanged. The following table shows, for common obstruction values, the loss of light and the maximum loss of contrast. For Newtonian telescopes, the spider also causes a loss of contrast, but it's negligible if the vanes are reasonably thin.

Obstruction	Loss of light	Maximum loss of contrast
15%	2%	10%
25%	6%	25%
35%	12%	40%
45%	20%	60%

Loss of light and maximum loss of contrast for common obstruction values (in diameter)

In an ideal world, all planetary instruments would be apochromatic refractors. But their size and, above all, their price become quickly prohibitive above 5". A telescope of good optical quality and much larger diameter possesses a better performance/price ratio, the improved contrast produced by the larger aperture largely compensating the loss due to the secondary mirror. A classical Cassegrainian or a good Newtonian with moderate obstruction (around 20%) can be a remarkable tool for the amateur specializing in planetary imaging. But even Schmidt-Cassegrain and Maksutov-Cassegrain designs, despite their larger obstruction, have demonstrated their capability in this field. A small obstruction is not a guarantee of good planetary results because it is rarely the limiting factor in the imaging system.

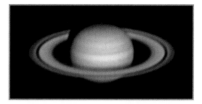
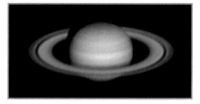
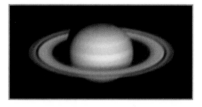
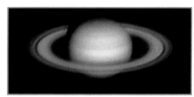

Images of Saturn classically processed (combined and unsharp masked) obtained with a refractor and a webcam. Paper disks have been placed in front of the telescope to simulate obstructions of 0%, 20%, 35%, and 50% respectively.

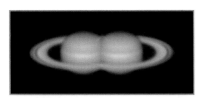

The apparent movement of a planet due to the rotation of the earth, in an interval of only 1 second

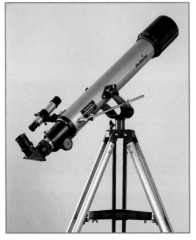

A nonmotorized azimuthal mount can be used for photography of the lunar disk but is not ideal for the planets

This equatorial mount is not motorized, but a motor is available as an option. Because of vibration and speed irregularities, manual tracking adjustments can be used to center the planet or the moon in the field but not for continuous tracking.

Collimation

Collimation was described in chapter 4. A misalignment of the optics can be considered an aberration much like a manufacturing defect of an optical component. In planetary imaging, it can destroy the optical quality of the telescope; ignoring this is not an option!

Collimation is difficult to perform when the atmospheric turbulence is strong. Do not attempt to refine the collimation on nights of bad seeing conditions (such a night is not favorable to planetary observation or imaging anyway).

Mounts and Tracking

The issues related to the different types of mounts will be examined in detail in chapter 7 because long exposures are the most demanding application for a mount. In the following sections, we'll look at the utility of each type of mount (fixed, equatorial, and azimuthal) for planetary imaging.

Fixed Mount

A fixed mount is any mount that's not motorized, such as a photographic tripod, a Dobsonian mount, and a manual equatorial mount. Because of the rotation of the earth, the apparent movement of the planets is about 15 arc seconds per second of time, almost the diameter of the globe of Saturn! This rapid movement creates problems that make it difficult to perform planetary imaging with a fixed mount:

- The exposure time must be sufficiently short to avoid causing a visible loss of sharpness. For example, for an exposure time of 1/10 second, the blur is 1.5 arc seconds, twice the width of Cassini's division.
- The planet goes out of the field very quickly and the telescope must be constantly reoriented. For example, at a focal length of 3000 mm, a planet crosses the sensor of a 1/4" video camera in less than 20 seconds; for a DSLR, this time is about 2 minutes.

In practice, only photography with a DSLR and a shorter focal length can be attempted, while keeping in mind that, with such a setup, it is impossible to obtain results similar to what is seen visually.

Motorized Equatorial Mount

The motorized equatorial mount is a simple and efficient solution for tracking any celestial object. Planetary imaging does not require a polar alignment that is as precise as it is for deep-sky imaging (see chapter 7). For short exposures, slight drift is of no consequence.

Motorized Azimuthal Mount

An azimuthal mount (sometimes called alt-azimuth or alt-az) has rotation axes that are vertical (elevation) and horizontal (azimuth). When computerized, it automatically orients itself in space and drives its two motors at the proper speed to track any celestial object.

Tracking in alt-azimuthal mode is all you need for visual observation, which requires only that the object remain in the field of the eyepiece. The main drawback of this system for photography is field rotation: the object appears to slowly rotate about its center over the evening. If only one image is used, as for a lunar quarter, this is not a problem. But if you wish to combine lots of images, as is the rule in video photography, the field rotation between the first and the last image of the series must be sufficiently small to be negligible. While registering planetary images that are shifted by translation in two axes is an easy task for astronomical software, it is very difficult to register them when they also suffer from rotation. In video photography, you should limit the acquisition duration of a set of images you intend to combine to a duration that depends on the rate of field rotation at the time of imaging, which itself depends on the position of the planet in the sky (see the sidebar "Field Rotation in Alt-Azimuthal Mode"). Field rotation has the following characteristics:

- It increases with the altitude of the planet above the horizon
- It decreases with the latitude of the observing site
- It's maximal when the planet is on the meridian (highest position in the sky)
- It's minimal when the planet is exactly placed toward the east or the west

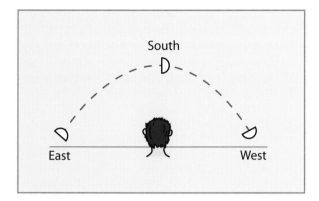

A human being can be considered to be an alt-azimuthal system; this image shows the field rotation phenomenon that occurs when you're looking at the moon successively at moonrise, when it passes the meridian, and at moonset.

Telescopes such as the Nexstar from Celestron and the Autostar (pictured) and LX from Meade are equipped with a computerized alt-azimuth mount

FIELD ROTATION IN ALT-AZIMUTHAL MODE

The amplitude of field rotation (R, in degrees) between two times separated by T minutes depends on the position of the planet in the sky, specifically its elevation (H) above the horizon and its azimuth (A, taken from north and positive toward east):

$$R = \frac{1}{4} T \, \frac{\cos L \cos A}{\cos H}$$

L is the latitude of the observing site. For example, if Jupiter is on the meridian (A = 180°) at an elevation of 50° as seen from a latitude of 45°, the rotation of the globe about its center during 1 minute is −0.28° (a negative value means that the rotation is clockwise).

At an arbitrary distance (d, in arc seconds or in pixels) from the center of the globe of the planet, the shift due to the rotation is (in the same unit as d)

$$B = \pi \, \frac{dR}{180}$$

For example, a rotation of plus or minus 0.28° of the globe of Jupiter, whose radius is about 23 arc seconds, causes a blur of 0.11 arc seconds. This blur must be less than the sampling value (see chapter 4).

The combination of these two formulas gives the maximum time (T, in minutes) depending on the maximum admissible blur (B) and the maximum radius (r) of the planet (both in the same unit, arc seconds or pixels):

$$T = 230 \, \frac{B \cos H}{r \cos L \cos A}$$

The Atmosphere

A famous astronomer once said, "The worse part of the instrument is the atmosphere." The atmosphere is constantly agitated, and the mixing of air masses with different temperature creates small-scale turbulence, causing rapid perturbations of the light rays. On a star seen with the naked eye, this disturbance reveals itself through scintillation. In a telescope at high magnification, the image of the star is altered in additional ways:

- It is subject to erratic movement
- Its Airy pattern becomes fuzzy, distorted, and spread. It is not recognizable except possibly for brief moments.

Airy pattern as seen with increasing turbulence. Beyond the second image (upper right), collimation becomes difficult and the performance of the telescope is significantly reduced.

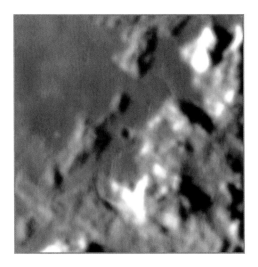

These two successive lunar images centered on Rima Hadley have been extracted from the same video sequence. They illustrate the erratic sharpness variations occurring in a fraction of a second.

In practice, depending on the current atmospheric conditions, one effect or the other may dominate and the distortions may be fast or slow. In such conditions, the effect is perceived differently depending on the diameter of the telescope. Let us assume that we are at a typical amateur site. With a telescope smaller than 4", the Airy pattern is frequently visible, even if it's agitated. On the other hand, observing a nice Airy pattern while using a 12" telescope is a rare occurrence. Most of the time it is strongly distorted or even unrecognizable. In some poor sites, it will never be visible. Because of the atmospheric turbulence (also called *seeing*) the yield of a telescope (the ratio between its actual and its theoretical performance) is reduced, more so if its diameter is large. This is why a diameter of 10" to 12" is a good compromise for planetary imaging from a typical site.

Seeing is a capricious and unpredictable phenomenon; noticeable changes may occur in an instant. A night may look mediocre at its beginning and become steadier later on, or the opposite may occur. While cold and dry winter nights sometimes offer excellent transparency because the sky is clear and thousands of stars are visible, the seeing conditions might be bad, these two factors being uncorrelated. In my location, the most stable nights for planetary imaging are windless, mild, and humid. I especially remember a magical night in April 1995 when Mars was motionless in the eyepiece of my 10" telescope. While observing, I was surrounded by a thin layer of fog and the telescope dripped with condensation.

ATMOSPHERIC DISPERSION AND ITS CORRECTION

Viewing objects at a low elevation above the horizon is unfavorable not only because of greater atmospheric turbulence but also because of atmospheric dispersion. The atmosphere acts like a prism and refracts the rays in the vertical direction. This effect varies according to wavelength: Blue rays are deviated by a greater amount than red ones. As a result, the blue component of the image is vertically shifted relative to the green one, itself shifted with regard to the red one. For example, when Venus is close to the horizon, a telescope will show a blue fringe at the top of its limb and a red fringe at the bottom. The angular separation between red and blue images is 1 arc second at an altitude of 50°, 2 arc seconds at 35°, and 4 arc seconds at 20°.

While images of a planet taken using a color sensor and while low in the sky exhibit such a shift, it is possible to reregister the three-color layers during processing. For a monochrome sensor, a yellow or red filter will help to decrease the dispersion. For such a sensor used without a filter or with a broadband filter (clear filter, or UV/IR cut only), a dispersion corrector can be useful. Planetary imagers capturing highly detailed images can even see an improvement while using a corrector with filters, particularly for a blue filter, where the change of dispersion with wavelength is greatest.

Another common misconception is that high-altitude sites are always better. Again, do not confuse transparency and seeing. Pic du Midi in France frequently offers good seeing conditions, but it is because this site is an isolated peak, higher than the surrounding summits, and the prevailing wind flows in a laminar fashion. The situation may be similar on the Chilean plateaus or on volcanic islands such as Hawaii or the Canaries. Hilly areas, and especially mountainsides and valley bottoms, may reveal themselves to be particularly poor for planetary observation, perhaps even worse than flat areas, because of their complex aerology. Good results have been obtained from seashores, for example in Florida or in Texas, thanks to the temperature uniformity resulting from the nearby ocean.

The effects of bad seeing depend on the elevation of the planet above the horizon due to the varying thickness

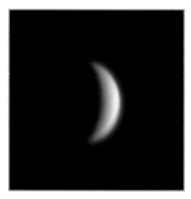

Venus was low on the horizon when this image was taken with a color camera on a refractor. Atmospheric dispersion spreads the colors vertically. This shift may take different directions in the image depending on the orientation of the telescope and the sensor with regard to the horizon.

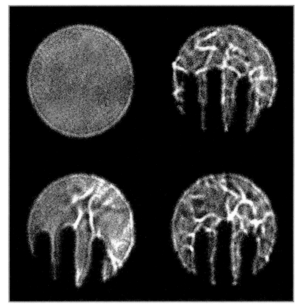

The human body is a formidable heater, as seen by these hot air plumes surrounding a hand placed in front of the aperture of a refractor

A dispersion corrector is composed of two rotating prisms designed to correct atmospheric dispersion with their own aggregate, but opposite, dispersion. The corrector is placed in front of the sensor. The adjustment of the prisms is performed manually while viewing a star (by means of an eyepiece or camera image) at the same elevation above the horizon as the planet. This adjustment must be modified after a significant change in elevation.

of perturbed atmosphere that the light rays must pass through. Compared to the zenith, at 30° elevation the light rays have to go through twice as much atmosphere and four times as much at 15°. This is why the hours surrounding the object's passage across the meridian (to the south for northern hemisphere observers and to the north for southern hemisphere observers) are preferred for imaging.

For a planet or the moon at a declination δ, the elevation of the planet as it passes the meridian for a locale with latitude L is $90° - L + \delta$. A declination as large as possible (positive for northern hemisphere observers) is good because the planet is higher in the sky.

Atmospheric turbulence is caused by the movement of air masses at different altitudes. Local phenomenon may also produce turbulence, especially if the line of sight passes over a chimney or a car whose engine is still hot. People standing in front of the telescope must move. Do not observe in winter through an open window; the mixing of cold and hot air destroys the sharpness of the image (of course, observing through a closed window is not good either because the window glass is far from the optical quality required for telescope optics). Astronomical domes, despite their aesthetic qualities, are not ideal thermally since the heat accumulated during the day or the heat created by people escapes the dome through the opening through which the telescope is pointed. A roll-off roof shelter is much better from a thermal point of view.

The third cause of turbulence is the telescope itself. When it is not in thermal equilibrium with the surrounding

air, movements of air occur and alter the images: a difference of about 2°C (4°F) may be sufficient to generate a visible effect! Also, when the mirrors are not in thermal equilibrium, they may be distorted and cause optical aberrations. From this point of view refractors are favored because a thermal surface deformation of a lens has less impact on the image than it does for a mirror and because the light beam goes through the tube only once, compared to two or three times for a reflector. Experience shows that leaving the telescope outside one hour before observing is generally beneficial. In winter, when it comes from a heated house, two hours may not be excessive, and a telescope left all day in a car in the sun will probably also take several hours to reach thermal equilibrium. Instruments with closed tubes, such as a Schmidt-Cassegrain, Maksutov, and others, can take a long time to reach good thermal equilibrium due to the "thermos bottle" effect and will benefit from the presence of rear vents or, even better, fans.

Cameras and Settings

Even a modest camera can be used to take planetary images. The number of photosites or pixels is a criterion of choice only for the moon, not for the planets; you don't need more than half a million pixels for the largest planet, Jupiter. A huge number of photosites are useless and lead to a small object lost in an image that is almost completely black. The white balance setting must be placed on daylight; leaving it in automatic mode would result in unpredictable colors because the camera cannot find a good white reference in the image. Fortunately, in RAW mode this setting does not change the contents of the recorded file, which can be altered later during processing.

The exposure mode must be manual, and the exposure time must be determined by trial and error to obtain an image as bright as possible but without overexposure. The histogram of the image is a good aid in detecting overexposure. Choosing the ISO setting is a compromise between two conflicting considerations:

- A lower ISO setting allows you to increase the exposure time and obtain a better signal-to-noise ratio (SNR)
- A higher ISO setting allows shorter exposure times but in the presence of atmospheric turbulence yields a noisier but sharper image

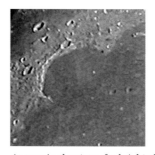

As seen in chapter 3, for bright objects the dominant noise is photon noise. These portions of a lunar image captured with a DSLR at ISO 100 (left, 1/250 second) and ISO 800 (right, 1/2000 s), and processed with an unsharp mask show that the image taken at the lower ISO is better because it has gathered eight times more light than the other. However, an exposure that's eight times longer may be detrimental with regard to atmospheric turbulence.

A compact or intermediate camera can be used if it is installed on the telescope with an afocal attachment (see chapter 4), just behind an eyepiece. The magnification of the image depends on the focal length of the eyepiece and the position of the camera zoom.

DSLRs are more straightforward to install on a telescope, either at prime focus or behind a Barlow lens, but they suffer from a problem common with their film ancestors: the movement of the mirror and shutter during the exposure. It inevitably causes vibrations that can degrade the sharpness of the image, even with a heavy telescope, at the long focal lengths employed. An intermediate solution is the mirror lock-up feature; initial pressure on the button puts the mirror up, and a second one launches the photograph. But the shutter is still moving, so a better solution is live-view mode, where the mirror and the shutter stay permanently open (or, on some cameras, only move at the end of the exposure).

Outside the atmosphere, DSLRs and CCD cameras would certainly win over video, thanks to their higher SNR. But atmospheric turbulence completely changes this result. Scientific studies of this complex phenomenon demonstrate that, in the presence of turbulence, the quality of the image given by a telescope varies quickly and is sometimes excellent for a short instant. The best way to benefit from these fleeting and unpredictable moments is by taking images continuously. At the slow pace of DSLRs, the odds of capturing a moment of clarity are much lower. Of course, the greater the turbulence, the fewer good

images in the video sequence. In other words, video does not cancel out the turbulence, but it helps to collect the best images from the current conditions. If the images are constantly fuzzy, even video cannot help!

With video cameras, the other side of the coin is mediocre SNR. The consequence is that any one image extracted from a video sequence is not of high quality. To obtain a good SNR, enabling the enhancement of fine details (see the section "Enhancement of Details" later in this chapter), tens or hundreds of images should be combined. Fortunately, at a rate of 15, 30, or even 100 frames per second, thousands of images can be recorded in a short time frame.

When you're imaging planets, the small number of photosites of the smallest video sensors (640 × 480, or VGA format) is definitely not a handicap. Even with a focal length of 10 m (which is already quite long), Jupiter, the planet with the largest apparent diameter, fits entirely on a 1/4" sensor. But with the moon and the sun, at a given sampling the number of photosites determines the field of view covered. Another important parameter is the quantum efficiency of the sensor (see chapter 2). The readout noise is not an important criterion if it remains within reasonable limits (fewer than 20 electrons) since in planetary imaging the photon noise usually dominates (see chapter 3). The size of photosites is not critical either because the focal length of the instrument can be adjusted to obtain the desired sampling (see chapter 4). This size partially determines the maximum charge capacity of the photosite in electrons, a characteristic also not very important because, when the gain setting is increased, we use only a portion of it anyway.

As for CCD cameras, astronomical video cameras are controlled via a computer and dedicated acquisition software (such as Lucam Recorder for DMK and Lumenera, Genika for IDS and Basler, Video Sky for DMK, QHY, Apogee, Basler, and Atik). The following basic parameters are recommended:

- Image size: Full sensor or window (crop)
- Number of bits: 8-bit is sufficient for the typical planetary light range, while 10- or 12-bit is possibly useful only in some specific cases (solar disk with prominences)
- Exposure time: T

- Number of frames per second (fps): Cannot be larger than 1/T.
- Gain setting (equivalent to ISO setting on a DSLR): To be adjusted in conjunction with the exposure time to get a good histogram range. The higher the gain, the shorter the exposure time, but the individual images will be noisier and will need to be combined in larger number.
- Acquisition duration (in number of frames or in seconds) in general sequences of 100 to 1000 images are recommended, limited by rotation of the planet being imaged.
- Sequencer (if any) allowing automatic acquisition of image sets through different filters (if a filter wheel is connected to the computer and can be driven by the video software).

PLANETARY IMAGING: 8-BIT OR MORE?

Many planetary video cameras contain analog-to-digital converters delivering 8-bit images only, while others offer a choice between 8-bit and higher digitization depths, generally 10- or 12-bit. The latter are intriguing but the question is, are the last bit(s) really useful and worth the factor of two loss of frame rate? Few current planetary cameras offer a dynamic range over 10 bits even at their lowest gain setting. When the gain increases (which is always necessary in high-resolution lunar and planetary imaging), the dynamic range decreases proportionally and may quickly fall to 8-bit or even less, making the last bits useless since they are down in the noise. If you have such a camera, form your own opinion by comparing digitization mode results after similar processing on the same target, preferably at minimum gain, such as in solar imaging with high light levels. At high gain, you'll certainly see no difference between 8-bit and beyond. And remember that the 8-bit mode offers a doubled frame rate and combining 4x more frames gives a benefit of a factor of 2 (1-bit) in dynamic range.

A webcam must have its lens removed and must be placed behind a magnifying optical system (Barlow lens or projection eyepiece) to obtain good sampling (see the next section, "Focal Length and Sampling"). The image acquisition can be performed through the control software

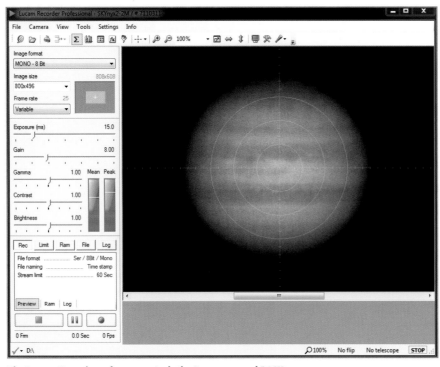

The Lucam Recorder software controls the Lumenera and DMK cameras.

This image of Jupiter was obtained by processing a 1-minute video sequence (30 fps) from a Canon 5D Mark II DSLR on a 14" telescope, captured using EOS Movrec

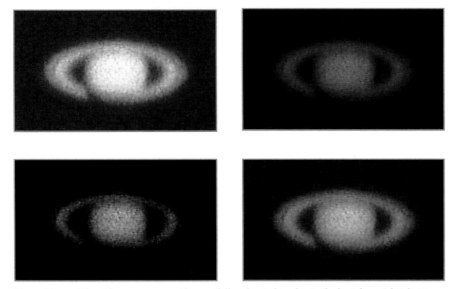

The settings of the video camera must be carefully adjusted to obtain the best from 8-bit digitization. On top left, the planet is overexposed; on top right, it is underexposed. On the lower left, the highlights are correctly exposed but not the darker areas, causing a loss of limb detail; on the lower right, the settings are optimal. Note the noise that characterizes video images.

accompanying the webcam or, for most common webcams, through astronomical software such as IRIS, Maxim DL, or Astroart.

As for a camera, the feature set of a webcam has many parameters; here are the most common:

- ❯ Image size: Choose the highest without interpolation. 640 × 480 for the basic models
- ❯ Exposure mode: Choose manual to avoid overexposure of the planet
- ❯ Brightness and contrast: Set to obtain a dark gray (but not black) background and a planetary image with good contrast and without saturated areas
- ❯ Black-and-white mode: When activated, this mode mixes the three color layers and may be used when color is useless (such as for the moon and sun) and only if the telescope does not suffer from chromatic aberration; otherwise, stay in color mode and select the best layer during processing

DSLRs are also capable of recording video, at up to 1920×1080-pixel resolution (full HD) at 24 or 25 fps. But this would be interesting for planetary imaging only if the resolution was obtained by cropping the sensor in its central area and not covering the whole surface of the sensor. Indeed, a resolution of 1920 × 1080 (about 2 million pixels) over a sensor that possesses 18 million pixels leads to only one photosite in nine being used (about one in three on the length and on the width). To maintain satisfactory sampling and avoid getting a planet three times as small, you should increase the focal length by a factor of 3. But, since the sensitivity of the photosites remains constant, this causes a 9x loss of brightness, which is extremely deleterious. Fortunately, for Canon DSLRs, the free program EOS Movrec allows you to record video from a selected portion of the sensor, using all photosites. Depending on the camera, these videos have a size ranging from 512 to 1024 pixels and a recording rate of between 15 and 30 fps.

Focal Length and Sampling

Jupiter occupies only about 50 pixels on the sensor of a video camera placed at the prime focus of a telescope with a focal length of 1 meter (40"), too small to record many details; the image is therefore under-sampled. With most instruments, the focal length must be amplified with the help of a Barlow lens or a projection eyepiece, as described in chapter 4. Experience shows that when the focal length is gradually increased, the size of the image increases as well as the number of details, up to a point where the quality of detail is not limited by the sampling but by diffraction or other factors such as collimation or turbulence. Beyond this stage, an increase in focal length is not only useless because what is enlarged is only fuzziness, it may also be harmful because of the longer exposure time needed to achieve good brightness; the image is oversampled. Although it applies only to double stars, the resolving power notion, described in the beginning of this chapter, can help us to determine adequate sampling for the planets; in other words, an optimal focal length. Theory and practice show that a sampling value roughly equal to half the resolving power is a good choice and allows recording quite a bit of detail. This rule of thumb, for an 8" telescope whose resolving power is 0.6 arc second, suggests that a sampling of 0.3 arc second per pixel is

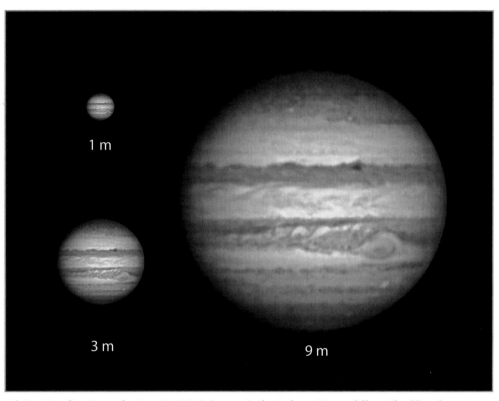

Relative size of Jupiter on the Sony VGA ICX-618 sensor in the Basler acA640 at different focal lengths

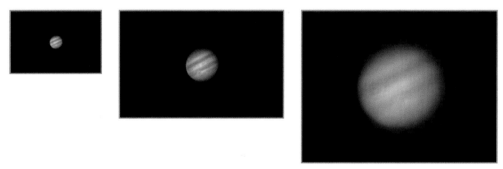

These three images of Jupiter have been taken with a 4" refractor, at focal ratios of 5, 13, and 26 respectively. At 5, the quality of detail is limited by inadequate sampling, while at 26, the limitation comes from other factors, such as diffraction or turbulence.

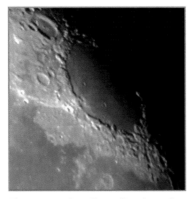

These cropped portions of two lunar images have been greatly enlarged and show that a monochrome sensor (on the left) is able to show more detail than a color sensor (on the right) despite a larger pixel size (9-micron and 8-micron photosites, respectively). The color sensor is handicapped by its Bayer matrix and by the low-pass filter placed in front of it, designed to avoid moiré effects on non-astronomical targets such as screens. Also, the monochrome sensor benefits from a shorter exposure time.

On the left, the flip mirror is inclined at 45° and directs the light to the eyepiece. On the right, it flips out to let the light go to the sensor.

optimal. For a video camera with 5 microns photosites, the focal length would need to be about 3600 mm (140"), corresponding to an F-number close to 20.

Going to a higher focal length or focal ratio is conceivable (25 to 30 in this example), but is worthwhile only under favorable conditions for optical quality, collimation, thermal equilibrium, focusing, turbulence, and so on.

Image Capture at the Telescope

Tonight the sky is clear and a planet is your target. Your instrument has been cooling outside for at least one hour. A typical imaging session proceeds as follows:

1. Assemble the instrument and approximately polar-align the mount (see chapter 7)
2. Check and adjust the collimation (see chapter 4), particularly for a transportable telescope and especially for Newtonian and Schmidt-Cassegrainian designs
3. Install the camera (DSLR or video) behind a focal length magnifying system (see chapter 4) designed to obtain adequate sampling
4. Center the planet on the sensor by displaying the image on the computer screen (video camera) or in the viewfinder (DSLR) or with the help of a flip mirror (see the sidebar below)
5. Focus on the planet (see chapter 4)
6. Set the camera and exposure
7. Periodically check the focus
8. At the end of the session, collect the calibration images (see chapter 3)

THE FLIP MIRROR: AN AID TO CENTERING AND FOCUSING

Numerous planetary photographers use, in addition to their video camera, a flip mirror device that was directly inspired by the reflex system of DSLRs. A mirror reflects the image to a sighting eyepiece placed at 90° (as for a star diagonal) and flips out of the way during exposure to let the light reach the sensor. The flip mirror must be placed just in front of the camera and its length must be taken into account in the calculation of the amplification factor, as described in chapter 4. Its use has several advantages:

- The planet can be centered or re-centered on the sensor without removing the camera (no risk of rotation)
- If the eyepiece is placed in parfocal position, the focusing can be performed visually or at least roughly set
- The collimation can be performed through the eyepiece, giving greater confidence that the eyepiece and the sensor are on the same optical axis

Considering the short exposure times, a dark frame is not necessary. Also, since the vignetting is normally invisible because of the use of a Barlow or eyepiece projection, the flat-field frame is necessary only for dust shadows. If the sensor is clean or if the planet is placed on a zone free of dust, the flat-field may also be optional. But a bias frame, and sometimes a flat-field frame also, is mandatory if the images contain vertical and/or horizontal stripes, a very common phenomenon with CMOS sensors.

Processing the Images

The processing of planetary images always follows this sequence:

1. Select the best frames
2. Register the selected frames
3. Stack them
4. Amplify the details
5. Perform the final touch-up: colors, brightness, contrast, and so on

THE ORIENTATION OF PLANETARY IMAGES

In space, there is no up and down. Therefore, you are free to orient your images as you wish, with the north up or down. However, avoid mirror image effects (vertical or horizontal) that can happen if the camera is placed behind a star diagonal and, more generally, after an odd number of reflections from mirrors (1 or 3) because there would be no match to the physical appearance of the object and it won't appear the way it would be seen from a space probe. If the image is formed after an even number of reflections from mirrors (0 or 2), there should be no mirror image effect, unless the acquisition software introduces its own.

However, conventions exist. The scientific custom is for the planets and the Moon to be displayed south up (if this convention seems strange to you, think about Southern Hemisphere observers for whom it is perfectly logical). If you have no reason to choose otherwise, orient your images south up; the planetary scientists will be grateful to you.

Select and Stack the Best Images

In video, it is absolutely not necessary that the planet remain strictly in the same location on the sensor during imaging. It would be impossible anyway, given turbulence and the inevitable tracking drift! It is even better if the planet moves a little between sequential raw frames because this smoothes defects such as bias level variations or residual dust shadows, these defects no longer being coincident after registration.

First-generation processing software programs appeared in the early 1990s. They were able to register images to a fraction of a pixel and stack them. But the best frames had to be selected manually, which was tedious. Today, given the high frame rates of video cameras, this would be humanly impossible. Fortunately, those programs have evolved to where they can make this selection themselves, sorting images using mathematical sharpness criteria that have proven their efficiency over visual selection.

Then came programs dedicated to planetary processing, such as AviStack and RegiStax, able to deform (or rather to "straighten") the selected frames before registering and stacking. Indeed, one of the consequences of atmospheric turbulence is distortion of the planetary image, resulting in various details not being aligned at exactly the same location across the globe. When the frames are just globally registered and stacked, this creates a blur due to the misalignment of the details frame to frame.

AutoStakkert! sets registration fields on a lunar video

The image at top is the result of a multipoint alignment by Autostakkert on a lunar video captured during moderate turbulence, causing significant distortion of the raw images. In the second image, after single-zone alignment is used (global alignment for the whole frame), the result shows less detail.

We now have fourth-generation programs (AviStack and RegiStax again, plus AutoStakkert!). They are capable of automatically selecting and registering frames not simply by centering the entire disk of the planet, but by aligning individual features across the disk, warping the images into alignment. As a result, if they are asked to select and stack the top 300 frames of a video sequence, each area of the lunar surface or the planetary disk will be the combination of 300 selected frames, but not necessarily the same frames from one area to the next. The benefit of these improvements is all the more visible when the turbulence is strong. All programs operate according to the following steps, irrespective of their user interface:

1. Open the raw video sequence, monochrome or color (an AVI or SER video file or a series of Flexible Image Transport System [FITS] files)
2. Make a reference image by globally stacking the best frames
3. Analyze the sharpness and distortion of each frame, area by area
4. Select and stack the best frames, area by area, registering each area according to the reference image
5. Display and save the result, in FITS or Tagged Image File Format (TIFF) files

The main parameters are as follows:

❯ The minimum brightness threshold. In the case of a planet or the lunar terminator, it is useless to include the sky background in the calculations.
❯ The maximum brightness threshold. Some crater borders may be overexposed and should not be taken into account in the sharpness assessment.
❯ The size of each area to be analyzed.
❯ The size of each area to be registered and combined (depending on the program chosen, this parameter may be merged with the previous one).
❯ The number (or percentage) of frames to stack.

It is seldom wise to choose analysis and focus areas with the smallest possible size. The software needs, within each area, a sufficient number of details to properly assess the sharpness and position. A size of 20 to 100 pixels is generally satisfying; several tests with different values of this parameter will allow you to determine its effect on the final image quality.

Other parameters may be available depending on the software used, such as, for example, the overall brightness threshold, set to exclude the images affected by a passing cloud or the exit of the planet from the frame, or a distortion threshold for excluding images too distorted by turbulence. One can also find benefit in batch processing on a group of video files. If calibration frames (offset and flat-fields) have been made, they will be taken into account at the appropriate step.

When one of these programs cannot open a compressed video file, it is possible to rerecord it in uncompressed AVI format with VirtualDub, a program also used for time-lapse images (see chapter 1).

At this step, the first question you may have is how many images you should select. As you saw in chapter 3, the aim of combining images is to get a better signal-to-noise ratio. Therefore, the number of images needed depends on the signal-to-noise ratio of the RAW images (which itself depends on numerous parameters, such as focal ratio, camera settings, brightness of the object, etc.) and on the strength of the processing applied after combination. In certain situations, only 50 images may be sufficient, while in other cases 500 images may not be excessive. Only testing and experience allow you to estimate the number of images needed, the wisdom of your choice being revealed by the final result. A noisy image means that too few images have been combined...or that the processing is too strong!

The second most frequent question is, for Venus, Mars, Jupiter, and Saturn, what is the maximum time interval between the first and the last images beyond which the rotation of the planet contributes visible blur? Of course, the smaller the detail the instrumental and atmospheric conditions allow to be recorded, the shorter the interval. For a planet of apparent diameter (D, in arc seconds) and rotation period (T, in minutes), using the mathematical constant pi, the blur (B, in arc seconds) is maximum at the center of the disk and, during an interval (Δ, in minutes), is calculated using the following formula:

$$B = \pi \, \frac{D\Delta}{T}$$

Comparing this value with the sampling is a good way to estimate if there will be blur caused by the length of the sampling interval.

WINJUPOS...OR HOW TO STOP TIME!

The objective of WinJUPOS software is simple: to allow you to stack monochrome or color frames of Mars, Jupiter, and Saturn acquired over a period of time exceeding the limits imposed by the rotation of the planet. It is even able to compensate for the field rotation that occurs with a Dobsonian mount. To do this, it projects each frame onto a sphere, rotates the sphere to a common angle, projects the frame back onto a flat surface, and then combines each frame with the others, in this way accounting for the position and rotation of the sphere to obtain a more accurate stack of the frames. This registration requires knowledge of the exact time for each frame with an accuracy of a few seconds.

The usual method of acquisition and processing with WinJUPOS for imaging with a monochrome camera and a filter wheel is as follows:

1. Acquire the image sequence while alternating filters in RGB-RGB (or LRGB-LRGB, for imaging with a luminance filter) sequence. Each video sequence should take about one minute, and be sure that the acquisition computer's clock is set precisely (if possible, synchronize using an Internet time service).

2. Process each video sequence as usual with Autostakkert, AviStack, or Registax.

3. Enhance the details of stacked images as usual with an astronomical processing program.

4. Rename each image with the rule required by WinJUPOS (date and time of the middle of each video sequence).

5. Open each image in WinJUPOS, which then measures the position, size, and orientation of the globe and any satellites present in the field and saves the data in a file (IMS).

6. In WinJUPOS, derotate and combine the red picture group to obtain the reference red image, and then process the green set and blue set similarly.

7. In WinJUPOS, derotate and combine the reference red, green, and blue images to obtain the final color image of the planet.

8. Export the image as a 16-bit TIFF file for final editing (contrast, color balance, etc.) in Photoshop or an equivalent program.

WinJUPOS performs measurements on a stacked Jupiter sequence taken with a green filter

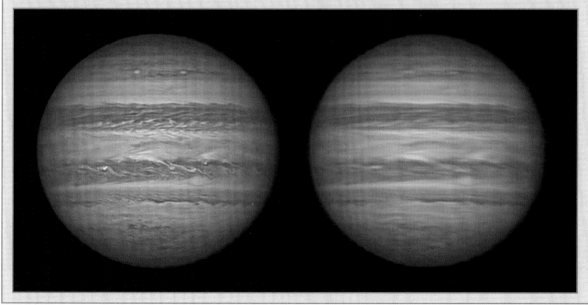

The left image was obtained by combining 18 WinJUPOS videos (6 per color) with a total acquisition time of 16 minutes using a 14" Schmidt-Cassegrain telescope and a monochrome video camera (1/4" sensor, 656 × 488 pixels). On the right, combining the frames without WinJUPOS illustrates the significant rotation of the globe of Jupiter over the same interval.

Values of blur at the center of the globe for the major planets, depending on their apparent diameter and the imaging duration

Duration	Mars 10"	Mars 15"	Mars 20"	Mars 25"	Jupiter 45"	Saturn 20"
1 min	0.02"	0.03"	0.04"	0.05"	0.2"	0.1"
2 min	0.04"	0.06"	0.08"	0.1"	0.5"	0.2"
4 min	0.08"	0.1"	0.2"	0.2"	0.9"	0.4"
8 min	0.2"	0.2"	0.3"	0.4"	1.9"	0.8"
16 min	0.3"	0.5"	0.7"	0.8"	3.8"	1.6"
32 min	0.7"	1.0"	1.3"	1.7"	7.5"	3.3"

Jupiter (average diameter at opposition is 45 arc seconds, average rotation period is 10 hours, or 600 min) is the most demanding planet and the limit can be as short as 1 minute for detailed views taken with a good 10" or larger telescope. For Mars, whose average diameter at opposition varies from 14 to 25 arc seconds and whose rotation period is 24 hours, 40 minutes, the formula shows that the limit is about 4 to 8 times larger than for Jupiter. Saturn is a unique case: If there is no seasonal storm on its surface, the globe and the rings possess rotational symmetry and images taken over a whole night can be combined. Otherwise, taking into account its apparent diameter (20 arc seconds) and its rotation period (about 10 hours), the time interval is 2.5 times longer than the interval for Jupiter. As for Venus, a rotation of its opaque atmosphere being a hundred hours or so, the time interval can be many minutes.

Programs implementing multipoint alignment allow you to increase the total length of an imaging sequence since they partially compensate for the rotation of the globe.

Calibrating, Registering, and Combining Images

If you have taken calibration images (flat-field and bias), the astronomical processing software will employ them to calibrate the selected raw images and to record a new set of calibrated images.

It is not necessary that the planet remain in exactly the same location in the frame during the entire imaging sequence. It is impossible anyway, considering the erratic movement caused by turbulence and the unavoidable tracking inaccuracy and drift. It is even preferable that the planet moves slightly between images, which smoothes any CCD defects or inhomogeneities over a few photosites, since these inhomogeneities will not be fixed in position after registration of the images relative to the planet.

Here too, astronomical software programs demonstrate their superiority; they know how to register a set of planetary images automatically, taking the first image as the reference. Thanks to advanced correlation algorithms, they are even able to register the images to a fraction of a pixel.

Then, the images are combined using one of the methods described in chapter 3, such as the sum or median method. Since video images are often 8-bit, a median combine must be avoided since the combined image would remain 8-bit, with no noise improvement for the next processing step. A sum is preferable. However, if the number of images is large, the sum may exceed the 15-bit or 16-bit range generally used by astronomical software, causing saturation of the planet. In this case, many software programs offer one of two solutions: either they scale the range of the final sum to make it compatible with a 16-bit range or they work in 32-bit.

Enhancement of Details

Once calibrated, aligned, and combined, planetary images can be processed with algorithms that increase the visibility of fine detail. Different techniques are used: sharpening, unsharp mask, and high-pass filter. The algorithms differ but they have many attributes in common:

- They increase the contrast of subtle details by boosting the high spatial frequencies of the image (hence their general designation as high-pass filters).
- They also amplify the noise that is generally greatest in the high frequency range of the image. As a result, they reduce the signal-to-noise ratio, and this is why is it necessary, particularly with video cameras, to combine a large number of images.

On the upper left, a single raw image; on the upper right, a combination of 300 raw images. At this stage, the difference is not that obvious, especially if the object is bright and the gain of the camera is low (moon, sun), but it is evident after an unsharp mask is applied (lower images). The noise becomes too high when only one raw image is used, and in this image of Jupiter, the Great Red Spot is not visible, while the combination of 300 raw images shows it well.

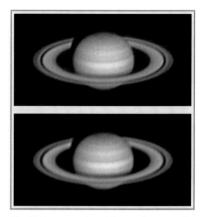

The edge effect caused by excessive unsharp mask processing is visible as a bright border along the left edge of the planet

▸ They cause edge effects. For example, a bright or dark border can surround the Martian polar cap or the shadow of a satellite of Jupiter on its globe. Edge effects can also affect the rings of Saturn, the lunar craters or the sunspots, and more generally, any steep transition between a bright zone and a dark zone.

The most common filter is the unsharp mask. It uses two parameters: the sharpening scale and the amplification factor. To adjust them correctly, it is useful to understand the principle of unsharp masking and its different steps, even if the software handles all of these steps transparently:

1. The initial image is made fuzzy by a low-pass filter that has a Gaussian form (like a bell) whose width, called *sigma* or *radius* depending on the software, must be chosen. It is the first parameter, and it determines the scale of the details to be amplified: a small value corresponds to the finest details, while a higher value affects details a bit less fine, and so on. The most common values used are in the range 0.5 to 3.
2. The fuzzy image is subtracted from the initial image to isolate only the details to be amplified.
3. The result of this subtraction is multiplied by a factor (called the *gain* or *intensity* depending on the software). This is the second parameter, and it allows adjusting the strength of the processing.
4. The result is added to the initial image.

Some programs, such as Photoshop or Paint Shop Pro, use a third parameter for the unsharp mask: on the basis of this parameter, the software does not apply the algorithm on the zones of the image where the variations of intensity are very low, below a threshold. It assumes that these zones are smooth and that these variations are only noise that is unnecessary to amplify.

Even if each video frame looks smooth, they must be combined to improve the signal-to-noise ratio before the unsharp mask is applied. For example, an unsharp mask with a factor of 5 (or 500 %) amplifies the noise about five times: it is necessary to combine at least 25 images (the square of 5) to compensate for this deterioration.

Astronomical software uses another powerful processing technique for the planets: wavelets. It works similarly to the unsharp mask technique but offers the ability to work individually on detail at different spatial scales. The image is broken into several sub-images called components, each containing one spatial scale of detail (in other words, a range of spatial frequencies). Each of these components can be boosted or suppressed by a factor. For example, the first one, which corresponds to the highest frequencies (the finest scale) sometimes contains only noise and can be amplified by a factor of 0 (zero). In the original image, each component has a factor of 1. Generally, only the first three components are modified; the other ones remain at 1.

A slight unsharp mask can be applied on 8-bit images, but it is preferable to work in 16-bit as soon as possible. For wavelet processing, 16-bit is mandatory.

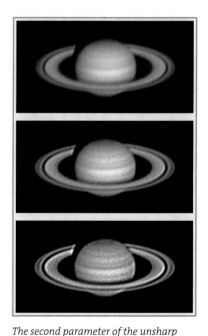

The first parameter of the unsharp mask is the width of the Gaussian curve. Here, its values are 1 (top) and 3 (bottom). It changes the scale of the details to be amplified.

The second parameter of the unsharp mask is the multiplying factor (here, its values are, from top to bottom, 3, 8, and 20). A higher value amplifies the details more, along with the noise, and artifacts may appear, for example, where the shadow of the globe projects itself on the rings.

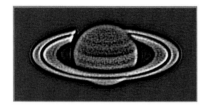

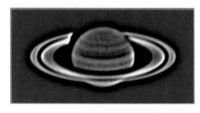

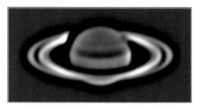

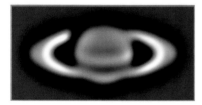

The first four wavelet components. The first one contains the finest detail but also a lot of noise. The scale of the detail becomes coarser with higher-level components.

Many other ways to enhance details exist, in particular, image restoration algorithms such as Van Cittert, Lucy-Richardson, and maximum entropy. However, they do not show any obvious superiority over unsharp-mask-based techniques or wavelets, and it is not necessary to provide a detailed discussion about them here. You can experiment with them if you wish. None of them is miraculous, and if used too strongly, they all have the same drawbacks: amplification of noise and image artifacts.

Color Adjustment

If the color balance settings of your camera have been set to daylight, the colors that you have obtained should be correct. If this is not the case, try to adjust the colors on the polar cap of Mars or on the rings of Saturn, which have a color perceived as white. If the images have been taken with a monochrome camera with a set of RGB filters, the three channels must be combined with an adjustment factor for each channel that is determined as described in chapter 7, which outlines how to create color images of galaxies and nebulae with a monochrome sensor.

Another processing step is adjustment of the color saturation. If you have carefully observed Jupiter or Saturn in a telescope, you have probably noticed that the tints of their cloud bands are soft pastel colors, much different

from the exaggerated colors sometimes published. For example, the Great Red Spot on Jupiter is pale and its pinkish-orange color changes slightly over time. Do not expect perfect fidelity if you attempt to obtain a result close to the visual appearance. The sensitivity curves of the eye and sensors are different, and the eye is a bad judge of color balance: a sheet of paper placed under an incandescent lamp appears white, while a photograph shows it to be clearly orange.

Animations

It is quite simple to make a small movie of the rotation of a planet on its axis from a series of images taken at intervals of several minutes. Each image (which, of course, is itself the result of a combination of RAW images, as described earlier) is registered with the first image of the series, following the same technique as the registration done before the combination. It is common for atmospheric transparency variations (caused by high clouds or a light film of dew on the optics) to cause a sudden or progressive change in the brightness of the planet, imperceptible when the images are viewed one by one but obvious when the movie is played since the eye is an excellent detector

Many shareware and freeware programs can construct an animated GIF. In Photoshop, the editing function must be initialized from an image in which each layer contains one of the frames of the animation. This image is then replicated as many times as necessary, and the layers are activated or deactivated in accordance with their appearance in the movie. The animated GIF file is created using the command Save for Web with adjustment of the display time for each frame or the time between two successive frames.

The adjustment of the color saturation (here using Paint Shop Pro) yields more dramatic color in the image, but it should be used with moderation

of brightness variation. In this case, the brightness of each image has to be adjusted manually so that it matches the previous image of the movie (this is the most tedious part of the task). For the same reason, the other defect to absolutely avoid is noise; even if some noise can be tolerated on a single image, in a movie it degrades the sequence's appearance with an unpleasant "swarming" effect.

Some amateurs have been able to assemble animations of a complete rotation of Jupiter (about 10 hours) when imaging under favorable conditions, such as a winter night at a high-latitude location with Jupiter at a high declination. The movement of the Galilean satellites may also produce spectacular movies, especially during mutual events such as the eclipse of a satellite by another, or by Jupiter, or a transit of the satellite or its shadow across the globe of Jupiter.

For small movies, the usual format is an animated GIF because like a JPEG or single GIF image, it can be placed directly on the page of a website. For larger animations, one of the file types described in chapter 1 for time-lapse movies is preferred.

Stereo Images

Everyday objects that are located within 10 to 20 feet of our eyes are seen in relief: our brain, using the differing images received by each eye, is able to reconstruct, at least partially, the third dimension. Thus, the spherical shape of a globe placed at a few steps is clearly recognizable. But the moon (and any other celestial body) is situated way too far from us to be perceived directly as a sphere. When we use the telescope, we guess it is spherical because we know that it is so and because the foreshortening that flattens the craters close to the limb suggests to us that it is not flat. To really perceive its shape, our eyes should be separated by thousands of miles, or even millions of miles for Jupiter.

To construct a stereo image from two images in terrestrial photography, the camera is shifted by several inches, or even several feet, between the images. Since it is impossible to move our telescope millions of miles in a flash to rotate around Jupiter or Mars, we must wait until the planet has rotated on its axis to present us with two slightly shifted views. The exposure spacing must be correctly chosen so that the rotation of the planet is several degrees. If this time is too small, the rotation (and then the stereo effect) is not perceptible; if it is too long, the relief effect is too strong and will look unrealistic. For Jupiter,

The method of parallel merging is illustrated on the left; force each eye to look at the image that is on the same side as that eye, by using a separation screen (a sheet of paper, here in green). The method of cross-eyed viewing is illustrated on the right; cross your eyes to force each eye to look at the opposite image.

Using cross-eyed viewing, you will see six Jovian disks in 3D with the impacts of the Shoemaker-Levy 9 comet that impacted Jupiter in July 1994. These images were taken from the Pic du Midi Observatory (France) with a monochrome CCD camera and a 5" achromatic refractor by Christian Buil and myself. A similar event, while of smaller extent, occurred in July 2009 with the appearance of a dark spot in the southern polar region, probably due to an asteroid or a comet in the 100-meter size class.

this interval is about 10 to 15 minutes, while for Mars it is 20 to 40 minutes.

The simplest method to obtain a 3-D color view consists of juxtaposing the two images on a screen and adjusting your vision to merge them. There are two ways to do that; some astrophotographers prefer one and some the other. If you place the images so that the one that is intended to be seen by the left eye is on the left and the one intended to be seen by the right eye is on the right, you will have to force the left eye to look at only the image on the left and the right eye to look at only the image on the right. The difficulty consists in keeping the eyes parallel, as if you were looking at infinity rather than at something up close, which is opposite the natural behavior of our vision system. A small sheet of paper placed between your nose and the screen helps prevent each eye from looking at the opposite image. The other method, the one that I prefer, is crossing your eyes to make the two images merge. In this case, the order of images must be reversed: the one for the left eye is on the right and vice versa. For either method, if the images are swapped, the globe of the planet will appear as a concave hollow instead of a convex sphere.

As for an animation, the images must be free from noise, because any difference between the two images other than their rotation gives an unpleasant result.

The Purpose of Image Processing

Some assert that the optical quality of an instrument is less important for imaging than for visual observation. While it is true that image processing offers a lot of techniques to increase the contrast and to enhance detail, in reality noise and image artifacts confound this idealistic point of view. Experience shows that the best final image is always obtained from the best raw image. As essential as image processing may be, and though the difference between a raw and a processed image may be spectacular,

image processing is only one link in the chain of imaging. It is designed to extract the best from the raw images, not to compensate for optical defects and focusing inaccuracies and, even less, to invent details that have not been recorded in the raw images. The quality of an image is built during acquisition and is revealed during processing. Processing an image accentuates certain information to the detriment of other details. You cannot process an image indefinitely. Don't trust a TV show where a so called "expert" determines the eye color of a suspect from a monochrome, fuzzy video image: it is fiction!

The best evidence of this is perhaps the images taken by the Hubble Space Telescope (HST). The first images delivered by the HST after its launch did not correspond at all to the expected performance. The contrast of the planetary images was low and the stars were surrounded by a strong halo. Investigation revealed that its 2.4-meter primary mirror suffered from a serious optical defect (spherical aberration). The simulations of this manufacturing defect show that the performance of the telescope in terms of contrast and sharpness was reduced by a factor of 5 to 10. This was confirmed by the early planetary images produced by the HST, images that could have been taken with a good 250mm amateur telescope with a webcam, despite all the efforts expended by NASA in implementing image restoration algorithms. NASA's algorithms recovered only a very small part of the expected performance. In 1993, the installation of corrective optics inside the HST demonstrated that this solution, although much more costly than image processing, was definitely better; the current HST planetary images have nothing in common with its first ones and are completely beyond the capabilities of any amateur telescope and most professional terrestrial telescopes. Adaptive optics techniques, implemented on some of the largest telescopes, seek the same objective: improving the image before it reaches the sensor. After that, it's too late.

The Trap of Overprocessing

In my opinion, the best skill in image processing is not necessarily to know by heart all of the techniques and algorithms but to understand their advantages and drawbacks so you can make proper use of them without overprocessing. Astronomical photography in general, and planetary imaging in particular, can be qualified as extreme photography: the focal lengths are large, and the planets are small, not so bright, and in continuous movement in the sky. The image is a fragile object that needs to be handled with care!

The temptation to process an image more and more is strong; after all, the cost is only several clicks with a mouse. But if the image is not satisfying after some basic processing (combining and unsharp masking), it is probably useless to pursue it further and try to make it show more than it can because the problem probably occurred during image acquisition: turbulence, collimation or an optical defect, inadequate sampling, and imprecise focusing, for example.

However, overprocessing an image so that noise or artifacts appear may be acceptable if the aim is to emphasize a specific detail; professional astronomers sometimes do that. But the following precautions should be taken:

1. Make sure the details that appear are real and are not artifacts
2. Warn the viewers of the image that some features may not be real and that it has been overprocessed to emphasize specific information

The fact that a detail looks real is not absolute evidence that it is real; we often see false divisions in the rings of Saturn (especially a false Encke's division) on overly processed images. I thought my very first solar images showed solar granulations... until I realized that it was noise!

The Planets and Their Satellites

Mercury

Mercury is the closest planet to the sun. It has no atmosphere and its surface is similar to that of the moon, with craters of all size everywhere. Its orbit is said to be inferior, so it exhibits phases like the moon.

Its maximum elongation from the sun never exceeds 28°, so it is always more or less drowned in the twilight glow. But, as with Venus (as you'll see in the next section), it is possible to photograph Mercury in daytime light. It is easier to spot Mercury during periods of maximum elongation. At those times it appears in the telescope as a very small lunar quarter (7 arc seconds only). If the sampling is sufficient, photographing this phase is not too difficult, but recording a few details on its surface is probably one of the greatest challenges for amateurs equipped with high-quality telescopes and situated in a site where the seeing is good.

The exceptional apparent gathering of Venus and Mercury on June 27, 2005, photographed in daylight using a monochrome video camera with a red filter on a 180mm telescope. The phases of the planets, only 3 arc minutes apart, are easily visible (quarter for Mercury and gibbous for Venus).

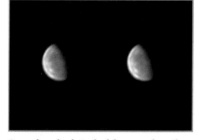

Seven hundred stacked frames of 2 milliseconds each with a 14" telescope and a video camera were needed to detect albedo variations on the disk of Mercury, which subtended only 6 arc seconds. Two videos taken minutes apart help to verify, by their similarity, that these spots are not just noise.

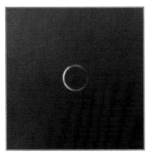

Venus photographed 25 hours after its solar transit of June 6, 2012, while it was only 1.9° from the sun. The diffusion and refraction of the sunlight through the Venusian atmosphere allow its complete circumference to be discerned.

Photographing Venus in UV light (here using a telescope of 150mm aperture and a monochrome video camera with a UV filter) can show the large cloud structures of the upper atmosphere

Venus

Just like Mercury, Venus is an inferior planet with phases. But photographing it is less difficult because its solar elongation can reach 47°, making it easily visible at twilight (in the morning or in the evening, depending on the period). Also, at that moment it is the brightest object in the sky after the sun and moon. In addition, its apparent diameter varies from 10 to 60 arc seconds (respective values for superior and inferior conjunctions, when Venus, the sun, and the earth are aligned) and is about 24 arc seconds at maximum elongation.

Venus can be observed and photographed almost every day because it is easily visible in a telescope during the daytime. To spot it, use the GOTO system of your mount if it is equipped with one, or use the difference of celestial coordinates from the sun if your mount has setting circles. As with Mercury, a yellow or orange filter may increase the contrast by decreasing the brightness of the blue sky. During a daytime observation of Venus or Mercury, it is essential to make sure that the sunlight never comes directly through the telescope and that, for aiming at or near the sun, an appropriate filter is used (see chapter 6).

Photographing the phases of Venus is easy with a focal length exceeding 500mm. Exposure times are short because the albedo (the percentage of sunlight reflected by the planet) is very high. But no surface detail can be recorded because a highly dense and totally opaque atmosphere completely surrounds Venus. The "horns" of Venus,

observed during inferior conjunction, confirm its presence. Through the eyepiece it appears intensely white, without details. However, the largest structures of the Venusian atmosphere can be photographed with the help of a violet or, better, ultraviolet (UV) filter, transmitting wavelengths shorter than 400 nanometers (nm) (Baader, Astrodon, and Schuler make such filters). It is by this mean that the amateur Charles Boyer, in the 1950s, determined the period of rotation of the atmosphere: four days. Because they're opaque to UV light, color sensors are unsuitable for this task. However, most monochrome sensors have a weak sensitivity to UV, sufficient to record Venus. But many telescopes have optical performance that deteriorates in the UV, particularly achromatic refractors and also Schmidt-Cassegrain telescopes, which exhibit spherochromatism at this wavelength. Note that the common photographic filters called UV filters are used to protect lenses and are opaque to UV, not transparent.

Mars

The Red Planet is one of the amateurs' favorites. It is a superior planet, so its phases are not pronounced, exhibiting a slightly gibbous shape at quadrature (when the sun-earth-planet angle is 90 degrees). Its observation and photography are easier during the several weeks before and after the Martian oppositions that occur every 26 months. Because of the pronounced eccentricity of its orbit, its apparent diameter at opposition varies by almost a factor of 2, from 13 arc seconds for unfavorable oppositions to 25 arc seconds for the best ones.

Thanks to its tenuous atmosphere, Mars clearly shows surface details, particularly in red light. One of the polar caps, a small white spot contrasting with the ochre color of the rest of the globe, is quite easy to capture, as well as the largest structures, such as Syrtis Major. A perseverant amateur equipped with a telescope of more than 200mm and a video camera in a good site can today record numerous small details on the Martian surface, including the largest known volcano of the solar system, Olympus Mons. However, unpredictable seasonal sand storms often cover a large part of Mars, masking all of its surface details. With a monochrome camera, color views can be obtained using either an RGB sequence or an L-RGB sequence, utilizing a luminance (L) filter, a transparent filter, or a visible filter (rejecting UV and IR).

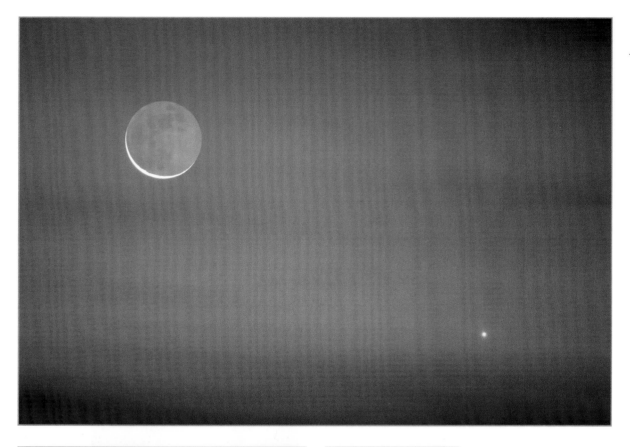

The conjunction of the moon and Venus on August 22, 2006, taken with a 500mm focal-length refractor and a DSLR

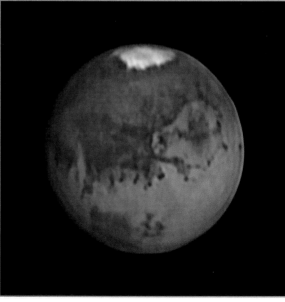

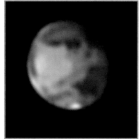

The apparent diameter of Mars at opposition varies from 13 to 25 arc seconds, as shown in these images taken (from left to right) during the oppositions of 2003 (video camera and 305mm telescope) and 1995 (CCD camera and 250mm telescope)

Jupiter

The giant planet of the solar system presents, at opposition, a nice, large apparent diameter of about 45 arc seconds. Its parallel cloud bands are easy to capture, even with a small telescope. The Great Red Spot is also pretty easy to capture... when it is visible. Indeed, considering the rapid rotation of the Jovian globe (9 hours, 56 minutes), it is visible for only a short time—about 2 hours—during each rotation. Ephemerides, websites, and astronomical magazines provide the times of its transits across the meridian of the planet. As was the case for Mars, dedicated amateurs are able to record a huge quantity of details, such as very thin bands and small cyclones. Because these details have low contrast relative to the brightness of the planet, any problem affecting the imaging is especially disadvantageous for Jupiter, as for Mars. In red, many details are visible but their contrast is low, while in blue light, high-contrast large structures are seen. With a monochrome camera, an infrared filter brings out a lot of detail in the Jovian atmosphere while reducing the level of atmospheric turbulence. Also, with a monochrome camera, color views can be in either RGB or LRGB. As for Mars, R-RGB and IR-RGB (red or IR layer used as luminance) combinations are to be avoided because they produce a result that does not correspond to reality.

Saturn

The rings of Saturn, one of the marvels of our solar system, are easy to photograph, thanks to their high contrast and their large apparent diameter (more than 40 arc seconds at opposition), at least when their inclination is not too small. When the earth is aligned with the plane of the rings, every 14.5 years (1995, 2009, etc.), the rings' extreme thinness make them invisible for several weeks. Cassini's division that separates rings A and B is also quite easy to capture at both ends of the rings and even, when their inclination is maximum, all the way around the periphery of the rings. On the other hand Encke's division (or Encke's gap), 14 times thinner than Cassini's division, is considerably more difficult and accessible only to telescopes over 200 to 250mm and under perfect conditions. The globe of the planet shows cloud bands, as Jupiter does, but they look less structured. However, seasonal storms sometimes appear; these are not easy to capture, considering their small size and low contrast. On Saturn, balancing the color is easy because the rings provide a good white reference.

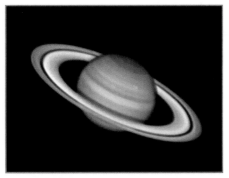

This small bright spot on the globe of Saturn is one of those rare and elusive storms visible with amateur telescopes

Due to the low contrast, it is difficult to discern one of the Galilean satellites of Jupiter (in this image, Io) when it passes in front of its globe, but photographing its shadow is not difficult

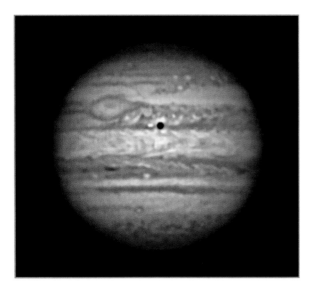

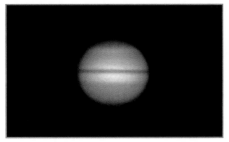

Every 14.5 years (half a revolution of Saturn around the sun), the rings look so thin that they disappear from our sight. It is only during these periods that we can see Titan, the biggest satellite of Saturn, projecting its shadow on the globe.

Uranus and Neptune

With these two planets, we reach the borders of the solar system. Their low magnitude (Uranus is barely visible with the naked eye in a dark sky) and their small apparent diameter (3.7 and 2.3 arc seconds, respectively) make them much less prolific in detail than the other planets. While it is not too difficult to record their nonstellar appearance or their slight hue, recording the cloud belts of Uranus is extremely difficult even for skilled amateurs equipped with quality telescopes with 10" apertures or larger. These details are more contrasty in red light and even more so in the infrared, so a filter removing blue and green light is absolutely essential. The optimum choice is probably a 685 nm IR filter.

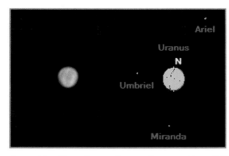

A combination of 5000 frames from a video of Uranus taken with a 14" telescope at an f-number of 21 with a 685 nm red filter and a monochrome camera. The WinJUPOS simulation (on the right) helped to verify that the visible cloud bands on the image had the correct orientation with respect to the poles of the planet. By briefly switching off the motor of the mount and watching the movement of the planet on the screen, one can determine the orientation of the camera axes relatively to the celestial sphere.

The Satellites of the Planets

Numerous planetarium software packages are able to show the true position of the natural satellites of planets that have them, allowing you to determine the moment when their angular separation from the planet is greatest, thus increasing the odds of capturing them in an image. Thanks to their brightness, the four Galilean satellites of Jupiter and Titan, the largest satellite of Saturn, are within the reach of any video camera. For the others, a CCD camera or a DSLR is preferable since the exposure exceeds 1 second.

No satellites orbit Mercury and Venus. Mars has two tiny satellites, Phobos and Deimos, with a magnitude of 10 to 15 depending on the distance from Earth. Since their brightness is comparable to that of Pluto, they would not be difficult to photograph if the dazzling disk of Mars were not right beside them; it is more than 200,000 times brighter than the satellites! At the exposures needed to record them, Mars is completely overexposed and is surrounded by a large halo of diffuse light. Thus, the difficulty consists of adjusting the parameters such as sampling and exposure time and choosing the moment when the satellites have the largest elongation so that they are not lost in the glare of the planet, especially Phobos, whose orbit is lower. A blue filter may help to decrease the brightness of Mars at the expense of increased exposure time.

The four Galilean satellites (Io, Europa, Ganymede, and Callisto) are much easier to photograph because their albedo (and thus the exposure time) is comparable to that of Jupiter. In very good conditions and with a powerful instrument, some spots can be captured on the largest one, Ganymede, whose apparent diameter is 1.7 arc seconds. At such a small diameter, the number of photosites covered is very small and the amateur must be careful about the reality of the details that appear on the images, especially if they have been taken with a color sensor. There are two ways to check the reality of details: (1) taking images at different moments and verifying that the movement of the detail corresponds to the rotation of the planet or the satellite, and (2) using the NASA Solar System Simulator at http://space.jpl.nasa.gov to display the appearance of any planet or satellite at a given date.

From time to time, one of these satellites projects its circular shadow on the globe of Jupiter. These shadows are easy to photograph, thanks to their high contrast, compared to the satellite itself when it passes in front of the planet. Jupiter has many other satellites, but they are much smaller and need a longer exposure time.

Several satellites of Saturn are easy to photograph, and especially the largest one, Titan, but with no possibility of capturing any detail because its apparent diameter is very small (less than 1 arc second) and because its surface is masked by an opaque and uniform atmosphere.

Uranus and Neptune also have several satellites, the magnitude of the brightest ones being close to that of Pluto (14 to 15). Photographing the satellites is complicated by the glow from the planet, but much less so than

Ganymede, photographed with a 305mm telescope and a monochrome CCD camera. The dark spot in the upper left of the small disk is Galileo Regio, the largest dark area on the surface of the satellite.

Seven satellites are visible in this photograph of the Jupiter-Uranus encounter taken on September 19, 2010, with a 1100mm focal-length refractor and a DSLR: the four Galilean satellites (from bottom to top: Io, Europa, Ganymede, Callisto) and the three satellites of Uranus (from left to right; Umbriel, Miranda, Ariel).

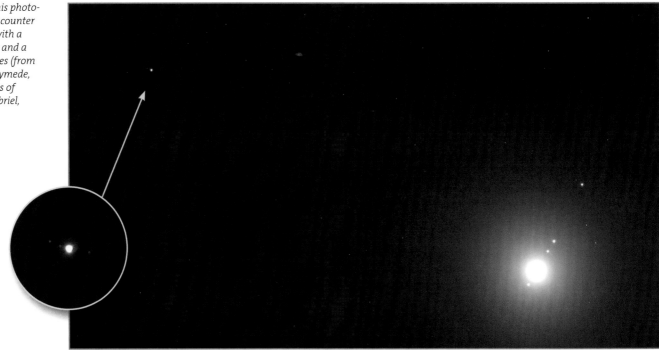

when photographing the satellites of Mars, since the Martian satellites are so faint. As for Charon, the only satellite of Pluto, its very low brightness (magnitude 19) and its proximity to Pluto (less than 1 arc second) make photographing it probably beyond the reach of amateurs.

Photography of the Moon

Lunar photography has many similarities with that of the planets, but also some differences that require consideration.

Lunar Close-Ups

For detailed images of lunar features such as craters, mounts, canyons, and domes, you use techniques similar to those for images of planets; video cameras can capture the smallest lunar details by taking advantage of moments of light turbulence. The focal lengths and the amplification systems are also similar. Of course, for a given sampling, the number of photosites determines the field of view, which is usually a very small part of the

lunar globe for the smaller sensors of video cameras. As is the case for visual observation, the region to favor is the terminator, where the low angle of the sunlight creates long shadows that emphasize the surface relief.

As for planets, the raw images taken with video cameras need to be combined to improve the signal-to-noise ratio before you apply further processing such as unsharp masking or wavelets. An interval of at least several minutes is available for these imaging sequences because the change of lighting near the lunar terminator is relatively slow. However, some shadows very close to the dark side can evolve quite quickly, and animations with images taken several minutes apart over a span of several hours can spectacularly illustrate the slow sunset or sunrise over the lunar terrain (1 lunar day lasts about 30 terrestrial days!).

Close to the terminator, the contrast and brightness differences are much stronger than for planets. The crater's edge that faces the sun is often very bright, and if you do not want it to be overexposed, you must reduce the gain or the exposure time. The overall image may then look a bit dark, but it is easy to lighten the dark areas while leaving the bright areas intact during processing with curve adjustment (see chapter 7).

The Peculiar Movement of the Moon

In contrast to the planets, whose movement among the stars is slow, the moon is much closer and rotates around the earth in about one month, rising about 50 minutes later each day. Thus, its eastward movement with regard to the stars, although it is only 3.5 % of the sidereal speed, is fast enough to be noticed in a few tens of seconds when you use a telescope set to sidereal tracking rate since that small rate difference amounts to about half an arc second motion per second of time (30 arc seconds per minute of time). This relative motion is clearly visible in a video obtained using a 5-meter focal length and a 1/4" sensor because details pass through the camera's field of view in about 5 minutes when you're tracking at the sidereal rate. Therefore, if you do not want the field of the combined image to be reduced, you have to make small and frequent manual speed corrections or, even better, use a mount with a lunar rate option. Although an average lunar speed is better than a sidereal speed, the best solution is offered by mounts whose speed on both axes is calculated and adjusted to the movement of the moon at the moment of observation. The movement of the moon breaks up into two variable components: one in right ascension and one in declination, the latter being at most one-third of the total movement.

Photographing the Whole Lunar Disk

Photographing the illuminated portion of the lunar disk requires a shorter focal length than for close-ups. Considering the relatively short exposure times, it can be performed with a nonmotorized mount, even though it's more comfortable to use a motorized mount.

A lunar crescent or quarter moon can fit in the large side of the sensor with proper orientation of the camera, while a gibbous moon, a full moon, or the earthshine must fit in the small side. The following table lists, for some common sensor dimensions, the maximum focal length to show the entire moon. The smallest video sensors are handicapped by their small number of photosites. For this task, a DSLR is much more preferable. Thanks to their good field coverage, Celestron Edge HD and Meade ACF telescopes are well suited to this task.

An image of the whole moon can be obtained with more detail, using a longer focal length, if it is made as a mosaic of multiple images (see chapters 1 and 7 for more on making panoramas and mosaics). Acquisition of the images must be performed very carefully, making sure that the adjacent fields overlap and that no part of the moon has been omitted. The number of fields used to make the mosaic is limited only by the diligence and the patience of the amateur!

The thin crescent moon and gibbous moon have less brightness variation between the terminator and the opposite edge than does a quarter moon. For the latter, as for galaxies, using curve adjustments during processing (see chapter 7) may be necessary. During imaging, the exposure time must be chosen so that the brightest parts of the moon are not overexposed.

Large side of the sensor	Lunar crescent or quarter	Gibbous or full moon, earthshine, lunar eclipse
3.7mm	330mm	220mm
7mm	600mm	400mm
10mm	900mm	600mm
15mm	1300mm	900mm
23mm	2000mm	1350mm
36mm	3200mm	2100mm

Focal lengths for the whole moon, depending on the size of the sensor. The figures take into account a margin of 20 % for framing. Note that the smallest sensor (first line) needs a telephoto lens rather than a telescope.

CAN THE APOLLO LUNAR MODULE REMAINS BE PHOTOGRAPHED?

The answer is categorically no. They are much too small and too far away. An Apollo lunar module is 14 feet wide, so a simple calculation shows that, at the distance of the moon, it subtends less than 1/400 arc second. Even the Hubble Space Telescope and the largest telescopes in the world are currently unable to take photographs showing the module or its shadow. But space probes can, if they are close enough to the surface of the moon, as accomplished by the *Lunar Reconnaissance Orbiter (LRO)* in the summer of 2009, which took dramatic pictures where lunar modules and buggy trails are clearly visible

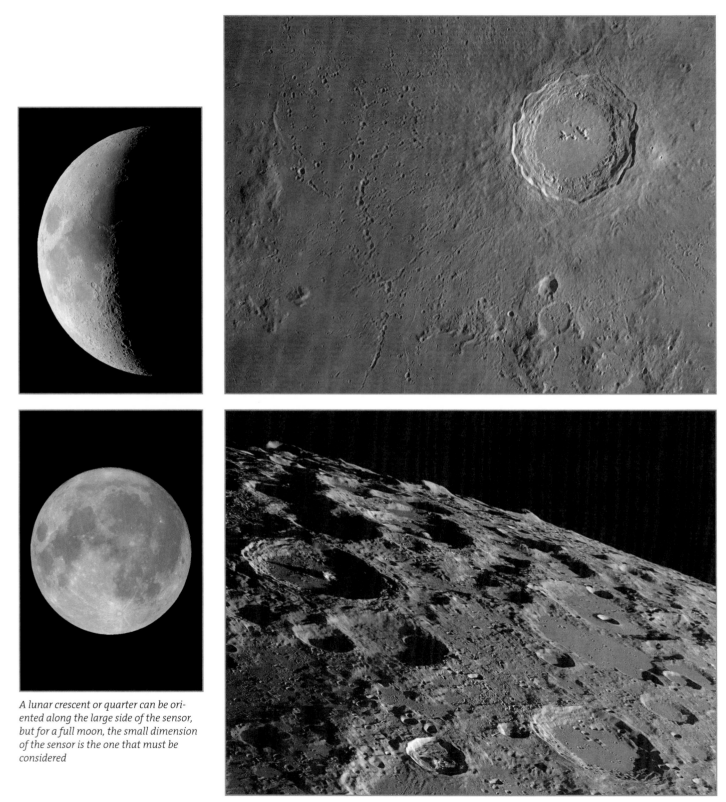

A lunar crescent or quarter can be oriented along the large side of the sensor, but for a full moon, the small dimension of the sensor is the one that must be considered

Lunar close-ups such as these, taken with a video camera and a 14" telescope, need good atmospheric conditions and telescope collimation

The Earthshine

Earthshine is easier to photograph within two to four days of the new moon. Since the dark side of the moon lit only by earthshine is more than a hundred times dimmer than the crescent, an exposure chosen for the crescent will result in the earthshine being dark and noisy, especially if the image is taken in 8-bit mode. The easiest solution is to overexpose the crescent with an exposure time from 10 to 100 times longer, but pay attention to the non-sidereal motion of the moon if your mount does not track it precisely. In practice, try different exposure times until you find the correct one, in which the crescent is not too overexposed and maintains an indented aspect. When processing, lighten the dark side. To improve the signal-to-noise ratio, you can combine several images. Promising results have been obtained with a set of different exposures combined using high dynamic range (HDR) software such as Photomatix.

Lunar Eclipses

A lunar eclipse occurs when the shadow of the earth projects itself upon the moon. The darkened portion is lit only by the solar rays refracted by the earth's atmosphere, giving the moon a reddish hue. Its brightness may vary noticeably from eclipse to eclipse, depending on the configuration of the eclipse and atmospheric conditions. For a partial eclipse, the imaging challenge is even greater than for earthshine: the difference of brightness between the eclipsed part and the lit part is about 10,000 times! As a result, it is impossible to have both areas correctly exposed on the same photograph. Considering the dimness of the eclipsed part, the required exposure time makes a motorized mount mandatory, unless a lens with a short focal length is used. Here too, HDR software gives interesting results if the selection of parameters that adjust the blending of different exposures is well mastered.

Appendix 6 describes how to make eclipse beads from several images taken at regular intervals.

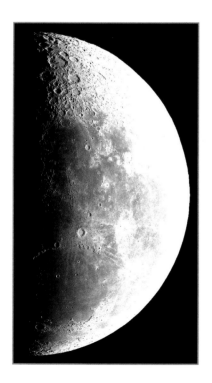 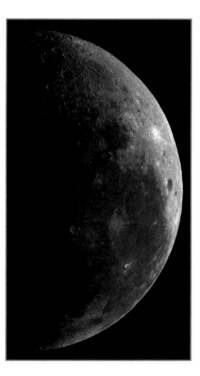 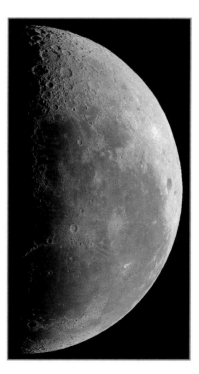

If the exposure time is set for the terminator, the opposite edge may be overexposed (left). On the other hand, if the exposure time is chosen for the opposing edge, the terminator becomes darker (center), but a curve adjustment in Photoshop on this 16-bit TIFF image imported from the astronomical program allowed balancing the high and low brightness levels (right).

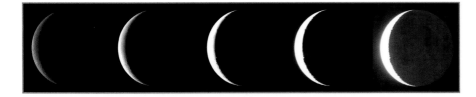

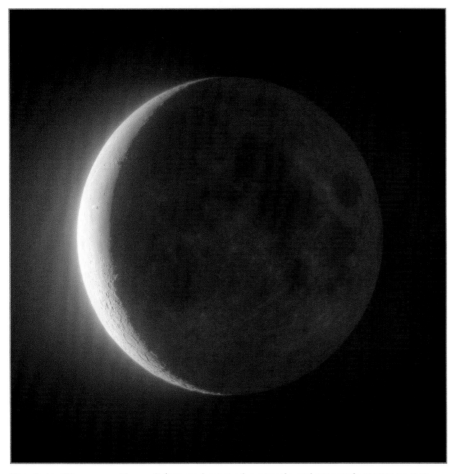

Five shots with exposure times of 1/4 second, 1 second, 4 seconds, and 15 seconds at ISO 200 were combined using Photomatix HDR processing software to obtain an image in which the earthshine is clearly visible without the crescent being overexposed

PHOTOGRAPHING YOUNG LUNAR CRESCENTS

At almost every new moon, enthusiasts try to detect (visually or photographically) the youngest possible crescent moon. It is characterized by its age; that is, the time difference from the closest new moon (a few hours after for the evening crescent or a few hours before for the morning one) and its elongation (angular distance from the sun). The most favorable conditions occur when the atmosphere is transparent and, above all, when the ecliptic makes a maximum angle with the horizon, which is in the evening in the spring and in the morning in autumn. It is at that time that, at equal elongation, the moon is highest in the sky just after sunset or before sunrise. When the elongation is less than 12°, a naked eye search becomes impossible and locating it by using the viewfinder, GOTO mount, or even an image is necessary.

In favorable atmospheric conditions, a 24-hour crescent (in this case 13° away from the sun in the dawn of July 24, 2006) is not too difficult to spot at twilight with a DSLR and a telescope or a telephoto lens

This is the youngest possible crescent, captured for the first time at the exact instant of the new moon on April 14, 2010. I used a video camera equipped with an infrared filter to dim the brightness of the sky (hundreds of times brighter than the crescent) in addition to a GOTO mount precisely aligned the night before for a "blind" aiming at the moon. The crescent moon, positioned only 4.5° from the sun, became visible only after I stacked hundreds of carefully calibrated frames. As with capturing the image of Venus on page 102, I had to implement serious protective measures to prevent sunlight from directly entering the telescope (the black arrow gives the direction of the sun). The image has been colored blue to better illustrate the crescent, whose irregularities are caused by the lunar relief.

Lunar Occultations

Sometimes, the moon masks a planet or a bright star for several minutes or a fraction of an hour. The hidden object disappears on the east side and reappears on the west side. When the planet appears or disappears on the dark side, the exposure time is, of course, the one needed for the planet. On the sunlit side, the difference in brightness between the illuminated portion of the moon and the planet or star may be large, especially for a dim planet occulted by a gibbous or full moon. In this case, the moon may be overexposed a bit. Advance warning of such occultations can be found in astronomical magazines and ephemerides. Occultations are excellent targets for an animated image sequence.

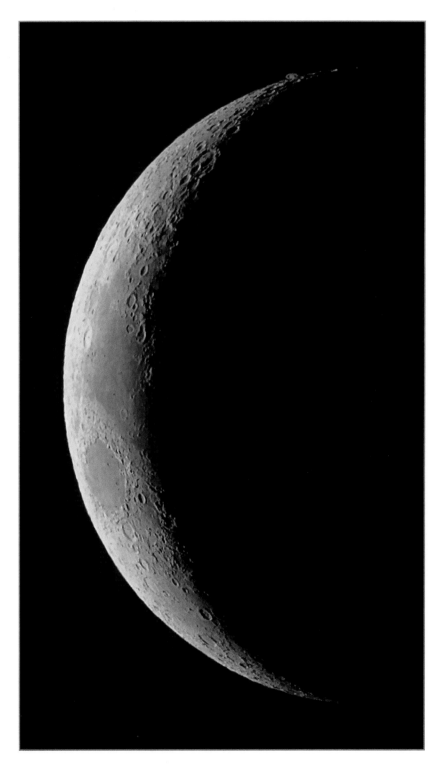

The planet Saturn (at the top of the image, on the edge of the crescent) is actually much larger than the moon, but because it is so far away, it appears tiny in comparison. This image was taken with a compact camera mounted on a 180mm telescope using an afocal attachment.

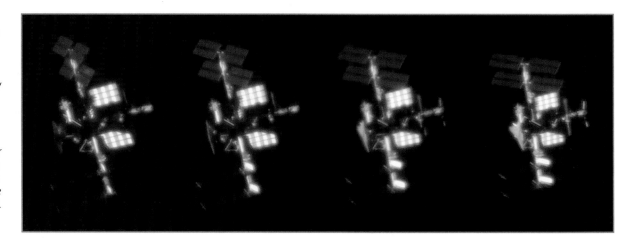

These images of the ISS are taken from a video obtained on February 28, 2011, with a 10" Schmidt-Cassegrain telescope and a monochrome video camera mounted on a Takahashi mount. The mount's electronics were considerably modified by Emmanuel Rietsch for satellite tracking and were used in conjunction with his software, Video Sky (a modification he also performs on EQ-G mounts). At the center left of the ISS, viewed from the rear and docked to the ISS, is the space shuttle Atlantis. Just to its right, astronaut Steve Bowen is on a spacewalk at the end of the ISS articulated arm (triangular structure). When the images are merged in pairs using the cross-eyed viewing technique described earlier in this chapter, the ISS appears in 3D. The solar panels of the ISS are at top and bottom. The large rectangular white checkerboard structures are radiators.

The ISS

The International Space Station (ISS) is the largest orbital object ever built by humans. There are apps for smartphones and many websites (CalSky, Heavens-Above) that predict its passages over your head, which last a few minutes and always occur at dawn or dusk. Its size (including solar panels) is 100 meters, which gives it, given its altitude (about 250 miles, or 400 kilometers), an apparent size larger than Jupiter: almost 1 arc minute at the zenith. Its solar panels are orange but the rest of the structure is white and highly reflective, so the ISS can exceed the magnitude of Venus. The recommended exposure time (to be refined by testing with your specific setup) is on the order of milliseconds.

Photographing the ISS would be easy for an amateur who has learned the basics of planetary photography if it weren't for its apparent movement, which exceeds 1° per second when its height above the horizon is more than 60°. The challenge is therefore to track it with sufficient precision to keep it within the sensor field, at least fleetingly, during its passage. The usual technique is to use a Dobsonian mount (see chapter 7) with smooth and precise hand movements coupled with a cross-hair-equipped high-magnification finderscope perfectly aligned for tracking the ISS visually. The mechanics of the system must be sufficiently reliable so that collimation and focusing (previously performed on a star or the moon) does not vary during the passage. Motorized consumer mounts (equatorial or azimuthal) are unfortunately not well suited to properly track the ISS. They do not have the desired agility, and most of them have only a few fast speed choices even though it is necessary to vary the speed almost continuously between 0°/s and 2°/s (and independently for each axis). As for programmed tracking based on the trajectory of the ISS calculated from its orbital elements (two-line element, or TLE), the precision of polar alignment or computer clock synchronization is not sufficient for photographing the ISS at a large focal length.

Video acquisition (with a video camera or a DSLR) helps to improve the odds of success, but some amateurs also get good results with a DSLR acquiring images in a continuous burst. Of course, the task is made more difficult as the focal length increases or the size of the sensor decreases. I suggest you start at short focal lengths and train on aircraft flying at high altitude (day or night) since they have the same apparent speed as the ISS. As with the planets, combining several successive frames is useful to reduce the noise, but you can use only a small number of them because the orientation of the station changes continuously during its passage. As a result, there is no option to apply the same enhancement processing used in planetary photography, and given the presence of noise and possible artifacts, you must be cautious in interpreting the small details that do seem to appear on the final images.

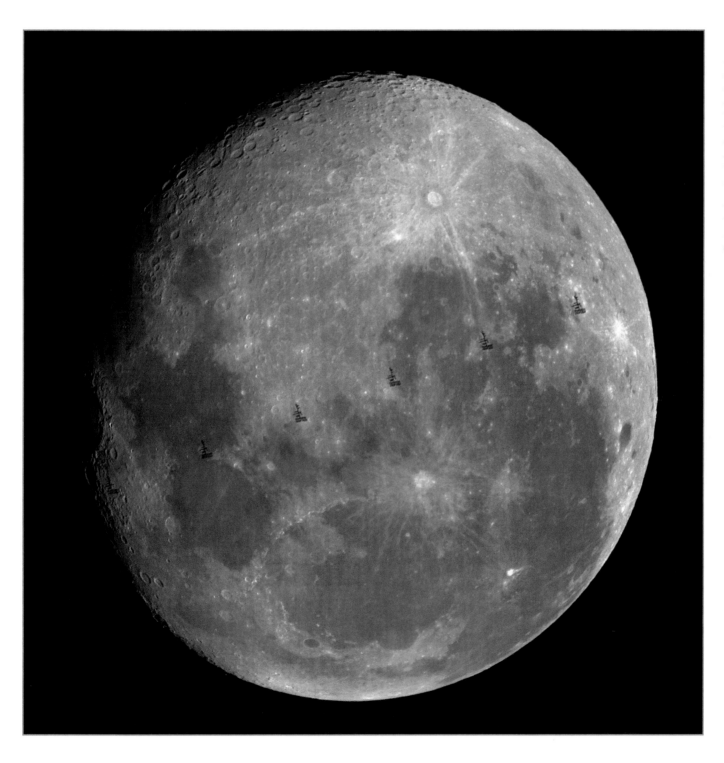

This lunar transit of the ISS was obtained at the prime focus of a 4" refractor using a video camera. Six successive frames were extracted from the video file and combined in the same manner as star trails (see chapter 1), but this time in minimum intensity mode to make the ISS visible in the final image as clearly as in each frame.

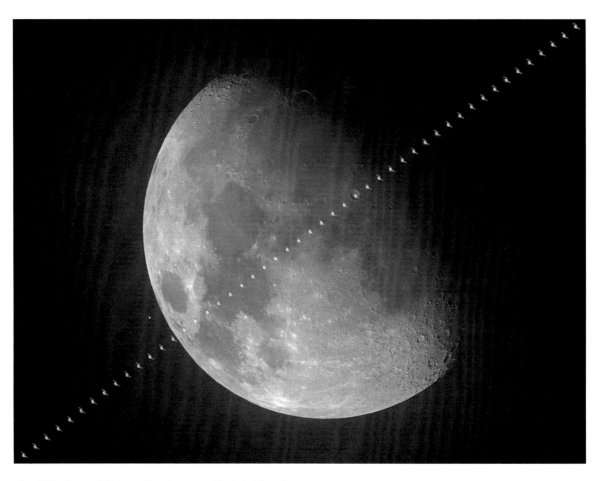

At twilight, the ISS is lightened by the sun and looks brighter than the moon.

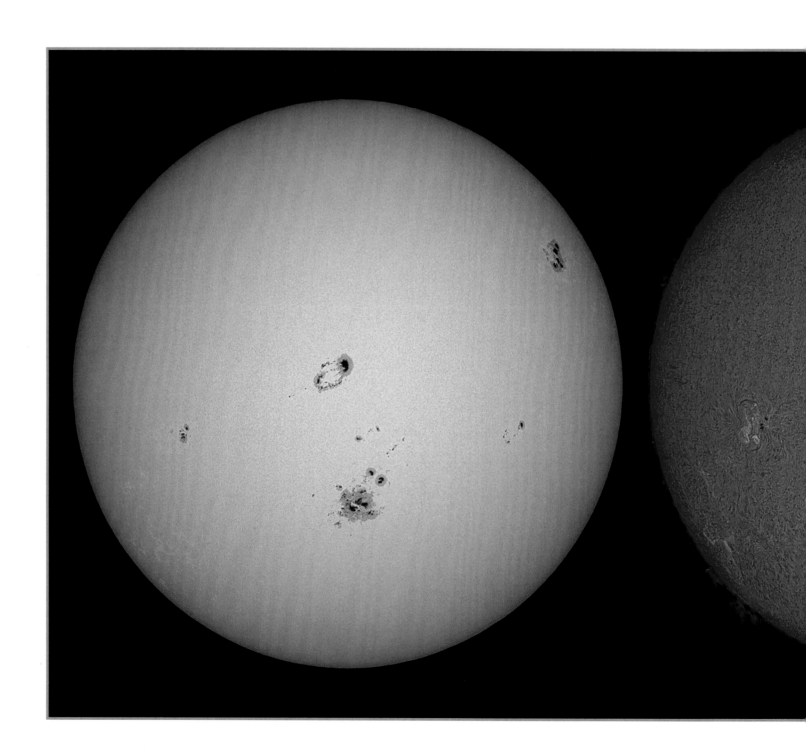

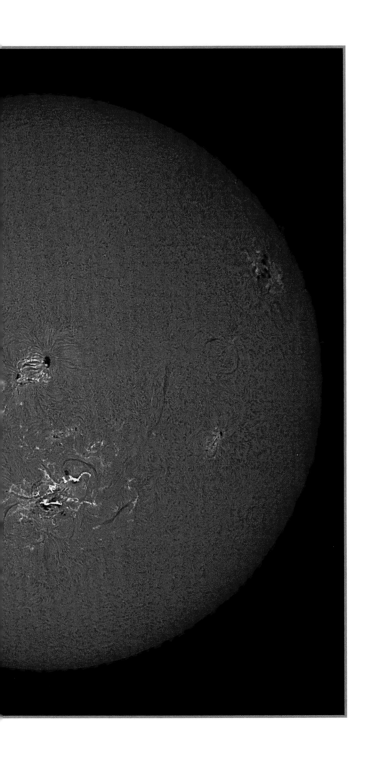

Chapter 6
The Sun

In our galaxy, the sun is an ordinary star. But it is 300,000 times closer to the earth than the second nearest star (Proxima Centauri). And for us, this changes everything: it is the only star on which we are able to photograph numerous and ever-changing details.

On the left, the sun in white light with the sunspots easily visible in the middle of the photospheric granulation, the largest showing a central umbra surrounded by a penumbra. Some faculae (bright spots) are visible around the sunspot group on the right. The image on the right shows a photograph taken at the same moment in Hα light: a bright flare is occurring in an active region.

Astronomers are perpetually dissatisfied. They always complain about the lack of light coming from celestial objects, except for the sun, which they criticize for being much too bright! In fact, the sun is the only object that can be dangerous to photograph, and its luminous flux needs to be decreased by a factor of about 100,000 for safety. Fortunately, the solar filters available to amateurs do that job very well.

These filters can be classified into two types: broadband filters (also called white light filters) and narrowband filters, the most common being the hydrogen-alpha (Hα) filters. The former show the visible surface of the sun with its famous sunspots, while the latter, by isolating the prominent red line of hydrogen, offer spectacular views of the active regions as well as prominences and, when they happen, the violent and quick solar flares. They are more expensive than the broadband filters, but anybody who has observed the sun through one of these filters will not forget the view! For full-disk views as well as for close-ups, solar and lunar photography are quite similar. This chapter, however, will concentrate on their major differences.

The Sun in Broadband Light

The layer of the sun that illuminates us is called the photosphere. Its temperature is about 10,000°F and it shows no color variation. At high power, it appears as a granular surface composed of convection cells with individual sizes of about 600 miles and with a lifetime of only a few minutes. From the earth, the span of a cell is about 1 arc second.

The photosphere also includes the sunspots that appear and disappear according to the variation of solar activity, which follows an average cycle of 11 years. They look dark relative to the surrounding area, their temperature being about 3600°F lower than the photosphere. Sunspots belong to active regions where the movements of matter are dominated by strong and complex magnetic fields. Faculae, small zones slightly hotter and brighter than the photosphere, are sometimes visible along the limb.

Using Broadband Filters

It is often said that an astronomer who would observe the sun without filters would do that only twice in his life: once with the left eye, once with the right eye! An instrument with an aperture of 100mm diameter collects a thousand times more light than the naked eye, light that's sufficient to ignite a piece of wood placed at its focal point.

DO NOT TAKE CHANCES WITH THE SUN!

Improvised makeshift means such as a piece of glass smoked with a candle or an overexposed photographic negative are to be absolutely avoided, whether they are placed in front of or behind the telescope, or binoculars, or the eye. Even if the sunlight seems to be correctly attenuated with one of these devices, the powerful ultraviolet and infrared rays could cause irreparable ocular damage, sometimes quickly, but sometimes in a cumulative manner over time. Note that the retina is not subject to pain and that it is impossible to realize that damage, is in progress. Particularly do not trust overexposed color slide film—the black dyes pass the invisible infrared completely.

Even the small so-called "sun" filters meant to be screwed onto the eyepiece and that sometimes accompany low-end telescopes must be thrown away without regret: they can burst in a few seconds from the heat. I had this experience when I was a child; fortunately my eye was not behind the eyepiece at that moment. Of course, photography presents lower risks but it is often necessary to visually center and focus the camera!

Fortunately, astronomical equipment manufacturers offer different means of filtration, adapted to all telescopes and to all budgets. With these filters, the sun can be observed safely at all hours. Of course, they must be used according to the manufacturer's instructions and handled and secured on the telescope by a person who understands their operation. A solar instrument must be under constant supervision when pointed at the sun, especially when kids or novices are around. In addition, unless it is also equipped with a filter glass of its own, the telescope finder must be blocked. The sun can be centered in the instrument by observing the shadow the instrument casts on the ground.

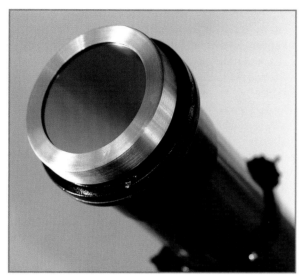

A glass filter in its support. For small telescopes, the filter covers the entire aperture; for larger systems, filters are available in smaller diameters with an off-center mounting.

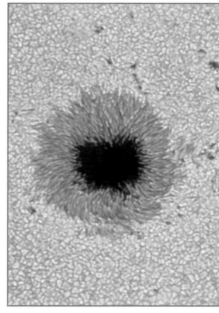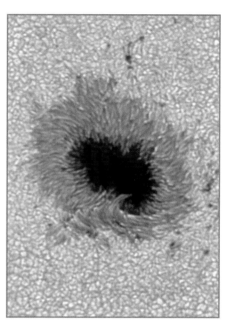

Sunspots photographed with a monochrome video camera and a flexible sheet on a 180mm Maksutov-Cassegrain telescope

The Aperture Filter

There are two kinds of filters that can be placed in front of the telescope: glass filters and flexible sheets.

The former is made from plate glass with parallel and polished faces on which a metallic layer that uniformly transmits only a very small amount of sunlight has been deposited. It is mounted on a circular support whose dimensions must match the external dimensions of the front of the telescope, which is specified when the telescope is ordered. As strange as it may seem, manufacturing a flat glass plate to the precision required in astronomy is much more costly than manufacturing a primary mirror for a Newtonian telescope of similar diameter, for a couple of reasons:

AstroSolar sheet, to be cut and mounted on a homemade support

❯ There are two faces to polish instead of one
❯ The coating is more complex to make because transmitting a small quantity of light uniformly over the surface of the filter is more difficult than reflecting all the light striking a mirror

This explains why quality aperture glass filters are relatively expensive.

The first flexible filter to appear was an extremely thin metallic sheet called Mylar, of the same type used for survival covers, with highly variable quality. Other sheets appeared later, such as black polymer. The AstroSolar sheet from Baader looks like Mylar but possesses a much higher optical quality than most other sheets and even than most glass filters, yielding sharp and contrasty images where the granulation is easily visible. Its performance/price ratio

is unbeatable. It is sold in rectangular sheets that must be cut to the desired diameter and installed, without tightness or folding, in a cardboard mount according to the instruction sheet. Handled with care, it is not especially fragile: I have used some for different instruments and they are fully operational after several years. The sheet comes in two versions; "visual" density 5 (an attenuation of a factor of 10^5 or 100,000) and "photo" density 3.8 (an attenuation of $10^{3.8}$ or 6300). The second is better for photography since it allows shorter exposure times, but it cannot be used visually without a complementary filter (neutral density or narrowband) that can dim the view and eliminate infrared and ultraviolet wavelengths.

The Herschel Wedge

The Herschel wedge, also called a Herschel prism, is not new. I used one in the 1970s on my first small refractor. But the one I use today has few things in common with my first one. Its finish is better, it is heavier and bigger (2" barrel versus 0.96"), and more expensive, several hundreds of dollars more. It looks—and works—like a 2" star diagonal. It accepts 2" or 1.25" eyepieces as well as a Barlow lens or a camera.

It contains an uncoated glass prism inclined so that the reflection from one of its faces transmits about 4% of the light to the eyepiece. The rest of the sunlight is evacuated by an opening on the back of the housing. But 4% is still very dazzling so the image must be dimmed by an additional factor of 1000 to 10,000 using one or multiple neutral filters of different densities, which are provided with the device. One can also use a Baader Continuum filter with an 8 nm bandwidth centered in the green (540 nm) or a narrowband filter primarily intended for photography of nebulae (see chapter 7). The advantage of a narrowband filter is that it reduces the atmospheric dispersion and the turbulence (see previous section). It also improves the image quality obtained with non-apochromatic refractors by reducing their chromatic aberration.

The image quality offered by a good Herschel wedge is even better than for the AstroSolar sheet; the image

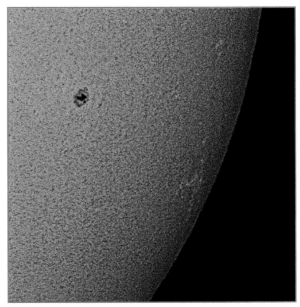

A Herschel wedge comprises a partially reflecting prism and a set of filters designed to attenuate the light transmitted to the eyepiece or to the camera

There are two clues that this image has been overprocessed:
- *As shown in the image on page 116, the solar granulation should fade as it is getting closer to the limb of the solar disk, unlike the behavior of noise*
- *The bright border around the sunspots is the sign of an edge effect caused by overprocessing (see chapter 5)*

is more contrasty because there is less light diffusion. However, they can be used only on refractors; use on a reflector must be avoided. Aperture filters eliminate the excess light and heat before it enters the instrument, but the prism does that near the focus. The secondary mirror of a reflector, subject to strong concentration of the light as it approaches focus, could be damaged. With a refractor, there is no risk for the eyepiece since light goes through it only after it is attenuated by the prism.

A Herschel wedge causes an inversion of the image (mirror image), and another inversion can be easily performed during processing.

Cameras, Imaging, and Processing

Once the question of filtering is resolved, solar and lunar photography techniques are similar. The same recipes work: video for the best details and then followed by processing, which consists of registration, combination, and sharpening. Be careful with the sharpening filters; nothing looks like the solar granulation more than noise enhanced by overprocessing! Photographs of the full solar disk are taken with DSLRs or CCD cameras, following the recommendations of the focal-length table on page 107 (right column, for full noon). A monochrome camera is fully adequate because the sun is colorless. With a color sensor, if the filter presents a dominant color, leave the camera in color mode instead of black and white, and extract the corresponding color channel later during processing.

For solar photography as well as lunar or planetary photography, the dynamic range of the sensor should be employed to the largest possible extent; in other words, the bright parts of the image must be close to the right edge (brighter levels) of the histogram. Outside the atmosphere, this would be naturally obtained with the lowest gain (or ISO) and the longest possible exposure time, for the highest signal-to-noise ratio. However, the exposure time is often shortened to freeze atmospheric turbulence. In this case, since the exposure time is so short, the gain or ISO must be increased so that the brightness range of the image fills the histogram. Of course, the signal-to-noise ratio of each raw image will not be as good. There is no rule that says how to adjust these parameters precisely; it depends on the level of turbulence.

During image acquisition with a video camera, adjust the parameters so that the umbra of the sunspots is not totally black, to ensure that you lose no information or detail. The final adjustment of the black level will be performed during processing.

The Problem of Daytime Turbulence

With solar imaging, there's one challenge you don't see with planetary photography: atmospheric turbulence is, on average, higher during the day than at night due to the heating of the ground by the sun. Therefore, using all of the potential of a telescope over 100mm to 150mm in aperture at a typical site is difficult. A big telescope, especially if it requires frequent collimation, is not the ideal solution for the sun unless you have the patience to wait for rare moments of steady seeing.

Also, although we favor observing planets when they are high in the sky (around the meridian) so that their light comes through a thinner atmosphere, this strategy may not be the best for the sun because a higher sun means higher heating of the ground, especially in summer. Odds are that the seeing is better in the early morning, when the sun is low. But this is only a guess—turbulence is unpredictable!

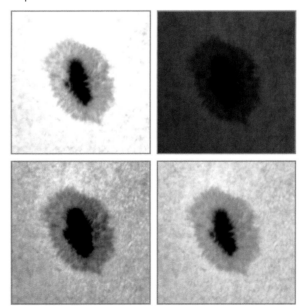

With a video camera, appropriate setting of exposure time, brightness, and gain puts the 8-bit range to best use. Upper left to upper right: image too bright (overexposed), image too dark (underexposed). Lower left to lower right: sunspot umbra too dark, and finally, good settings with no loss at high and low light levels.

The Orientation of Solar Images

When the instrument is installed on an equatorial mount, it is easy to orient the camera so that the sides of the sensor are parallel to the axis of the mount (right ascension and declination). In this situation, the edges of the images align with the celestial equatorial axis but they are not parallel to the solar coordinate system (solar equator and polar axis) because of two factors: the inclination of the solar equator on the ecliptic and the inclination between the ecliptic and the celestial equator at the position of the sun. Thus, depending on the time of year, the angle between the polar axis of the sun and the celestial vault varies from −26° to +26°. Ephemeris data, found on specialized websites or certain planetarium programs, give this angle, often called the *P angle*. The convention is that it is considered positive when the solar north pole is turned eastward.

For example, you may need to know the orientation of the solar axis to determine the solar latitude of a sunspot group and then identify the solar activity cycle to which it belongs. If you need to orient your image according to the solar angles and if you use an equatorial mount, the simplest solution is to orient the camera according to the celestial axis (north up) and, at processing, rotate the image by the P angle. If the mount is azimuthal, the angle between the ecliptic and the horizon must also be taken into account in the correction.

This image has been obtained with the camera oriented along the axis of the equatorial mount. At the moment of shooting, the P angle was +6.9°.

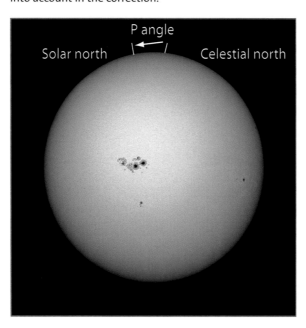

P angle

Solar north Celestial north

The Sun in Hα

You will see in chapter 7 that the light called hydrogen-alpha (or Hα) is emitted by ionized hydrogen gas and is deep red at a wavelength of 656.3 nm. This light occupies a unique place in the nebular photography. For the sun too, this wavelength is of great importance: it shows the chromosphere, the layer just above the photosphere. It is very thin, only 1500 miles. The active regions are still visible, the shaping of the movements of matter by the magnetic fields being especially spectacular. Sometimes, a colossal release of energy (a solar flare) occurs inside one of these regions and appears as bright spots or filaments; its duration rarely exceeds 30 to 60 minutes.

The Hα wavelength also renders visible the well-known prominences. Most of them can be classified into two types:

❷ Quiescent prominences (the great majority) are condensations of solar matter denser and cooler than the atmosphere where they form (the corona). They are relatively stable and can last hours, days, or even weeks, evolving slowly and finally vanishing.

❷ Eruptive prominences are brutal ejections of matter coming from flares. They are brighter than quiescent prominences, their lifetime is shorter (usually only several minutes), and their evolution is fast. They sometimes show morphological changes in a few seconds.

The quiescent prominences absorb and diffuse the light. They look bright when they are seen at the limb, against the sky background, but they are actually darker than the chromosphere. When they are seen against the solar disk, they look dark and are called *filaments*.

The number of active centers, flares, and prominences are, on average, higher during periods of maximum activity that last several years and recur every 11 years. However, in more than 20 years of Hα solar observation, I have never once seen the sun completely without prominences.

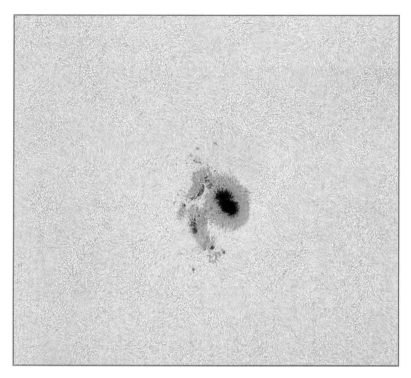

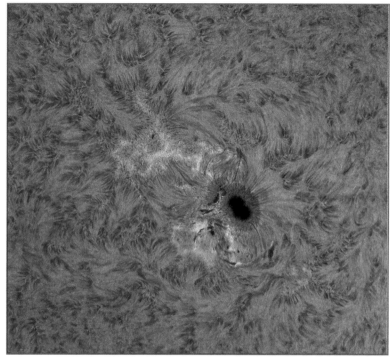

Close-up of active regions, on the left in white light and on the right in Hα. These regions are generally much larger in Hα.

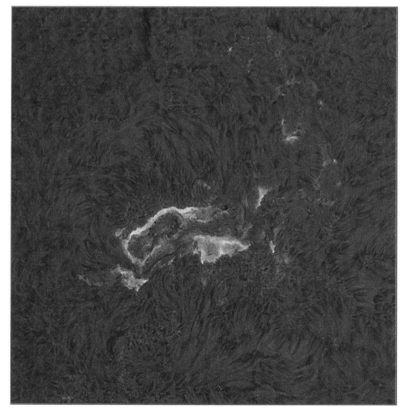

On the left, a solar flare spreads out more than 125,000 miles. On the bottom, the flare visible on the photograph on page 116 was also discernible in white light, a very rare event.

A giant quiescent prominence rises up to 155,000 miles over the chromosphere

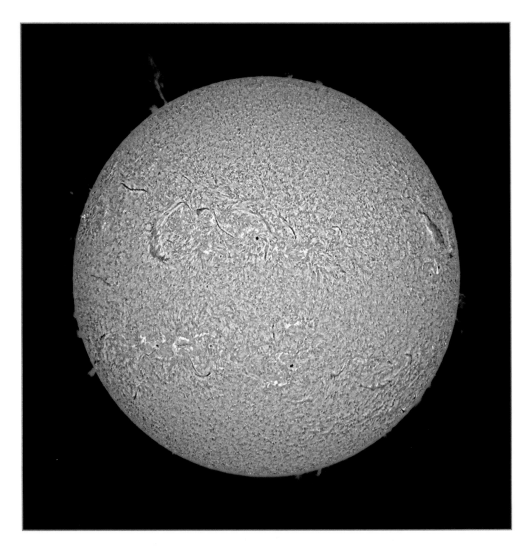

The Hα Interference Filter

Both a broadband filter and an Hα filter eliminate nearly all the sunlight but not in the same way. The former dims all wavelengths equally, while the latter rejects all of them except for a very narrow band of wavelengths centered on Hα. Therefore, the filtering mechanisms are completely different and are much more complex (and costly!) for the Hα filter.

In chapter 7, I will discuss Hα filters used to photograph emission nebulae, which have a passband of wavelengths they transmit 3 to 20 nm wide. But, to reveal the chromosphere and the prominences, you need a filter with a much narrower bandwidth, about 0.1 nm. For such filters, the manufacturers even specify their product in angstroms (Å), 1 Å being 0.1 nm. To summarize, an Hα filter for deep-sky photography and an Hα filter for photographing the sun are different and not interchangeable.

The bandwidths of filters available for amateurs are between 0.3 Å and 1 Å, the price increasing with the narrowness of the bandwidth. At 1 Å and wider, the prominences are easily seen at the limb, against the black sky background, but the chromospheric structure is barely or perhaps not even discernible. As the bandwidth narrows, this

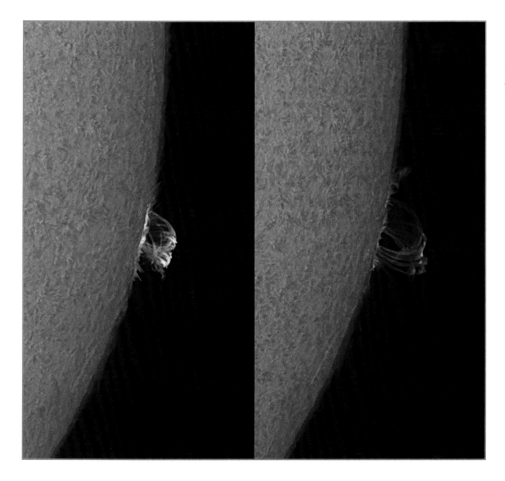

The magnetic loops are well seen in this eruptive prominence that evolved quickly. The thin fringe at the edge of the solar disk is the chromosphere.

structure and the active centers become more evident and the magnetic structures more contrasty, the prominences remaining visible even if some lose a bit of brightness.

All Hα filters available are composed of two elements that are inseparable and sold together, one for the aperture of the telescope and the other for the eyepiece end. They are adaptable to most types of instruments except for Newtonians; the focus can no longer be reached when they are added to Newtonians.

Two technological solutions currently exist that give similar results. Lunt and Coronado offer optical elements to be installed on a personal telescope and also complete sets for observing the sun. The element at the front of the instrument (the *etalon*) is the most sophisticated and most expensive. It is paired with a *blocking filter (BF)* near focus whose role is to isolate the only interesting wavelength of those transmitted by the etalon.

Other manufacturers (DayStar, Solar Spectrum), place the etalon at the exit of the telescope, just in front of the eye or the camera, and the focal ratio at this point must be between 25 and 30. This ratio can be obtained with a Barlow lens or, preferably, a telecentric device such as the Baader TZ-2 or TZ-4 (magnification of 2 and 4, respectively), producing a more uniform field. A glass filter called an *energy rejection filter (ERF)*, whose color is red or yellow, should be placed at the front of the instrument to protect the etalon from the sun's heat. Note that the ERF cannot be replaced by a white light filter such as AstroSolar film since the Hα wavelength must be transmitted without any attenuation.

The bandwidth of a solar Hα filter is so narrow that its position in the spectrum shifts according to its temperature and may even exclude Hα if too hot or too cold. To compensate for this effect, the most common solution

Two Hα filters ready to be installed on telescopes, respectively DayStar (top) and Coronado (center). On the bottom. a special-purpose telescope for the observation of the sun: the PST from Coronado.

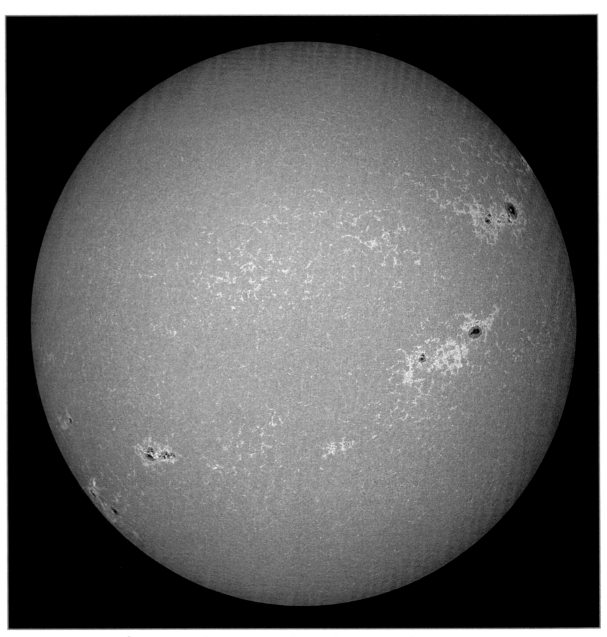

Image taken with a Lunt 3 Å Calcium K-line filter on a 106mm refractor. Solar structures and active regions show good contrast through such a filter.

is to slightly incline the etalon with a manual knob, the adjustment being correct when the contrast of the chromosphere is maximal. On some models, manufacturers maintain the filter in a constant temperature chamber with a thermal control system or adjust the optical thickness by enclosing the etalon in a chamber with adjustable gas pressure.

The Calcium K Filter

Hα is not the only interesting wavelength on the sun. The Calcium K (CaK) line, which is in the ultraviolet at 393.3 nm, shows a contrasty region between the photosphere and the chromosphere. On these images, active centers and flares are visible, the prominences being much dimmer than through an Hα filter. The filter is composed of one element with a bandwidth of several Å, placed before the focus. Since this wavelength is almost invisible to the eye, the filter is typically used for imaging with a monochrome sensor.

Cameras, Imaging, and Processing

As with nebulae (see chapter 7), color sensors are not well suited to Hα. Indeed, only one photosite of four receives it. Moreover, even red photosites show a low sensitivity at this wavelength, due to the infrared-blocking filter in the camera. Finally, a color sensor typically gathers 20 times fewer photons than a monochrome one! Thus, the difference in terms of sharpness and signal-to-noise ratio can be considerable. Even if Hα images can be occasionally obtained with a color sensor, it is in the interest of the amateur who wants to follow solar activity and to regularly take solar images to use a monochrome one.

It is not uncommon to see interference fringes on Hα images. They take the appearance of intensity variations in large stripes, more or less rectilinear, and they are due to optical interference in the sensor and its protective glass filter. For reasons that are unclear, they appear with some filter/sensor combinations and not with others. Slightly tilting the camera may help to solve the problem. If this does not work, a good flat-field (see the sidebar "The Solar Flat-Field" later in this chapter) provides another solution.

Top left to top right: RAW image from a color video camera and then with the red channel extracted from the previous image

Bottom left: RAW image taken with a monochrome video camera (the sharpness and the contrast are higher, with an exposure time four times shorter).

Bottom right: The color camera has been set to black-and-white mode. The image is dark and the contrast is low; the red channel was averaged with the blue and green channels where there is...nothing.

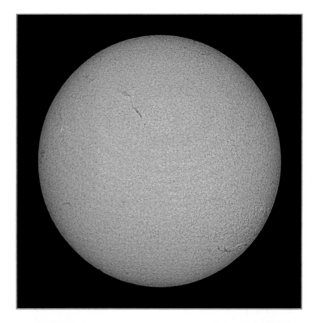

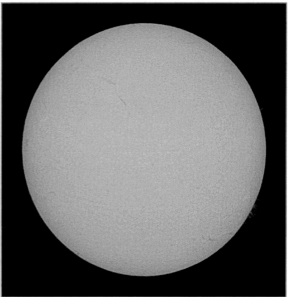

These red channels from images taken with a DSLR show that RAW format (on the top) is preferable to JPEG (on the bottom) for the sun too. The JPEG compression affects primarily the color component of the image (its chrominance) and is particularly damaging in Hα.

 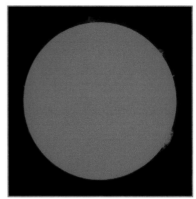 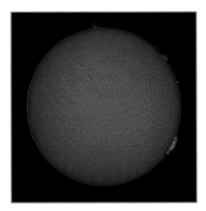

For the image on the left, the exposure time was set for the disk: the prominences are very dim. For the image in the center, the exposure time was multiplied by four: the prominences are correct but the disk is overexposed. The center image was copied in Photoshop as a layer on top of the left image to create the third image on the right. The disk was erased with the circular eraser (with a diameter equal to the solar disk). With a DSLR, this combination can be made from a single image exposed for the prominences by employing the trick of using the green channel for the disk image because this channel is partly sensitive to Hα.

Disk or Prominences?

Seen visually through an Hα filter, the prominences and the disk are visible simultaneously but the former are significantly dimmer than the latter, and this difference is obvious in photographs. Therefore, a good exposure time for a prominence leads to an overexposed disk, and a good exposure for the disk leads to dim prominences. So, to produce an image in which the disk and the prominences are well balanced, you need to do some processing. One method consists of selecting the external zone of the disk, a very simple operation with consumer programs such as Photoshop, with color range selection functions. Then, the external zone is brightened with the help of curves or levels adjustments.

Another method consists of using selections and layers to combine two images of different exposure time, one for the prominences and one for the disk. The general principle is to copy the image with the prominences as a layer on top of the image of the disk and to erase (with the eraser or the color range selection) the overexposed central part of the top layer. The main challenge is to obtain a transition between the disk and prominences that does not look too artificial.

Colorization and Animations

The images taken with a monochrome sensor are naturally in black and white; with a grayscale image, the details are easier to perceive on the screen. But numerous amateurs prefer, for aesthetic reasons, a solar image with color. This is easy to achieve. In your processing program, display the image in color mode with 16 millions colors and adjust the curves or levels of each RGB channel. If true color is desired, the color of Hα light should be pure red, but this color is not satisfying on a screen or when printed, so a more orange or yellow tint, increasing to white for the brighter areas, usually looks better. To obtain this look, you must suppress the blue component totally and the green component partially; the photographs on pages 123 and 125 have been rendered this way.

There are many ways to colorize a solar monochrome image, such as adjusting the levels in Photoshop and, more specifically, playing with the midtones input level. You can keep the value 1 for the red layer and use green and blue channel values of 0.7 and 0.1, respectively. The solar disk assumes an orange tint with more or less saturated color, the brightest areas turning white.

The sun is certainly the best subject for animations and movies, described in chapters 1 and 5. For slowly changing prominences, an interval of several minutes between the images is generally satisfying, while tens of seconds may be better for flares.

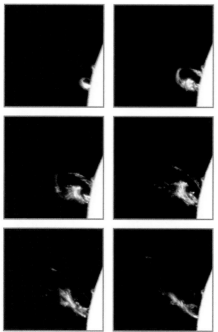

Six images of a fast flare, taken in 4-minute intervals

To assemble the two components of a mosaic, open them in Photoshop and enlarge the working area for each component so that it largely covers the field of the final assembly. Then copy one over the other as a new layer and put Photoshop in Difference mode. With the Move tool, shift one image until the common area they share becomes as dark as possible (some noise should remain). Then change the layer to Lighten mode. If the transition remains visible (a common effect caused by small variations of atmospheric transparency during the exposures), play with the curves and levels of one of the layers.

THE SOLAR FLAT-FIELD

Taking flat-field images is one of the challenges of solar photography. When you're capturing video with a small sensor, vignetting is generally invisible and flat-fielding is unnecessary if the sensor is clean. However, if narrowband images show interference fringes, flat-fields may be the only way to solve the problem. When a broadband aperture filter is used, it can be simply removed and the telescope aimed toward a cloud, a white wall, or any white screen.

With a Herschel wedge or an Hα filter, the situation is more difficult because you cannot expect a realistic flat-field if they are removed. One solution is to strongly defocus the instrument (although it is usually not advised for flat-fielding) and take several shifted images or a video sequence of the center of the solar disk. Another solution consists of gently shaking the telescope with the hand during the short video sequence that will be used to make the master flat-field in order to blur the undesirable small solar details.

Mosaics

If the sensor is too small to cover the whole solar disk, you can extend the field by creating a mosaic of images taken successively while focusing on various areas of the subject. When shooting, check that there is an overlap of a few dozen pixels between all zones that will connect. Each image in the mosaic should be processed identically, as described above. You can try to assemble them using a panorama program (PTGui, AutoStitch, AutoPano, etc.), but these programs don't always accurately interpret the structure of a solar image in front of a dark background. Therefore, using Photoshop or another image editing program, you may need to manually align the images and adjust the brightness so all the images appear consistent.

Solar Eclipses

A partial eclipse or an annular eclipse is photographed using the same techniques as used for the non-eclipsed sun when using a broadband filter or an Hα filter.

Photographing the Sun during a total eclipse is completely different. During this fleeting, breathtaking moment, the solar disk is completely masked by the new moon and only the solar corona is visible, with pink prominences around the edge. If one of the filters described earlier in this chapter had been used before totality, it must be removed for this phase, which is not dangerous for the eyes. In practice, considering the briefness of totality,

using an aperture filter rather than a Herschel wedge or an Hα filter is the best solution for the partial phases since the instrument can be quickly modified to work without a filter (focus does not change when an aperture filter is removed or replaced). To avoid the complexities of tracking, use an equatorial mount that has been polar-aligned the night before the eclipse if possible.

The totality phase is the only occasion for observing and photographing the solar corona. Photography of the corona is difficult because its structures are quite tenuous and exhibit a tremendous range of brightness; while comparable to that of the full moon at the edge of the solar disk, the brightness decreases quickly with radial distance from the edge. It has probably the greatest brightness variation of any celestial object and obtaining an image that looks like what we see with the naked eye or with binoculars is almost impossible. Of course, a single image cannot record the entire corona. Several must be taken with increasing exposure time, each showing a part of the corona that is not overexposed or underexposed. These images must then be combined using layers, following the method described earlier for Hα images.

Another difficulty arises from the fact that the images must be registered beforehand, but there is no easy reference for registration; the black disk of the moon moves during the eclipse with respect to the sun and its corona! An HDR program is a good solution for total eclipses if it is able to register the images and accommodate their huge brightness variation.

The focal length in the table on page 107 should be divided by a factor of 2 to 10 to give a field of view sufficient to include the corona, depending on the limit of the corona you wish to reach. For the outer corona, a motorized mount is needed.

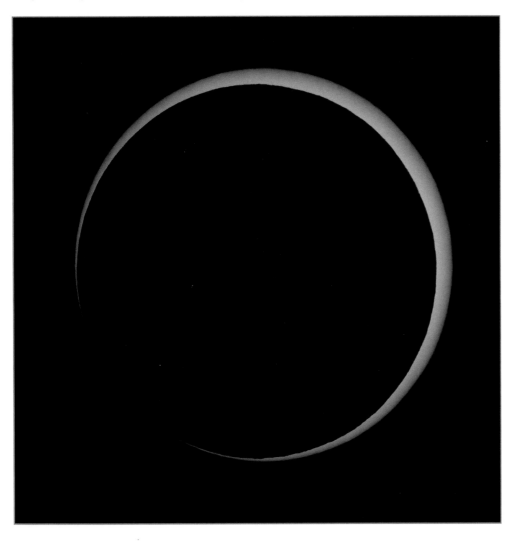

The annular eclipse of October 3, 2005, taken from Spain with a refractor and a Herschel wedge. Such an eclipse is just a special case of a partial eclipse. At the precise moment of third contact, a depression in the lunar topography shows a very thin arc of the solar disk.

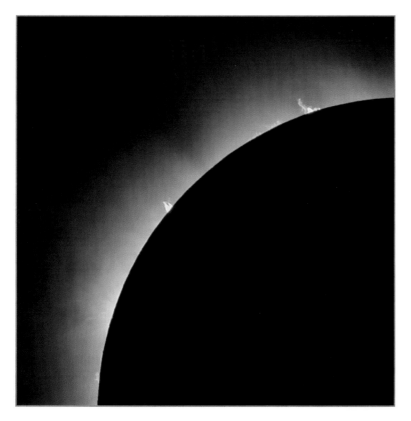

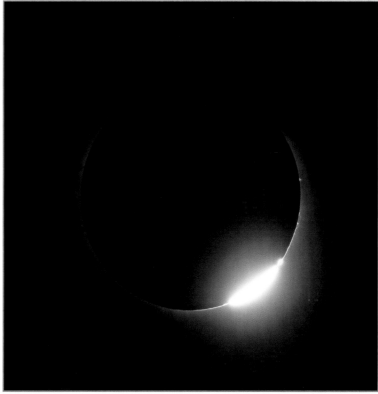

Part of the corona	Relative brightness
Prominences	4
Inner corona	1
Corona at 0.5 solar radius	1/15
Corona at 1 solar radius	1/60
Corona at 4 solar radius	1/250
Corona at 8 solar radius	1/1000

Relative brightness of the different parts of the corona, whose distance from the solar edge is given in solar radius units. For your preliminary tests, you can assume that the inner corona and the full moon have a comparable brightness.

The phenomena known as Baily's beads and the diamond ring, visible for very short moments when small portions of the solar disk appear through lunar limb depressions, can be photographed with the same exposure time (or shorter) as prominences.

PLAN AND REHEARSE YOUR IMAGING

A total eclipse lasts only a few minutes and is accompanied by an atmosphere of extreme excitement and feverish activity. To have a chance of success, your exposure sequences must be carefully prepared and rehearsed again and again in conditions as close as possible to those of the eclipse (including the darkness of totality!). They must be automated as much as possible to allow you some additional moments of visual contemplation.

In general, for any rare and/or short event such as an eclipse, an occultation, an intense meteor shower, or a transit, make preliminary tests, use equipment that you know very well, and practice. I have photographed eclipses several times; such astrophotography and last-minute improvisation do not go hand in hand!

An exposure time equal to that used previously for the full moon, with the same equipment, shows the inner corona and prominences and, when the last solar rays disappear (or reappear), Baily's beads and a part of the chromosphere. Eclipse of March 29, 2006, photographed from western Egypt.

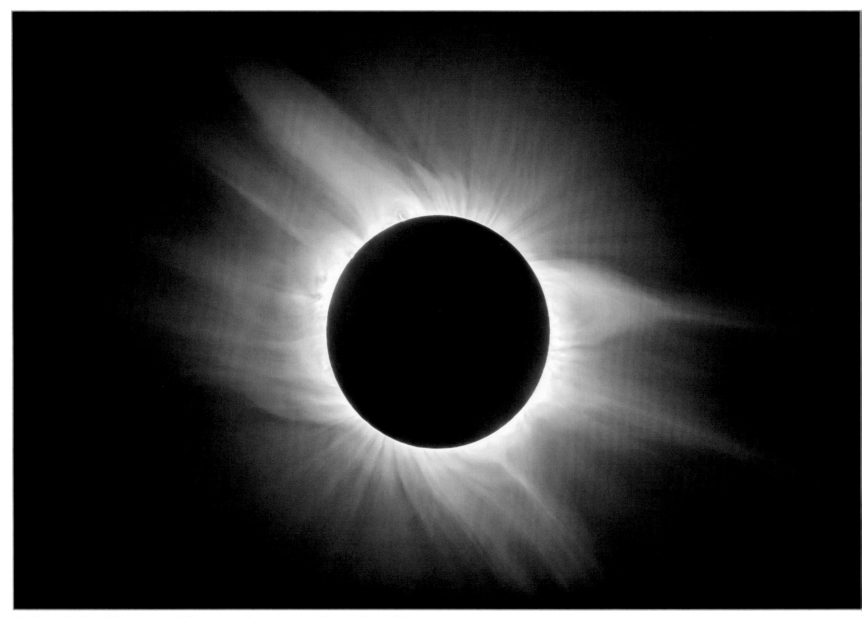

For the total eclipse of March 29, 2006, five images of exposure increasing by a factor of four per step (1/250, 1/60, 1/15, 1/4, and 1 second) were combined with HDR processing to produce this wide dynamic range view of the solar corona. The earthshine on the moon also can be seen. The HDR program Photomatix was used to register the images before they were combined.

Solar Transits

Of all the planets, only Mercury and Venus can pass in front of the solar disk as seen from Earth. Their transits generally last several hours. Photographing transits requires no special techniques compared to normal solar photography. Again, spectacular animations can be achieved.

Venus made solar transits in June 2004 and June 2012. The next will take place in 2117 and 2125. Those of Mercury are more common, on average 13 per century. The next transit will take place on May 9, 2016, and November 11, 2019. After that, you must wait until 2032 or 2039.

The ISS also transits the sun. The visibility of a solar or lunar transit of the ISS is similar to that of a total solar eclipse: in both cases, the event is visible only from a narrow strip of land running across part of the earth. These conditions are even tighter than a solar eclipse, the width of visibility not exceeding 10 miles (it may even fall under 3 miles). Fortunately, transits are much more frequent (see the sidebar "Where to See a Solar Transit?"). The durations of these transits are also much shorter than those of solar or lunar eclipses: the shortest are less than half a second. The reason is that the ISS really whizzes along, with a speed bordering 5 miles per second (about 17,000 miles per hour), completing one orbit of the earth in just 95 minutes.

WHERE TO SEE A SOLAR TRANSIT

The orbit of the ISS is inclined 51.6° to the equator. This means that the areas around this latitude, such as Canada and the northern part of the United States (as well as northwestern Europe: France, the United Kingdom, Germany, Belgium, and the Netherlands) are especially favored with frequent twilight passages of ISS and many solar and lunar transits. From Minnesota, for example, you can view a hundred solar transits per year. But from an area similar in size located near the equator, like Singapore, you can view only about 30 solar transits annually.

The Characteristics of a Solar Transit

The characteristics of a solar or a lunar transit are directly related to the altitude of the sun above the horizon: the higher the sun in the sky, the shorter the transit duration, the narrower the band of visibility, and the larger the apparent size of the ISS.

The following table shows, for a given altitude of the sun, the transit time, the width of visibility on the ground, and the apparent size of the ISS (including solar panels). The figures are approximate; the precise values vary from one transit to the next. For example, if the width is 4 miles, you must be positioned within 2 miles of the centerline to see the transit. In practice, to capture a transit with a duration close to the maximum possible, you need to be less than 1 mile from the centerline.

The transit of Mercury on May 20, 2001, photographed from France in Hα. The planet is the small black spot in the lower-right part of the solar disk.

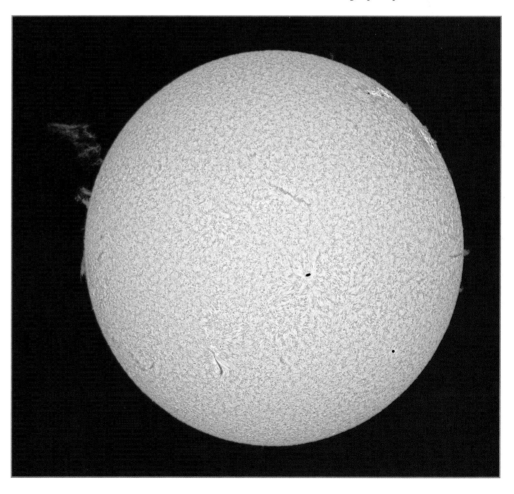

Altitude above horizon	Maximum duration of transit	Total bandwidth of visibility	Apparent size of ISS
60°	0.5 s	3 miles/4.7 km	45"
45°	0.75 s	3.5 miles/5 km	40"
30°	1.5 s	4.5 miles/7 km	30"
15°	2.5 s	6 miles/10 km	20"

The observation of a transit is never the result of chance. It requires a mobile observer who can be in the right place at the right time. Of course, you can wait for a transit visible from your backyard, but given the narrow width of the visibility band, you will enjoy only one or two solar transits per year—if the weather is favorable and you are available at that moment! The search for a suitable location around a town or a village where you've never been and to which you may never come back, is in my opinion also part of the adventure, although this search is not as easy as you might imagine because you need to avoid highly urbanized or wooded areas as well as private property. Once set up, you may be visited by walkers, neighbors, or even policemen puzzled by your equipment. Keep this book with you; it will help to explain what you are doing there.

Fortunately, you do not need to struggle with complex orbital calculations; calsky.com fully supports them for you (see the sidebar at right), detailing specific places and moments for the chosen transit.

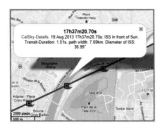

Monday 19 August 2013

Time (24-hour clock)	Object (Link)	Event
17h37m20.47s	ISS	Crosses the disk of Sun. Separation=0.050° Position Angle=294.5°, Position angle vertex=250.8°. Transit duration=1.49s Angular diameter=37.0° size=109.0m x 73.0m x 27.5m Satellite at Azimuth=255.5° WSW Altitude= 30.9° Distance=747.6 km In a clock-face concept, the satellite will seem to move toward 0:38 Angular Velocity=20.9'/s Centerline, closest point →Map: Longitude= 4°49'34"E Latitude=+45° 46'33" (WGS84) Distance=0.70 km Azimuth=335.2° NNW Path direction= 65.3° ENE ground speed=8.586 km/s width=7.7 km max. duration=1.5 s Orbit source: NASA predicted orbit
22h30m40.52s	ISS	Close to Moon. Separation=6.744° Position Angle=34.3°, Position angle vertex=57.4° Angular diameter=34.7° size=109.0m x 73.0m x 27.5m Satellite at Azimuth=140.5° SE Altitude= 27.9° Distance=796.1 km (in shadow) In a clock-face concept, the satellite will seem to move toward 7:05 Angular Velocity=19.5'/s Centerline, closest point →Map: Longitude= 5°16'16"E Latitude=+46° 51'25" (WGS84) Distance=125.43 km Azimuth= 15.5° NNE Path direction=127.8° SE ground speed=9.065 km/s width=16.7 km max. duration=1.9 s Sun elevation=-16° Elongation from Sun=162° Orbit source: NASA predicted orbit

As seen above, CalSky provides two transits for my choice of date (August 19, 2013) and place (the center of Lyon, France). The first solar transit will be visible directly from that location with a visibility width of 7.7 km and the ISS an apparent size of 37". Transit duration at this point is 1.49 s, near the maximum of 1.5 s at the center of the band, which is very close (0.70 km). The second is a lunar transit visible from a band 16.7 km in width, 125 km to the north-northeast (NNE) of the selected place, and lasting 1.9 s. It is nighttime (the sun is 16° below the horizon) and the ISS will appear in silhouette as it is in the shadow of the earth. On the left is the map of the centerline of the solar transit.

Equipment and Settings

Photographing a solar transit requires the same precautions as conventional solar imaging. Given the brevity of the transit, a flexible sheet solar filter or a Herschel prism is an interesting option. Indeed, one of the challenges of transits is the huge apparent speed of the ISS: more than 1° per second as it passes across the zenith. It is therefore necessary to freeze the movement with a very short exposure time so it doesn't appear blurred in the photo, possibly less than 1/1000 s. Even with such short exposure times, the ISS will move several arc seconds. For a maximum duration of transit (D, on the centerline), the blur (B) for an exposure time (T) is, in arc seconds

$$B = 1900\,\frac{T}{D}$$

For example, an exposure time of 1/2000 s causes, for a transit time of 0.5 s, a blur of 1.9 arc seconds. This value is to be combined with the sampling (see chapter 4) to convert it to pixels.

Whatever the type of instrument or camera, the focus must be set, in advance, on the sun itself (either on sunspots, if present, or on the limb). Fortunately, good focus on the sun is also good for the ISS, given the altitude at which it orbits.

The brevity of a transit inevitably raises a difficult question: how and when do you trigger the photo? Waiting to see the ISS biting into the edge of the sun is a risky game that is likely to end in a burst of nasty language, even with a DSLR (and I'm not talking about compact cameras, which generally trigger shooting a good second after pressing the shutter button). ISS transits have one thing in common with the solar eclipses: the last second stress before the fateful moment! A less risky alternative is to use the DSLR in burst mode. In this regard, all cameras are not equal: in RAW mode, the high-end Nikon D4 works at 10 frames per second for 10 seconds, while the modest Canon 1100D operates at 2 frames per second for 3 seconds (at least with fast memory cards; with entry-level ones, performance may be slower). In JPEG mode, images are of lower quality but the bursts are much longer, almost unlimited on many cameras. A burst of 4 seconds leaves little margin for error: it must be initiated 2 seconds before the calculated transit time, and to do this, you need a precise time reference, such as, for example, a DCF77 radio-controlled

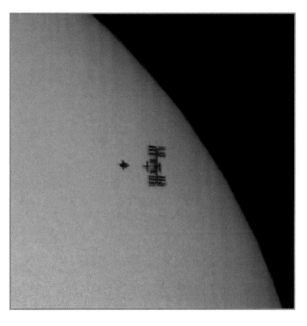

It was in the region of Madrid, Spain, that I found weather on May 16, 2010, that allowed me to get this simultaneous transit of the ISS and the space shuttle Atlantis, *a few tens of minutes before docking, during the STS-132 mission. This is an exposure of 1/8000 s with a Canon 5D Mark II on a 150mm apochromatic refractor with a Herschel prism and neutral filter. Transit time was 0.5 s.*

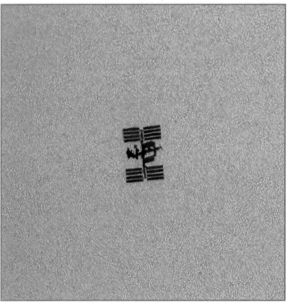

Six days later, in Switzerland (Berne), atmospheric conditions were especially favorable to imaging Atlantis *docked to the ISS (on the left, between the solar panels).*

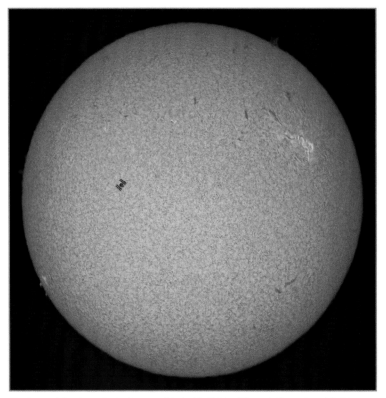

The ISS is by far the largest artificial satellite ever built (and it will certainly hold that record for a long time). For the moment, far behind in terms of size, the Chinese space station (Tiangong) is visible from all latitudes below 45°, but unfortunately its orbital data is currently not known as precisely as the ISS. Next comes the Hubble Space Telescope, with a length of 44" and an average altitude of 360 miles (maximum apparent size 6"), visible only from latitudes under about 30° due to the lower inclination of its orbit on the equator. There are also various spy satellites similar in size and altitude to Hubble, most notably the US Keyhole and Lacrosse satellites. Their transits would be visible from most inhabited areas on Earth, but their orbital data is much too imprecise to predict a transit. As for geostationary satellites, their small size and high altitude (22,300 miles) gives them an angular size less than 1/10 of an arc second, making them completely invisible during a solar or lunar transit.

Photographing transits is also possible in Hα light, although the reduced light transmission of this type of filter is not consistent with a very short exposure time. With this type of equipment, forget DSLRs (too insensitive to the Hα line except with a modified anti-IR filter, as described in the next chapter) and instead use a monochrome video camera. This image has been colorized during processing.

watch (Casio) or clock. A GPS is recommended to find a suitable observation site and check that it is well within the band of visibility, but as surprising as it may seem, consumer GPS units do not indicate the time accurate to 1 second.

It is also possible to use a DSLR in video mode or an astronomical video camera. You will have a lower resolution (1 to 2 million pixels against 10 to 20 million), but you will solve the problem of triggering by launching the video capture tens of seconds before the scheduled transit time. First set the exposure time and then adjust the ISO sensitivity (or gain in video) so that the image has sufficient brightness on the screen without reaching saturation (check the histogram). Be aware that the higher the gain (or ISO), the stronger the noise in the image and the less effective the processing that can be applied afterwards

(especially sharpening using the unsharp mask technique, or using wavelets). Of course, stacking several images is, in the case of transits, impossible.

The photography of lunar transits is similar in many ways with that of solar transits. Calculations by CalSky are equally reliable, and the usable cameras are the same (video cameras or DSLRs in burst mode or in video mode). Here too, but even more crucial than for the sun, is the problem of extremely fast movement of the ISS, which forces us to use a very short exposure time and, consequently, to increase the ISO or gain setting more than we would like, especially during a lunar phase far from full moon. This will require moderation during processing to keep the inevitable noise present in the RAW image from exploding.

A lunar transit is likely to occur either in the middle of the night or at dawn or dusk (or even in daylight). In the first case, the ISS will be seen as a dark silhouette as it is located in the shadow of the earth. In the second case, if it is not yet in the shadow of our planet, it will appear brighter than the moon itself (remember that the magnitude of the ISS can compete with that of Venus).

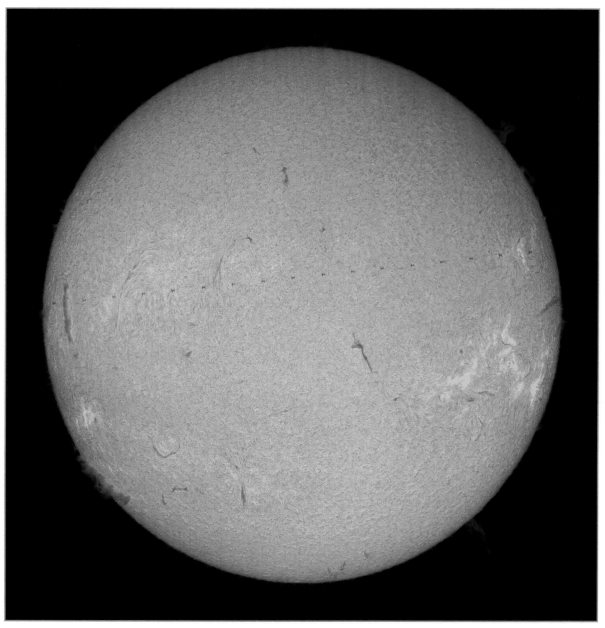

Solar transit of the Chinese space station Tiangong 1 with docked module Shenzhou 10

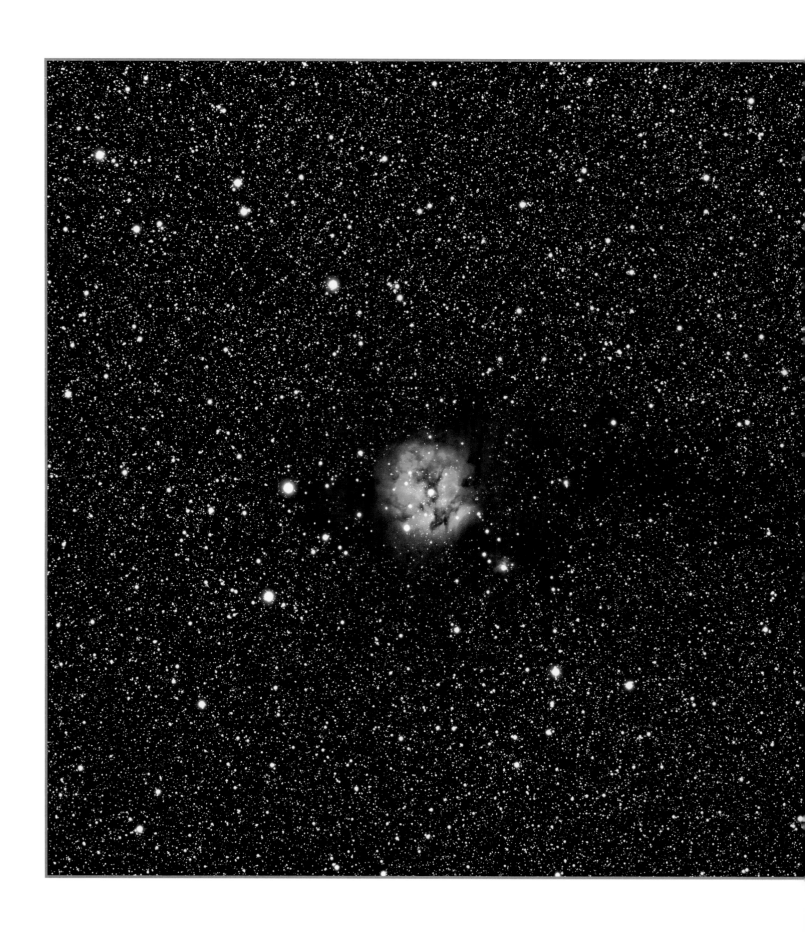

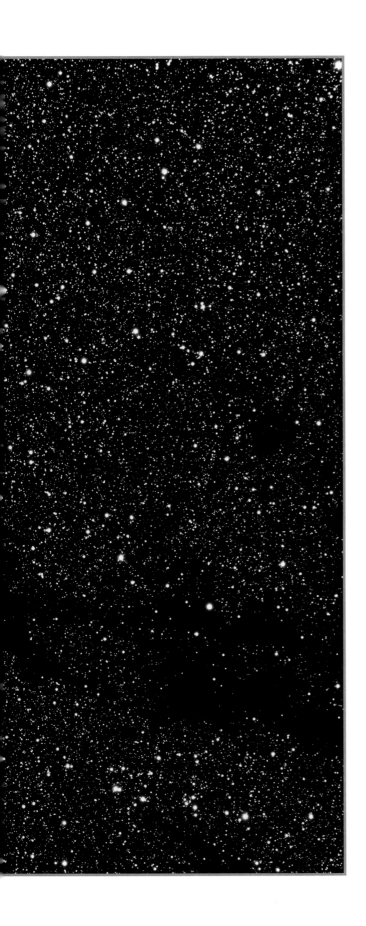

Chapter 7
Imaging Deep-Sky Objects

Grouped under the term deep-sky are all celestial objects other than the sun, the moon, and the planets. This group includes constellations, star clusters, nebulae, galaxies, and even comets and asteroids, the latter because even though they belong to the solar system, they are photographed with the same techniques used for nebulae and galaxies.

The Cocoon Nebula (IC 5146) is located in Cygnus, fully in the Milky Way. At about 4000 light years from us, it extends across a dozen light years and is outlined by dark clouds of gas and dust with a sinuous extension to the right of the image that masks background stars.

A common characteristic of all deep-sky objects is their dimness compared to the planets and the moon. With modern cameras, an exposure of several seconds shows the galaxies as they appear in a small amateur instrument, usually as little more than a faint, fuzzy patch. To record subtle structure such as spiral arms, an exposure of several tens of seconds—or even better, several minutes—is necessary.

This requirement places certain demands on the equipment and on the way it is used. For example, deep-sky astrophotographers prefer telescopes and lenses with a fast focal ratio as well as those with good image quality across the entire field of the sensor. They prefer cameras with the highest quantum efficiency and seek out dark observing sites. An equatorial mount is also of the highest importance; it must be stable and easy to align on the celestial pole and above all, provide good tracking.

In certain situations, the astrophotographer will have to guide the telescope, adjusting the tracking in real time to stay precisely locked on the object to be photographed. Digital cameras are much more sensitive than their predecessors and the exposures can be shorter, but on the other hand, a small tracking error is recorded more quickly!

Telescopes for Deep-Sky Photography

The criteria of choice for a deep-sky telescope, as well as the characteristics required of it, are not exactly the same as for planetary photography. The main reason is that deep-sky objects are dim and need exposures from several minutes to several hours to be recorded. In addition, the objects vary widely in angular extent, from constellations that stretch across tens of degrees to galaxies smaller than one arc minute.

The images of celestial bodies shown in books seldom give a realistic impression of their relative angular size. Despite its apparent sharpness, this image of M33, obtained with a focal length of 750mm, has an angular resolution much less than the image of Jupiter on page 91, as shown in this view where they are printed at the same scale.

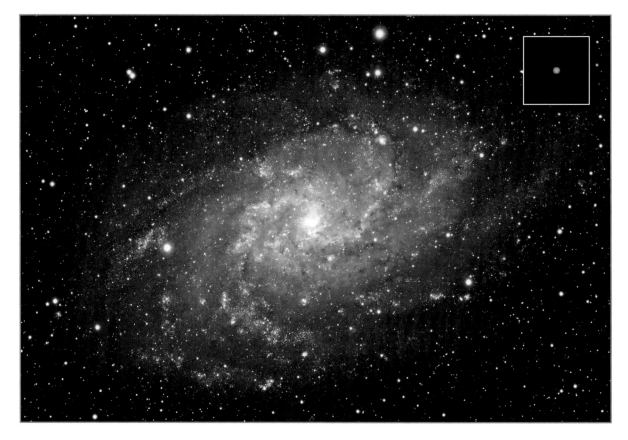

Focal Length and Focal Ratio

In planetary photography, except when the target is the complete lunar disk, the focal length of the telescope is of little importance because it must always be amplified to reach the resolution limit of the telescope. But, as in conventional photography where the focal length of the lens is a primary consideration (you cannot photograph the same scenes with a wide-angle lens and with a telephoto lens), each range of focal lengths is optimal for a subset of deep-sky objects:

- Wide-angle lenses are useful for the Milky Way and constellations
- Telephoto lenses and short focal-length telescopes (under 1000mm) are optimal for open star clusters, nebulae, larger galaxies, and galaxy clusters
- Long focal lengths are best for individual galaxies, globular clusters, and planetary nebulae

In other words, there is no perfect telescope for all deep-sky objects. For example, a focal length of 500mm covers most large diffuse nebulae and the larger galaxies, such as M31 or M33, but produces tiny images of planetary nebulae and most other galaxies. In this case, you could imagine amplifying the focal length with a Barlow lens as is done for the planets, but the focal ratio increases in proportion and this is unfavorable for good signal-to-noise ratio with reasonable exposure times. Indeed, if you multiply the focal ratio by 2, you will need to quadruple the exposure time to obtain the same signal-to-noise ratio on each photosite. In practice, deep-sky objects are never photographed at focal ratios of 15 or 20.

Barlow lenses and eyepieces, so useful for the planets, are never used in deep-sky photography. From this discussion we see the importance of a second parameter: the diameter of the telescope aperture. To use a long focal length and keep a reasonable exposure time means the diameter must be increased also. But, of course, larger diameter means a heavier, and more expensive, telescope and mount! Such an instrument will be able to show more detail on smaller galaxies, but its narrower field of view may not encompass large diffuse nebulae.

Imaging stars is quite different. Due to the infinitesimal angular size of stars, even the largest telescopes cannot show detail on their surface. As a result, a longer focal length is not useful, except to separate stars in an open or globular cluster. Of course, a larger-diameter aperture allows you to record fainter stars; using the same exposure time but increasing the diameter of the telescope by 60 % reaches stars approximately one magnitude fainter. But determining the limiting magnitude for a given configuration is not easy because it depends on many parameters, particularly the diameter and focal length of the telescope, the spectral sensitivity of the sensor, its readout noise and thermal signal, the presence of filters, the sky background, and the sharpness of the image. You can expect that a monochrome CCD camera with a 200mm (8") aperture telescope can show a 19th magnitude star in a dark sky with a 10-minute exposure. For a color sensor, reduce this by one to two magnitudes, and remove several more magnitudes for a badly light-polluted sky.

Other considerations other than the field of view sometimes force the user to use a shorter focal length, particularly the tracking accuracy of the mount. While tracking with a wide-angle lens is not difficult, keeping a 2000mm focal-length telescope aimed so that the target does not move by 1 pixel during a several-minute exposure is another story! Tracking difficulties are proportional to the focal length of the telescope. Another issue is the atmospheric seeing: as soon as the exposure time exceeds 1/10 second, the agitation and distortions of the image are integrated, resulting in stars with an angular width on the photograph that is generally larger than 2 arc seconds—a size that is much larger than the Airy pattern. Increasing the focal length beyond a certain limit does not improve the fineness of detail; it only enlarges the fuzziness due to

MECHANICAL QUALITY

For a planetary telescope as well as a deep-sky one, mechanical quality is essential. This refers to the quality of materials (metal, plastic...), the machining and assembly accuracy, and the ability to bear a photographic load. For example, a Newtonian or a refractor designed to use a CCD camera plus a focal reducer or field flattener must have a focuser that is strong enough, and accurate enough, to achieve and hold a focus position to several hundredths of a millimeter without flexure or slippage, even when the instrument is aimed at the zenith.

turbulence or to tracking inaccuracies. For most amateur CCD camera pixel sizes, this limit is generally between 1000mm and 2000mm.

For these reasons, working at a sampling scale smaller than 1 arc second per photosite is beneficial only if the equipment, the observing site, and the experience of the astrophotographer are exceptional. Deep-sky photography with a focal length longer than 2000mm is demanding and may be quite frustrating for the amateur wanting to enjoy it without too many complications.

FIELD CURVATURE

The parameter characterizing field curvature is the radius (R) of the sphere through the points of sharpest image detail. At a distance (d) from the optical axis, the focus shift (ε) is

$$\varepsilon = \frac{d^2}{2R}$$

Since ε is proportional to the square of d, the effects of field curvature are almost a hundred times more pronounced in the corners of a 24 × 36 sensor than in the corners of a webcam sensor!

On the sensor, the size (s) of the blur spot is (F being the focal ratio)

$$s = \frac{\varepsilon}{F}$$

The parameter R is specific to each telescope type and design; as soon as you know it, you are able to calculate the blur at the edge of your sensor and compare it to the focusing tolerance (see chapter 4) to determine if the field curvature is negligible or not and if you need a field flattener.

Assume, for example, that you are using an APS-C DSLR (15 × 22.5mm sensor) with an 800mm focal-length refractor. For such a telescope, R is equal to the focal length divided by 2.7. The corner of the sensor is 13.5mm from the center (half the length of the diagonal), so that $\varepsilon = 13.5^2/600 = 0.3$ mm. If the focal ratio of this telescope is 6, this focus shift corresponds to a blur spot around 0.05mm in diameter (10 5-micron photosites) and a field flattener may be necessary to improve the edge of the field.

Clearly, photographing galaxies and nebulae using a DSLR on a 4000mm focal-length telescope is unreasonable because the corresponding sampling of 0.3 arc seconds per photosite is appropriate for planetary imaging but not for deep-sky work!

Although the attributes desired in an instrument are not the same for planetary and deep-sky imaging, numerous telescopes are good for both. However, the universal instrument does not exist, and each type or model of telescope is more suited to one or the other type of imaging. Amateurs who want to cover all fields of astrophotography, and who can afford it, often use several telescopes, just as photographers use different lenses for their DSLRs.

Field Coverage

A deep-sky object may occupy a large part of the field viewed by the instrument and the camera and is surrounded by stars. Therefore, uniform image quality over the entire field is essential. This is not easy for instrument designers, especially for fast focal ratios with large sensors. With most telescopes, the stars are distorted, elongated, or attenuated as they get closer to the edges of the field, for the following reasons:

- Coma: The stars become asymmetrical and look like small comets (from which comes the term *coma*) and have a small tail directed away from the center of the field. This effect is similar to one caused by misalignment (see chapter 4). In extreme cases, coma gives the image a *Star Wars* appearance, where all the stars seem to smear away from the center of the field.
- Astigmatism: The stars are distorted and may become oval or cross shaped.
- Field curvature: At the focal zone, the image is sharpest not on a plane but instead on a spherical surface. When focusing is good in the center of the field, the periphery of the image is fuzzy, and vice versa (see the sidebar at left). Field curvature must not be confused with another aberration well known in photography with wide-angle lenses: distortion, whose effect is to transform straight lines (such as the horizon) into curved ones; distortion is not a problem with telescopes.
- Vignetting: The edges of the image are darker than the center, as described in chapter 3 and in the appendix.

Astigmatism distorts the stars, rendering them elongated or cross-shaped

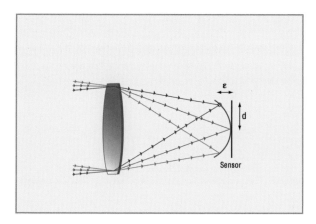

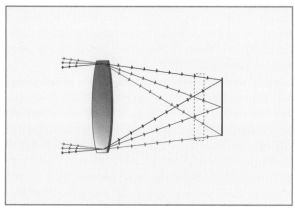

The field curvature radius (R) is the radius of the sphere that defines the surface of sharpest image detail. The smaller the radius, the more curved the field. Optical accessories (the second figure) called field flatteners are designed to remove the curvature.

On extended objects like galaxies and nebulae, the aggregate consequence of coma, astigmatism, and field curvature is a loss of sharpness and detail at the edges.

In practice, all of these aberrations are often present, but depending on the telescope type and characteristics, one of them is generally dominant. Defining a precise limit beyond which a given defect would become unacceptable is difficult; it depends on the level of degradation that you are willing to accept, on the enlargement applied to the image, and on the global sharpness of the image.

All telescopes are able to produce good field coverage across the small sensor of a webcam, but only a few, called *astrographs*, are compatible with a 24 × 36mm or larger sensor. Manufacturers sometimes state the size

of the usable photographic field of their telescopes, but some are more optimistic than others, and in the absence of a standard of measurement, the sizes are not always comparable. For example, some spot diagrams (the shape and size of the image of a star at different places on the sensor) are calculated on a flat focal plane while others are calculated on a curved one; of course the curved surface spot sizes are more flattering, but the flat one is more informative for the user! If no figure is quoted, that may be a sign that field coverage is not the best quality of the instrument.

Photographic Lenses

Although photographic lenses are designed for large sensors (most of them for 24 × 36mm fields), they can show pronounced degradation at the edge due to astigmatism, field curvature, and vignetting, particularly at full aperture. The situation usually improves when the diaphragm is closed by one or two stops. In daylight photography, soft corners often pass unnoticed; they can even be an advantage for portraits. But, stars are point sources and are the most merciless test for a lens. With most lenses, do not expect stars in the corners to be as sharp as they are in the center, except for top-quality lenses; a lens with a slight difference is still a good lens.

Chromatic aberration (described in chapter 5) causes colored halos around stars and a global loss of contrast. The effect is most visible at full aperture on bright stars, where an affected image will show a strong blue-violet halo.

Top-of-the-line lenses usually offer better field coverage. Despite the fact that zoom lenses are in fashion, I for one prefer a good fixed focal-length lens and currently use 14mm f/2.8, 24mm f/1.4, 50mm f/1.4 and 135mm f/2 lenses, which produce a smaller focal ratio at full aperture and a uniform field with good contrast.

In astrophotography, forget the image stabilizers that are available with some lenses. They are completely useless.

The Newtonian Telescope

The main aberration of a Newtonian telescope is coma; astigmatism and the field curvature are moderate and generally not limiting (the field curvature radius is equal to the focal length of the primary mirror). At a given distance

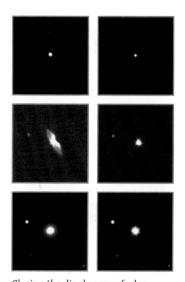

Closing the diaphragm of a lens (in this example, from f/2 to f/5.6) makes the stars sharper in the center of the field (upper images, left to right) and even more at the edge (center images). In addition, the chromatic aberration disappears on bright stars (lower images).

The most commonly used coma corrector is the Tele Vue Paracorr, designed for Newtonians between f/3 and f/8. It covers a linear field of view 20mm to 25mm in diameter

Astro Systeme Austria (ASA) offers fast Newtonian astrographs (focal ratio 3.8) coupled with high-performance field correctors

from the optical axis, the amount of coma is inversely proportional to the square of the focal ratio of the telescope. This means that a Newtonian at f/3 or f/4 may have a sharp field of view of only a few millimeters in diameter (see the sidebar "The Coma of the Newtonian Telescope"): at 10mm from the optical axis of a 200mm f/4 Newtonian, the length of the coma tail is about 30 arc seconds! At such a fast focal ratio, a coma corrector is especially useful. There are two main types of coma correctors:

- ❯ A Ross corrector, composed of two lenses, which gives good results even if the center of the image loses some sharpness
- ❯ A Wynne corrector, composed of three or four lenses, which gives a better result but is more expensive

A coma corrector is optimized for a precise distance from the sensor; therefore, the recommendations of the manufacturer should be carefully followed.

The Refractor

The Newtonian telescope is not the only one that suffers from off-axis aberrations. Most refractors are corrected for coma but astigmatism remains and, above all, field curvature is pronounced. At the same focal length, the field curvature radius of a refractor is 2.7 times smaller than for a Newtonian (R = F/2.7, F being the focal length of the refractor). For example, the curvature is the same for a

THE COMA OF THE NEWTONIAN TELESCOPE

The length (L) of the coma tail depends on the focal ratio (F/D) of the telescope and the distance (d) from the optical axis:

$$L = \frac{3d}{16\,(F/D)^2}$$

For example, at 5mm from the optical axis of an f/5 Newtonian, L is about 0.04mm. With 6-micron photosites, a bright star is spread across six photosites.

500mm Newtonian as for a 1400mm refractor. The shorter the focal length, the stronger the curvature. The radius of curvature depends only on the focal length and not on the diameter or the type of refractor (achromatic doublet, apochromatic doublet or triplet).

For a large sensor on a short refractor, a field flattener may be useful; only certain high-end refractors (Takahashi FSQ-106 and Tele Vue NP101) do not need such a flattener because their more complex design already includes rear element(s). Generally speaking, all instruments suffer more or less from field curvature and only optical elements close to the focal plane can correct it. Note that a coma corrector for Newtonian telescopes and a field flattener for a refractor are very different devices and are not interchangeable at all.

Manufacturers of top-of-the-line refractors such as Astro-Physics (first image), Takahashi (second image), and TMB (third image), offer flatteners perfectly adapted to their products as an option; some of these flatteners also serve as focal reducers. Tele Vue (fourth image) also offers reducers/flatteners for refractors of focal length 400mm–600mm and 800mm–1000 mm.

Portions of images obtained with a 24 × 36 sensor on a 500mm focal-length refractor. The first two images show what happens when focused in the center of the image: the stars in the center (#1) are sharp but the field curvature makes the stars in the corners (#2) fuzzy. The third image shows what happens when focused in the corners: off-axis astigmatism appears (#3), but it is the center of the image (#4) that is most damaged by field curvature.

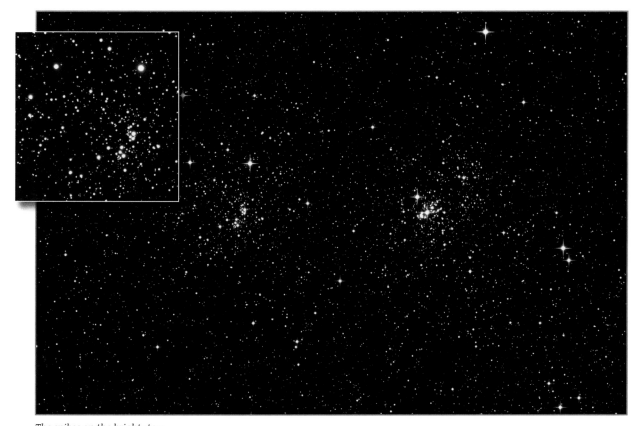

DIFFRACTION SPIKES

The spikes that radiate from the brightest stars on photographs are caused by the diffraction of light around the spider vanes on a Newtonian or Cassegrain telescope. A spider with four vanes makes four spikes, while three vanes make six spikes.

On an image taken with a photographic lens, the visible multiple spikes are caused by the lens's diaphragm blades.

A photograph taken with a refractor does not show spikes unless thin threads or fishing wire have been placed in front of the aperture to create them artificially. The length and the thickness of the spikes depend on the thickness of the wires.

The spikes on the bright stars of this image of the Perseus double cluster were obtained with two thin threads stretched across the aperture. Some amateurs prefer the images with spikes, some without.

The chromatic aberration of an achromatic refractor appears most clearly in the blue with a color sensor and in the near infrared with a monochrome sensor (on the left). An infrared-blocking filter removes the halo in the near infrared (on the right).

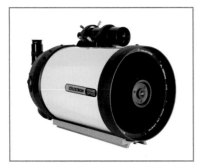

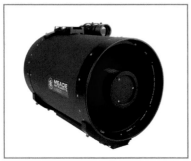

The Celestron Edge HD (top) and Meade ACF (bottom) represent a significant evolution of the classical Schmidt-Cassegrain in terms of field coverage

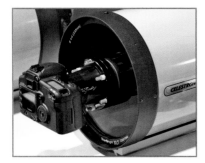

The HyperStar system can accept a DSLR or a CCD camera. The obstruction caused by the prime focus location of the camera is not crippling for deep-sky imaging, especially with a small DSLR like the Canon 100D.

The Cassegrain Family of Telescopes

All telescopes in the Cassegrain family have several things in common:

> A concave primary mirror and a convex secondary mirror

> A relatively high focal ratio (generally 8 to 10, or even more)

The classical Cassegrain includes a parabolic primary mirror and a hyperbolic secondary mirror. Some manufacturers even offer a hybrid Cassegrain-Newtonian telescope with an interchangeable secondary mirror and two focus locations. Off-axis, the Cassegrain shows coma and astigmatism equal in magnitude to a Newtonian of equal focal ratio. But for all members of this family, the field curvature is much stronger, its amplitude depending on the design characteristics.

Both mirrors of another variant, the Ritchey-Chrétien, are hyperbolic, so it's therefore more difficult to manufacture and to collimate. The Hubble Space Telescope is of this type. The advantage of this design is the elimination of coma, leaving only a bit of astigmatism and, above all, field curvature. Offering the best off-axis correction of the Cassegrain family, Ritchey-Chrétiens are particularly recommended for deep-sky imaging with large sensors, and of course with a field flattener. Companies such as Optical Guidance Systems (OGS), PlaneWave, Officina Stellare, and Alluna Optics offer large-diameter Ritchey-Chrétien telescopes at f/8 or f/9 with dedicated field flatteners.

The Dall-Kirkham is another variant, and its primary mirror is elliptical and the secondary mirror spherical. Easier to make, it possesses relatively strong coma in addition to the usual field curvature. As for now, only Takahashi offers a Dall-Kirkham telescope, the Mewlon, with optional reducer/correctors.

The Schmidt-Cassegrain is the most widespread variant thanks to an automated and relatively cheap manufacturing process invented by Tom Johnson (Celestron) in the 1970s, with the two main manufacturers being Celestron and Meade. It consists of a spherical primary mirror, a glass plate with a special shape designed to correct the spherical aberration of the mirror, and a secondary mirror. It shows noticeable coma and field curvature, the radius of curvature being close to 10 % of the focal length of the telescope (about 200mm for a 200mm f/10 Schmidt-Cassegrain).

Dedicated reducers/correctors are available that decrease the focal ratio from 10 to 6.3, but they also reduce the usable size of the focal plane (this is a common characteristic of all focal reducers). The field of view usually does not exceed a circle that's 25mm in diameter; beyond this limit, aberrations and vignetting become unacceptable. Therefore, with or without a reducer, they are not compatible with a 24 × 36mm sensor but can work with an APS-C–sized one. Meade has a reducer that decreases the focal ratio to 3.3; in this case the sensor cannot be larger than 10mm to 12mm diagonal.

Variants of this formula, the Meade ACF and the Celestron Edge HD, emerged in early 2010, producing a larger corrected field and better collimation stability. The Meade ACF, like its predecessors, has two mirrors and a Schmidt plate, and its performance approaches that of the Ritchey-Chrétien by correcting the coma. Celestron added another step of correction with a refractive corrector integrated into the central baffle, producing a flatter field. It offers a large dedicated focal reducer that can reduce its focal ratio by a factor of 0.7 while maintaining its performance.

Starizona Corporation offers, for 8" to 14" Meade and Celestron Schmidt-Cassegrains, the HyperStar system, which replaces the secondary mirror with an adaptor that includes a field corrector. This allows the camera (DSLR or CCD) to be mounted at the prime focus of the primary mirror, just before the corrector plate. The reconfiguration takes only a few minutes and the advantage is a fast focal ratio (f/2) and wide field due to the short focal length obtained (400mm to 700mm), which comes at the expense of the fineness of detail that can be recorded.

The Maksutov-Cassegrain design utilizes a thick, curved glass plate (meniscus) in the front. There are two types: the Gregory, whose secondary mirror is just a reflective coating deposited in the center of the meniscus, and the Rumak, which is constructed with a full secondary mirror as in the Schmidt-Cassegrain. The latter offers both remarkable field coverage with very low coma and astigmatism and moderate field curvature (but still higher than for a Newtonian of same focal length). The Maksutov-Newtonian design is another variant where the curved secondary mirror is replaced by a flat mirror at 45°; its main advantage is much less coma than a Newtonian of the same focal ratio.

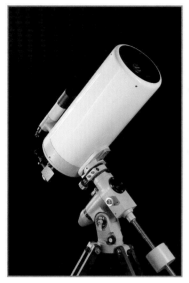

From the outside, nothing distinguishes a classical Cassegrain from a Dall-Kirkham (first image) or a Ritchey-Chrétien (second image). A Schmidt-Cassegrain (third image) is recognizable by its thin corrector plate, while the Maksutov-Cassegrain (fourth image) uses a thick meniscus element.

Other Optical Formulas

The types of telescopes just described represent almost all instruments used by amateurs. But the imagination of designers is boundless, and numerous other formulas have been invented, often combining mirrors and lenses, such as the Schmidt-Newtonian, Wright-Newtonian, Lurie-Houghton, Houghton-Cassegrain, Mangin, Sigler, Dall, Dilworth, and so on. Each type has its own pros and cons, and they are too rare to be described in this book; you can find a detailed description in *Telescope Optics: Evaluation and Design* by Harrie Rutten and Martin van Venrooij (Willmann-Bell, 1988) and *Telescopes, Eyepieces and Astrographs* by Gregory Hallock Smith, Roger Ceragioli and Richard Berry (Willmann-Bell, 2012).

The Takahashi CCA-250 (f/5 modified Cassegrain with a two-lens corrector) falls in the group of atypical astrographs, as well as the desirable Riccardi-Honders optical formula, which is made up of two mirrors (one of which is aluminized on its rear face) and a field corrector. The Officina Stellare Veloce RH models (200mm and 300mm at f/3), and the Astrophysics RH 305mm are of the same type.

Collimation

We often read that the collimation is less important in deep-sky imaging than for planets. This is only partially true because a misalignment can cause an asymmetry of an image: the optical axis is no longer in the center of the field and a portion of the image will be degraded by coma, astigmatism, field curvature, or vignetting. With a photographic lens, an asymmetry of the image in terms of the sharpness of the stars may be a sign of lens misalignment during manufacture or due to mishandling.

For a Newtonian telescope, alignment of the primary mirror while viewing a star or with a collimation laser is not sufficient, especially when a large sensor is used. The eyepiece holder must keep the sensor perpendicular to the optical axis; otherwise, parts of the image are out of focus. For the same reason, the angle of the secondary mirror must be at exactly 45°. This implies a very careful collimation that begins with the secondary mirror and

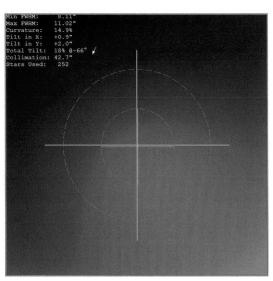

CCDInspector assesses the uniformity of the field and quantifies a possible optical or mechanical misalignment or tilt

Another example of the colocation of a nebula and an open cluster: NGC 7635 (the Bubble Nebula, in the center) and Messier 52. As with other deep-sky images in this book made with a CCD camera, the processing consisted of calibration, registration and stacking, gradient removal, applying curves to the luminance layer, and LRGB colorization.

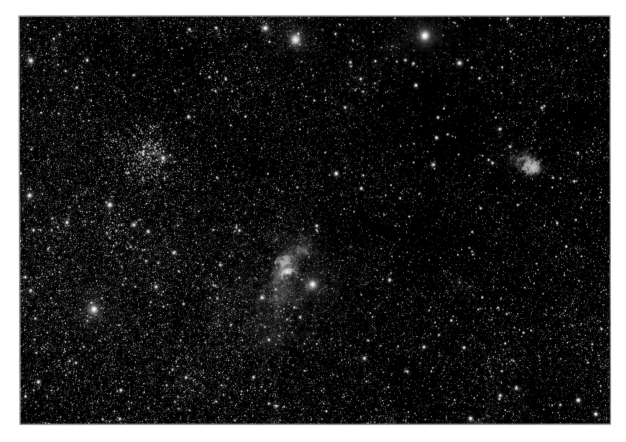

may require adjusting the eyepiece holder, if possible. For deep-sky imaging, the quality of the centering and the perpendicularity of the sensor can be checked using CCDInspector, which extracts the distribution of FWHM values across the field from an image and displays it in graphical form.

Mounts for Deep-Sky Imaging

This chapter could have begun with this topic, which is of primary importance in deep-sky photography. The stability and tracking accuracy required of a mount are considerably more stringent for astrophotography than for visual observation or planetary photography. When choosing a telescope for deep-sky photography, the same attention must be paid to the mount as to the optical tube. Spending a comparable sum of money for each is not uncommon. This is particularly true since some manufacturers, to advertise the highest diameter/price ratio, offer lightweight mounts with large apertures, which is like selling powerful motorcycles equipped with bicycle wheels!

MOUNTS AND ACCEPTABLE LOAD

Manufacturers and distributors often state a maximum load for the mounts they offer. However, it is impossible to define a precise limit, and there is no commonly accepted method of calculation. A mount recommended for a 10-kilogram (kg) payload may actually be more stable than another one recommended for 12 kg simply because the manufacturer of the 12 kg mount is more optimistic. Also, this load sometimes includes counterweights. These specifications are generally acceptable for visual observation without wind, but for photography, it is wise to decrease the stated maximum load by 30 % to 50 %.

Another important consideration is not only the weight of the optical tube assembly but also its size: at equal weight, a compact tube will be more stable than a longer tube. The sturdiness of the tripod is also quite important.

Finally, remember to include the camera and its accessories in the total load, as well as a dew shield and possibly a guide telescope.

Fixed Mounts

As discussed in chapter 1, a motorized mount is essential for long-exposure deep-sky photography because the rotation of the sky is perceptible after only a few seconds with a wide-angle lens. For a 1-meter focal-length telescope, the maximum exposure time is less than 1/10 second!

Motorized Alt-Az Mounts

With the azimuthal (alt-az) mount, field rotation is even more problematic for deep-sky photography than it is for planetary photography (see chapter 5). To eliminate it, a de-rotator can be used for certain telescopes. This device is a motorized rotating system that is installed in front of the camera and connected to the computerized tracking system of the telescope; the rotation speed is constantly adjusted to compensate for the field rotation.

This solution has been implemented on many professional telescopes, but the de-rotator is controlled with computers and servo-control systems. For the amateur, this solution is quite costly and complex since three motors are running simultaneously, versus only one for an equatorial mount. Currently very few amateurs use a de-rotator.

A motorized azimuthal mount is not optimal for the long exposures needed in deep-sky photography

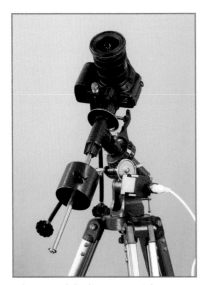

A bottom-of-the-line equatorial mount can be sufficient for photographs with a wide-field lens, such as the one shown on page 60.

Motorized Equatorial Mounts

The principle of the equatorial mount is simple: one of its axes is set parallel to the rotation axis of the earth so that rotation around this axis can compensate for the apparent movement of the sky. Different types of equatorial mounts are available, and each has some advantages and drawbacks.

The German Mount

The German mount, referring to the German astronomer Fraunhofer who invented it two centuries ago, is the one that is used by almost all deep-sky imagers. It offers good stability as long as it is correctly dimensioned with regard to its load. In addition, it has two important advantages:

- Its polar axis is generally hollow and equipped with a polar finder that allows a quick and precise polar alignment (see page 154 for more on polar finders)
- When the photographer owns several optical tubes (for example, a short refractor for wide-field photography and a telescope for planetary photography), he can install them alternatively or even simultaneously for autoguiding, if the mount permits.

Several manufacturers nowadays offer small equatorial mounts for travelers that are able to support a DSLR and its lens, and the sturdiest can even support a small refractor.

THE MERIDIAN FLIP

One of the major drawbacks of the German mount is the meridian flip: around the meridian the mount must be turned over, the telescope passing from the west side of the mount to the east side, to avoid bumping the tripod. This is not a problem in visual observation, but in photography the image rotates by 180° and exactly repeating the same framing and guide star is not so easy.

Depending on the area of the sky and the length of the telescope, it is possible to work past the meridian position by one or 2 hours, sometimes more.

When there is a risk of touching the tripod before the end of the imaging sequence, the side (east or west) of the tube relative to the mount must be carefully considered; when possible, the tube must be oriented eastward because in this position the instrument will be able to track the object long after the meridian.

If your mount is equipped with setting circles, determine the maximum imaging session duration before a flip by manually rotating the mount up to the position where the tube touches the tripod, and note the number of hours in right ascension (RA) that this position is past the meridian.

The iOptron SkyTracker and Vixen Polarie (first two images) pocket mounts attach to a photo tripod and carry a DSLR with its lens through a ball head attachment. With a weight of about 2 lbs (without accessories), they can carry a payload of about 4 and 6 lbs, respectively. Bulkier, but able to carry much heavier equipment (20 lbs or so), the AstroTrac and Losmandy StarLapse (third and fourth images) are still transportable. All of them are powered with batteries and can use a polar finderscope. The first two offer, in addition to sidereal speed, a speed reduced by half, designed for time-lapse movies (see chapter 1), while the StarLapse has a larger range of speed options.

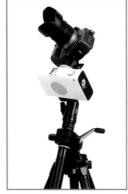
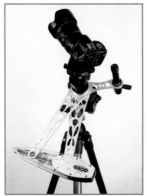
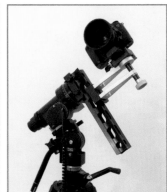

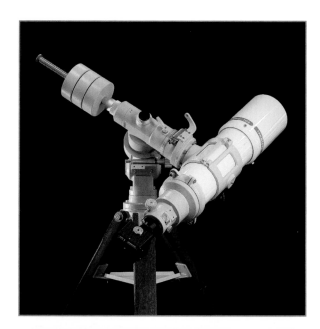

The Fork Mount on an Equatorial Wedge

Schmidt-Cassegrain telescopes are offered with either a German equatorial mount or a fork mount. When the latter is laid down flat on its base, it is in alt-azimuth mode. To make this mount equatorial, you use a wedge with an inclination that's adjustable so that the arms of the fork become parallel to the rotation axis of the earth. Unfortunately, this often makes the instrument less stable.

The pros and cons of the fork mount on an equatorial wedge are quite different from those of the German mount: on one hand, no integrated polar finder for easy polar alignment is available, and optical tubes are not interchangeable; on the other hand, no heavy counterweight is required and no meridian flip problem exists.

The Dobsonian Telescope on an Equatorial Wedge

Originally, the Dobsonian telescope was a Newtonian with a manual azimuthal mount. Nowadays, it is possible to add a computerized system for motorized tracking, but in deep-sky photography the problem of field rotation remains. To avoid it, you can use an equatorial platform. This is composed of a flat double plate on which the telescope is set. Once aligned on the polar axis, the telescope tracks the stars in equatorial mode for 30 to 90 minutes. After this time, the telescope mount must be reset to the beginning of the next tracking interval, causing a loss of the object accompanied by a sudden field rotation. While in theory they are suitable for deep-sky photography, this kind of mount has given very few photographic quality results, probably because of the difficulty of precise polar alignment (a fine adjust polar adjustment system is mandatory) and the limited duration of equatorial tracking before the table must be reset for a new tracking interval.

With the help of an equatorial wedge, an azimuthal mount can be transformed into an equatorial one. However, the stability and the tracking precision are not always adequate, and the absence of a polar finder and a system to balance the tube with the camera or a guiding telescope in place can make it difficult to use.

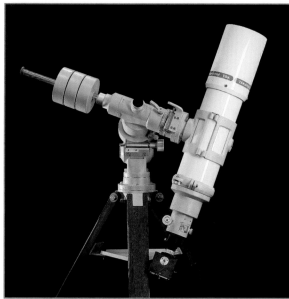

On the top, the instrument is pointed at an object that crosses the meridian at a low elevation; the clearance on each side of the meridian is large. On the bottom, it points at an object passing at high elevation; the end of the tube can touch the tripod on one side or the other.

An equatorial platform for a Dobsonian telescope (SkyVision)

THE REMOTE OBSERVATORY AND THE ASCOM INITIATIVE

To benefit from better climatic and light pollution conditions, or to be able to take images of the other celestial hemisphere, some skilled astrophotographers have set up remote observatories, that is, observatories that don't need a permanent human presence and that can be controlled from a long distance. Such an installation requires mastering a number of subsystems:

- A high-speed link between the user's home and the remote site to control the observatory and to download the images obtained
- Motorized systems for opening the shelter roof and moving the telescope
- A pointing system with sufficient accuracy to place the object within the field of view of the camera
- Motorized systems for focusing and rotating the camera (including a 180° rotation for meridian flip compensation) and an autonomous autoguiding system
- Careful routing of the cables and control of the movements of the mount to avoid any twisting of the cables around the mount or any contact between the telescope and the mount or the pier
- All needed safety and security devices, such as a cloud and rain sensor for automatic shelter closing, an autonomous power supply for observatory closure in case of network power supply failure, a remote computer reset control, and intrusion detection

Electronics and digital data and interfaces are available more and more in all types of astronomy equipment. The Astronomy Common Object Model (ASCOM), created by a group of astronomy software developers and astronomy device manufacturers devoted to vendor-independent plug-and-play control, offers downloadable software components (platform and drivers) based on a standard communication protocol to easily interconnect astronomy programs with devices such as domes and roofs, mounts, cameras, filter wheels, focusers, and rotators. This is especially useful for remote observatories.

For more information, visit http://ascom-standards.org/.

Polar Alignment

Aligning an equatorial mount consists of making its polar axis (i.e., its rotation axis in right ascension) coincident with the rotation axis of the earth. Since nothing is perfect, an alignment error always remains, the amount depending on the alignment method. In visual observation, a coarse alignment performed with the naked eye by directing the mount toward Polaris (the pole star) may be sufficient. But in deep-sky photography, this method is insufficient, in large part because Polaris does not coincide with the true pole, being three-quarters of a degree away (1.5 times the apparent diameter of the full moon!).

For long exposures, a large alignment error has two consequences: a constant drift of the field and a slow field rotation. Fortunately, the field rotation on an imperfectly aligned equatorial mount is much less pronounced than with an azimuthal mount, but it may not be totally negligible on exposures longer than a few minutes. If the rotation is not perceptible on each individual exposure, then it is not a big problem because astronomical processing software packages can register the series both in translation and in rotation. However, if the field rotation is visible on an individual exposure, the exposure duration must be decreased or, better yet, the polar alignment must be improved.

There are different methods, varying in precision and ease of use, to refine the polar alignment. For a transportable telescope, a remaining error of less than 5' is good.

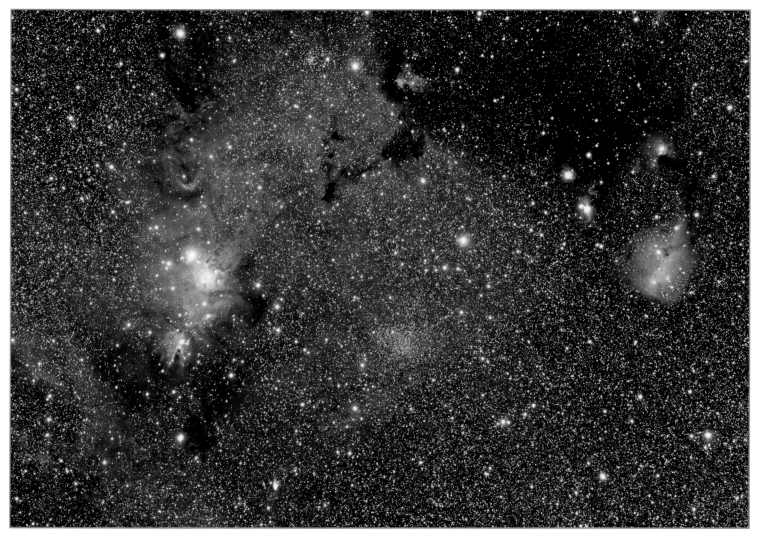

This image of the vicinity of Monoceros, obtained with an astrograph of 530mm with a focal ratio of f/5 and a 24 × 36mm CCD camera, covers a field of 2.6° × 3.9°. Centered inside the Milky Way, this region abounds in open clusters and bright and dark nebulae (including the famous Cone Nebula).

Polar finders of the "star locking" type. Several centering reticles are designed to locate several stars close to the celestial pole, including Polaris. The finder and/or the mount must be rotated around its axis so that the direction of the reticles showing the surrounding stars or constellations corresponds to the current orientation of the sky. Then the mount is mechanically aligned with the pole with the help of its azimuth and elevation adjustment system. These polar finders are generally less precise than the others presented on this page.

A polar finder of the "sidereal time" type. Polaris must be placed on the external circles, at a position that must be calculated (for example, by the software program Polar FinderScope) and that depends on the date, time, and longitude of the observing site.

A polar finder of the "date-time" type. Once the date and time scales (external circles) are adjusted properly, Polaris is placed into the small rectangle graduated in years.

Using a Polar Finder

A polar finder is a small refractor that covers a field of several degrees and is installed parallel to the RA rotation axis of the mount. The fastest and the easiest way to polar-align a mount is to use a polar finder. The precision of a good polar finder is better than a few arc minutes, but not all of them offer this accuracy. Most German mounts contain a polar finder that is integrated into the mount through a hole down the center of the mechanical axis. Seen through the finder, a transparent engraved glass reticle shows a pattern (and possibly numbers) that helps to align the mount on the celestial pole. In addition, a polar finder manual rotation system, plus a bubble level and a latitude scale, are often available to adjust the rotary position of the reticle into alignment with the current angle of the celestial sphere about the pole.

With the best polar finders, the reticle designed to mark Polaris is even graduated in years, since the position of the pole star relative to the celestial pole slowly drifts due to precession of the equinox. Other reticle patterns are available for Southern Hemisphere observers to work with the dim stars surrounding the southern celestial pole.

The polar alignment of the mount is mechanically performed with the fine motion adjustment knobs for elevation (on the right) and azimuth (on the left). Then, these knobs are not touched again during the imaging session. On most mounts, a scale (here a quarter of a circle graduated from 15° to 55°) allows approximate positioning of the mount in elevation.

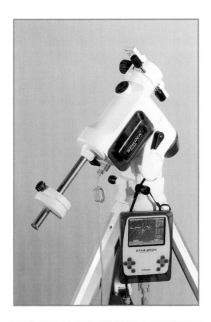

The Vixen Sphinx (top) and Losmandy Gemini (bottom) computerized systems have features to align the mount without even a view of the celestial pole. Several stars are observed and the alignment error is calculated and then corrected manually by the user at the end of the alignment sequence. A connection for an autoguider is visible on the command panel of the Gemini.

Computerized Polar Alignment

Let me say it again: a computerized GOTO system that asks the user to point at one or several stars at the beginning of the observing session is sufficient for visual observation and short exposures but not for deep-sky photography, even if it is equipped with a GPS and a compass. For long exposures, the mechanical polar axis of the mount must be *physically* aligned with the celestial pole; otherwise drift and field rotation can ruin the images.

Some computerized systems for equatorial mounts (for example, the Gemini system used on Losmandy German mounts) contain a polar alignment assistance system. The user has to successively center several stars through the telescope with the help of a reticle eyepiece while indicating to the mount which star is centered. After repeating this with three to six stars, the mount is able to calculate the alignment error and shift the last star to a position where the user just has to recenter it in the eyepiece, but this time only with the polar alignment movements. Using this system, the polar axis of the mount is physically aligned with the celestial pole, a mandatory condition for long-exposure imaging.

Alignment with the Telescope Finder

Without a polar finder, the finder of the telescope can be used to obtain a rough polar alignment with the help of a star map that shows precisely the position of the celestial pole with regard to the surrounding stars. Then, when the telescope is rotated around the polar axis of the mount (i.e., in RA), the reticle should stay centered on the pole; if not, the finder is not aligned with the mount. Since the finder has no star field reference marks, this technique is not able to quantify the alignment error, and the methods of Bigourdan or King, described later in this chapter, should be used to improve the alignment.

Refining the Polar Alignment

If your images show that the method of alignment used is not sufficiently accurate, there are two complementary methods you can use for refining it. They are both based on observing the drift of a star through the telescope; the drift is indicative of the alignment error, both in direction and amplitude. These methods require several minutes to

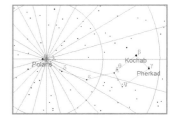

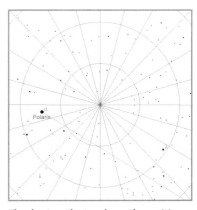

The chart on the top shows the position of the northern celestial pole in relation to the surrounding stars. On the bottom, a view zoomed in on the Polaris area (the declination circles are 30' apart). Depending on the time of observation, this chart must be rotated to correspond to the actual orientation of the constellations.

A reticle eyepiece is a short focal-length (around 10mm) eyepiece that includes a glass engraved with lines and marks. This glass is generally illuminated. The marks enable the user to determine precisely the drift of a star for polar alignment purposes or for the periodic error of the mount. Some of them show just a cross, while others have a more sophisticated pattern for precise measurement.

an hour to perform and are most useful for the permanent alignment of a mount in an observatory. There are two means to observe the drift of a star:

❯ A reticle eyepiece, coupled to a Barlow lens if needed
❯ A video camera. The sampling must be sufficiently fine to show small drifts on the computer screen. Software programs such as PEMPro, K3CCDTools, WCS, and Astro-Snap are able to transform the drift measurement (direction and amplitude) into the polar alignment correction, making polar alignment faster and more precise.

These methods are iterative. After each correction of the polar alignment of the mount, the drift is measured again, the process continuing until it reaches a negligible value. A change in the drift direction is the sign that the correction of the polar alignment has been too large. During the alignment, do not confuse the different axes of the mount: use only the RA and declination axes to center the star on the reticle and only the altitude and azimuth axes for the polar alignment correction.

Beware of the directions as seen in the eyepiece. Do not forget that an eyepiece inserted directly, without a star diagonal, gives a totally reversed image (up-down and left-right) with regard to the naked eye. With a star diagonal, the up-down direction is no longer reversed. On the screen

of a camera, the image corresponds to the orientation of the unaided eye. In case of uncertainty, you can gently push the end of the optical tube in the north-south direction and see which way the star moves. For example, if pushing the tube so that its front is going north helps to recenter the star on the reticle, it is a sign that the star was drifting north.

The Bigourdan Method
This method is performed in two steps:

1. A star close to the celestial equator and near the meridian is centered in a reticle eyepiece whose crosshairs are parallel to the north-south and east-west directions. The north-south drift of the star after several minutes gives the direction of the polar alignment correction in azimuth. East-west drift must be ignored.
2. A star situated eastward or westward and at 10° to 20° above the horizon is centered in the reticle, its north-south drift giving the elevation polar alignment correction.

On the left, Bigourdan method step 1: if the star drifts northward, the polar axis of the mount points too far westward. On the right, step 2 for a star to the east: if the star drifts northward, the polar axis is too high above the horizon. For a star in the west, the rule is reversed: a drift northward is a sign of a polar axis that is too low.

At the end of step 2, go back to step 1 to check that the adjustment is still good.

The main drawback of this method is that atmospheric refraction can contribute some drift of a star at step 2, contributing to the drift caused by the alignment error.

The King Method

The King method is based on only one star—for example, Polaris—very close to the celestial pole. The reticle crosshairs must be oriented along the vertical and horizontal directions. This orientation can be verified by moving the mount with the polar alignment movements: the star must remain on the axes of the reticle. The drift of the star along the two directions is linked to the polar alignment error by a rotation of 90°, as follows:

- A vertical drift toward the zenith means that the polar axis of the mount is too eastward
- A westward drift means that the polar axis is too high above the horizon

One would initially expect that the drift is much lower than with the Bigourdan method because of the proximity of the star to the celestial pole. Actually, this is not true; the drift is faster with this method, and the two adjustments can be made simultaneously. The drift is also not affected by the atmospheric refraction. However, there is an additional requirement compared to the other method: the tracking speed must be extremely close to the sidereal speed or the drift caused by the difference of speeds will be mixed in with the drift caused by the alignment error.

Tracking Errors

Imagine yourself on a train in motion. You can easily observe the details of the landscape, even if the train shakes due to track irregularities. Your eyes naturally lock onto these details. During the day, you can take a photograph of the landscape through the window. But at night, if you want to take a photograph of the landscape illuminated by moonlight or city lights, you will have to expose for several seconds, and this time, the movements of the train will probably blur your photograph.

The situation is similar in astrophotography: even if your mount tracks the stars correctly during visual observation, the situation can be different with a camera because the tracking requirements become much more stringent. Do not forget that the pixels of the sensor are measured in microns! Therefore, in certain situations, the astrophotographer will need to implement a guiding system (that is, a system that measures and corrects the

tracking errors in real time) instead of letting the mount run without any feedback.

Periodic Drive Errors

In astronomy, the optical elements are not the only ones that must be made with high precision. Some mechanical elements also have to be manufactured with great care, such as the gears that contribute to the tracking by coupling the rotation of the motors to the axes of the mount. Most mounts are equipped on both axes with a worm screw driving a toothed wheel. The worm screw is driven by a motor, generally with a set of gears between motor and worm, to give the worm the right rotation speed.

If you have a mount with a 100mm diameter wheel and a sand grain of 1/100 mm slips into one of its teeth, when the worm screw uses this tooth, a tracking error will occur with amplitude of 40 arc seconds, about the apparent diameter of Jupiter! Fortunately, the grease that covers the mechanism helps push out any grit, but in this example, a tracking precision of 4 arc seconds would require mechanical pieces manufactured to a tolerance of better than 1/1000 mm (0.00004").

In practice, the unavoidable manufacturing imperfections in these mechanical elements cause continuous tracking irregularities: the objects seem to slowly wander back and forth in right ascension around a mean position. The oscillations are easily visible and measurable with a reticle eyepiece and are called *periodic errors* because they cyclically repeat in a more or less identical shape over a period of time. The irregularities of tracking caused by the worm screw recur in the same way after exactly one turn of this screw, several minutes later.

All other mechanical elements also have their own periodic errors, but with different intervals, and all of these errors combine to give the visible tracking oscillations. However, generally one element dominates in terms of error amplitude. Most of the time it is the worm screw. So the graph of the error (see appendix 5) generally shows a clear periodicity that corresponds to one turn of the screw.

The period and amplitude of the periodic error depends on the mount. Low-end mounts may have an error of 30 arc seconds to 1 arc minute, peak to peak, per turn of the screw. The fork mounts of Schmidt-Cassegrain telescopes that are not equipped with a PEC system (as discussed in the next paragraph) are often in this realm. On the other

The common tracking mechanism used on equatorial mounts consists of a motor driving a worm screw through a set of gears on each axis and the screw driving the toothed worm wheel

hand, the heavy German mounts, such as those manufactured by Astro-Physics, Takahashi, and Losmandy, show a periodic error of 3 to 10 arc seconds. However, the amplitude is not the only parameter to be taken into account; the rapidity of the oscillation also matters. A mount with a periodic error of 20 arc seconds and a 10-minute cycle, but with smooth errors, may be more efficient than a mount with a periodic error of only 10 arc seconds but with a 4-minute cycle and many sudden jumps, because the former will allow unguided exposures 2 to 3 minutes longer than the latter.

Many mounts include an electronic system called PEC (for periodic error correction) that records and compensates for periodic errors. Errors are measured and the resulting corrections applied either during assembly of the telescope at the manufacturer's shop or by the user. In the second case, the user must track the star manually with a reticle eyepiece (or with an autoguiding system, see the section below on autoguiding) during one turn of the worm screw. Once these errors are recorded in the memory of the mount, they are taken into account by the tracking system of the mount and real-time changes in motor speed are applied to compensate for them. In practice, the PEC system does not completely cancel the periodic error, but it allows, in the best-case scenario, a mount with a periodic error of several tens of arc seconds to be brought to the level of high-quality mounts, that is, between 5 to 10 arc seconds.

One efficient solution to reduce the periodic error on midrange mounts is to buy a higher-quality worm gear. Several astronomical retailers offer such gears for some common mounts.

As with the collimation of the mirrors of a telescope, the adjustment of the mechanical elements, especially the worm screw, is essential to obtaining good results (see appendix 5).

A new type of drive motor, long used in industrial machines requiring high precision, appeared in amateur astronomy in the early 2010s: the direct drive motor. A large motor is directly integrated with the axis of the mount. As a result, say farewell to gears, tangent screws, and their periodic errors. Each motor must be coupled with a high-resolution encoder (see the sidebar "The End of Autoguiding?" later in this chapter). The SkyVision Nova and ASA DDM mounts are of this type.

The Other Tracking Errors

Periodic errors and polar alignment errors are not the only causes of drift during long exposures. Here are some other common causes:

- Atmospheric refraction. When the elevation of an object above the horizon changes during the exposure, the amplitude of the refraction also changes, causing a vertical drift. This effect is perceptible at low altitude (below 25°); on wide-angle photographs, the refraction is large enough to cause distortions in the portions of the image closest to the horizon.
- The tracking speed of the RA motor may be slightly different from the exact sidereal speed.
- Mechanical flexures and play within the telescope (optical tube and mount), such as, for example, the mirror shift on Schmidt-Cassegrain telescopes (see chapter 4). On a German mount, the counterweights must be placed so that they balance the optical tube with its accessories, but with a slight bias because if the balance is "perfect," the usual play of the worm screw within the teeth of the larger wheel may cause random tracking oscillations.

Guiding the Exposure

If you notice drift in your images, the first thing to do is to determine the cause. First refine the polar alignment to see if the drift improves. If you see sudden jumps, you may have to check your tracking mechanism (see appendix 5). Never hesitate to replace the camera with a reticle eyepiece for these tests; you will notice much more with your eye! Ultimately, if the telescope is not able to track correctly for several minutes, reduce the duration of each individual exposure. If this solution does not suit you, consider implementing guiding. The principle of guiding is simple: a star of adequate brightness is chosen within the photographed field or just outside of it, its position is monitored over short intervals, and the speed of the motors is constantly adjusted to compensate for the drift of the guiding star.

Do not confuse tracking speed and correction speed. Tracking speed corresponds to a uniform movement of the mount so that the telescope stays centered on an object. The basic speed is, of course, the sidereal rate that is used for stars, the nebulae, the galaxies, and even the planets and most asteroids. Some mounts offer other speeds, particularly solar and lunar rates and even a programmable speed to track a particular object such as a comet.

On the other hand, correction speed refers to the small adjustments of the tracking speed made during photographic guiding. Correction speed is expressed in fractions of the sidereal rate. For example, a correction speed of 0.3, or 30 %, means that when a correction is activated in RA, the mount slows down to 70 % of the sidereal speed toward the east or speeds up to 130 % toward the west.

For precise photographic guiding, the correction speed must be less than the sidereal speed so that all moving parts of the tracking mechanism in RA always turn in the same direction. Otherwise, a correction toward the east would lead to a reversal of the rotation direction, producing errors due to mechanical play, commonly referred to as gear backlash.

This technique assumes that the tracking system allows very small adjustments, about 1 arc second. This means that the mount offers slow correction speeds, less than sidereal speed. The high speeds employed to find objects (GOTO) are not usable for precise tracking. All midrange and high-end mounts offer at least one slow speed, often called *photo speed*.

Two technical solutions are available for guiding: parallel guiding and off-axis guiding.

Parallel Guiding

Parallel guiding is the solution that is used by most amateurs. It consists of installing, in parallel to the main telescope, another optical tube (short achromatic refractor or small reflector) dedicated to guiding. Apart from its cost, the main difficulty with this technique lies in reconciling two contradictory needs:

> ❯ Having a mounting system between the two tubes that is sufficiently rigid to eliminate differential flexure between them
> ❯ Having the means to offset the pointing direction of the guide telescope slightly to center a suitable guide star

Fastening the guide telescope with only a standard photographic tripod screw is generally not sufficient. Indeed, consider that a flexure of 1/1000" (0.025mm) at the end of a 500mm long guide telescope fastened in its center produces a blur of 20 arc seconds, much larger than the periodic error of a good-quality mount. In this case, the cure may be worse than the disease. The fastening system must hold the guide telescope at well-separated points, either with a dovetail bar, if it is very short, or with the help of two separated rings if the tube is longer.

To slightly adjust the pointing direction of the guide telescope, it can be mounted on a sturdy rotating head, or the rings can be equipped with adjustment screws, just like a finder. However, if the guide sensor is sufficiently large, and sensitive enough to find a suitable guide star at any place in the sky, a fixed mounting can be considered, and this greatly reduces the risk of flexure. Of course, no link of the mechanical chain that joins the two tubes should be weaker than the others.

The installation of a guide telescope in parallel increases significantly the total load on the mount and may cause balance problems on certain telescopes, especially those with forks.

Off-Axis Guiding

The off-axis guider is a small accessory placed just in front of the camera. It uses a small right angle prism to intercept a small portion of the light; the prism is just outside the imaging sensor's frame and positioned to avoid casting a shadow on the image area (however, a shadow may be visible with larger sensors and a telescope with a fast focal ratio). This prism directs the light toward an autoguiding camera (see the next section). It enables using dimmer stars than is possible with parallel guiding since it benefits from the larger aperture of the telescope (minus the off-axis vignetting!). It is lightweight and free of flexure, but finding and centering a guide star may be harder than

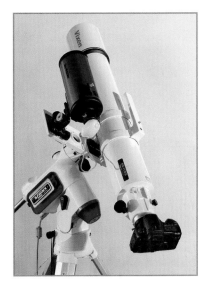

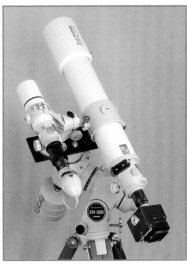

Two examples of the installation of a guide telescope on a rotating head. A small Maksutov telescope is a good solution because it is short and lightweight.

The off-center prism is easily visible in this photograph of an off-axis guider installed on a Newtonian telescope and equipped with a reticle eyepiece

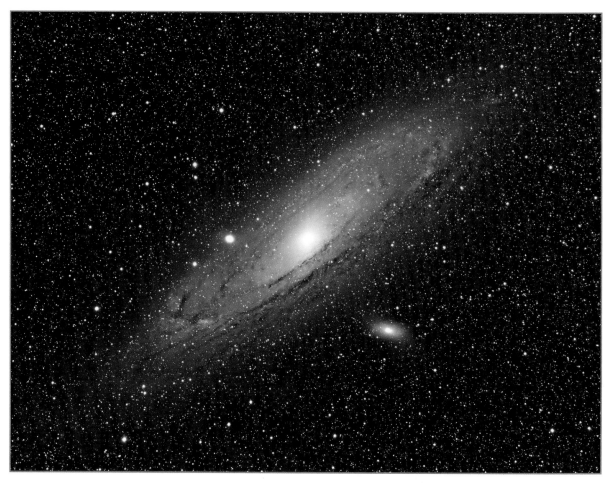

The Andromeda Galaxy (M31) taken with a 530mm focal length refractor and a CCD camera (LRGB)

with parallel guiding, forcing the user to rotate the guider (and the main camera) to find one.

Focusing must be done first for the main camera and then for the guiding eyepiece or camera by moving it inside the drawtube. Telescopes suffering from poor field coverage may produce distorted and blurry stars on the guider, but this is not a crippling problem for autoguiding. On certain instruments, however, mounting difficulties arise:

- ❯ With a Newtonian telescope, the increase in the distance between the telescope and the camera (back focus) may make it impossible to focus
- ❯ If a focal reducer or a field flattener is used, the insertion of the off-axis guider may confound the ability to place the sensor at the optimal distance

Autoguiding

Until the late 1980s, guiding was done only visually, using a reticle eyepiece inserted in one of the systems described earlier, and the hand paddle on the control pad of the mount was used to make tracking corrections in real time. Since the onset of the SBIG ST-4 autoguider camera in 1989, the eye has been superseded by a sensor and the brain by software. Properly used, autoguiding is a powerful means to obtain round stars that contribute to the sharpness and the beauty of an image. It is more precise, faster, and less tiring than visual guiding. However, it is not a panacea that would defeat gusts of wind or change a defective or badly adjusted mount into a perfect one. And, of course, it does not exempt the amateur from performing a good polar alignment.

The first image of this series shows a star photographed at a sampling of 1 arc second per pixel (for example, a camera with 7 micron pixels on a 1500mm focal-length telescope). Its full width at half maximum (FWHM, see chapter 4) is 1.75 pixels. The next images represent increasing FWHM blurs at the same sampling: 0.5, 1, 2, 4, and 8 arc seconds, respectively.

When the telescope is precisely maintained on the guide star, a polar alignment error manifests itself as a field rotation about the guide star. Since the amplitude of the blur is proportional to the angular distance between the guide star and object being imaged, it is better to choose a guide star inside the photographed field or as close to it as possible.

Despite its name, the autoguider does not do everything automatically: the calibration phase needs user attention. First, a guide star must be found and carefully centered, and then the autoguider is installed and focused with its axes preferably parallel to the mount axes. The exposure time must be long enough to produce a good signal-to-noise ratio on the images captured by the autoguider—without saturation, but short enough to have a correction update rate consistent with the drift of the star due to periodic error.

In the calibration phase, the autoguider has to learn in which direction and at what speed the star moves in the image when each of the four correction directions (east, west, north, south) is activated. To do so, it activates sequentially each correction for several seconds and then measures the new position of the star. After this is done, it will know, by a simple reverse calculation, which correction to apply to correct an error in guide star position.

Once the autoguider is calibrated, the autoguiding phase can begin and the guiding cycle tirelessly repeated: take an image, measure the drift, calculate the correction, and then correct the mount pointing. Then the main camera exposure can take place. The cycle time is generally from one-half to several seconds, depending on the brightness of the guide star. If this cycle time is too long, drifts may appear because the mount is rotating at a fixed rate between the two corrections.

Autoguiding programs offer an additional parameter, generally called *aggressiveness*. When it detects an error, a feedback system such as an autoguider must never correct it at 100%. Indeed, due to the uncertainties of measurement caused by seeing and noise, it must correct only a part of the drift, such as, for example, 50% to 70%. At 100%, oscillations and even instability may appear, increasing the drift instead of reducing it. On the other hand, if this parameter is too low (for example, 10%), the correction of an error such as a hop caused by grit in the worm gear will be too slow. When you start autoguiding, try different values to determine the one that gives the minimum average error.

Three standalone autoguiders: Lacerta M-GEN, LVI SmartGuider, and SBIG SG-4

Cameras and Software for Autoguiding

To guide a telescope, you can use almost any webcam, CCD camera, or video camera sold for astronomy along with a computer and software dedicated to autoguiding (such as Guidemaster, PHD Guiding, K3CCDTools, GuideDog, and Astro-Snap) or general acquisition and processing software (such as MaxIm DL and Astroart). A standard webcam needs a brighter star than other cameras because of its color sensor and particularly the limited exposure times. Here are some autoguiding options:

- A standalone autoguider (does not need a computer), such as SBIG SG-4, LVI SmartGuider, and Lacerta MGEN
- An astronomical video camera of the type used in planetary imaging (chapter 5) for use in conjunction with a program such as PHD Guiding or Guidemaster; for example, the iNova cameras (PLA, PLC, and so on) and the Orion StarShoot, preconfigured for autoguiding
- A two-sensor CCD camera that's able to simultaneously image and autoguide

Only Santa Barbara Instrument Group (SBIG) offers this dual sensor, clearly visible on the photograph of the KAF-3200E on page 27. The main sensor is used to acquire images while a smaller sensor, placed at its side so that focusing is equal on both sensors, collects light from a guide star. The advantage is that the system is compact, controllable with a single program (Prism, MaxIm DL), and

immune to flexure. With the STL series the guide sensor was placed behind the filter wheel and suffered from loss of light to the guide star when narrowband filters were used. The later STXL model solved this problem with a guide sensor fed by light picked off in front of the wheel.

In addition, with a mount containing an autoguiding port, a cable must be used to link it to the computer or to the autoguider. The cable can be purchased or home-made based on the mount manufacturer's instructions. Two types of connections are available, depending on the mount:

- A link based on digital data transmitted by a standard communication protocol, such as the LX200 protocol. Corrections orders are transmitted to the mount under the form of a logical command telling the direction and the amplitude of the correction to be made. This protocol was introduced by Meade, but some other manufacturers have copied the standard, such as, for example Astro-Physics and Vixen (SkySensor, now discontinued)
- An analog link using four electrical wires (one for each direction: east, west, north, and south). A correction is signaled by making a connection to a fifth wire (ground) for the required time. Takahashi mounts are of this type.

Adaptors are available to link an autoguider of one type to a mount of the other type. In addition, a lot of connectors

exist: serial, USB, telephonic (RJ11), and so on. Before using a given camera for autoguiding, find out which autoguiding software is compatible with this camera and what type of link and cable you have to use. In addition, some applications were developed to control mounts of a particular brand, especially EQMOD for Sky-Watcher, Orion EQ, and Vixen mounts. Also, there is an ASCOM standard protocol for communication between electronic equipment (mounts and pointing systems, focusing devices, cameras, filter wheels, etc.).

Experience shows that for good measurement accuracy of the guide star position, it is preferable that the sampling (see chapter 4) on the autoguider is less than twice that of the main telescope. Otherwise, it is always possible to place a Barlow lens in front of the autoguider.

The SBIG Adaptive Optics (AO) Systems

Since 1998 SBIG has offered, along with its other products, a fast autoguiding device to be placed in front of its dual-sensor cameras. A thick glass plate (6mm) is slightly tilted while it's driven by the autoguiding system, and this tilt causes a shift of the image on the sensor to compensate for tracking errors. The frequency of movement of the tilt element can be as fast as 8 to 40 frames per second, depending on the brightness of the guide star and AO device. This system is precise and is easy to calibrate and use. Above all, it is not as dependent on the quality of the mount and its mechanical play as other through-the-mount techniques are.

SBIG also offers remote guide heads that can be directly connected to the main camera. This head can even be used in conjunction with the AO system if it is associated with an off-axis device (a MOAG by Astrodon, for example), inserted between the main camera and the AO.

Starlight Xpress also offers a complete system using a similar principle (glass plate, off-axis device, and autoguide camera) named the SXV-AO and usable with any DSLR or CCD camera as the main imager.

Is Autoguiding Mandatory?

Autoguiding is not always essential. The two main parameters to consider are the periodic error and the sampling. Let's consider two very different situations:

- You use a mount whose periodic error is 30 arc seconds to take photographs of the sky with a 24mm wide-angle lens and a DSLR
- You use a mount whose periodic error is 10 arc seconds with a 2-meter focal-length telescope and a camera with 6.8-micron photosites

In the first case, the sampling is 60 arc seconds per pixel, twice the periodic error; guiding is not necessary. In the second case, the sampling is 14 times smaller than the periodic error, so the drift during one turn of the worm screw will be about 15 pixels; autoguiding must be employed.

Between these two extreme situations, defining a precise limit is difficult. An essential criterion is the tolerance you choose. Some amateurs accept a blur of several pixels because they reduce their images before displaying them, while others want perfectly round stars on the image displayed at full scale. One thing is sure: the larger the focal length, the more visible the tracking errors. If you want to keep astrophotography simple, stick with telescopes with short focal lengths, under 1000mm. Of course, such a focal length is not able to show as much detail as a longer one, but it is the price you have to pay for round stars!

Some final advice: If you use a DSLR, make your first imaging attempts without autoguiding. If you notice drift on most images, refine the polar alignment. If they persist, check to see if the drifts are along the RA axis and verify the adjustment of the RA worm screw (see appendix 5). If this is not sufficient, use a common solution for amateurs who do not want to use an autoguider: lessen the individual exposure time to a fraction of a turn of the worm screw and the fraction of bad images should decrease. But if this solution leads to too short of an exposure time, think about autoguiding...or changing your mount or your telescope!

THE END OF AUTOGUIDING?

Will high-resolution digital encoders eventually succeed in sending autoguiding to the museum of astronomical accessories? At this time (2014) their use is restricted to high-end mounts such as an Astro-Physics AP1600, ASA DDM, and 10 Micron HPS. The principle is simple: encoders installed inside the mount on each axis measure the rotational position with sub-arc-second accuracy (which means a resolution of at least several million steps per revolution). Using this positioning data, a simple electronic control system drives each motor so that the speed of rotation of the corresponding axis remains rigorously constant, thereby offsetting any periodic error in real time before it commits a misdeed. With this approach, polar alignment errors and flexures dictate the maximum allowable exposure time.

The globular clusters Omega Centauri (left) and M13 (right), imaged with a CCD camera and refractors of 530mm and 1100mm focal length, respectively, and printed at the same scale

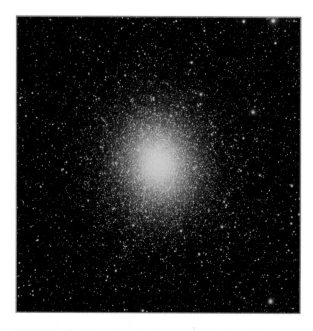

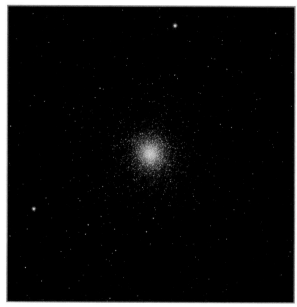

On wide-field photographs of the sky, the stars generally show pale colors and the constellations are not always easily recognizable. Their visibility can be improved by spreading their light, as on this photograph taken with a partially diffusing anti-Newton glass placed in front of the lens.

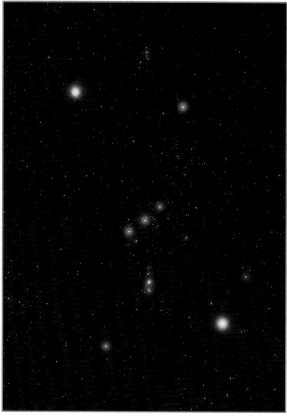

It's easy to photograph the double star Albireo due to its brightness and large angular separation, but it is also photogenic because the two stars exhibit strong colors. This exposure was 1 second with a DSLR using an 800mm refractor. Close double stars need planetary techniques: focal length extenders and video cameras.

Deep-Sky Objects

The term *deep-sky* encompasses different families of celestial objects quite varied in nature, dimension, and morphology. Special attention must be paid to the wavelengths of luminous radiation they emit because the optimal way to photograph them and to process the resulting images is deeply linked to this attribute.

Stars

Like the sun, the stars glow with a continuous spectrum: all wavelengths (all colors) of visible light are represented in various proportions depending on the surface temperature and composition. The most massive and hottest stars look bluish, while smaller and colder stars look reddish and emit little green and blue light. The sun is a yellow-white star.

Open clusters such as the Double Cluster in Perseus (shown on page 145) are numerous in the Milky Way and often contain young, hot stars. Their apparent angular size range is quite variable and can exceed one degree, as in the case of the Pleiades or the Hyades, famous open clusters in Taurus.

Globular clusters are old and mainly made up of old and yellowish stars; these stars have a much longer lifetime than the massive ones you'll find in open clusters.

There are several hundred globular clusters surrounding our galaxy. The most impressive are in the southern celestial hemisphere. Omega Centauri, whose apparent diameter is 1°, and 47 Tucanae, in the vicinity of the Small Magellanic Cloud (SMC), are both examples of globular clusters. Omega Centauri is visible for viewers observing from south of about 30° north latitude. In the Northern Hemisphere, the most famous is M13 in Hercules, spanning 20 arc minutes.

Outside the vicinity of our galaxy, the biggest globular clusters surrounding other galaxies like M31 (the Andromeda Galaxy) and M104 (the Sombrero Galaxy) can be photographed as very small diffuse patches.

Some close stars show measurable movement against the background stars. The fastest is Barnard's Star in Ophiuchus, six light-years from the sun, with an apparent speed of 10 arc seconds per year, which makes its movement easily detected on photographs taken one year apart. Its magnitude is 9.5.

Diffuse Nebulae

Diffuse nebulae are large clouds of gas (mainly hydrogen) and interstellar dust that give birth to stars. Almost all nebulae that amateurs can photograph belong to our galaxy and therefore are more numerous in the Milky Way. For photography, two main types must be considered: reflection nebulae and emission nebulae.

Reflection nebulae are illuminated by nearby stars. They show a continuous spectrum, with a bluish tint caused by the preferential scattering of blue light by very small particles of dust. The most famous are the nebulae that surround the main stars of the Pleiades and NGC 1975, which lies in the shadow of its neighbor M42 (the Orion Nebula).

Emission nebulae are more numerous and possess a totally different spectral signature. Their matter is ionized by radiation from surrounding stars, reflecting little of this light, reemitting it instead. This emission of light occurs

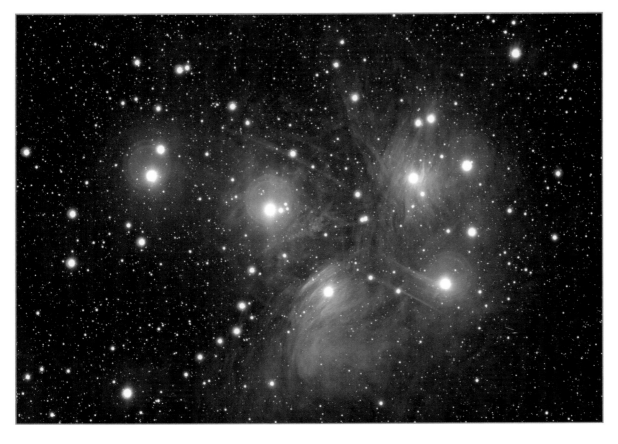

The main stars of the Pleiades are surrounded by reflection nebulae

The relative proportions of different emission lines in the light of M8, the Lagoon Nebula in Sagittarius

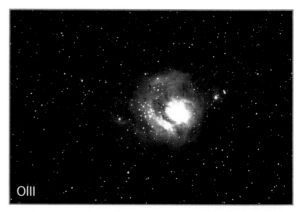

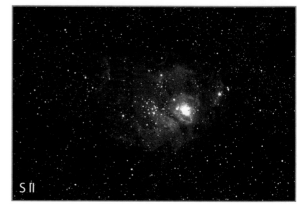

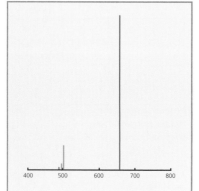

The main spectral lines of emission nebulae: from left to right: Hβ, OIII (double line), Hα. The relative intensities may vary from one nebula to another, but Hα is always dominant, followed by OIII and Hβ.

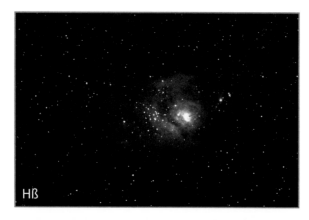

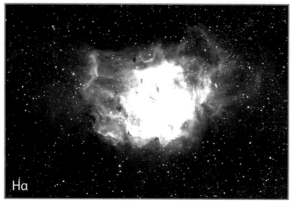

within extremely narrow-wavelength bands, with precise values that physicists call monochromatic emission lines. The spectrum of the nebulae is discontinuous and gives information about their chemical composition because each element (hydrogen, oxygen, sulfur, nitrogen, helium, etc.) has its own emission line wavelengths. Two of these elements are most prominent in the visible spectrum:

- Hydrogen, which emits a series of lines, the main ones 656.3 nm (the Hα line) and 486.1 nm (the Hβ line). Hα and Hβ are pronounced H alpha and H beta, respectively.
- The doubly ionized oxygen that emits two lines at 495.9 nm and 500.7 nm (the OIII lines), the longer wavelength line is always more intense than the first. OIII is pronounced O three.

Some other lines can be found in nebulae, especially SII (ionized sulfur) in the deep red, not far from Hα at 674 nm.

The true color of each emission line can be assessed by looking through the filters toward a white surface, during the day. The Hα line is deep red, the Hβ is blue-green, and the OIII lines, although theoretically placed at the limit between green and blue, are greener. The Hα line always dominates; for many nebulae it is the only line that's easily detectable. Unfortunately, our night-adapted vision is almost blind to this wavelength.

When we observe emission nebulae through a telescope, our eye mainly perceives the OIII lines, giving the brightest nebulae their greenish tint. We do not see the colors of the fainter nebulae since our night-adapted vision sees objects in black and white (all cats are gray in the dark!).

There is one other type of nebula: the dark nebulae. Without any nearby or internal star, they do not reflect or emit light. They are visible only because they mask the stars or the bright nebulae behind them. The most famous are the Coalsack (a big dark nebula in the Southern Cross)

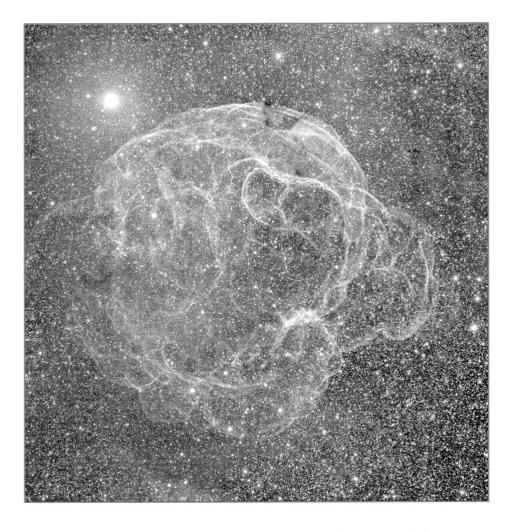

Simeis 147 (also known as Sh2—240) is a supernova remnant about 40,000 years old. It spans more than 3° between Taurus and Auriga. Its low brightness required several hours of exposure with a CCD camera, an Hα filter, and a 300mm telephoto lens in December 2007, when the planet Mars (top left) visited the area.

and the Horsehead Nebula in Orion, the area around the Horsehead showing all types of nebulae: emission, reflection, and dark (photograph on page 24).

The range of angular sizes of emission nebulae is broad, with the largest spanning several degrees. By the way, is it difficult to give precise limits to the large nebulae complexes such as in Orion that encompass the area of M42, the Horsehead Nebula, and Barnard's Loop.

Planetary Nebulae

Planetary nebulae are shells of matter with a quasi-symmetric shape surrounding a star. Their name comes from the fact that astronomers thought that they were gas and dusk cocoons surrounding a young star and a budding planetary system. Nowadays we know that they are actually stars that have expelled a part of their matter into space at the end of their life. Their radiation, essentially entirely composed of spectral lines, is close to that of the emission nebulae. Numerous chemical elements are detectable, but mostly hydrogen and oxygen again. Relative intensities of lines differ from one planetary nebula to another, but it is generally OIII at 500.7 nm that dominates,

The contribution of different emission lines to the visible radiation of M27, the Dumbbell Nebula in Vulpecula. Notice the deep morphological difference between the OIII and Hα regions.

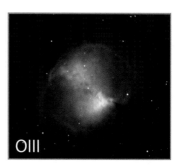

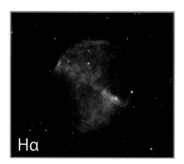

The main lines of planetary nebulae are identical to those of emission nebulae, but this time OIII is generally dominant

The Helix Nebula, photographed with a CCD camera and broadband RGB filters. Hα constitutes most of the light of the external shell, while OIII is mainly visible in the central area. There is a second external shell, much dimmer than the rest of the nebula, of which a portion is discernable in the top of the image.

giving the brightest ones their characteristic greenish tint. After OIII at 495.9 nm, Hα and Hβ are the next most prominent spectral lines.

Other lines can be found, especially sulfur and helium, in addition to an ionized nitrogen line at 658.4 nm (NII), very close to Hα and very bright in M57 (the Ring Nebula in Lyra). NII is so close to Hα (2 nm) that it can be separated from its neighbor only with the narrowest available Hα filters (3 nm) coupled with a telescope with a high focal ratio (at least 8). For instance, at f/5, the rays arriving from the edges of the telescope aperture pass through the filter with an angle of 5.7° from the normal, which causes a shift of the NII filter bandpass of 1.5 nm toward the blue, almost on top of the Hα line. Since this wavelength shift is inversely proportional to the square of the focal ratio, it is reduced by 4—from f/5 to f/10. If the filter has a bandpass

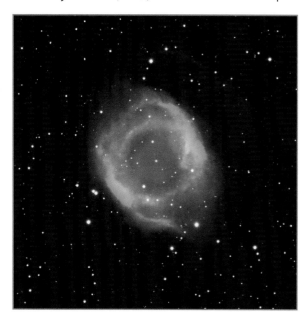

greater than 4 nm, both lines get mixed together.

The planetary nebula with the largest apparent diameter is NGC 7293, the Helix Nebula in Aquarius, which spans about half the angular size of the full moon. It is followed by M27, which measures 7 arc minutes. Most planetary nebulae are smaller than 1 arc minute and you therefore need a longer focal length and finer sampling than most emission nebulae to obtain a detailed view.

Galaxies

Galaxies emit a continuous spectrum because stars are the main contributors to their light. The heart of a spiral galaxy generally appears reddish or yellowish because it is composed of old stars, while the spiral arms contain more young stars, which gives them a bluish tint. Most elliptical galaxies (such as M87, the largest galaxy of the Virgo Cluster) contain old stars and show a yellowish color.

Except for a few galaxies (M31, M33, and the two Magellanic Clouds), none exceeds half a degree in size. The famous Whirlpool Galaxy (M51 in Canes Venatici) covers 10 arc minutes. The largest galaxies of Leo, Virgo, and the Big Dipper span between 5 and 15 arc minutes. These areas encompass magnificent galaxy clusters and contain thousands of galaxies smaller than 1 arc minute that are accessible to long-exposure photography—a good occasion to venture off the beaten track!

Quasars are very distant and bright galaxies that appear only as points, like stars. The most famous is 3C273 in Virgo, which has the greatest brightness: magnitude 13. It is easy to photograph as soon as it has been located relative to the surrounding stars. Thousands of other quasars are sprinkled across the celestial vault, but their magnitude, rarely brighter than 18, requires much longer exposure times.

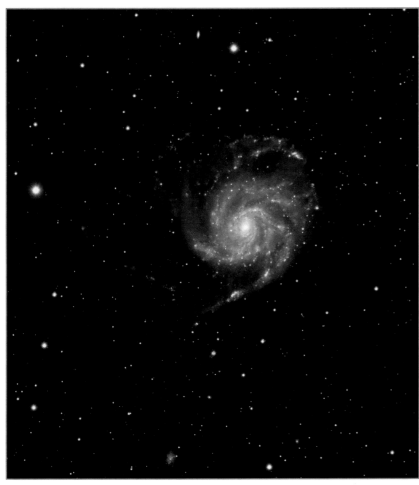

Galaxies such as M101 in the Big Dipper often include small HII regions that show a mix of red (ionized hydrogen) and blue (young stars)

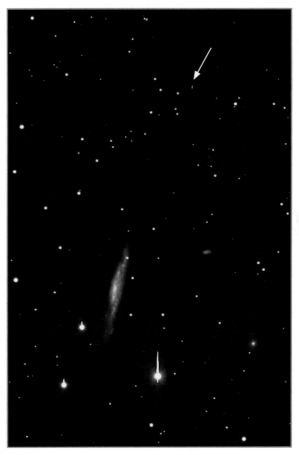

In this crop of the galaxy M101 obtained in a few minutes of exposure with a DSLR and a refractor, the bright spot to the right of the core is not visible on the image of the same galaxy at left. This is the supernova SN 2011fe that appeared in August 2011. Peaking at magnitude 10, visually accessible to a 2" telescope, it was one of the brightest supernovae in 20 years.

An exposure of 30 seconds with a 5" refractor and a DSLR is sufficient to photograph the brightest quasar, 3C273

The double quasar in the Big Dipper, which is near galaxy NGC 3079. Although 50 times dimmer than 3C273, it is one of the few gravitational lens mirages accessible to amateurs; one of the two components is a gravitational image of the other produced by a galaxy too faint to be photographed. Because they are 5.7 arc seconds apart, a sampling of 2 arc seconds per photosite is necessary to separate them well.

Comets

These wanderers through the solar system reflect the light of the sun, and so their spectrum is mostly continuous. Typical comets are composed of a head, a colorless dust tail, and a bluish gas tail. Some emission lines are often present in the head, especially molecular carbon lines (C2) between 450 and 550 nm, giving them a greenish tint.

The main difficulty of comet photography comes from their movement against the stellar background. Comparison of their angular speed with the arc-second-per-pixel sampling recommended allows determining the approximate maximum exposure time, considering the fact that a comet is a somewhat fuzzy object and therefore hides a small blur better than stars would. A nice comet visible to the naked eye can drift hundreds of arc seconds in an hour; in this case, use a short focal length and short exposure times, and when processing, register the series of images on the nucleus. There are two ways to avoid this extra effort:

- Use a computerized mount with programmable speeds in RA and Declination
- Autoguide on the nucleus of the comet if this nucleus is not too dim or fuzzy. Besides wide-field photographs showing the complete comet with a background of stars, detailed views of the nucleus or the tail of the comet taken at a longer focal length can reveal changes day by day or even hour by hour, such as sudden jets of gas or dust and sometimes even fragmentation of the nucleus.

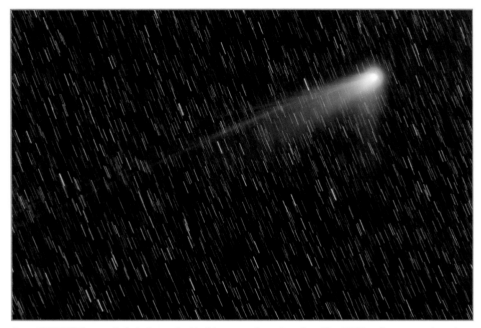

Comet NEAT (C/20001 Q4) photographed in May 2004 from Angola with a DSLR and a 200mm lens, in 13 exposures of 5 minutes. The camera was installed on an equatorial mount with tracking speeds in RA and declination that had been set to follow the movement of the comet against the stars.

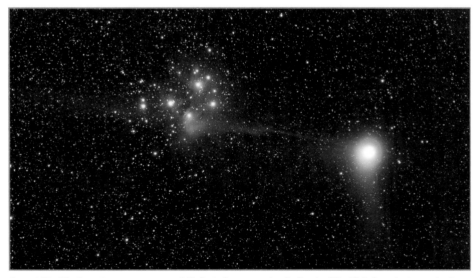

Comet Machholz on January 7, 2005, while its tail was passing in front of the Pleiades, photographed in four exposures of 5 minutes each with a 200mm lens and a DSLR

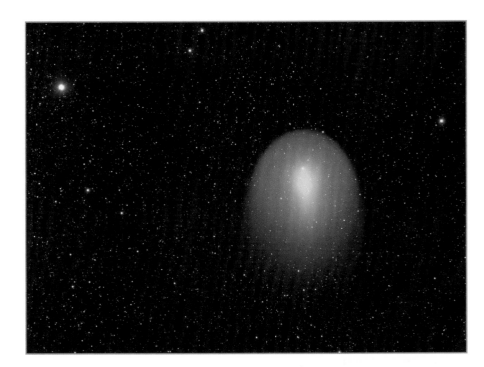

With its unexpected brightness and atypical shape, Comet Holmes left its mark in the autumn of 2007

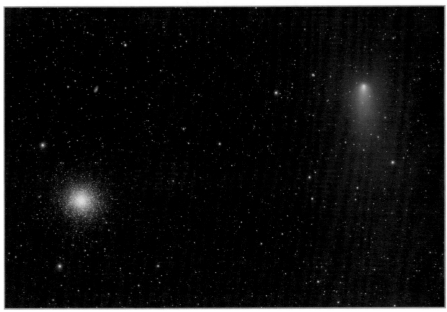

On May 4, 2006, the comet Schwassmann-Wachmann 3 grazed the globular cluster M13

Vesta was of magnitude 8 when it was photographed in 1 second with a DSLR on a 4" refractor. This portion of two exposures, taken 1 hour apart and combined, shows its movement against the stars.

Asteroids

As with stars, no terrestrial telescope is able to enlarge the asteroids enough to show surface details or even their shape. Photographing them is similar to photographing stars, except that they have their own movement, like comets. Their angular speed against the stars depends mainly on their distance to Earth. The small Earth-crossing asteroids that are likely to approach our planet may have, at closest approach, rapid movement exceeding several degrees per hour. They need a computerized mount to locate and track them based on their orbital data.

However, the vast majority of asteroids orbit within the asteroid belt between Mars and Jupiter and have a relative movement of about 1 arc minute per hour. Depending on the sampling value and the exposure time, the asteroid may appear as a star or as a small line showing its movement. As for the planets, each asteroid also has opposition periods during which it is closer and brighter.

The brightest asteroids have a magnitude of about 6 at opposition; as a result, photographing them is easy, even with a video camera. Thousands of asteroids are known and the list lengthens every day, but their magnitude is generally more than 15. Asteroids are common on deep-sky photographs taken in the direction of the ecliptic.

The asteroid 19458 Legault (magnitude 17 at opposition) can be spotted on this photograph through its small movement during 1 hour of exposure (CCD camera on 5" refractor). During one of the individual exposures, the tail of a plane passed through the field of view, which was briefly illuminated by its strobe lights, freezing the plane's movement.

It only took 1 minute for the small near-Earth asteroid 2012 DA14 to leave a trace of 15 arc minutes, half of a lunar diameter (dotted circle), 2 hours after its passage only 21,000 miles (34,000 km) from the center of the earth

Since 2006, Pluto has been classified in the dwarf planet category, in the company of Ceres and Eris. Its apparent diameter (about 0.2") prevents the amateur from perceiving it as other than a star, and its less-than-magnitude-13 brightness requires deep-sky-length exposures. Once its approximate position is determined with planetarium software such as TheSkyX, Stellarium, or Starry Night, the best way to identify it is to notice its movement relative to the stars that surround it. On these crops of 10 stacked 30-second exposures, taken with a 130mm aperture refractor and a DSLR, Pluto moved 1.5' relative to the background stars in the space of 24 hours.

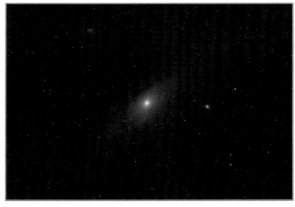

This accumulation of 1-minute exposures over a total period of more than 6 hours, 30 minutes at the prime focus of a 1100mm focal-length refractor without motor drive shows that geostationary satellites (here an Astra family group) are not perfectly motionless in the sky but slightly oscillate about a mean position. CalSky.com calculates the positions (altitude and azimuth or right ascension and declination) of all geostationary satellites visible from a given location, making them easy to target using a GOTO mount.

The Atmosphere

For deep-sky imaging, the qualities desired of the atmosphere and the telescope are quite different than for planetary imaging. For faint objects, the atmospheric transparency is an important factor: if the air is foggy or hazy, the signal will be weakened and the light pollution probably more corrupting. High-altitude sites that are located above the soot that can affect the lower layers of the atmosphere are best for deep-sky photography.

Pollution by carbon dioxide or ozone is invisible and is not a problem for astronomy. In contrast, the light pollution associated with cities is a disaster for astronomers because the darkness of the sky is critical for deep-sky observation and photography. As you saw in chapter 3, the sky background is a signal that is accompanied by noise that can obscure faint objects. From highly polluted sites, this is the dominant noise in the image, far greater than

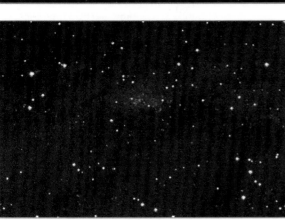

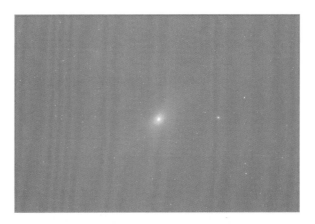

These two raw images of M31 have been obtained with the same telescope (4" refractor at f/5), the same DSLR, and the same exposure time (3 minutes). The first one has been taken from a mountain site, while the other was taken from my home, 30 km from Paris (often called the City of Lights).

Close-up on the two M31 images. Now they have been calibrated and the sky background level subtracted, but the associated noise, which cannot be removed, obscures the fine structure of the spiral arms on the polluted image.

other sources of noise. Even photography of bright objects such as the Orion Nebula is degraded. From moderately polluted sites, obtaining the same signal-to-noise ratio as from a dark site requires much longer exposure times, and even with extremely long exposure times (tens of hours), the signal-to-noise ratio reaches a ceiling and cannot equal what could be obtained in the absence of pollution.

The spectrum of a light-polluted sky is quite complex and depends on the type of lighting used in the vicinity. Mercury and low-pressure sodium vapor bulbs, common in public lighting, as well as fluorescent lamps have emission lines mainly situated in the 400 to 440 nm (blue) and 540 to 600 nm (green) bands. Incandescent and high-pressure sodium bulbs are different: they emit a continuous spectrum with a peak in the green and red.

The Moon also causes natural light pollution. The amount strongly depends on the moon's phase: while small in the crescent phase, it is very intense at full moon. The phenomenon is the same as the scattering of light by the sun during daylight; the sky during a full moon is blue.

At typical amateur sites, and at short focal lengths (under 500mm), the seeing has little or no importance. But over 1000mm, it may become perceptible, and at over 2000mm it becomes a determining factor affecting the sharpness of the image. If you live in a place where the seeing is often mediocre, you will suffer from oversampling and derive little benefit from a longer focal length.

Color, Black and White, and Filters

Colored filters have considerable utility in deep-sky astrophotography. There are two types of filters, the ones that help to acquire color images with a monochrome sensor and the ones that reduce light pollution.

Broadband Filters

As shown in the spectral transmission curves of chapter 2, the red, green, and blue filters that are integral to color sensors are broadband filters, that is, they transmit a wide range of wavelengths, with a bandpass about 100 nm wide. The RGB filters sets offered by astronomical manufacturers are of a similar type. All these filters are suited to terrestrial objects illuminated by the sun and produce images whose color rendering is close to that perceived

when visually viewing a sunlit scene. Therefore, they give good results on celestial sources with continuous spectra: stars, galaxies, reflection nebulae, and comets. When it comes to color photography of these objects, there are no special challenges, even if different filters sets may give slightly different results.

The situation is different with emission and planetary nebulae. The response of the sensor (color sensor or monochrome sensor with additional filters) depends on the positioning of the transmission bands of each filter with respect to the emission lines. A slight shift of these bands may deeply modify, both in intensity and in color rendering, the way that the camera will show the nebula, especially considering the following two points:

- The Hα line lies close to the upper limit of the transmission band of the red filter of most color sensors (taking into account the infrared-blocking filter), leaving some of them with low sensitivity for this line.
- OIII and Hβ lines lie at the boundary between the blue and green bands. Depending on the exact position and overlap of these bands, the transmission and therefore color rendering may vary strongly between blue, cyan, and green.

For example, the Canon DSLRs have good sensitivity to OIII, roughly equal between green and blue photosites, giving this line a cyan tint (while it looks more green in the eyepiece). Unfortunately, the sensitivity on Hα is very low. These cameras, as well as DSLRs from other brands, yield emission nebulae images with a color between red, blue, and magenta.

On the other hand, all astronomical RGB filters sets offer excellent transmission of Hα, over 90%. However, as for color sensors, the rendering of OIII may vary significantly between blue, cyan, and green.

When CCD imaging was introduced in the 1990s, color images were created by combining red, green, and blue images obtained using monochrome sensors and RGB filters sets. The drawback of this method was that it required a long total exposure time to achieve good signal-to-noise performance. Nowadays, monochrome sensors are still widely used in astrophotography because of their high sensitivity, but most color images are obtained with four filters instead of three. The fourth one is called

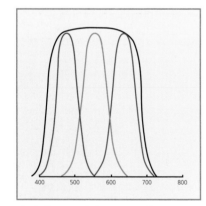

Typical transmission curves of astronomical broadband filters for use with monochrome sensors. The black curve corresponds to a filter generally called visible *or* luminance *and designed to transmit all visible wavelengths, blocking ultraviolet and infrared. Another filter, called* clear, *is sometimes used; it transmits all wavelengths just as if there were no filter but it keeps the same focus position used for the other filters of the set.*

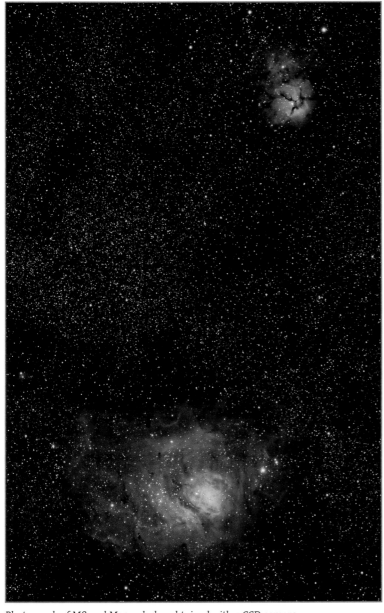

The transmission curves of these two sensors (imaginary but realistic) are almost identical, the curves of the second one being slightly shifted toward longer wavelengths. The difference is imperceptible in everyday photography as well as for galaxies and stars. But, on the emission lines (circles), the rendering is different. With the first sensor, the sensitivity in Hα is low and OIII is mainly detected by the green photosites: a planetary nebula may appear greenish. With the second one, Hα is better detected and OIII is mainly collected by blue photosites: a planetary nebula may look magenta, a mix of red and blue.

Photograph of M8 and M20 nebulae obtained with a CCD camera and an RGB color filter set. The preponderance of Hα is obvious.

M8, a nebula in Sagittarius, photographed with a DSLR. The deficit in Hα is significant.

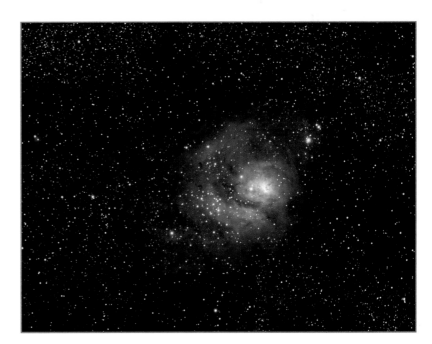

Green Filters **Blue Filters**

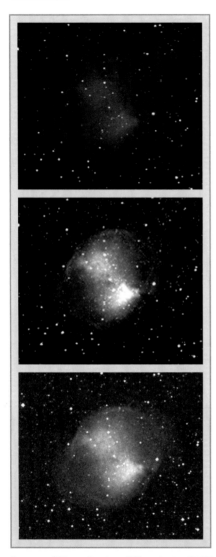 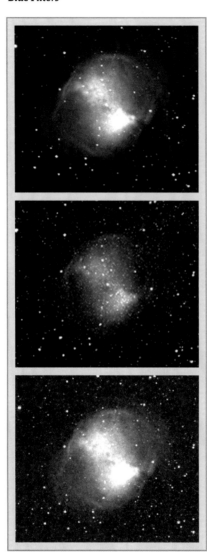

The Owl Nebula (M97) photographed with a CCD camera and the RGB filter set number 1

luminance and it's transparent to all visible wavelengths; it is designed to produce the most important element of the result, the channel that has the best sharpness and the best signal-to-noise ratio.

The assembly technique, called LRGB, is based on a property of the human vision: the details of a scene are essentially perceived through its monochrome component, called its luminance. Its colored part (the chrominance) can be of relatively mediocre quality without serious consequence to the appearance of the image. This interesting property has been used for a long time with TV broadcast images, where the luminance and chrominance are separated, the main part of the bandwidth being devoted to the luminance channel without visible damage to the final image. Thus, the red, green, and blue images are used just to colorize the luminance image and the exposure time used for the RGB components can be much shorter than before. They can even be obtained with 2 × 2 binning. Finally, the result is better than the one obtained with a color sensor using equivalent total exposure time.

Images of M27 using two different sets of RGB filters: Green (left column) and blue (right column).
 A CCD camera was used to obtain set one (top row) and set two (middle row). For the first set, OIII is essentially transmitted by the blue filter, while with the second set, the colors are better balanced with an equal transmission of OIII by both the blue and green filters. Note that for both sets, the transmission of the red filters for Hα is good.
 The third set of images, on the bottom row, were taken with a Canon DSLR. The blue filter of the sensor (bottom right) shows better transmission of OIII.

Two general choices are available for broadband filters:

1. Filters whose color is identified by their *Wratten* number: 56 green, 25 red, etc. Numerous manufacturers of astronomical accessories offer them; they are inexpensive and generally used for the visual observation of the planets. They are seldom used for color imaging because they are too absorbing, especially the blue and green ones. Moreover, they are transparent to infrared, producing odd colors in RGB images.

2. Dichroic or interference filters, although more expensive, are more selective and offer a better transmission, over 80 %. Moreover, they block infrared. Another advantage is that most filters sets are parfocal: the focus is identical between filters (same optical thickness), saving time at the telescope.

A comparison of Wratten filters (top) and astronomical RGB filters (bottom) show the superiority of the latter in terms of color transmission. Note that this photograph is not totally realistic with regard to the real color of the filters because the camera has used its own filters in capturing this illustration.

Narrowband Filters

Most observers of planetary and emission nebulae use narrowband filters (called OIII or UHC), with bandwidth about 10 to 20 nm. The advantage of these filters is that they transmit about 90 % of the two OIII lines while rejecting all other wavelengths, reducing the light pollution by a factor of more than 10. They are most useful in urban sites or when the moon is present, but they also improve the contrast and the signal-to-noise ratio in rural skies. They dim the stars to a similar extent, reducing the blooming effect for sensors without an anti-blooming capability and enhancing the nebulae in areas rich in stars. Of course, they are useless for broad-spectrum objects: stars, galaxies, and reflection nebulae.

Numerous astronomical manufacturers offer narrowband filters sets for photography that cover the main emission lines: Hβ, OIII, Hα, and SII. The most used is Hα, of course, which suits all emission nebulae. The OIII filter is particularly useful on planetary nebulae. Bandwidths from 3 nm to 15 nm are available; the narrower the bandwidth, the more efficient the elimination of the pollution, but also the more expensive. Filters of 3 nm to 4 nm are compatible with focal ratios above 5; for a focal ratio smaller than 5, a 5 nm to 10 nm filter is preferable because, for optical reasons, the light cone is too wide for an ultra-narrow filter and can cause some loss of light.

Even if narrowband filters are primarily designed to be used with monochrome sensors, nothing forbids their use

These three filters transmit 80 % to 90 % of the Hα line but have different spectral bandwidths. On the left, a simple red filter of 100 nm bandwidth; in the center, a 14 nm filter; and on the right, a 5 nm filter. The latter is the most efficient to remove the light pollution but it is also the most expensive. The transmission curve of narrowband filters is usually not square but instead bell-shaped, and the bandwidth figures given by the manufacturers correspond to the spectral width where the transmission is half the peak transmission (similar to the calculation of FWHM explained in chapter 4).

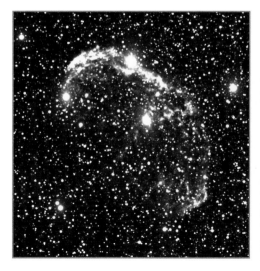
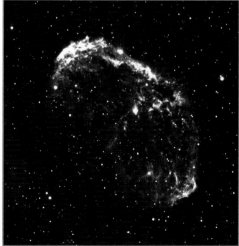

These two images of the Crescent Nebula were taken with a CCD camera equipped with a broadband red filter (left) and a narrowband Hα filter (right).

with a color sensor on emission or planetary nebulae in order to reduce strong light pollution. Of course, since the narrowband filter is superimposed on the sensor filters, only those photosites whose color overlaps with those of the narrowband filter are sensitive. Thus, an Hα filter illuminates only the red pixels, one-fourth of the total sensor photosites. In this situation, all the objects in the photograph will take the color of the filter, and the corresponding layer (red in the case of Hα) must be extracted during processing to produce a monochrome image. This solution is much better than setting the camera in monochrome mode since this mode mixes the desired layer with the others where there is nothing but noise.

Numerous other filters are available, with names such as UHC (for Ultra High Contrast), NBN (for Narrow Band Nebula), Nebular, and Deep Sky. Their bandwidth is 20 nm to 60 nm and centered on OIII and Hβ lines, making them less efficient than narrowband filters. Some of them are designed for visual observation. Their transmission at Hα and even in the infrared may vary hugely from one model to another. For photography, it is important to carefully check their transmission curve.

As for broadband filters, narrowband filters are available in two diameters: 1.25" and 2" (circular or square), to be chosen based on the size of the sensor. When several narrowband filters are used, it's possible to reconstruct a color image (see pages 198 and 199). For DSLRs, another possibility is for special filters to be placed in the entrance plane of the camera body, just in front of the reflex mirror.

The Astronomik clip-filters are available for Canon APS-C sensors in narrowband and light-pollution variants. All Canon lenses are compatible with them except for the EF-S family.

Light-Pollution Filters

Retailers also offer light-pollution filters, with names such as LPS (Light Pollution Suppression), LPR (Light Pollution Rejection), and CLS (City Light Suppression). Their bandwidth is larger than those of the filters described earlier, hundreds of nanometers or even more. Their intent is the elimination of the main urban pollution emission lines (mercury and sodium). Unfortunately, their utility is poor for reducing light pollution when observing objects with a continuous spectrum, so it would be better to talk about pollution reduction instead of pollution elimination.

According to the manufacturers, light-pollution filters are also usable on stars and galaxies, but they are much less efficient for improving the contrast of emission and planetary nebulae than narrowband filters. They should be considered to be all-purpose filters that may help a bit in moderately polluted sites. Used with a color sensor, they produce a large color shift, although it is less pronounced than for narrowband filters.

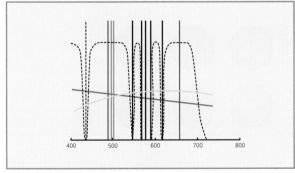

A transmission curve for a typical antipollution filter. The main emission lines of urban lighting are drawn in black, the continuous spectrum of incandescent bulbs in yellow, and the lunar skyglow in blue.

The installation of a filter (broadband, narrowband, or light pollution) is easy with a CCD camera equipped with a filter wheel. In the case of a DSLR, a ring that allows placing the filter in front of the camera must be found. Attaching to a photographic lens is more problematic: the filter will be placed either at the rear of the lens, if a slot is available (some telephoto lenses have this kind of filter slot), or at the front of the lens, if its thread is compatible with the standard filter thread of the lens.

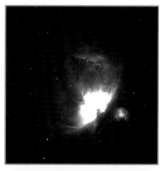

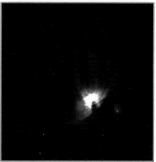

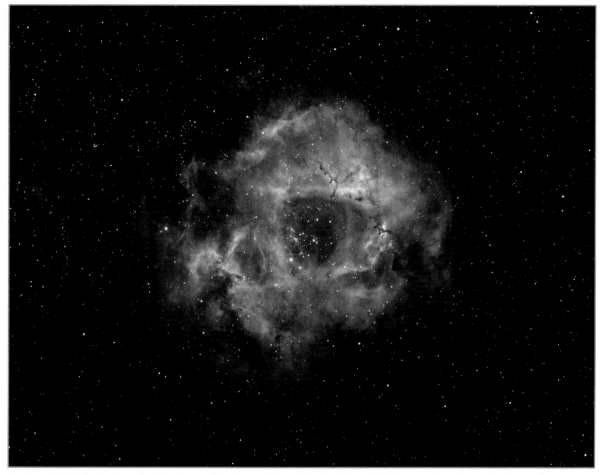

The Rosette Nebula photographed in 5 hours with a Canon 6D modified by Richard Galli (www.eosforastro.com). The very first processing step consisted of extracting the red pixels (5 megapixels among 20) from all of the RAW and calibration files.

These two images of the Orion Nebula were taken with a CCD camera equipped with an Hα filter. On the bottom, the IR-blocking filter extracted from a Canon DSLR has been put in the light beam, this filter transmitting only about 20 % of Hα (the same experience with an OIII filter shows that the IR-blocking filter has good transmission for this line, about 95 %). Add to this fact that, for DSLRs, only one photosite on four receives Hα light! In short, fewer than five Hα photons out of a hundred are captured by a DSLR sensor, against 100 % for the monochrome sensor.

DSLRs: Infrared-Blocking Filters and H-Alpha

As seen in chapter 2, the colored filters that cover the photosites of a color sensor are transparent to the infrared between 700 nm and 1000 nm. This is why an additional filter (infrared blocking or IR blocking) rejecting this portion of spectrum is placed just over the sensor by the camera manufacturer. It's the price you pay to obtain differentiated and realistic colors...at least for daylight illumination. But much of the Hα light is rejected because, unfortunately, the cutoff wavelength of these filters lies just short of this line. As a result, the balance sheet of received photons is disastrous. Not only is just one photosite out of four able to receive Hα, but on most DSLRs, the absorption by the IR-blocking filter may exceed 80 %.

For a nebula such as the one shown on page 62, obtained with a monochrome CCD camera on a 4" refractor, the loss of Hα photons caused by the use of a DSLR would be equivalent to reducing the aperture to less than 1 inch! This calculation is actually optimistic because the rare Hα photon received would be drowned in background light and the associated noise that would not have decreased. It is likely that even with a huge increase in the exposure time, the loss of photons could never be overcome.

To improve the sensitivity to the Hα line, amateurs remove the IR-blocking filter placed over the sensor of their

The IR-blocking filter that covers the sensor of a Canon DSLR has a slightly bluish color that hints of its absorption in the infrared and deep-red wavelengths

Canon DSLR. Of course, this operation has the potential to damage the camera and voids the warranty, considering that the operation requires almost complete disassembly and reassembly, soldering iron in hand. Once the filter is removed, three options are available:

- Replace the original filter with an IR-blocking filter (KG3 glass), whose cutoff frequency is located just beyond the important 656.3 nm line. On emission nebulae, the gain on the Hα line is significant (typically four to five times). The gain is zero on OIII as well as stars and galaxies. Daytime photography is still possible because autofocus works, with the condition that the replacement filter has the same optical thickness as the original filter (to a few hundredths of a millimeter). The slight shift in the color balance due to the surplus of red can be compensated with a custom setting of the white balance, determined using a gray card (see appendix). The colors of the stars and galaxies therefore remain realistic.
- Replace the original filter with a clear filter (transparent to all wavelengths) of the same thickness. The near-infrared radiation is now available, and autofocus remains functional. To again achieve realistic colors, you must add an IR-blocking filter (an Astronomik clip-filter, for example), otherwise the IR will "pollute" all colors. An additional risk with a refractor or objective lens is that the focus may be slightly different between the infrared and the visible, making it difficult to achieve a good focus.
- Don't replace the original filter (total defiltering). All wavelengths are available, as in the previous solution, but the autofocus does not work anymore, and focusing at infinity with most lenses is no longer possible due to the focal shift caused by the absence of the filter. Focus is only possible in live-view mode with a telescope.

Several specialized companies can carry out these modifications on an already purchased DSLR or on a new camera body (Hutech). After the 20Da was released in 2005, Canon offered the 60Da in 2012, an astronomical variant of the 60D corresponding to the first option with a special IR-blocking filter transmitting more than 60% of Hα (against about 20% for the original filter). Unfortunately, its high cost made it less attractive than the third-party modifications described previously.

Selecting and Setting the Camera

You can use any camera capable of exposures longer than 30 seconds for deep-sky photography. A compact or intermediate camera can be used only for piggyback imaging, but most of them have exposures limited to 10 to 30 seconds, and their image quality is much lower than that of the best DSLRs in terms of noise and dark current. On a telescope, a DSLR is installed without its lens and, if necessary, behind a field corrector or a focal reducer.

Needless to say, the number of pixels is a major parameter for most people when it comes to buying a digital camera. But the image quality does not depend directly on it, no more than the quality of a book is proportional to the number of pages it contains! A given camera with 10 million photosites may deliver better images that another camera with twice as many photosites but poorer electronics or quantum efficiency. For equal sensor sizes, more photosites implies that the photosites are smaller. This means that more details can be recorded, but only if factors like the instrument quality, focusing, tracking, and seeing permit it. In addition, this means that fewer photons reach each photosite during a given time period, leading to a lower signal-to-noise ratio for each photosite.

Most CCD cameras have desirable characteristics, such as cooling, a USB link, 12V power supply, and so on. An important additional criterion is the sensor: the number and size of the photosites and the quantum efficiency, the latter varying by more than a factor of two from one sensor model to another. Another criterion may be the autoguiding capabilities of the camera. The presence of temperature regulation is also important because it makes the dark signal repeatable from frame to frame, which is always a problem with DSLRs because their temperature varies unpredictably. The cooling power (maximum difference between sensor and ambient temperatures) is also important as well as some dew prevention characteristics (sealed chamber, dessicant, window heater, etc.).

Some sensors are offered with and without antiblooming capability. Select an antiblooming sensor if you plan to photograph large star fields. However, it is not necessary for galaxies or for nebulae with narrowband filters. For Kodak (Truesense) sensors, you can also choose the cosmetic "grade" in many cases, that is, its level of quality according to the manufacturer's test. I have used grade 0, grade 1, and grade 2 Kodak sensors and never really

noticed the difference in astronomy, so my advice is to take the lowest grade, since it is much cheaper, and spend the money you saved on good filters.

DSLR or CCD Camera?

DSLRs have done a great job popularizing astrophotography and offer an interesting price/performance ratio. In addition to their versatility, they offer a sensor much larger than CCD cameras of similar price.

But CCD cameras remain a good choice for deep-sky photography, mainly due to their monochrome sensors that provide unbeatable versatility and sensitivity. Photons are rare: at the focal plane of an 8" telescope, only a dozen photons may be received each second from a magnitude 20 star! Out of a hundred photons of each color reaching a color sensor, you can estimate that fewer than 20 green, 10 red, and 10 blue photons are finally transformed into electrons. For the Hα line, this number is as low as 2 to 3. On the other hand, a monochrome sensor transforms 30 to 80 photons of any color (including Hα) into electrons. The advantage of the DSLR in terms of sensor size (that is, in terms of field of view) is offset by a much lower number of photons received. Finally, even if it has a smaller sensor, a CCD camera may collect a larger total number of photons than a DSLR!

The amateur who wants to regularly take deep-sky images and who is ready to invest significant time and money in this activity should pay as much attention to the camera as to the telescope and its mount, considering that the camera is one link of the photographic chain and that all these links must be well balanced. Is it worth buying a big telescope that collects a large number of photons if it is used with a sensor that rejects most of them and if the images must be scaled down to hide seeing and tracking problems caused by the long focal length? A smaller telescope equipped with a more efficient camera may offer many advantages, such as transportability, lower sensitivity to seeing and tracking problems, and a wider field of view, thanks to a short focal length. Choosing what instrument to put in front of a good sensor is as important as choosing what sensor to put behind a good telescope.

For the amateur who wants to obtain the best deep-sky results in color and in black and white, a set of filters (RGB and narrowband) used with a monochrome sensor offers significant advantages over a DSLR:

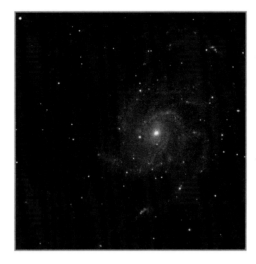
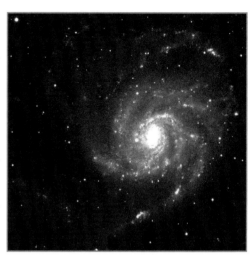

The superiority of a monochrome sensor is obvious on nebulae and also on galaxies, as shown by these two images taken with the same telescope and exposure time using a DSLR (left) and a CCD camera (right). The display has been adjusted to give the same signal-to-noise ratio.

- All photosites are sensitive to the light transmitted by an RGB or a narrowband filter, with quantum efficiency between 20% and 80% depending on the sensor and the wavelength. With a color sensor, only 50% of the photosites gather green photons, only 25% gather either red or blue photons, and the quantum efficiency does not exceed 35%.
- The exposure time in each color can be adjusted to produce a homogeneous signal-to-noise ratio for all colors, leading to an optimized total exposure time. In contrast, with a color sensor, the signal-to-noise ratio is not balanced between colors because the red and blue channels are underrepresented compared to the green.
- Narrowband filters offer new imaging perspectives and enable astrophotography in light-polluted sites.

Note that setting a DSLR in black-and-white mode makes the camera mix the RGB layers in JPEG mode and does nothing in RAW mode. This setting has no direct influence on the image contents stored in the RAW file and therefore gives no gain in sensitivity. Consequently, this is by no means equivalent to a monochrome sensor.

What Exposure Time?

Whether the camera used is a DSLR or a CCD camera, one of the first questions that come to the mind of the astrophotographer is, "What exposure time should I use for each individual exposure?" The exposure time should be as long as is permitted by the following two criteria: (1) The

quality of the tracking. (2) The saturation of the image. It is normal that the bright stars of the field are overexposed, but the main object (nebula, galaxy, or globular cluster) must not contain saturated areas because there would be an irreversible loss of information.

Another consideration complicates this answer. You saw in chapter 3 that taking only one long exposure of an object is not wise because this exposure might be tainted by satellites, planes, clouds, or cosmic rays, or by some accident like a bump against the instrument, a wind gust, a loss of the guide star, or a focus shift. For example, if you plan to spend 30 minutes exposing a galaxy, it is better to take 6 exposures of 5 minutes or 10 exposures of 3 minutes rather than a single one of 30 minutes duration.

The exposure time may vary hugely depending on the equipment and the object. In practice, most amateurs use individual exposure times ranging from tens of seconds for a very bright object such as the heart of the Orion Nebula to 20 minutes for a very dim object, the most common times being between 1 and 5 minutes.

This question leads to another one: What total exposure time is optimal? In other words, how many individual images should you take? Here too everything depends on the object and the equipment used and also on your requirements for the final level of signal-to-noise ratio in the image. Do you just want to confirm the presence of an object, or do you want to take the most beautiful possible image, deep and soft, where noise is not visible? In the second case, you may have to accumulate exposures for several hours. The most demanding amateurs sometimes even expose 20 or more hours, spread over several nights! With a little bit of practice you will be able to assess, from the appearance of one exposure, the approximate number of images you need to take to reach your goal, remembering that the signal-to-noise ratio roughly increases with the square root of the total exposure time.

Another common question is: Now that I know it is better to split a long exposure into several shorter ones, is there a point at which the shortness of the individual exposures is harmful to the image quality? Can a series of 3600 exposures of 1 second each be equivalent to an exposure of 1 hour? The answer is no, it's not. Actually, it is a question of readout noise; if it were nil, they would be equivalent. Indeed, the readout noise is the only parameter that increases with the number of individual exposures (at equal total exposure), because each image makes its own contribution.

All other parameters (thermal signal and photon signal with their associated noises) depend only on the total exposure time and not on the way it is split into individual exposures. Of course, no camera has zero readout noise. In practice, the duration of each individual exposure can be reduced without disadvantage as long as the readout noise remains negligible in relation to the other noise contributions in the image, most notably the background photon noise. Then, the image is said to be "sky background limited." A method to determine the optimal individual exposure time is described in appendix 7. Let's consider two extreme situations:

1. Your sky is polluted or your target is bright: The photon noise (from the background or from the object) quickly dominates all other noises and the individual exposure time can be relatively short.
2. Your target is dim and your sky is dark (or you are using narrowband filters, which darken the sky): You'd better not reduce the individual exposure too much or the readout noise may have a significant influence.

For LRGB exposure sets with a monochrome sensor and color filters, use these basic guidelines:

❯ Roughly half of the total exposure time should be used for the L (luminance) series and half for the remaining RGB series. For example, use 2 hours (120 minutes) for L and 2 hours for the RGB set.
❯ Instead of using an equal exposure time for the RGB series (for example, 40 minutes each for a total of 120 minutes), equalize their signal-to-noise ratio by using exposure times proportional to the RGB coefficients (see appendix 7) associated with your camera and your filter set; for example, if the RGB coefficients are 1.3, 1, and 1.7, expose $120 / (1.3 + 1 + 1.7) = 30$ minutes in G, 39 minutes (1.3×30) in R, and 51 minutes (1.7×30) in B for a total of 120 minutes. For simpler work with dark frames, you can use the same individual exposure time, such as 3 minutes, leading in this example to 13 R frames, 10 G frames, and 17 B frames.

The manufacturer Astrodon offers Tru-Balance RGB filter sets optimized for a given sensor so that the RGB coefficients, and therefore the exposure time ratios, are all equal to 1.

These images of M27 were taken with the same telescope, the same DSLR, and the same exposure time (6 × 2 min). They differ only in ISO setting (from left to right, ISO 100, ISO 400, ISO 1600). On the screen of the camera, the RAW images look brighter at higher ISO, but once the displayed levels were adjusted using the processing software to show an equivalent brightness, the signal-to-noise ratio of all of the images is nearly the same.

For the acquisition of RGB series, my advice is to alternate RGB filters (R-G-B-R-G-B-R-G-B instead of R-R-R-G-G-G-B-B-B). This way, if an unexpected event occurs (clouds, fog, battery failure) you will have at least several images of each color. Moreover, the three series will be more homogeneous with regard to light pollution and gradients.

The Other Settings

In RAW mode, only two parameters change the image data recorded in the file: the ISO setting and long-exposure noise reduction (described in chapter 3). Settings for white balance, color space, high ISO noise reduction (do not confuse it with long-exposure noise reduction), and automatic vignetting correction (if available for your lens and camera) have no direct influence on the image contents and may be set to any value at shooting. These setting are just recorded as information in the file and they can be changed during demosaicing.

The best ISO setting for deep-sky photography is often subject to endless discussions between amateurs and deserves a detailed explanation. Increasing the ISO value yields a brighter image of the object on the camera screen, but we also know that it is noisier and that bright objects saturate more quickly. On a DSLR, as opposed to silver film, modifying the ISO setting does not change the ability of the sensor to transform photons into electrons; it is still the same sensor, with the same characteristics.

Actually, the camera translates the ISO setting into either electronic or digital amplification of the data delivered by the sensor relative to the native ISO setting, which is generally ISO 100. For example, on a Canon DSLR, an ISO 400 image is the native (ISO 100) image electronically amplified by a factor of four. Of course, if the signal is amplified, the noise is amplified too, and the higher ISO choice is not as interesting as it may appear at first glance. This is why the term *sensitivity* for the ISO setting is ambiguous and often leads to misinterpretations. Basically, the ISO setting is a convenience that is useful mainly for everyday JPEG photographs; it's used to adjust the range of the image light levels to fall within the narrow 8-bit range of this format. In deep-sky astrophotography, it is much less important. The idea that an exposure of 1 minute at ISO 400 would have the same quality as an exposure of 4 minutes at ISO 100 is incorrect; the signal-to-noise ratio of the latter is much better.

The ISO setting acts like amplifier gain; increasing it amplifies both the photon signal and the photon noise by the same amount, offering no benefit to the photon SNR. The same reasoning can be applied to the thermal SNR: no difference. However, increasing the ISO setting may provide some benefit. It is a question of readout noise, and only that. On current Canon DSLRs, a measurement of the readout noise in electrons at each ISO setting shows that this noise is not constant but decreases as the setting increases, up to a level where it becomes constant. Appendix 7 outlines a simple method to determine the optimal ISO setting for a given camera.

If you remember only one thing, remember that *the most important parameter, by far, is the total exposure time; the ISO setting is secondary*. Because the optimal individual exposure time and optimal ISO setting are partly linked, the basic principle is the shorter the exposure time, the higher the ISO setting. Do not hesitate to perform tests while varying these parameters to determine their true influence on your images.

In some cases, such as short exposures with a DSLR on a tripod or when using narrowband filters, increasing it to

the optimal setting may give some benefit, but often this advantage is negligible. If your individual exposure time is sufficiently long to reduce the readout noise to negligible levels, the benefit of increasing the ISO setting is likely to be undetectable. In any case, the very high ISO settings that can be found on some cameras (ISO 12,800 or even ISO 25,600 and beyond) are essentially for marketing and are completely useless. After all, recall that CCD cameras do not have ISO settings at all, and they do without them very well!

No other setting of the camera (white balance, sharpness, color saturation, noise reduction) has an influence on the data contained in the RAW file.

With a monochrome CCD camera, only the binning mode can be modified. In 1 × 1 binning, you have the largest possible image in terms of the number of pixels because each photosite of the sensor is associated to a pixel in the image. In 2 × 2 binning, the photosites are gathered by groups of four to obtain 1 pixel: the overall field of view is unchanged, the number of pixels is divided by 4, and the signal-to-noise ratio is increased. Details are lost only if, in 1 × 1 binning, the stars are quite sharp (FWHM under 2 pixels).

Finding Objects

Deep-sky objects are more difficult to find than the major planets. Most of them are invisible through the viewfinder of a DSLR, and even through an eyepiece. Several techniques simplify placing them within the field of view of the camera. When the target is approximately centered, exposures of several seconds at high ISO settings help to center it more precisely and possibly to change the orientation of the camera for better framing.

Centering with a Finder

Widely used for visual observation, the finder is also usable for photography under the condition that the precision of its adjustment is a fraction of the field of view of the camera. For a good 7 × 50 finder, this precision is about 12 arc minutes. If the target is not visible, it must be centered by referring to a map of the surrounding star field.

Centering through the Telescope

Considering the darkness of the field of view as seen through most focusing screens, almost all objects are invisible through a DSLR. The camera can be removed to place an eyepiece at the focus, but this is not without complicating refocusing and flat-field correction.

Centering with Coordinates Circles

Many equatorial mounts are equipped with right ascension and declination setting circles. These circles are not always perfectly accurate, especially the RA one, so the most-used method is as follows:

1. Carefully center on a bright star situated not too far from the target
2. Jot down the values displayed by the coordinates circles
3. Using a planetarium program, calculate the RA and declination coordinate offset between the star and the target
4. Shift the mount so that the coordinates displayed by the circles change by these differences

The pointing precision of most circles is poorer than the precision you would get using a good finder. Therefore, this method is to be used only for wide-field photographs.

Centering with a GOTO System

Numerous mounts offer a GOTO system that allows, after preliminary location of one or several stars, aiming at any object whose data is stored in the GOTO's system database. This system is efficient for astrophotography only if its accuracy is consistent with the field of view given by the camera, which itself depends on the size of the sensor and the focal length, as explained in chapter 4. If you are not sure about the accuracy of your mount, make tests by moving from bright star to bright star.

BEWARE OF DANGLING CABLES!

The cables that link the main camera or the autoguider to an external power supply or to the computer must not be left hanging freely to the ground because the resistance of the cables to bending would most certainly lead to blurring in the image, all the more when cables become rigid in cold air. Do not forget that a shift of 1/1000" at the end of a 40" tube held at its center causes a blur of 10 arc seconds! Arrange the cables over the central part of the mount so that they do not dangle and the tracking movement of the mount is not hindered by their weight.

Imaging

A deep-sky imaging session typically proceeds as follows:

1. Assemble the telescope, including a possible guide telescope.
2. Check the collimation (chapter 4) if necessary.
3. Approximately polar-align the mount.
4. Mount the camera to the telescope, possibly with a focal reducer, a corrector, or an off-axis guider (chapter 4).
5. Balance the telescope in RA and declination, but leave a slight imbalance to avoid random backlash movements.
6. Precisely polar-align the system. Assembling and balancing the telescope often leads to small shifts of the polar alignment; it is important to align it after these operations.
7. Find, center, and frame the first celestial object to be photographed.
8. If necessary, find a guide star, install the autoguider, then focus and calibrate it.
9. Precisely focus the main camera (chapter 4) and choose its parameters (RAW mode and ISO setting for a DSLR).
10. Start up the autoguider, and after a few seconds of good tracking, launch the imaging sequence on the main camera.
11. Periodically stop the autoguider and refocus the main camera (every 1/2 to 2 hours, depending on the sensitivity of the telescope to temperature variations and the change in nighttime temperature).
12. Take the calibration images: dark, flat-field, and associated bias frames (chapter 3).

WHAT FWHM?

As you saw in chapter 4, the full width at half maximum (FWHM) is a reliable criterion of sharpness. All astronomical programs are able to measure it on non-saturated stars and give its value in pixels or, knowing the sampling value, in arc seconds. Ideally, the FWHM would be 1 pixel. But a star can easily fall across 2 or more pixels. And, above all, numerous factors can increase FWHM: seeing, tracking errors, optical aberrations (on-axis or off-axis), focusing errors, and such.

In practice, with a monochrome sensor, it is possible to have an FWHM of 1.5 pixels or less with a telescope of short focal length and good optical quality. With a color sensor, the FWHM is usually higher because of the interpolation inherent in the Bayer matrix; it cannot go under 1.6 pixels. As the focal length increases, the seeing and tracking errors increase the FWHM, reaching commonly 3 pixels or even more at several meters focal length. In this case, the image is oversampled and, with a CCD camera, 2×2 binning becomes an interesting option.

Preparing for the Imaging Session

I strongly recommend you choose your imaging targets in advance. First, you must determine which constellations will be well placed in the sky during the night, with the help of a rotating map or a planetarium program (such as Starry Night, Stellarium, or TheSkyX, for example). Do not forget that the preparation of the instrument (assembly, polar alignment, focusing, autoguider setting, etc.) may take half an hour or more, to which must be added the time needed to take the photographs and the downtime between exposures (for example, to transfer the image to the computer or to refocus).

Second, you must check that the field of view of the camera is compatible with the size of the target. Numerous planetarium programs are able to draw a rectangle that represents the field of view of your camera on the sky, based on the dimensions of the sensor and the focal length of the telescope.

Many photographers claim that framing represents half of the quality of a photograph. In astronomy, it's impossible to change the lighting, move the subject, or get

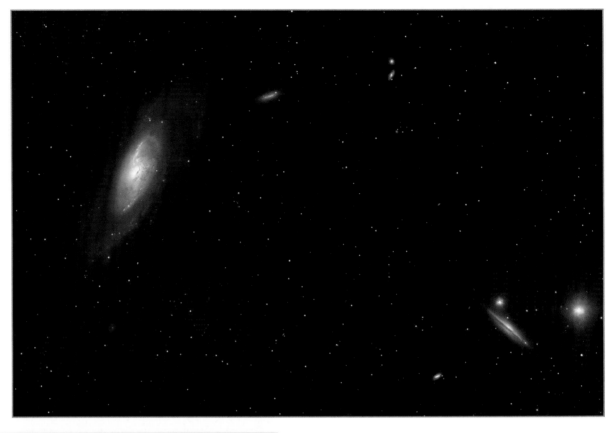

A galaxy is rarely alone. The top image shows the area surrounding M106. Below, the same field is shown using The SkyX from Software Bisque. In that figure the central rectangle represents the field of view after selecting the camera and telescope model in the database. A larger field of view includes several smaller galaxies surrounding M106. With SBIG dual-sensor cameras, TheSkyX shows the guide sensor (off-center rectangle) and helps guide the rotation of the camera (circles) to find a suitable guide star.

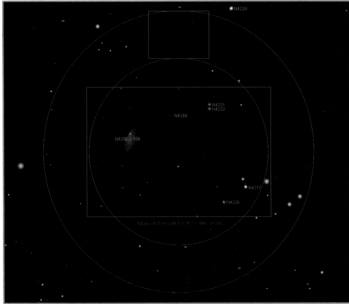

closer to it, so the framing is of the highest importance, whatever the target: constellations, sunspots, lunar craters, nebulae, groups of galaxies, and so on. When the frame contains only one interesting object, it is commonly placed at the center of the image, but if the primary target is surrounded by other deep-sky objects that could enrich the photograph, centering it may not be the best strategy.

When imaging a nebula larger than the image area, it is important to include the most interesting portion. Do not forget that you can rotate the camera to make better use of the widest dimension or the diagonal of the sensor. The image is available immediately to check your compostion, so sloppy framing is unforgivable! Do not systematically choose only objects that just fill the entire frame: a nebula or a galaxy that "floats" in a large field of stars can make for a pleasing photograph.

The Dithering Technique

As surprising as it may sound, when you want a sequence of images of the same object, positioning them all at exactly the same location in a series of raw images is not the best technique. A slight shift of a few pixels in a random direction between successive images is better because some defects may remain even after calibration (for example, weak columns, hot pixel residues, thermal artifacts not perfectly removed) and are better eliminated by a combination method such as a median sum or kappa-sigma combine if they are not fixed at one location after registration of the images. Also, calibration frames always contain noise, and these shifts prevent this noise from affecting all calibrated images identically (image stacking helps to reduce the noise temporally, while dithering averages it spatially). In other words, you need fewer calibration frames and obtain cleaner final images when using the dithering technique, especially with cameras that are not cooled or have no temperature regulation. Some DSLRs have such low dark current it may even be conceivable to skip taking dark frames.

Without an autoguider, unavoidable tracking errors automatically cause this slight shift, the drawback being that the direction of shift is not random but more or less constant along the series of frames, leading to the risk of visible background structure. With an autoguider, it may be useful to stop it periodically, slightly shift the mount by a few pixels in a random direction, and launch the autoguider again. Some autoguide programs are even able

When you're using a DSLR without auto-guiding, the residual polar alignment error and mechanical flexure creates a slow drift that can produce a nonrandom dither. However, diagonal background patterns may appear because the drift is not random in amplitude and direction.

DISPLAY LEVELS IN ASTRONOMICAL SOFTWARE

For each opened image, every astronomical program offers two adjustment parameters called levels. Depending on the program, these two parameters are called high/low, maximum/minimum, or black/white. In certain programs, they are called background/range, the background corresponding to the low level and the range corresponding to the interval between the low and the high levels. These levels are used to change the way the image is displayed on the computer screen, but they don't change the digital image data. They have no equivalent in consumer programs in which a modification of the data occurs anytime a setting is changed.

The astronomical program displays the image after a comparison between the digital value of each pixel and the levels chosen. The low level corresponds to pure black: any pixel whose value is under this level is displayed as black on the screen. Conversely, the high level determines pure white: any pixel value above it is displayed as white. The pixels whose value lies within the range between the high and the low levels are displayed linearly as a gray level corresponding to their position in this range: dark gray for the values close to the low level, light gray for the ones close to the high level, and so on.

Even if the program offers an automatic adjustment of the levels, the user must fine-tune them manually. The high level must be set so that the brightest zones of the interesting parts of the galaxy or the nebula are bright without being saturated (pure white). Of course, many stars will certainly appear white, but this is not a problem; it is fine that the stars that were saturated during imaging are displayed as pure white. The low level setting is important. It must be a value a little bit under the average background of the image. The aim is to have a background that is displayed as dark gray in order to reveal the fainter regions of nebulosity or the outer reaches of a galaxy. If the low level were equal to or greater than the background of the image, these faint parts would disappear and leave artificial and noisy transitions in the image.

Typically, the low level should be set 5% to 10% under the background of the image. For example, if the background is 200 and the high level is set to 1000, the low level should be set to between 120 and 160. When the image is exported to an image-editing program, the background then goes to 10 to 25 (in 8-bit). A good adjustment of the low level is possible only if the flat-field correction is good and the gradients have been removed; displaying the background as pure black is an easy way to hide calibration defects, but it is a mediocre solution!

In CCDStack, the options for the display levels are Background and Maximum

to do this operation automatically. In this case, they must be synchronized with the shooting sequence of the main camera so that any shifts occur between exposures, which is easy with dual-sensor CCD cameras since it is the same program that drives both.

Processing the Images

Once the images are acquired, deep-sky image processing is usually executed in a certain sequence: calibration, registration and combination, gradient removal, levels and curves, improving sharpness, noise reduction, cosmetic touch-up, and creating mosaics. Consumer programs are able to perform some operations, such as curve adjustment of brightness, but they are no substitute for astronomical programs that are specifically designed for most of the operations described in the following sections.

Calibration

Processing begins with the calibration of the raw images using the master calibration frames that have been collected beforehand. Dark current and flat-field artifacts in each image must be corrected *before* registration. This correction is highly important because the defects are practically impossible to remove by other means. Many astronomical programs can calibrate a series of images in a single operation: you enter the name of the series and the names of the master calibration frames and at the end of processing a new series of calibrated images is created.

When the images come from a DSLR, they must be calibrated with a program able to handle the RAW format corresponding to the camera (each DSLR manufacturer has its own RAW format, which sometimes even changes with time) before color conversion (*debayering* or *demosaicing*). The color conversion of each calibrated image is then performed; this operation has to be done *after* calibration but *before* registration.

A common mistake is to try to register the images before color conversion; this causes absurd colors in the final image because pixels corresponding to different colors are mixed together. If your favorite processing program does not recognize the files from the new DSLR that you just purchased, you can always convert its proprietary RAW files to DNG RAW format (a standard format recognized by all programs) with Adobe DNG Converter, which you can download from the Internet.

Registration and Stacking

The second operation is to register and stack the calibrated images (monochrome or RGB), once again using an astronomical program. As for planetary images, astronomical programs have algorithms designed to register a series of deep-sky images with a precision of a fraction of a pixel. To do so, it measures the position of one or several nonsaturated stars (generally using an algorithm that mathematicians call centroid calculation) and shifts each image so that all objects are aligned to the position they had in the very first image of the series. If the shifts between images are only translations (horizontal and vertical shifts), only one reference star is necessary.

With polar alignment error, there is field rotation and then two stars that are far away from each other are used by the program to calculate the rotation and translation corrections needed for each image. For imaging sessions of several hours on the same object, a slight field rotation between the beginning and the end of the session is common because perfect polar alignment is impossible to reach. Because the shift between images is never a whole number of pixels, the program uses pixel interpolations on each image to register it precisely.

The stacking of the registered series is then performed by the sum, median, or sigma-clipping method or a similar method, as explained in chapter 3. The median is valuable for canceling isolated defects, but it works only if the light levels of all images are consistent; that is, if there is no variation of transparency or light pollution between the first and last image. Such variation may easily occur if the moon has set or risen during the session, if the rotation of the sky has put the field closer or further from light pollution sources, if moisture or thin clouds developed in the atmosphere, or if a small amount of dew appeared on the optics. In this case, the median combined image

ends up being mostly one image from the set (and not a good median), so the images have to be corrected beforehand with a multiplying factor (transparency variation) or with an offset factor (background variation) to make their backgrounds consistent, an operation that advanced astronomical programs are able to do. The sigma-clipping algorithm is a bit less sensitive to such variations, and the simple sum is not sensitive at all, but it does not remove isolated defects. Another solution is to make medians on small groups of successive images (three or five) and sum the set of medians obtained.

What about combining images of the same faint target taken in similar conditions (instrument and camera, exposure time, filter...) but with different sky background levels? For example, what if you shot one-half of the series before moonrise and the other half after? Let's suppose that each frame is "sky background limited" and let's look at how the SNR evolves according to the background ratio between the two parts. Of course, if the ratio is 1 (same background), as discussed in chapter 3, the improvement in the SNR is 1.4x (the square root of 2). At a ratio of 2 (background of the second series is twice that of the first), the improvement of the SNR of the first half falls to 1.15x only. If the ratio is 3, the SNR of the first half remains unchanged: the second half is useless. If it's greater than 3, the stack's SNR decreases.

The conclusion is this: stack images only if their background levels are close, use dark nights for dim targets and polluted nights for brighter ones, and at the end of the night, when the sky background starts to get brighter in the images, end the series.

The red, green, and blue photosites of color sensors are not equally sensitive; the green ones are more sensitive than the others, leading to a dominant greenish color. To achieve a good color balance, you must apply a coefficient to each color channel of the RGB image; when the camera works in JPEG mode, it also applies internally a set of coefficients that depend on the white balance setting (daylight, cloudy, tungsten, etc.). Each DSLR model has its own set of coefficients, and they change if its IR-blocking filter is modified; the method to calculate them is given in appendix 7.

At this point, you can choose to continue with an astronomical program or with a consumer program such as Photoshop; both are able to perform the next operations. All processing needs 16-bit data, except perhaps the very last steps, so the image must be transferred via a 16-bit image format. There are two such formats: FITS and 16-bit TIFF (note that TIFF is also available in 8-bit!). Of course, all astronomical programs are able to record FITS files because it is their most common working format, but the image is monochrome and a color image is transferred through three files, one for each color channel. In addition, most of them are able to export 16-bit TIFF files. However, the consumer program must be able to open them and process the data in 16-bit mode. All functions of the professional version of Photoshop work in 16-bit mode (even if, strangely, the values are still displayed in the 0–255 range instead of the 0–65535 range as they should be in 16-bit), while only the basic functions (brightness/contrast, curves tool, etc.) work in 16-bit mode in the simpler, less-expensive version, Photoshop Elements.

You can transfer a monochrome FITS file into Photoshop using the free software plug-in FITS Liberator, which is available for download at www.spacetelescope.org/projects/fits_liberator. Be careful that the image stays in 16-bit mode during the entire chain of processing; it's useless to convert an image into 16-bit that has been recorded in an 8-bit format!

Gradient Removal

Most of the time, even if the quality of the flat-field cor-rection is good, the image will look like it's tilted; its back-ground will be brighter toward one side or in one corner, showing the direction of the source of light pollution (the horizon for urban pollution or the direction of the moon in the sky). This effect is called a gradient, and it's all the more visible when the field is large, but it may be noticeable even with long-focal-length telescopes. A gradient may also appear if the flat-field correction is imperfect.

Fortunately, light pollution gradients are generally lin-ear: the brightness variation is constant from one end of the image to the other. Powerful astronomical programs

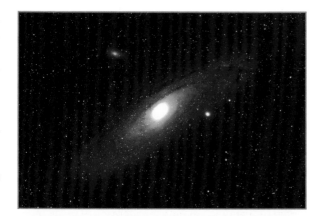

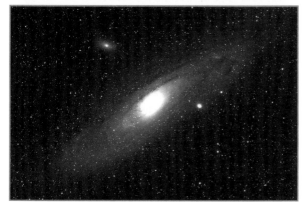

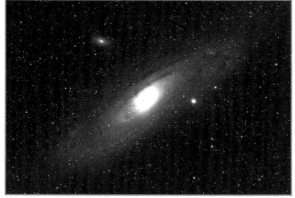

If, after a good flat-field correction, the image shows a smooth brightness variation from one side to the other, the cause is probably light pollution. In this example, before gradient correc-tion (on the top) the background is brighter toward the horizon, where the pollution sources are located. On the bottom, a linear gradient correction has been employed to correct the defect.

After a series of RAW images are registered and stacked in an astronomical program, a dominant green color cast usually ap-pears (top). After application of the color balance ratios specific to the camera model, the color balance of the galaxy becomes satisfactory (center); however, light pollution makes the back-ground reddish. This color can be removed by tweaking the black point of each RGB layer individually during levels adjustment (bottom).

such as MaxIm DL, PixInsight, PRISM, and GradientXTerminator (a specialized plug-in for Photoshop) offer gradient removal functions that work well in most situations. They model the background at hundreds of points and the synthetic background image obtained is then subtracted from the original image.

The order of the polynomial that models the background depends on its complexity. For a linear background, a first-order correction is sufficient. For color images, depending on the program, the gradient is removed in one operation on the RGB image or on each color channel separately.

If the imaging session lasts several hours on the same object, the position of the field toward the sources of light pollution changes with time, transforming the linear gradient of each raw image into a more complex one in the final stacked image.

My experience has taught me that a better gradient correction is obtained if the gradient removal is applied to each calibrated image of the series, before they are registered and stacked.

Photoshop also includes a linear gradient creation tool, but it is more painstaking to use because it requires several manual operations. The light levels and the directions of the gradient in the image must be determined by the user with clicks on several background points.

Levels and Curves

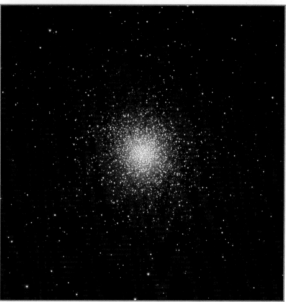

On the top left, the levels have been adjusted for the center of M13, making the periphery invisible. On the top right, they have been adjusted for the periphery but the center of the cluster appears saturated on the screen. Curves or levels processing allows both areas to be visible simultaneously (bottom). This image was obtained using a DSLR on a 1000mm focal length telescope, 30 exposures, 2 minutes each.

Most deep-sky objects possess huge brightness variations across their extent, often with a factor of 100 or more. This is particularly true for globular clusters and galaxies with a bright core. Without further processing, it's impossible to display the image so that all parts are visible simultaneously. All brightness compression functions work on the same principle: they compress the dynamic range of the image by enhancing the brightness of the faint levels without modifying the bright ones too much. In mathematical terms, the image becomes nonlinear. The functions are described here for Photoshop, but they are similar in other programs, such as DxO Optics Pro and Paint Shop Pro.

Once the image is open in Photoshop, use the Levels command panel (Image/Adjustments menu). Under the histogram are three settings, from left to right: Black Point (0), Gamma (1.00), and White Point (255). By using the sliders or entering numeric values, raise the black point

and lower the white point and/or increase the gamma (always to greater than 1). The goal is to obtain a result where the sky is dark gray without being pure black (adjusted by sliding the black dot just below the base of the histogram) so that the dark parts of an interesting object (nebula or galaxy) are easily visible without saturation of its brightest areas.

Do not hesitate to apply this operation several times in a row, especially if the original TIFF image appears very dark. It is important to work continuously in 16-bit because 8-bit allows only limited modifications (obviously, converting 8-bit images into 16-bit is useless). Do not be concerned if Photoshop displays the values on the interval 0 to 255 and not 0 to 65535 as you would expect. It definitely performs the calculations internally in 16 bits if the top of the image displays the mode Gray/16 or RGB/16.

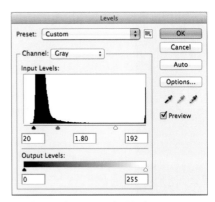

For this levels setting, the black point is adjusted to 20 (just under the base of the histogram), the white point to 192, and the gamma to 1.8. Histogram values to the right of the white point are not a problem if that data represents stars.

For a color image, use the color histogram to set the black point, by superimposing the lower level of the three RGB histograms. On the top, the sky background is orangish; on the bottom this dominance is corrected. A color that is dominant on the right of the histogram should not be considered (in this situation, blue dominates because the image is that of the Pleiades nebulae).

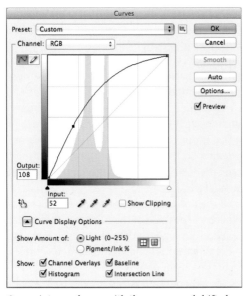

One point was chosen with the mouse and shifted vertically to give this curve a convex shape (concave downward), which brightens the low levels without saturating the high ones

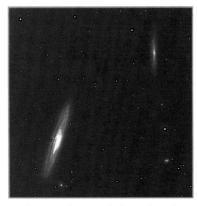

Unsharp masking applied to a deep-sky image, using coefficients typical for planetary imaging. The noise is amplified and dark rings ("panda eyes") appear around the stars.

For a color image, if the sky background exhibits a dominant color due to light pollution, set the black point independently on each RGB layer to neutralize the color of the sky. To do this, use the color histogram to verify the correct positioning of the three RGB histograms' lower levels. Use the pipette tool to make sure the background is gray. If the background is yellow, adjust the blue-black point; if it is magenta, adjust the green-black point; if it is cyan, adjust the red-black point.

Similar results can be obtained with the Curve tool. The black and white points are the two input levels (horizontal axis), while a change of the gamma can be produced by bending the curve about one point (or several).

Rather than applying these operations directly on the image, you can use an adjustment layer setting Levels or Curves. If you save the image in PSD, a Photoshop proprietary format, you can simply change the parameters of this layer later.

If you prefer an astronomical processing program such as MaxIm DL, PixInsight, or CCDStack, you can use them instead of Photoshop because they have similar functions for adjusting levels and curves.

Operations designed to lighten the dim parts of the image all have the same drawback: These parts have the worse SNR and the noise is boosted along with the signal. Since this produces a result noisier than the original image, you should use images that already have good SNR. In addition, these operations enlarge the stars by boosting their low levels (also known as their *feet*).

Improving Sharpness

The unsharp mask and wavelet techniques that were so useful in planetary imaging cannot be used in the same way with deep-sky images, for two reasons:

- They amplify noise, and the SNR of deep-sky images is much lower than it is for planetary images
- They create artifacts, most easily visible on stars, which can exhibit dark rings (called "panda eyes")

Sharpening tools such as the unsharp mask, wavelets, and high-pass filters must be used with moderation and careful attention to detail. Astronomical software offers other algorithms, such as deconvolution and image

Applying an unsharp mask with a large radius (more than 10 pixels) and a low gain may help to increase the contrast of medium-scale details for large nebulae

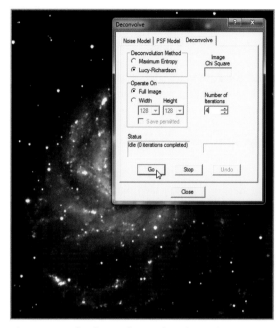

The most popular deconvolution algorithm is the Lucy-Richardson (shown here in MaxIm DL)

restoration techniques. The most famous algorithm is the Lucy-Richardson (LR) algorithm, but there are others, like the algorithm based on the Van Cittert–Zernike theorem, and Maximum Entropy. These algorithms exploit the fact that a star is a point light source and use one of the stars of the image or a synthetic point spread function (PSF) to determine the atmospheric and instrumental degradation specific to that image and apply the reverse operation. The processing is applied iteratively, and the user can adjust the number of iterations.

On paper, these algorithms are wonderful. In practice, they amplify the noise and can create artifacts, working correctly only if the SNR of the images is high, which is never easy to get with deep-sky photography. On over-sampled images (FWHM over 2 pixels), they can slightly improve the sharpness and mitigate some smearing due to tracking errors. But do not assign excessive virtues to them. Improving the raw image quality, such as by improving focus or achieving more accurate tracking, is always more profitable (see the sidebar "Can the Apollo Lunar Module Remains Be Photographed?" in chapter 5). Applied in excess, they can even lead to strange-looking pictures in which you no longer know what is real and what is not.

Noise Reduction

Many general image-editing programs (PixInsight, Photoshop, for example), as well as dedicated programs such as Noise Ninja and Neat Image, offer advanced noise reduction functions that can act separately on the luminance (brightness) and chrominance (color) channels. Test them

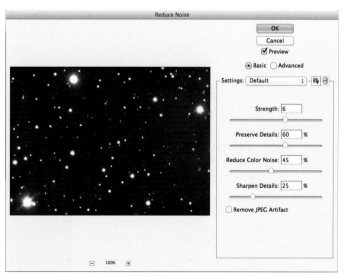

Modern processing programs include separate noise reduction parameters for luminance and chrominance channels

by beginning with the chrominance channel since color noise is often the most visible and objectionable. Do not, however, apply the parameters to excess because you may obtain a "watercolor" effect and wash out details and color. Never forget that the best noise reduction is achieved when imaging, by increasing the quantity of light gathered!

Cosmetic Touch-Up

When a CCD camera without antiblooming is used, the brightest stars may show a blooming effect. The simplest way to remove this artifact is to use the Clone Stamp tool (assuming that nothing interesting was underneath the blooming streak).

The few pixels remaining after processing (due to dark current or cosmic rays) can be removed by the same means. Advanced astronomical programs are even able to record the position of a number of hot pixels, lines, and bad columns (identified from a dark frame) and replace them by the mean or median of surrounding pixels during calibration.

Removal of blooming with the Clone Stamp tool

Mosaics

One way to increase the field of a photograph is to make mosaics: contiguous fields are assembled side by side, just as with panoramas in everyday photography.

At the telescope, the easiest solution when you're moving from one field to the next is to orient the sides of the sensor along the mount axes because the shift is necessary only in one direction (RA or declination). All adjacent fields must overlap by at least 20 % of their area. This area will be used by the assembling software to register the images. Of course, the exposure time and the processing of all fields must be identical.

Special attention must be paid to flat-field correction and gradient removal because the paramount difficulty is ending up with invisible transitions. Even a variation of a few percent will cause visible discontinuities at transition regions. Variation of brightness and background level between the component fields is common due to changes in light pollution or atmospheric transparency; an adjustment of these levels is often necessary. The different images must also have been cropped beforehand to remove the edge artifacts resulting from registration of the raw images used to build each of them.

Here too there are several solutions for the assembly of the fields, using either astronomical programs or consumer programs. For example, MaxIm DL includes a mosaic tool that is able to automatically register the fields, equalize the background, and create a larger image covering the new field.

Despite similar exposure times, these two portions of the nebula IC 1396 suffer from mismatched background brightness visible along their overlap area (image on left). They must be matched, either manually or automatically (depending on the mosaic program used) before assembly, as was done on the image on the right.

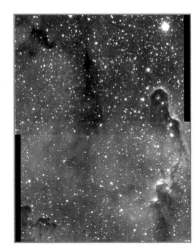
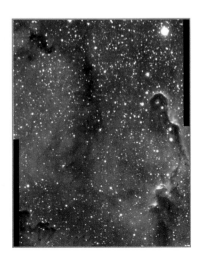

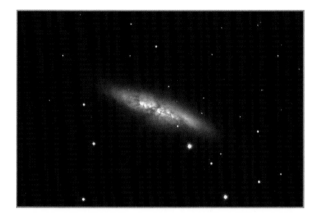

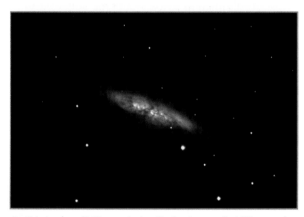

On this image of M82, rendering the background visible reveals faint extensions of the galaxy (on the top), while a background displayed as pure black makes them disappear (on the bottom) and may cause unrealistic transitions

ASTROPHOTOGRAPHY, STACKING, AND PHOTOMONTAGES

Stacking images is a powerful and commonly used technique for simulating a long exposure time and improving the signal-to-noise ratio. As you have seen, it consists of combining images of a celestial scene (sunspots, solar prominences, lunar craters, planets, star fields, galaxies) taken in a sufficiently short interval of time so that the morphology and the composition of the entire field of view has not visibly changed. For nebulae and galaxies, this time is virtually unlimited. But, in the case of dynamic scenes (for example, the passage of a fast comet near a galaxy or a nebula) or a wide-field photograph of the Milky Way taken with a long exposure and tracking, with sharp landscape features in the field, you may be tempted to create a photomontage of the various elements from images taken at different times or with different equipment. This might capture your perception of the event and be pleasing to the eye, but it is a technique that departs from astrophotography and enters into graphic artistry. It is imperative to clearly warn the viewer that the scene has been simulated.

Panorama programs such as PTGui do a good job, especially with photographs taken with wide-angle lenses, because they include a correction of the field distortion that is unavoidable with such lenses. In Photoshop, the Photomerge tool can be used to find the overlap zone for several images and merge them. It is also possible to manually assemble images by superimposing layers (as described in chapter 1, Making a Panorama). If no further significant image processing of the mosaic is needed, it's acceptable to work in 8-bit mode; otherwise, a program able to process 16-bit data is preferred.

Color Processing

In nature, only electromagnetic radiations of different wavelengths exist; color is just an ingenious device created by our brain to help us differentiate different wavelengths across the visible spectrum. Three techniques can be used to obtain color information for celestial bodies: a color sensor, a monochrome sensor with RGB filters, and a monochrome or color sensor with narrowband filters. The processing to obtain a color image depends not only on the imaging means used but also on the type of celestial body and on the way we want the colors to appear in the final image.

The primary colors used to synthesize color in astrophotography are red, green, and blue. The mix of the three is white and the mix of two lead to yellow (for red plus green), magenta (for red plus blue), or cyan (for green plus blue).

The pipette tool in Paint Shop Pro displays the RGB values of the selected pixel

HOW TO CHECK THE COLORS

Strictly speaking, processing color images requires a computer with a calibrated video monitor. Calibration is performed with the help of a probe that is put against the screen. The probe measures how the colors are displayed by the computer and determines the proper adjustment of video parameters so that the hues correspond to a universal color standard. Thus, they are as close as possible to the ones displayed by another calibrated computer.

Even with a calibrated computer, we all don't have the same perception of colors. To control the colors, do not hesitate to use the tools offered by the processing program that you use, particularly the pipette tool that displays the RGB values of the pixel under the pointer. This way, you can check these basic rules:

- An area of the image that is supposed to be gray has equal RGB levels.
- A saturated area (especially the core of bright stars) is pure white (255/255/255 RGB levels).
- The background is colorless with an average level between 10 and 25.
- There are no green or magenta stars. In nature, stars can be white (the majority), bluish, yellowish, orangish, or reddish, but not green or magenta. This means that quantitatively, stars cannot have RGB levels where the G value is above or below the B and R values.

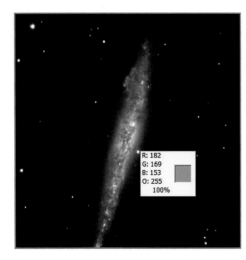

R: 182
G: 169
B: 153
O: 255
100%

Processing the Colors of Stars and Galaxies Photographed with a Color Sensor

This is the simplest case. Use the RGB balance factors that have been determined for your camera (see appendix 7) and the colors obtained will be consistent with the ones that your eye would perceive if it was sensitive to colors of faint objects or if these objects were much brighter. If a light pollution suppression filter has been used, a dominant color is unavoidable because of the elimination of certain wavelengths bands.

Processing the Colors of Stars and Galaxies Photographed with a Monochrome Sensor and LRGB Filters

Amateurs first used the tricolor RGB technique in the 1990s. It has one major drawback: it requires a good signal-to-noise ratio in all colors and a long total exposure time. This is because most of the light is rejected by the filters; for example, red and green are eliminated by the blue filter. The required total exposure of a monochrome sensor is significantly reduced compared to a one-shot color sensor.

The luminance, red, green, blue (LRGB) technique avoids this disadvantage and is now universally used by amateurs equipped with monochrome CCD cameras. It relies on a property of human vision: the details of a scene are mostly seen through the monochrome image component, called the luminance. The color component (chrominance) can be of relatively poor quality in terms of resolution and signal to noise without signficantly impacting the result (this property was used for a long time for the transmission of television images, for which the amount of information transmitted is much higher in luminance than in chrominance, without the audience perceiving a degradation of image quality).

In astronomy, the principle of LRGB is to combine a monochrome image, with the best possible SNR and resolution, with a three-color RGB image of lower quality and used only for colorization of the monochrome image.

To obtain a good SNR in a reasonable time, the luminance image is obtained without a filter, or with an IR blocking filter letting through all visible light. RGB images may be carried out in 2 × 2 binning, which allows reducing exposure times by a factor of four. In this case, you have to

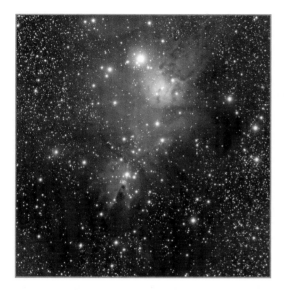
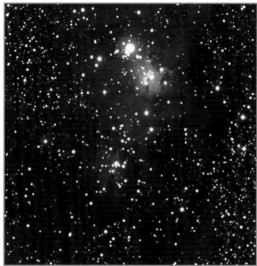
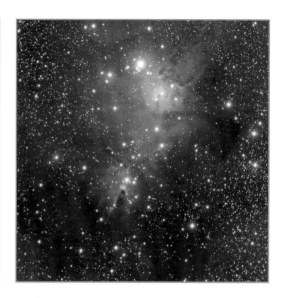

enlarge them by a factor of two before combining them with the L image. Since their SNR is far less important than the SNR of the L image, the exposure time accumulated in all three colors does not need to exceed that used for luminance. For example, you may choose 60 minutes for luminance and 60 minutes for all RGB images total, which will result in 2 hours of acquisition, while an RGB approach would need 8 hours (and even more with a DSLR color sensor) to achieve a comparable result. At equal total exposure time, the LRGB outperforms all other imaging modes in quality of results.

Each set of luminance, red, green, and blue images must be processed using the following operations:

1. Calibrate, register, and stack the images.
2. Remove the gradients.
3. Scale each color image by the RGB coefficients specific to the camera and filter set, to be determined according to the procedure presented in appendix 7.

The images must now be assembled to make a color image. This operation can be performed with astronomical software or with image processing software such as Photoshop. With the latter, the general technique is to use the special *Lab* mode as described in the next steps:

1. Open the four images (luminance, red, green, and blue) in Photoshop.
2. Resize the red, green, and blue images to match the luminance image if they were taken using binning.
3. Assemble the red, green, and blue images into an RGB color image.
4. Fine-tune the levels of each color layer to obtain a satisfying color balance.
5. Convert this color image into a Lab image (Image > Mode > Lab Colors).
6. Copy and paste the luminance image so that it replaces the L layer of the color Lab image.
7. Convert the image obtained to RGB mode (Image > Mode > RGB Colors).

Before converting the Lab image to RGB, you can apply noise reduction processing to the RGB layers. For stronger colors, the final RGB image can be reused, after color saturation enhancement, as a new color image to be combined as described in the preceding steps with the original luminance image. Note that the Lab mode is available only in the full version of Photoshop and not in Photoshop Elements. An alternative solution, available with Photoshop Elements and Paint Shop Pro, is to copy the luminance image as a new layer into the RGB image and then convert it into the Luminosity blending mode before merging all layers.

Part of the image from page 153. In LRGB, the monochrome image (on the left) is colorized using the RGB image (in the center) to produce a color image (on the right) that benefits from the sharpness and good SNR of the monochrome component.

The Veil Nebula in Cygnus is the most beautiful supernova remnant. It emits essentially only in Hα and OIII wavelengths. As seen here and on the following page, the images captured in the light of these two lines have been combined so that Hα is used for the red layer and OIII is used for the green and blue layers. The two brightest regions of this large nebula are shown.

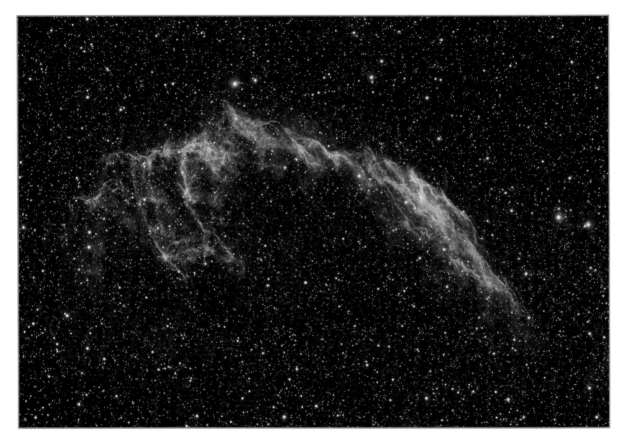

The color balance coefficients are constant for a given sensor and a given set of filters and they can be determined definitively as described in appendix 7.

A good calibration and gradient removal process is even more critical with LRGB images than with monochrome images because any background unevenness makes color adjustment challenging.

Processing the Colors of Emission Nebulae Photographed with a Color Sensor

Processing is much trickier in this case. The sensitivity to Hα wavelengths and the color rendering of OIII may be different from one color sensor to another, with little margin for adjustment of the colors during processing if you want the stars to show realistic colors.

As mentioned, you can use an Hα filter with a color sensor to suppress the light pollution when you're photographing emission nebulae. Of course, after demosaicing,

all objects in the image will be completely red and the image must be converted to a monochrome one. Thus, the best solution is to extract the red component of the RAW image with an astronomical software package, without demosaicing it. Of course, the number of pixels will be reduced by a factor of four, but it is a better solution than merging the RGB layers after demosaicing because the G and B layers contain nothing but noise.

Processing the Colors of Emission Nebulae Photographed with a Monochrome Sensor Using RGB or Narrowband Filters

The colors of emission nebulae obtained with a monochrome sensor and broadband RGB filters can be adjusted using color coefficients to produce realistic star colors. The situation is much better than with a color sensor since the transmission of astronomical R filters is always very good in Hα (and SII), the main line of emission nebulae. However,

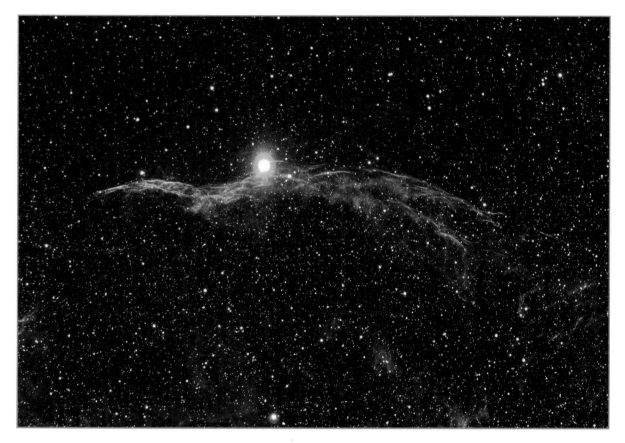

as with color sensors, the OIII line can take any hue from blue to green, depending on the particular filter set used.

To produce a more realistic representation of the emission lines, you could use other coefficients determined from the quantum efficiency (QE) of the sensor and the transmission of the filters for each line. However, in this situation, the stars will assume unrealistic colors with an incorrect tint.

If only two filters are used, an Hα and an OIII, you could assign Hα to the red channel and OIII to the green and blue channels. If three filters (SII, Hα, and OIII) are used, their images can be assigned to the red, green, and blue layers, respectively, of the final image to achieve the famous mapped colors SHO palette (also called the Hubble palette because this is how the famous picture of the Eagle Nebula taken with this telescope was colorized). Logically, you should balance the layers with coefficients determined from the values of sensor sensitivity for each line. For example, if a sensor is half as sensitive to OIII as to Hα, you should enhance the OIII layer by a factor of two before combining them to get the color image. But then the Hα line would probably crush the other lines, especially SII, producing a greenish nebula with little color variation. Making all lines equally visible ends up amplifying the layers corresponding to the weaker lines, with two consequences:

- When imaging, this amplification should have been taken into account by using an exposure time for the weaker lines that is proportionally longer in order to reach a comparable SNR after processing.
- The stars will take a strong dominant color, typically magenta in SHO, if the SII (assigned to red) and OIII (assigned to blue) lines are rebalanced over Hα. Skillful amateurs separate the stars from the nebulae (by selection in Photoshop) and apply different color coefficients to each part before merging them, leading to more realistic stars colors.

PROCESSING, REALISM, AND AESTHETICS

Typically, processing a planetary image consists of trying to make an image that's as close as possible to what is visually perceived through the telescope, possibly with a higher contrast to give a better view of the details. But processing deep-sky images is less straightforward since the result obtained cannot be compared to deep-sky visual observation; very few galaxies show spiral arms through an eyepiece, and none of them show color through amateur telescopes. Thus, it is difficult to define the correct look or representation of a deep-sky image. Nevertheless, most processing operations attempt to get close to what the eye would see if it were more sensitive to low intensities and to the color of dim objects or if the celestial objects would emit a more intense light, as in the following examples:

- Image calibration and signal-to-noise ratio improvement. Photon noise is not perceived visually and human vision does not suffer from thermal signals and does not notice vignetting and gradients.
- Brightness compression. The response of the eye is not linear but logarithmic, more or less similar to an inward curve.
- Color adjustment with daylight RGB balance coefficients. Color coefficients adjusted to yield more realistic colors, for example, stars that are white overall.
- Narrowband imaging. Allocation of a color corresponds to the true color of each emission line (for example, red for Hα).

On the other hand, some processing operations are of a different type because they tend to move the result away from reality to favor an aesthetic goal, especially the "mapped colors" technique and selective processing. The latter consists of selecting different areas in the image and processing them differently (sharpness, saturation, contrast). This may lead to an image in which the natural order of luminous intensities is not maintained, such as, for example, an image of the Orion Nebula in which the core looks dimmer than the wings despite the fact that the core is much brighter. In my opinion, any approach is tenable as long as the viewer is warned about the processing applied, especially for the techniques that move away from reality.

THE DEEP-SKY IMAGING PROCESS STEP-BY-STEP

If possible, make your first attempts in deep-sky imaging with a short-focal length telescope or even with a wide-angle photographic lens if you can. The objects will be easier to find and tracking will be less problematic. During the first night, familiarize yourself with the camera and the mount: polar alignment, object research and framing, focusing, capturing the images, and verification of the images as they are recorded on the screen of the camera or on a computer.

Once these techniques are mastered, select an object, take several exposures of it, and several calibration frames (dark, flat, and bias frames). The next day, carefully calibrate each image, and register and combine them. Play with the levels. If needed, remove any gradients.

When you are comfortable with your equipment and basic processing techniques, you can try deep-sky photography with a longer focal length, but realize that you may need autoguiding equipment and software. If you own a CCD camera with a filter wheel, attempt LRGB imaging only when you have mastered the production of a pleasing monochrome image.

The possibilities of manipulating the colors do not stop here. For example, an Hα narrowband image can be colorized with color images taken with RGB broadband filters. If the main emission line is Hα, as it is for most nebulae, the colors of the nebula and the stars are realistic, with the additional advantage of a field less crowded with stars, thanks to the narrowband filter used for the luminance component. Moreover, the Hα image can be taken in a sky polluted by city lights or moonlight. Actually, any combination of colors is possible, as long as the viewer is warned of the processing applied and what each color represents in the final image!

To conclude, let me say that a beautiful image does not always require a set of color images and that a monochrome image of a nebula taken in Hα can also be quite visually appealing. If the nebula emits only Hα light, a colorization in red does not give additional information and even decreases the contrast because the details are better perceived in black and white.

Perceived problem	Possible causes
The stars at the edges or in the corners of the image are fuzzy or elongated, whatever the exposure time	Field coverage of the instrument is incompatible with the sensor used (coma or astigmatism aberrations)
	Inappropriate distance between the sensor and a focal reducer or a field corrector
The stars are fuzzy in the center or in the corners of the image, depending on the focusing position and the exposure time	Field curvature (use a field flattener)
The stars are fuzzy or elongated on one side of the sensor, whatever the exposure time	Collimation defect or camera not perpendicular to the optical axis
The stars are drifting and this drift is proportional to the exposure time	If the drift is along the RA axis only, the periodic error or tracking speed is not equal to the sidereal speed
	If the drift is partly or totally along the declination axis, this could be imprecise polar alignment, mechanical flexures between the main telescope and the guide telescope, an overloaded mount, or abnormal mechanical play
The stars are surrounded by a diffuse halo	Chromatic aberration
	Dew on the optics
The image is globally not sharp	At a short focal length, imprecise focusing
	At a long focal length, imprecise focusing and/or bad seeing
The final processed image is noisy	Too little total exposure time for the object chosen, the sensitivity of the camera, the F/D ratio of the telescope, and/or the level of light pollution
The edges of the image are dark or show dust shadows	Flat-field correction not performed or defective
	Field coverage of the telescope not compatible with the size of the sensor used (especially with a focal reducer)
The background in the image is not uniform	Flat-field correction not performed or defective
	Stray light reflected from non-blackened surfaces
	Presence of gradients due to light pollution
There are residual hot pixels	Dark correction not performed or defective (change of temperature or dark frame too old)
The colors are not satisfying	Wrong color balance coefficients (for a DSLR)
	For emission nebulae, sensor with low sensitivity to certain emission lines

Several common problems and their probable causes. The cures have been described within this chapter. To understand the origin of a problem, study your images. For example, periodic error can cause a blurring of the images only in RA, while a defective polar alignment also causes a drift in declination. Try to change the settings and the parameters to see if the problem also changes; for example, the drift or the field rotation due to a bad polar alignment is proportional to the exposure time, while the elongation of the stars caused by astigmatism or coma is not.

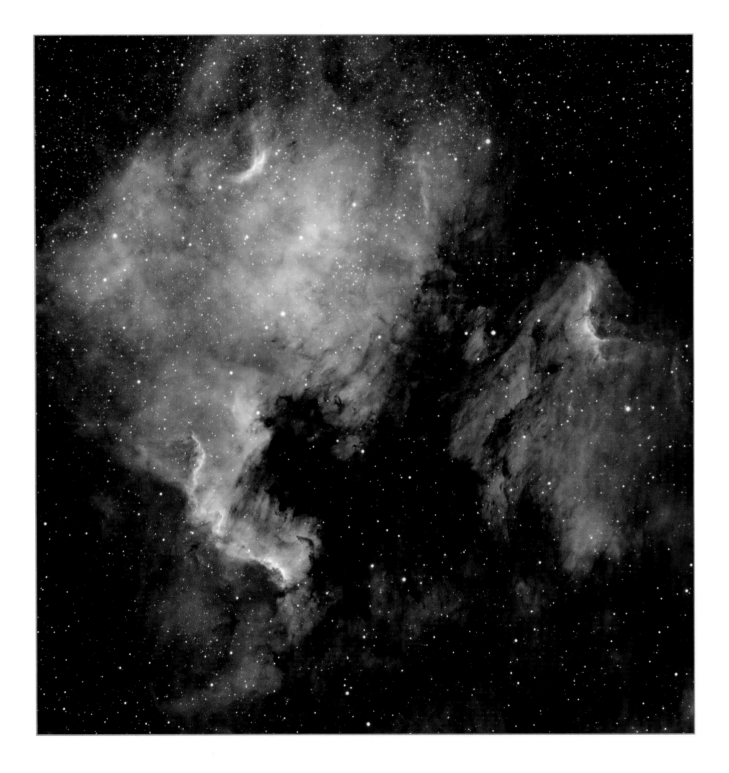

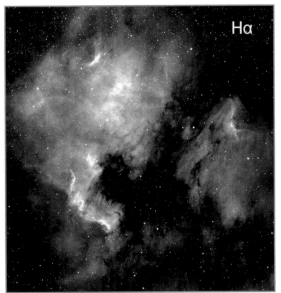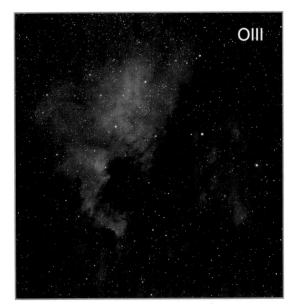

◀ *This false color image of the North America and Pelican nebulae covers 3° and shows the SII, Hα, and OIII lines isolated with a set of 3 nm wide narrowband filters using a CCD camera from a very light-polluted area, with cumulative exposure times of 12, 2.5, and 4.5 hours respectively. Each 5-minute raw frame was calibrated and all of them were registered. Then, each stacked group was assigned to a layer in the MaxIm DL Combine Color function in LRGB mode: Hα to luminance and green, SII to red, and OIII to blue.*

 To compensate for the weakness of OIII, and especially SII with regard to Hα, their respective amplification factors were 3.5 and 10. Final adjustment of levels, curves, and color saturation was done using Photoshop after export from MaxIm DL in 16-bit TIFF format.

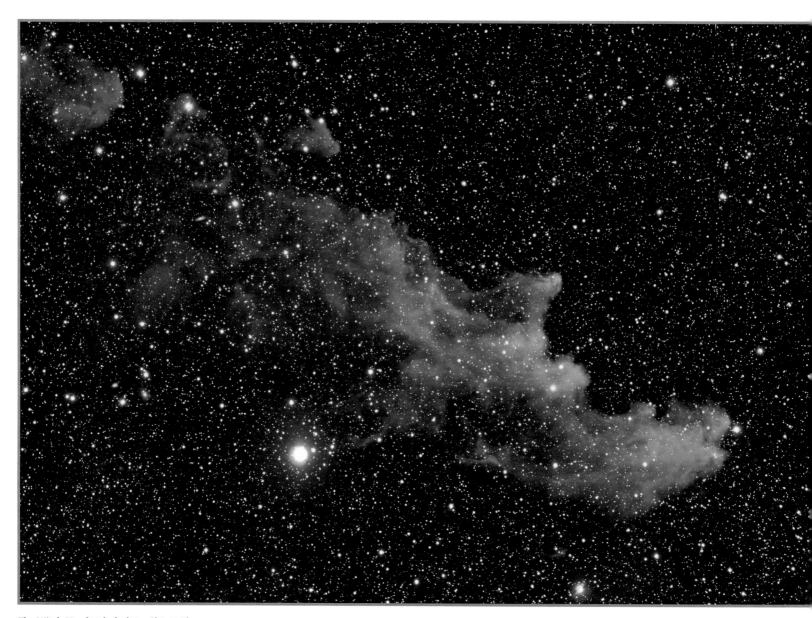

The Witch Head Nebula (IC2118) in Eridan

Appendices

Appendix 1:
File Formats and Operations

This appendix provides a discussion of the formats commonly used in astronomy and basic operations that any astronomical software is able to apply. You can find additional information in many books about digital photography.

Common File Formats

All of the information contained in an image is stored in a file. Each of the many ways to organize the parameter and pixel data inside the file is called a format. Each format has its advantages and disadvantages and is used for a particular purpose.

TIFF Format

TIFF stands for Tagged Image File Format, and along with JPEG, is one of the most used photographic formats. Its structure is simple: It is a sequence of numbers that represent the digital values of the pixels in the image. From the position of a number in the sequence, you can determine the pixel it corresponds to in the image. Of course, three numbers per pixel are required for a color image: one for the red layer, one for the green layer, and one for the blue layer. The volume of the corresponding file is easy to calculate: each pixel needs 1 byte (black-and-white image) or 3 bytes (color image). For example, a color image of 6 million pixels requires 6,000,000 bytes per color, or 18 million bytes in total, which corresponds to a file size of about 18 megabytes (MB).

An important feature of TIFF is its ability to encode images in 8-bit or 16-bit depth for each color. In the second case, the file size is doubled: 36 MB for a color image with 6 million pixels.

The bitmap (BMP) format is a cousin of TIFF because they are both uncompressed formats (see the next section, "JPEG Format"), but a bitmap file can store only 8 bits per color.

JPEG Format

The TIFF format would be perfect...if it did not lead to huge files, too large to place on a website, send via email, or store on a low-capacity memory card. This is why compressed formats were invented, such as JPEG for images, MPEG or DV for videos, and MP3 for audio. These files are encoded and decoded using highly sophisticated mathematical algorithms designed to reduce the number of bytes needed for storage while preserving the quality of the original data as much as possible. There are two types of compression:

- ❯ Lossless compression: Once a file is decompressed, all of the initial data is restored without any deterioration (the famous ZIP compression algorithm is of this type)
- ❯ Lossy compression: Data loses quality and artifacts may appear, all the more so when the data is highly compressed and the number of bytes is small

In the first case, the reduction in file size is relatively small and does not exceed 50 % on most images. In the second case, the JPEG compression rate is set by the user when the file is saved, and the reduction is much more significant. The final file size depends not only on the resolution of the image but also on its content: at equal compression ratio,

ADDITIONAL INFORMATION

In addition to the digital data representing the numerical values of each pixel, an image file contains general information about the image or the image parameters. Formats are more or less flexible in this regard; some are used to store information or comments on the imaging parameters, such as exposure time, instrument or lens used, and camera settings (this additional information is called EXIF data). For example, although adjusting the white balance does not affect the numerical values contained in a RAW file (see RAW Format below), this setting is stored as a comment in the file so that the software decoding the RAW file can use it.

an image rich in detail (or noise!) requires more bytes than a uniform or blurred image.

Although this is not an ideal situation, the fact that an image (or a video) is compressed does not mean in any way that it can't be used and give good results. Everything depends on the magnitude of the loss and the subsequent use of the image; a strong compression will be more acceptable on an image already processed and meant to be posted on a website than it would be on an image subject to additional processing (large changes in contrast or sharpness, for example).

GIF Format

Graphics Interchange Format (GIF) is an 8-bit format primarily used for animations because it is optimized for holding a small sequence of images with an adjustable update time between consecutive images. Its main limitation is its range of 256 colors per pixel, which is small. It has been gradually supplanted by the Portable Network Graphics (PNG) format, which has more extensive capabilities: up to 16 bits per color and lossless compression.

Almost all still images appearing on web pages are JPEG and animated GIFs are used for short animations.

RAW Format

The RAW format was born with the first high-end digital cameras. It is the equivalent of negative film for film photography. We should be talking about RAW formats, though, because each manufacturer has its own. They are all designed to save the raw data directly from the sensor and the digitization chain without any transformation (although in some cameras there may be modifications to the digital data to remove defects such as banding). The structure of the Bayer matrix is retained as it is, without interpolation being carried out for the creation of the three RGB layers. This interpolation will be performed later by the software that will decode the format (see appendix 3). At most, a lossless compression is applied. In other words, a RAW image is nothing more than a monochrome image that is structured exactly like the Bayer matrix covering the sensor, and each pixel corresponds to one and only one photosite. For these reasons, a RAW image takes two to three times fewer bytes than an 8-bit color TIFF image. The term *color filter array (CFA)* is sometimes used to refer to such an image.

Another advantage of the RAW format is that it contains data coded beyond an 8-bit depth, usually in 14-bit, which corresponds to 16,384 levels (2^{14}).

FITS Format

It would have been appropriate to start this discussion with the Flexible Image Transport System (FITS) format because its place in astronomy is important. It is indeed a comprehensive standard format created by and for the scientific community and adopted widely by both professional and amateur astronomers. FITS is the preferred format of astronomical software, which are able to open, process, and save this format, usually only for 16-bit monochrome images.

Although 16-bit pixel values range from 0 to 65,535 ($2^{16}-1$), some astronomical software clips this to 15-bit (0 to 32,767) or interprets the top half of the range of digital values (32,768 to 65,535) as negative (−32,768 to 0).

This format includes a header that summarizes exposure parameters: camera, instrument, target, exposure time, and other settings.

Proprietary Formats

Some CCD camera manufacturers and astronomical software developers have created their own formats as an alternative to FITS for 16-bit images, monochrome, or color (for DSLR or CCD camera images). This includes, in particular, SBIG type 3 for SBIG, CPA for Prism, and PIC for IRIS.

AVI Format

With the Audio Video Interleaved (AVI) format, we leave behind the world of still images to enter the world of video. This format is designed to store a large number of images; a simple video sequence recorded at a frame rate of 30 frames per second contains 1800 images! Astrophotographers are interested in this format because it is used by many webcams and video cameras. AVI contains 8-bit data, compressed or not (see chapter 5).

SER Format

The SER format is to video what RAW is to photography. This format is used by numerous astronomical video cameras to record images in noncompressed sequences, from

Format	File name extension	Compression (with loss)	Number of bits per layer
TIFF	.tif	No	8 or 16
GIF	.gif	Yes; number of colors reduced to 256	Fewer than 8
JPEG	.jpg	Yes	8
FITS	.fit or .fts or .fits	No	16
RAW	Variable according to the manufacturer; for example, .cr2 for Canon, .nef for Nikon, .orf for Olympus	No	Conform to the digitization capabilities of the camera (generally 14-bit)

Summary of the most used images formats and their main characteristics.

8- to 16-bit. Of course, the files can be huge: with a 1 million pixel sensor, 1 hour of video at 60 frames per second results in a 216 MB file with 8-bit data, to be doubled if the data is 10-bit or more. This format is recognized by specialized planetary processing software.

Format Conversions

During format conversion, a fundamental principle is to stay over 8 bits as long as possible and go to a compressed format as late as possible. Converting an 8-bit image to 16-bit is usually a mistake because it does not create information, but when 8-bit images are to be stacked (see chapter 5), it may be desirable to move to 16-bit.

Some astronomical software is able to simultaneously handle the three RGB channels of a color image. Other software must deal with three images (or three sets of images) separately.

Displaying Images

How images are displayed on the screen depends on the type of software used. In consumer software, an image is always presented in its full dynamic range: pixels at 0 are displayed in black, while bright ones at 255 are white (for a monochrome image). In between, the gray levels are arranged linearly. For example, a pixel at 128 will be represented as medium gray. When we touch up the contrast and the brightness of the image, the digital values are recalculated: if our mouse is positioned over a reference pixel, we can see that its value has been changed.

The display methodology is different with astronomical software. It has two values to set, the high threshold and low threshold, usually by means of sliders. The former is used to select the value to be displayed as pure white, the latter setting the value displayed as pure black. For example, if you open a 16-bit image in one of these programs and then position the high threshold to 4000 and the low threshold to 2000, all pixels with a value lower than 2000 will be displayed as black, while those greater than 4000 will be displayed as white. A pixel at 3000 is displayed as medium gray. Changing thresholds produces the same visual effect as changing the contrast and brightness of the image, but only for display; pixel values are not changed.

Note that when Photoshop displays a 16-bit image, it shows values between 0 and 255, as it would do for an 8-bit image, and not between 0 and 65535 as does astronomical software. But, it performs operations with greater accuracy, as if the digital values were decimal numbers with digits after the decimal point, not visible but used in the calculations.

Common Operations on Images

The basic operations described in the following sections are commonly used in astronomical image processing, either directly by the user or implicitly through complex algorithms and calculations. Any astronomical software mentioned in this book is able to perform these operations.

Arithmetical Operations

Many arithmetical operations can be performed on the values of each pixel in an image: addition, subtraction, multiplication, division, etc. Arithmetical operations between images can also be made; for example, calibration (chapter 3) uses subtraction and division of images pixel by pixel.

With some operations, there may be a saturation of pixel values. For example, if an image is processed in 8-bit,

multiplication of the image by a factor of two will cause the original values lying between 128 and 255 to clip to 255. In addition, subtraction operations may lead to negative values that some software packages retain and others just clip to zero.

Resizing

To resize an image is to transform it into an image having a larger or smaller number of pixels. Since the final number of pixels is different from the original number, the software must perform interpolation (discussed in chapter 2). There are many interpolation algorithms, from the simplest—duplication of pixels—to more sophisticated ones like bicubic interpolation.

Inversions

An inversion (also called a symmetry or mirror effect) consists of reversing the order of the rows of the image, or its columns. For example, you saw in chapter 6 that the Herschel wedge reverses an image, as does a mirror.

Windowing

Windowing consists of cropping out a rectangular portion of an image by selecting the coordinates of the four corners or directly with the mouse. This operation is often used to remove the black borders remaining after registration and stacking of a series of images.

Rotations

The two parameters for a rotation are the central point (pivot) and the rotation angle. A given angle of an image is rotated around a given point. This processing, which uses interpolation like demosaicing or translations operations do, is intentionally designed to correct field rotation between multiple images to be stacked (chapter 7). When the rotation is performed without a prior change of the image dimensions, parts of the image are lost as they go outside the limits of the image area, and black areas can also appear at the periphery.

Translations

A translation consists of shifting the contents of the image horizontally and/or vertically by a given number of pixels. This operation is most commonly used for the registration of images before stacking. With the help of interpolation, astronomical software is able to perform a translation by a noninteger number of pixels—for example, 10.3 or 3.95—which greatly improves the accuracy of registration.

Appendix 2:
Astronomical Cameras and Software

This appendix presents, in alphabetical order, most manufacturers of astrophotography equipment: CCD cameras, video cameras and accessories (filters, filter wheels, flip mirrors), and some astronomical software widely used by amateurs. Note that this list and related descriptions, compiled in 2013, is not exhaustive and is subject to change. Review the companies' websites regularly!

Video and CCD Cameras

Apogee
Products: CCD cameras for deep-sky imaging
Country: United States
Website: www.ccd.com

Atik Cameras
Products: CCD cameras for deep-sky imaging
Country: Portugal
Website: www.atik-cameras.com

Celestron
Products: CCD cameras for deep-sky and planetary imaging
Country: United States
Website: www.celestron.com

Finger Lakes Instrumentation (FLI)
Products: CCD cameras for deep-sky imaging
Country: United States
Website: www.fli-cam.com

IDS Imaging Development Systems
Products: Planetary video cameras
Country: Germany
Website: http://en.ids-imaging.com

The Imaging Source
Products: Planetary video cameras
Country: Germany
Website: www.theimagingsource.com/fr_FR

Lumenera
Products: Planetary video cameras
Country: Canada
Website: www.lumenera.com

Point Grey
Products: Planetary video cameras
Country: Canada
Website: http://ww2.ptgrey.com

Quantum Scientific Imaging (QSI)
Products: CCD cameras for deep-sky imaging
Country: United States
Website: http://qsimaging.com

Santa Barbara Instrument Group (SBIG)
Products: CCD cameras for deep-sky imaging
Country: United States
Website: www.sbig.com

Starlight Xpress
Products: CCD cameras for deep-sky imaging
Country: United Kingdom
Website: www.starlight-xpress.co.uk

Filters and Photographic Accessories

Manufacturer	Main products	Website
Astrodon	LRGB, narrowband and near-infrared filters, off-axis guiders, IR-blocking filters for DSLR	www.astrodon.com
Astronomik	LRGB, antipollution, narrowband and IR-pass filters for CCD cameras and DSLR, filter wheels	www.astronomik.com
Baader	All types of filters: LRGB, antipollution, narrowband, UV, IR, IR-blocking, solar, etc. Broad range of mechanical and optical accessories	www.baader-planetarium.de
Custom Scientific	LRGB and narrowband filters	www.customscientific.com
Hutech	LRGB, antipollution, and narrowband filters; modified DSLRs; focusers; focal reducers	www.sciencecenter.net
Optec	LRGB and narrowband filters, filter wheels, focal reducers, focusers, rotators	www.optecinc.com
RoboFocus	Motorized focuser with temperature compensation	www.robofocus.com
Starizona	HyperStar lenses	http://starizona.com
True Technology	LRGB filters, filter wheels, flip mirrors	www.trutek-uk.com

Astronomical Software

The programs listed in the following table are able to support most or all astronomical processing algorithms described in this book. Some also include additional algorithms for image analysis (astrometric and photometric measurements) or functionality to aid equatorial mount polar alignment, collimation, instrument control, and planetarium features. Many of them include controls for video cameras, CCD cameras, and DSLRs, and some are specialized for such operations.

Software	Application	Website
Astroart	Acquisition and general processing	www.msb-astroart.com
AutoStakkert!	Planetary processing	www.autostakkert.com
AviStack	Planetary Processing	www.avistack.de
CCD Commander	Imaging automation	ccdcommander.com
CCDWare (CCDNavigator, PEMPro, CCDInspector, CCDAutoPilot, CCDStack)	Planetarium, mount optimization, optical alignment, imaging automation, general processing	www.ccdware.com
DeepskyStacker	General processing	deepskystacker.free.fr
FocusMax	Focusing	www.focusmax.org
IRIS	General processing	www.astrosurf.com/buil/us/iris/iris.htm
MaxIm DL	Acquisition and general processing	www.cyanogen.com
PixInsight	General processing	pixinsight.com
PRISM	Acquisition and general processing	www.prism-astro.com/us/index.php
RegiStax	Planetary processing	www.astronomie.be/registax
TheSkyX	Planetarium, telescope control	www.bisque.com/sc

Appendix 3:
From the Sensor to the Image

The production of a digital image is not limited to the collection of light by the sensor. After the collection of light the readout phase occurs, during which the electrons stored in the photosites are collected and digitized as described in chapter 2. Finally, for a color sensor, the demosaicing operation takes place to produce an image with three components (red, green, and blue).

Readout of the Image

Readout of a noninterline CCD sensor (also called a *full-frame sensor*) follows the principle of the first figure on the following page. For interline CCD sensors, readout is performed according to the second figure on the following page.

In CMOS sensors, the contents of each photosite can be read out directly. There is no need to successively shift their contents.

Obtaining a Color Image

With a monochrome sensor, the final stage of the rendition of a digital image is simple: each pixel of the image corresponds to one and only one photosite, and the image is a true reflection of what the sensor recorded. The number generated by the analog-to-digital converter (ADC) for a given photosite is proportional to the quantity of photoelectrons accumulated by the pixel (given the possible presence of bias and thermal signals, as explained in chapter 3).

However, with a color sensor, things get complicated. If we merely associate a photosite to each pixel in the image, it would not have a convincing appearance. For example, let's suppose that we have photographed the blue sky: the image would look like a checkerboard, with a bright pixel on one of every four pixels (corresponding to the photosite covered with a blue filter). But everyone knows that in a

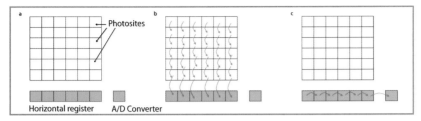

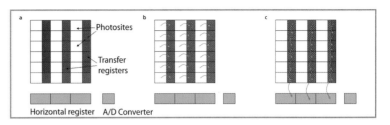

In addition to its photosite array, a CCD sensor contains an additional line of photosites, which are shielded from light and called the horizontal register (a). At the end of exposure, when digitization begins, the application of an appropriate sequence of voltages causes the global transfer of the accumulated charge of each line to the one located immediately below (b), while the last line is transferred to the horizontal register. The latter is then shifted one position to the right (c) to transfer the content of the first photosite to the amplifier and subsequently perform digitization. After that, the horizontal register is shifted one step further to read out the contents of the next photosite, and so on for all the photosites of the horizontal register. Once this register has been fully digitized, a new vertical shift can then be performed (b again) to transfer the next line.

These operations are sequentially repeated for all sensor lines and photosites by means of a built-in microprocessor controlling the clocks. Binning is performed using multiple shifts. For example, for 2 × 2 binning, two lines are shifted into the horizontal register, and then 2 pixels at a time are clocked into the readout amplifier summing junction.

In CCD interline sensors, widely used in video cameras, each column of photosites is accompanied by a second column shielded from the light (a). At the end of the exposure, the contents of the former is very quickly transferred into the latter (b). The readout can then be performed as described for a noninterline CCD sensor through the sequence of shifts of the content of the shielded columns into the horizontal register (c), but without the need for a mechanical shutter masking the sensor at the end of the exposure.

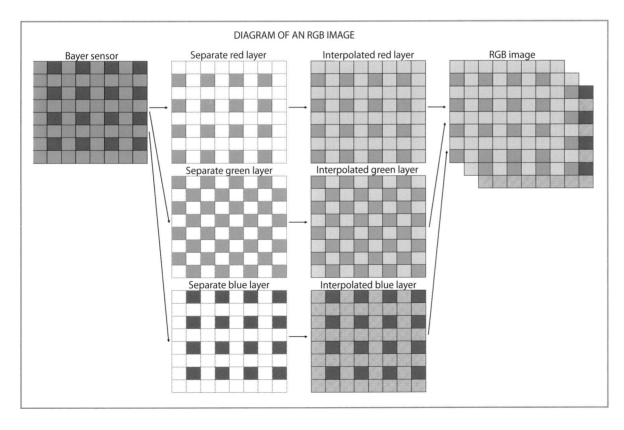

DIAGRAM OF AN RGB IMAGE

The reconstruction of an RGB image from data collected using a Bayer matrix sensor (solid colors) is done by means of interpolation to fill in the missing data (dotted colors)

THE FOVEON SENSOR

The Foveon sensor has no color filter grid. It can distinguish photons of different wavelengths by another technique, taking advantage of the fact that blue photons penetrate less deeply into the silicon than do green photons, and green ones are shallower than red ones. The sensor is structured in three layers, just like color film; each layer is responsible for storing electrons from photons of each color. Unlike a sensor with a Bayer matrix, a Foveon with 3 million photosites collects 9 million data points, which corresponds to the amount of information required for direct construction of an image with 3 million pixels, without any interpolation. This is why manufacturers of cameras equipped with this type of sensor state that the number of photosites must be tripled when being compared to a sensor based on the Bayer matrix.

This solution is attractive in principle, but for the moment the cost of these sensors is higher and characteristics such as quantum efficiency and color separation are still being improved. It is hoped that future technological advances will produce sensors that are more efficient and competitive, and more useful for astronomy!

The Foveon sensor exploits the fact that photons penetrate more deeply into the silicon at longer wavelengths

110 to the right one, we give the value 105 (the average) to the blue pixel associated with our green photosite. When this operation is done for all pixels of the image by computing the missing values, it is called *demosaicing* the Bayer matrix, or even *debayering*. The type of interpolation described previously is quite simplistic. In practice, the interpolations performed rely on more complex mathematical algorithms including a few more neighboring photosites.

Black-and-White Mode with a Color Camera

Some cameras offer a black-and-white mode in their setup menus, which works by mixing the three color components. This method may seem attractive for monochrome objects such as the moon and sun, but conversion to black-and-white can easily be done later in the computer. Using a black-and-white shooting mode during capture does not offer any value to astronomy because of the following reasons:

- It does not improve the true sensitivity (quantum efficiency) of the camera because the Bayer filter matrix covering the sensor has not been removed
- It has no influence on the data in the raw file

Appendix 4:
Uniformity Defects—Causes and Remedies

color image, each pixel must have its own color, so it must have three values: one for red, one for green, and one for blue. In other words, a color image of 10 million pixels actually contains 30 million data points. But the sensor has only 10 million photosites: where did the additional 20 million come from? From interpolation!

Consider the green photosite of the first line of our color sensor (on the previous page). It is surrounded by two blue photosites, one to its left and one to its right. This green photosite is not sensitive to blue light and therefore we do not know the amount of blue light that reached it. The best we can do is to assume that the most likely value for this unmeasured value falls somewhere between the values determined for its blue neighbors. For example, if the converter assigned 100 to the left blue photosite and

You saw in chapter 3 that vignetting and dust shadows can be corrected by processing the collected images with a flat-field image. However, it is still important that these defects be as small as possible in the raw images, for the following reasons:

- Vignetting causes a degradation of the SNR by loss of light. After correction, the periphery of the image is noisier than the center.
- It is all the more difficult to obtain fully representative flat-field images (and therefore good levels of correction) when the defects are pronounced

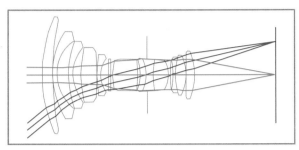

The inclined light beam sees the lens entrance pupil as an ellipse and converges obliquely toward the periphery of the sensor, with a greater distance to travel compared to the central beam reaching the center of the sensor (Document: Leica)

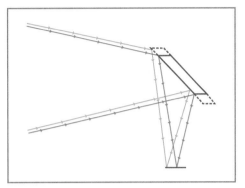

The Newtonian telescope secondary mirror shown in this figure is undersized for imaging: it reflects all of the light rays traveling to the center of the field (green) but not those to the periphery of the field (red). A larger secondary mirror (dashed lines) would offer a more fully illuminated field. Many books and websites provide formulas to calculate the size of the secondary mirror as a function of the required photographic field.

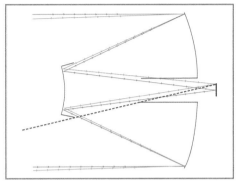

While preventing stray light from reaching the prime focus directly (dashed line), the baffling of Cassegrainian family telescopes causes vignetting whose magnitude depends on the design and position of focus. A focal reducer increases this effect because the field of the sensor is expanded and the focus of the instrument is moved back.

Vignetting

The causes of vignetting at the image plane are diverse and can include geometrical, optical, and mechanical effects as follows:

1. **Geometrical:** The aperture of the instrument, as seen by light rays arriving obliquely, is not a circle but an ellipse, with a collecting surface that decreases as the incidence angle increases. On the camera side of the instrument, these rays reach the sensor nonperpendicularly and have traveled a slightly greater distance, which also results in a decrease of the light intensity on peripheral pixels compared to the center of the sensor. This effect is particularly noticeable with wide-angle photographic lenses.

2. **Optical:** One of the optical elements is undersized with respect to the field to be covered. For example, some Newtonian telescopes have a secondary mirror whose diameter is just large enough to reflect the light rays to a point at the center of the field, but a portion of the rays traveling to an off-axis point miss the secondary. In a telescope, the secondary mirror design is a compromise between the desire to minimize the central obstruction and the constraints of deep-sky photography. Telescopes specifically designed for deep-sky imaging with large sensors generally have a larger secondary mirror than those optimized for visual use.

3. **Mechanical:** An element of the instrument blocks light rays coming from the periphery of the field. Several common components are particularly likely to cause this effect if they are not correctly designed for imaging:

 ❯ The dew shield: If you build one for your instrument, be sure to size it large enough, considering the field to be covered. The dew shields designed by manufacturers for their photographic lenses or astronomical instruments are always properly sized.
 ❯ In the Cassegrain telescopes (including the Schmidt-Cassegrain), the baffles that extend between the primary and secondary mirrors. These baffles are essential because they prevent the light from the sky background from reaching the eye or sensor directly, which would have a disastrous effect on the contrast of the image. Baffle design is always a compromise between suppressing stray light and minimizing vignetting at the edge of the field. On refractors, the internal baffles, comprising several sharp-edged diaphragms, are designed to prevent stray light reflections off the walls of the tube and can also cause vignetting.
 ❯ The internal tube of the focuser, in particular on refractors where it may be long
 ❯ Any element placed just in front of the camera: adapter ring, filter, off-axis guider, etc.

Vignetting Caused by a Camera Adapter

This deserves some attention because the remedy is simple. Let's suppose you use a 1.25" male ring to install your DSLR via a T-ring (see chapter 4) on an instrument with a focal ratio of 5. In this example, the front of the male ring is located about 100mm from the sensor. A simple calculation allows us to infer that the width of the light beam reaching the center of the sensor, 100mm in front of it, is 100/5 = 20mm. The whole cone of light rays passes through this ring, whose inner diameter is about 27mm (shown in green in the following image), at least for the central cone heading to the center of the sensor.

For those rays directed toward the periphery, this situation is different. To simplify, we can assume that the cone aimed at a point located 10mm off-axis from the center of the sensor is parallel to the central cone and laterally displaced 10mm from it (shown in orange in the following image). For this cone, the ring's inner diameter needs to be at least (20 + 10) = 30mm, which is not the case. As a result, the ring causes vignetting.

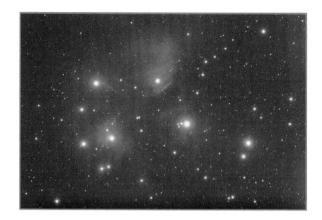

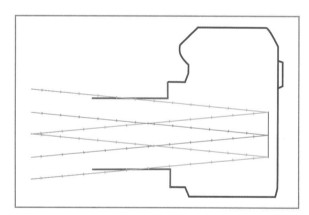

This diagram of a DSLR shows that an adapter with a 1.25" ring (blue) can cause vignetting

Let's generalize: to determine whether a mechanical element placed on a telescope (focal ratio, R) at a distance (T) in front of the sensor (diagonal, D) causes vignetting or not, use the following formula to calculate the minimum opening and verify that the inner diameter of this element is greater than or equal to this value:

$$D + \frac{T}{R}$$

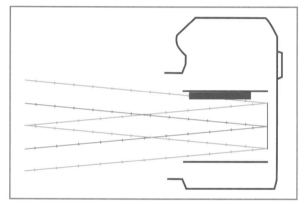

Another cause of vignetting: When my DSLR is mounted on my short focal ratio refractor (f/5), the bottom of the RAW image (top) shows a loss of light. This is due to vignetting by the reflex mirror (center, blue), which in the flipped-up position, is aligned with the top of the sensor (remember that telescopes and lenses produce a reversed image). A flat-field image (bottom) shows this effect clearly.

Vignetting Caused by a Filter

Another classic cause of vignetting is placing filters in front of the camera. For example, a filter with a mechanical diameter of 1.25" has an optical aperture of about 26mm. It is obvious that with a 24 × 36mm sensor (44mm diagonal), there will be vignetting. In this case, you should use a 2" filter.

Dust

Visible round spots on the images are from dust particles close to the sensor, including those on its surface. It is easy to demonstrate that the size of the shadow of a small particle located at a distance (D) from the sensor is equal to D/R (R being the focal ratio of the telescope). Thus, for a focal ratio of 10, a particle located 5mm in front of the sensor produces a shadow 0.5mm in diameter, clearly visible, while if it were 50mm in front of the sensor, its shadow would be 5mm diameter and be invisible on the image. In other words, do not worry about dust particles far away from the sensor, especially those located on the telescope mirrors or lenses. They will cause no visible effect on the image.

The first way to avoid spots is to prevent particles from being deposited on the sensor. When you change the lens on your DSLR, do it quickly and, if possible, in a place with little dust, keeping its opening facing down. Keep the cap on your video or CCD camera nosepiece when it is not installed on the telescope. The second way is to clean the sensor. Photography magazines regularly publish articles on various cleaning methods. But even after cleaning, it is difficult to achieve a sensor that's 100 % clean. Camera manufacturers and camera repair shops offer professional sensor cleaning services. If there are a few remaining dust particles, do not worry; they will be corrected by a good flat-field frame.

The easiest way to verify the presence of dust on the sensor is to capture a flat-field image at the largest possible focal ratio: the spots will be small and obvious. With a digital camera, simply set the lens to the smallest aperture (f/16 or f/32) and aim it at a wall or the sky. With a CCD or a video camera, you can use a long, narrow tube placed in front of the sensor or illuminate it with a small LED at a distance.

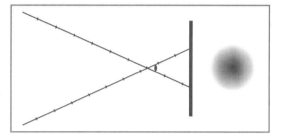

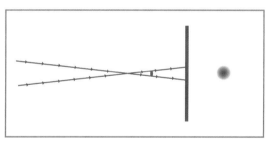

A fast focal ratio (top) causes larger and lower contrast shadows than a large ratio (center). But, the distance between the dust particle and the sensor also plays a role, with the shadow being smaller and darker if the particle is closer (bottom).

Appendix 5:
Checking and Adjusting an Equatorial Mount

Measuring the Periodic Error

Measuring the periodic error is a good way to verify that the actual tracking quality is in conformity with expectations. This operation is performed, after careful polar alignment, by monitoring the drift of a star near the intersection of the celestial equator and the meridian. Only the tracking errors in right ascension are measured to identify periodicities, over several turns of the worm. The measurement is made, with the help of a camera recording at a rate of one image per second or higher, by plotting a graph of stellar position as a function of time. The axes of the camera should be aligned to those of the mount. The entire procedure can be handled by PEMPro (CCDWare), which is also able to train the periodic error correction (PEC) system of the mount from the measurements.

The free software PEAS (which stands for Periodic Error Analyzing Software, available at www.grecner.cz/astro/peas_a.htm), used in conjunction with other astronomical software, is also able to determine and analyze the periodic error curve. Otherwise, you can apply the following processing on a series of images extracted from the video sequence:

1. First, the star position in each frame of the series is determined using astronomical software able to store a text file containing the drift of the star along both axes (in pixels) for each frame.
2. Next, the list of values is copied into a Microsoft Excel spreadsheet and a chart is created from the data, graphing the drift in right ascension as a function of time. To calibrate the x- and y-axes, you need to know the interval of time between two successive frames and the sampling resolution in arc seconds (chapter 4).

Adjusting the Mount

Tuning a German mount is simple, but essential, if you want to obtain good photographic results, with or without PEC and autoguiding. The main adjustment involves the right ascension axis worm wheel and worm gear. As with any set of gears, a little play will exist between them. To check the play, tighten the mount slip clutch (if it has one) and try to gently move the mount back and forth in right ascension by taking the optical tube in one hand and the counterweight bar in the other hand. You can have as little backlash as you want, but it must remain perceptible. If you feel absolutely nothing, the worm is probably pressed tight against the gear and then you may experience the following problems:

- The motor may struggle and even stumble if it is not powerful enough
- The mechanical parts will be subject to premature wear
- Vibrations can be transmitted from the motor to the optical tube, which may affect the sharpness of the image
- The tracking can become irregular, with increased periodic error

The adjustment of the worm is made by trial and error: loosening its screws, positioning the worm, tightening the screws, and checking the play. If the temperature drops, the play decreases and may even disappear, so it is preferable to tune the mount at outdoor operating temperatures. When I adjusted the position of the worm

Gently swinging the mount in right ascension allows you to check the play between the worm and the gear

This periodic error chart was made from the measured position of a star in a series of webcam images over 30 minutes. The x-axis is scaled in seconds of time, the y-axis in arc seconds. The rotation period of the worm of this mount can easily be deduced from the graph; it is 10 minutes. The black line shows the linear trend. Its tilt relative to the x-axis may come from a tracking speed slightly different than the sidereal speed, or simply from a small polar alignment error.

These mounts have an external adjustment of the worm, making adjustment easier. For other mounts, the mechanism is internal, but the adjustment can be done by slightly shifting the position of the housing containing the worm.

on my first equatorial mount, I reduced the periodic error from 30 arc seconds to 10! As for collimation—even if the mount has been tuned by the manufacturer or the dealer—the adjustment may change during transportation. On another of my mounts, because of the vibrations transmitted from the motor, the Airy disk was split in two, looking like a figure eight: the instrument lost more than half its resolving power! A simple adjustment of the worm was enough to correct the problem.

If the gear train is accessible, make sure there is a hint of play between them: block one with the hand while trying to rotate the next. When you balance your German mount in right ascension and declination, leave a slight imbalance to one side to avoid a small oscillation due to mechanical play. Although less critical, also check the mechanism in declination by using the same method.

If your mount has a manual slow-motion adjustment, check the smoothness of the mechanism by rotating the telescope, using the slow motion control, one full turn in right ascension. You should notice no tight spots. If you find one at every turn of the worm, the worm may be skewed or even slightly bent. If tight spots occur in certain right ascension positions, your mount drive may suffer from one of the following defects:

● The gear is slightly eccentric with respect to the polar axis. If you cannot adjust its position, increase the play of the worm accordingly.
● The gear and worm wheel need to be greased, which sometimes occurs with older mounts. Use high-quality grease that remains fluid regardless of the temperature, such as ones with Teflon or silicone. If you think the original grease is not good, you can even degrease the mechanism before applying the new one (note that solvents such as trichloroethylene degrease very well but are toxic, so handle carefully!).

Amateurs who are surprised that manufacturers design instruments on which the worm or the mirrors need to be adjusted by the user must not forget that a bicycle needs to be adjusted and lubricated regularly also. Certainly, an astronomical instrument's gears are not as coarse as those of a bicycle, and the mechanical precision required for the instrument is a magnitude or more greater than for a bicycle.

Tangent worms are held in place at their ends by stops (also visible in this photo in the form of a metal disc with small holes) that, if they are too tight, can cause rotation irregularities

Appendix 6:
Making Eclipse Sequences

Conventional eclipse sequences (*beads*) consist of a lunar or solar central disk corresponding to the moment of maximum of the total or partial eclipse, framed by an equal number of disks before and after the maximum. The sequence is displayed in a landscape view at the observation site. The path of the sun or moon and the scale of the images are realistic: each disk is located at a position and orientation corresponding to its actual position in the sky. In addition, the diameter of the disks and their mutual angular spacing are consistent. Of course, the astrophotographer is free to make beads in a less realistic composition: different scales, arrangement in a straight line, circle, spiral, and so on.

Preparing for Imaging

The method to achieve regular beads is identical whatever the type of eclipse: solar or lunar, total or partial. It begins with a careful image plan. The starting point for calculation is the time corresponding to the maximum of the eclipse. Calculate the two time intervals separating the maximum from the beginning and the end of the eclipse (in the ephemeris, they are called the first and last contacts). Beware that these intervals are generally close but not identical! Then divide them by the number of disks that you want to insert in the final image before and after the maximum to obtain the time separation of individual shots.

For example, an eclipse begins at 9:02 and ends at 11:44, with maximum at 10:20. Time intervals are respectively 78 minutes and 84 minutes. If you want to make a string with six disks before the maximum and six disks after, the two periods will be 13 minutes and 14 minutes, respectively. The moments of image capture will then be as follows:

- Before maximum (period of 13 minutes): 9:02, 9:15, 9:28, 9:41, 9:54, 10:07
- Maximum: 10:20
- After maximum (period of 14 minutes): 10:34, 10:48, 11:02, 11:16, 11:30, 11:44

Often, the beginning or the end of the eclipse is not visible from the observation site because the sun or moon has already set or not yet risen at that time. The number of disks before and after the maximum can then be different and the period for the shortened half can be the one calculated for the fully visible half of the eclipse. If the maximum is not visible, the period is simply calculated by dividing the duration of visibility of the eclipse by the desired number of disks.

During imaging, use a stopwatch or an intervalometer. In the excitement accompanying an eclipse, it is easy to forget one frame of the sequence! The position of the lunar or the solar disk in each frame does not matter because it will be placed in the desired location later during processing. However, it is safest to approximately center it to avoid potential problems with vignetting or loss of sharpness in the corners.

Assembling the Frames

The disk positioning calculation in the final image sequence is simple. To determine the positions, use the horizontal coordinates—altitude on the horizon (h) and the azimuth (A)—of the eclipsed body for every frame you plan to combine, provided by an ephemeris or any good planetarium software. If Δh and ΔA are the altitude difference and the azimuth difference between two frames (in degrees), respectively, the differences in pixels (horizontally and vertically, respectively) between the centers of the two disks on the image should be as follow, D being the diameter (in pixels) of the lunar or solar disk:

$$\Delta x = 1.9\,D\,\Delta A \cos h$$
$$\Delta y = 1.9\,D\,\Delta h$$

The preparation of the final bead image is iterative, with Photoshop or a similar program. The starting frame can be a fully black image or a photograph of a landscape taken shortly before or after the eclipse and resampled to the proper size. Each eclipse frame is then copied and pasted as a new layer on the working image and then moved with the mouse to position the center of the disk on the location calculated using the previous formulas, with the help of the cursor coordinates indicated by the software. The two layers are then merged and the next frame added with the same operation. It is easier to start by placing

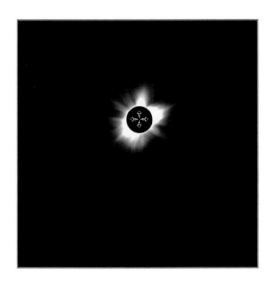 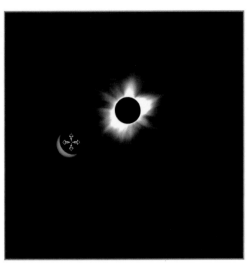

The making of the bead image begins with pasting the frame showing the maximum of the eclipse on the start image (landscape or black image) as a new layer and placed in the desired location using the mouse (left). Each new frame is then subjected to the same operation (right).

the central disk and then place all other disks in order of distance away from it.

The Orientation of the Disks Taken in Equatorial Mode

If the pictures were obtained with a camera on a tripod or an alt-azimuth mount (see chapter 5 or 7), the disks are correctly oriented in rotation. In contrast, if an equatorial mount was used, each of the disks needs to be rotated before assembly to produce the orientation that would have been obtained with an alt-azimuthal mount. The angle of rotation is called the parallactic angle, and its value (q) is given by the following formula, taken from Jean Meeus's book *Astronomical Algorithms, 2nd Edition* (Willmann-Bell, 1998):

$$\tan q = \frac{\sin H}{\tan \Phi \, \cos \delta - \sin \delta \, \cos H}$$

with:

Φ: observation site latitude
δ: declination of the sun or the moon
H: hour angle, calculated as follows:

$$H = \theta_0 - L - \alpha$$

with:

θ_0: sidereal time
L: observation site longitude (positive toward west, negative toward east)
α: right ascension of the sun or the moon

All these parameters must be expressed in the same units (for example, degrees) before being combined. If the angle (q) is found to be negative, the rotation of the disk is counterclockwise, and clockwise if positive. This method assumes that the camera is aligned to the equatorial axes; the larger dimension of the sensor is parallel to right ascension.

Lunar Beads Centered on the Shadow of the Earth

Another way to make lunar beads is to consider that the fixed point is not the landscape but the shadow of the earth, across which the moon glides during an eclipse as demonstrated in the image on the next page.

This time, we must work in equatorial coordinates instead of alt-azimuthal. Of course, this shadow (not visible, except indirectly when it masks a part the moon) follows the rotation of the sky, but it also moves against the stars as the earth rotates slowly around the sun during the eclipse. The equatorial coordinates of the center of the shadow are easy to get if you realize that it is located exactly opposite the sun: if α_s and δ_s are the right ascension and declination of the sun, respectively, the center of the shadow has equatorial coordinates as follows:

$$\alpha_0 = \alpha_s \pm 180°$$
$$\delta_0 = -\delta_s$$

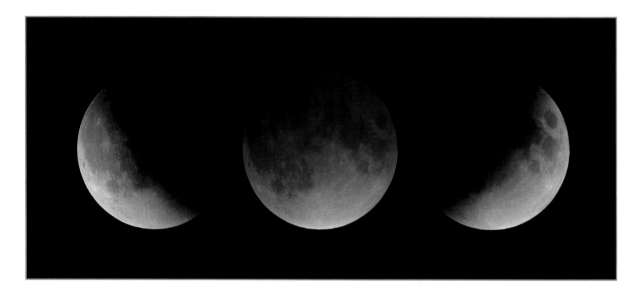

This image illustrates a lunar bead. The totality phase picture required an exposure time 2000 times longer than the partial phases (4 seconds versus 1/500 second). These images were taken November 2003 from the Netherlands with an intermediate camera attached, in an afocal configuration, to a 180mm telescope.

Next, we can calculate the equatorial coordinate differences $\Delta\alpha$ and $\Delta\delta$ (in degrees) between each frame and the center of the shadow of the earth. The differences in pixels in the final image are finally given by the following:

$$\Delta x = 1.9 \, D \, \Delta\alpha$$
$$\Delta y = 1.9 \, D \, \Delta\delta$$

Now, the correction of the parallactic angle must not be performed. Therefore this type of lunar bead is easier to make with a camera on an equatorial mount. With an alt-azimuthal mount, prior to assembly, each disk should be rotated by the angle –q, where q is the parallactic angle calculated using the formula given previously.

Appendix 7:
Optimizing the Camera Settings

Optimum Individual Exposure Duration for Deep-Sky Imaging

After deciding on the total exposure time for a given target, you must choose the duration of each individual exposure that will be collected. To determine the optimum individual exposure duration at which a longer single exposure has no value, follow these steps:

1. Take pictures with increasing exposure time, by a factor of two, with your usual conditions (site, instrument, camera, settings, filters)
2. Calibrate each image carefully with master dark and flat-field frames made from at least 10 dark and flat-field frames, convert it in RGB if it's a RAW image, and correct any background gradient
3. Using astronomical software, measure the background noise (standard deviation, or *sigma*) in small portions of the image without stars or nebulosity
4. Make the same measurement on a single bias image minus another single bias image, and divide the result by the square root of 2 (1.41) to obtain the readout noise.

The optimum individual exposure time is reached when the background noise exceeds the readout noise by a factor of three to four. At that level, the images are said to be "sky background limited." Of course, this duration may exceed the capability of your mount, especially if you do not autoguide.

For example, on calibrated exposures of 1 minute, 2 minutes, 4 minutes, and 8 minutes, you might obtain background standard deviations of 13, 17, 23, and 32 analog-to-digital units (ADUs), respectively. If the readout noise is 6 ADUs, the optimum exposure time is therefore around 4 minutes. This means that for a total exposure time of 40 minutes, the final SNR will be better with

10 exposures of 4 minutes than with 40 exposures of 1 minute, but it would not be significantly improved if you used 5 exposures of 8 minutes.

This optimum duration is shorter when the readout noise is low or when the sky background level is high. Therefore, the use of a narrowband filter or a telescope of higher focal ratio increases the individual exposure length, while using a sensor with higher quantum efficiency or lower readout noise decreases it.

Optimal DSLR Deep-Sky ISO Setting

In planetary, lunar, and solar photography, selecting the lowest sensitivity or ISO setting (100 for most DSLRs) provides the best SNR because it allows longer exposure times so you are able to collect a higher signal.

On faint deep-sky objects, experience shows that at equal exposure time, different ISO settings provide relatively close results in terms of SNR. Of course, with higher ISO settings, the image looks brighter on the screen of the camera, but the noise is higher too. This should not surprise you if you remember that this setting does not affect the intrinsic sensitivity of the sensor (its quantum efficiency) but simply boosts the amplification of information from it. You can deduce from chapter 3 that the photon signal and the associated noise are amplified in the same way. The ISO setting therefore has no influence on the photon SNR.

The same principle goes for the thermal signal and its noise: equal SNR is obtained whatever the ISO setting. The only component of the image that this setting can influence is the readout noise. On most DSLRs, particularly on Canon cameras, while the readout noise seems to increase when measured in ADU (because of the ISO amplification), when expressed in electrons it actually decreases as the ISO setting gets higher, at least to a certain ISO threshold. This behavior is characteristic of CMOS sensors. The optimum setting corresponds to the value after which the readout noise does not decrease anymore (or very slightly), and therefore using a higher value yields no benefit. The method to find this setting is as follows:

1. Take a series of bias RAW images at the shortest duration (for example 1/4000 second) at different ISO settings: 100, 200, 400, 800, 1600, etc.
2. Open these images in an astronomical software program, without demosaicing them (RGB conversion), and measure the standard deviation in small areas.
3. Normalize the measurements to ISO 100: the ISO 200 deviation value is divided by 2, the ISO 400 value by 4, the ISO 800 value by 8, and so on. This calculation then gives numbers proportional to the readout noise in electrons.
4. A chart is made with the ISO setting along the x-axis and the normalized standard deviation in the y-axis.
5. The optimum setting is slightly after the bend of the curve, where the readout noise reaches a limiting value and the curve flattens out.

This method cannot be used with Nikon DSLRs because their bias level is set to zero in the RAW file, preventing a reliable measurement of the readout noise. In this case, you can use the DxOMark measurements.

On the Canon 100D, I have measured bias frame standard deviations of 7.5, 8, 10, 15, 25, 44, and 84 ADUs, at ISO 100, 200, 400, 800, 1600, 3200, and 6400, respectively. Normalized to ISO 100, they become 7.5, 4, 2.5, 1.9, 1.6, 1.4, and 1.3. The optimum setting lies around ISO 1600, where the curve becomes almost flat.

For any DSLR model, the DxOMark Dynamic Range charts offer an alternate method of calculating the optimum ISO setting. By placing the cursor on each point of the curve, you can determine the level at which the curve becomes straight; in other words, where a dynamic range value differs from the previous one by at least 0.8 to 0.9 EV (exposure value). In this example, the optimum ISO setting is about ISO 1600 for the Canon 650D and ISO 200 to 400 for the Nikon D7100. To obtain these charts, go to www.dxomark.com/index.php/Cameras/Compare-Camera-Sensors, select your camera(s) in the list, click Compare up to 3 items, then Measurements, and finally Dynamic Range.

White Balance Coefficients Applicable to DSLR (RAW) and RGB Imaging

The RGB coefficients to be applied to each color channel are stored inside a RAW image so that a program like Camera Raw or DxO can obtain a color balance in accordance with the camera setting. But, when such an image is opened in astronomical software, no coefficient is applied and the image shows a dominant color, usually green.

Each DSLR model has its own coefficients. In addition, if its IR-blocking filter has been changed (chapter 7), the coefficients have changed too. The coefficients may already have been determined by other amateurs, but if this is not the case, here is the method:

1. Take a flat-field frame by photographing, in RAW mode, a white paper sheet (or better, a gray card) directly exposed to sunlight with your DSLR; the white balance setting should be Daylight. Try to limit vignetting by closing the diaphragm of the lens to f/11 or f/16.
2. Immediately examine the RGB histogram on the screen of the camera to make sure the image is gray and does not show a dominant color.
3. Open the RAW file in your astronomical software, subtract a bias frame (chapter 3), and then convert it to RGB.
4. Determine the three coefficients from the ratio of the intensities of the RGB components. For example, if the mean intensities are 1000, 1500, and 1200 ADUs, respectively, the RGB coefficients normalized to green are 1.5, 1, and 1.25, which, once applied to the image, would produce a common intensity value of 1500 for each component.
5. This method is also applicable to an RGB filter set and a CCD camera. In this case, apply step 4 with the three RGB images obtained using the same exposure time, after subtraction of a bias frame.

When imaged in sunlight, a gray card enables determining the RGB coefficients for a DSLR or a CCD camera with a set of filters. Gray cards are available at photographic equipment retailers.

Appendix 8: Meteor Showers

Meteor shower	Radiant	Optimal date
Quadrantid	Boötes	January 3
η-Aquarid	Aquarius	May 5
Perseid	Perseus	August 12
Orionid	Orion	October 20
Leonid	Leo	November 17
Geminid	Gemini	December 14

Several remarkable meteor showers. The observation period falls across several days before and after the optimal date.

Index